UPROAR!

THE FIRST 50 YEARS OF THE LONDON GROUP 1913–63

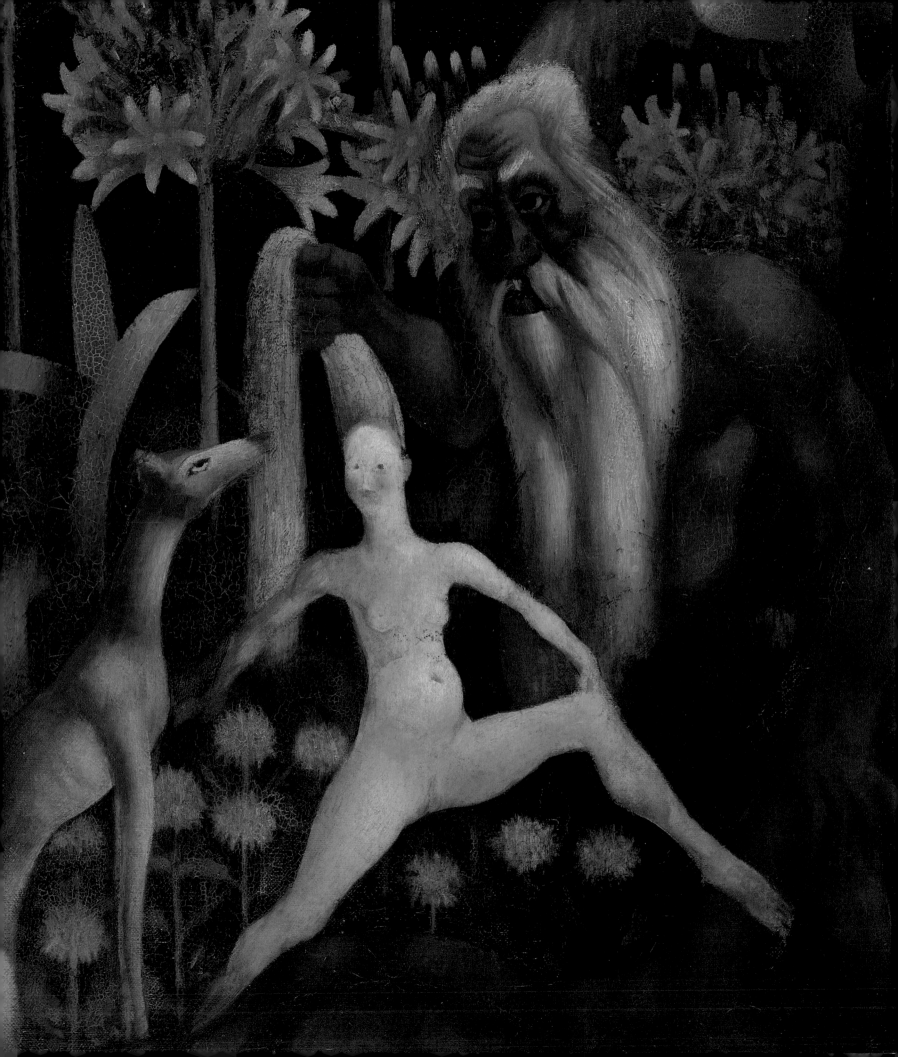

UPROAR!

THE FIRST 50 YEARS OF THE LONDON GROUP 1913–63

EDITED BY SARAH MACDOUGALL AND RACHEL DICKSON

LIBRARY & LRC

Art, Identity, Migration

LUND HUMPHRIES

This publication is published to
coincide with the exhibition
Uproar! The first 50 years of The London Group
at Ben Uri, The London Jewish Museum of Art
31 October 2013 – 2 March 2014

Ben Uri
in association with
Lund Humphries

Ben Uri
*108a Boundary Road,
London NW8 0RH*

www.benuri.org.uk

Lund Humphries
*Wey Court East, Union Road,
Farnham, Surrey, GU9 7PT
UK*

and

*110 Cherry Street, Suite 3-1
Burlington, VT 05401-3818
USA*

Lund Humphries is part
of Ashgate Publishing

www.lundhumphries.com

British Library Cataloguing-in-
Publication Data
A catalogue record for this book is
available from the British Library

Library of Congress Control Number:
2013943401

ISBN 978-1-84822-144-4

Edited by Sarah MacDougall
and Rachel Dickson,
assisted by Rachel Stratton

Picture research by Lauren Barnes,
Monica Keska, Rachel Stratton and
Rosie Wardle

Catalogue designed,
typeset and produced by
Isambard Thomas, London

Printed by Zanardi, Padova

EDITORIAL NOTE

In deference to the current Group,
we have retained the capitalisation of the
definite article in The London Group
throughout, except in quotations.

All dimensions are in centimetres, height
before width unless otherwise stated.

In the Artists' Biographies, schools of art
are referred to in full when first
mentioned, and thereafter abbreviated.

DETAIL ILLUSTRATIONS

p. 2
Cat.9, Mark Gertler, *The Creation of Eve*,
1914

p. 7
Cat.46, Euan Uglow, *Big Bertha*, 1953

pp. 10–11
Cat.17, William Roberts, *At the
Hippodrome*, 1920–21

pp. 14–15
Cat.5, Spencer Gore, *Harold Gilman's
House at Letchworth, Hertfordshire*, 1912

pp. 22–23
Cat.34, John Piper, *Abstract*, 1937

pp. 38–39
Cat.2, Ethel Sands, *The Pink Box*, c.1913

pp. 66–67
Cat.47, Ivon Hitchens, *Red Spring*, 1955

pp. 170–171
Cat.6, Wyndham Lewis, *Sunset among
Michelangelos*, c.1912

pp. 188–189
Cat.4, Robert Bevan, *A Sale at Tattersalls*,
1911

pp. 194–195
Cat.25, Paul Nash, *Northern Adventure*,
1929

p. 224
Cat.40, Victor Passmore, *Abstract*, 1948

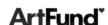

ACKNOWLEDGEMENTS

We extend thanks to all our lenders: Aberdeen Art Gallery and Museums Collections; Annely Juda Fine Art; British Council Collection; British Museum, London; Estate of Lynn Chadwick; Gillian Jason, Modern and Contemporary Art; The Hepworth Wakefield; Jonathan Clark Fine Art; Kettle's Yard, University of Cambridge; Leeds Museums and Galleries (Leeds Art Gallery); Leicester Arts and Museums Service; Manchester City Gallery; Museums Sheffield; The National Trust; Norwich Museum and Archaeology Service; Pallant House Gallery, Chichester; Ruth Borchard Collection, c/o Robert Travers Works of Art Ltd, Piano Nobile, London; The Samuel Courtauld Trust, The Courtauld Gallery, London; Southampton City Art Gallery; Tate; University of Leeds Art Collection; Victoria and Albert Museum; Whitworth Art Gallery, The University of Manchester; Williamson Art Gallery and Museum, Birkenhead; and many other private collectors who wish to remain anonymous.

We are indebted to all our external catalogue contributors: Dr Wendy Baron OBE; Dr Jonathan Black; Dr David Boxer; Dr Grace Brockington; David Cleall; Joanna Cheetham; Dr Richard Cork; Prof. Paul Edwards; Jane England; Stephanie Farmer; Rachel Fleming-Mulford; Hugh Fowler-Wright; Mel Gooding; Irving Grose; Prof. Anna Gruetzner-Robins; Frances Guy; Susan Haire; Dr David Boyd Haycock; Hannah Higham; Jane Hill; Neville Jason; Andrew Lambirth; Dr Alexandra MacGilp; Paul Martin; Jenny Pery; David Redfern; Dr Evelyn Silber; Dr Richard Shone; Quentin Stevenson; Claire Stewart; Dr Robert Upstone; Michael J K Walsh, Assoc. Chair (Research) School of Art, Design and Media, Nanyang Technological University, Singapore; Alice Wiggett; Dr Denys Wilcox; Philip Wright and Prof. Emeritus Maurice Yacowar.

Thanks are due to our book designer Isambard Thomas, to our copy-editor Harriet Powney, to Jane Horton for compiling the index, and to Lucy Myers and Emma Lilley of our distribution partner, Lund Humphries, for their continued enthusiasm for Ben Uri's exhibition programmes.

We also thank all the following for their help: Moich Abrahams; Layla Bloom; Sophie Bowness; Beau Brady; Dr Emma Chambers; Peter Clossick; Paul Conran; Stephen Coppel; Patricia Cowen ; Tim Craven; Philip Crozier; Elizabeth Fisher; Fiona Ford; David Fraser Jenkins; Henrietta Garnett; Rebecca Herman; Charlotte Heyman; Ruth Hibbard; Gillian Ingham; Gillian Jason; Alice Kadel; Hannah Kauffman; Simon Lake; Clarissa Lewis; Val Long; Sarah Marchant; Marlborough Fine Art; Miranda McLaughlan; Jessica Michael; April Miles; Siân Miller; Jean Milton; Danny Moynihan; Nigel Noyes; Michael Phipps; Justin Piperger; Simon Rendall; Katherine Richmond; Crispin Rogers; Frankie Rossi; Judith Russell; Gill Saunders; Colin Simpson; Ruth Shrigley; Gillian Smithson; Frances Spalding; Clementina Stiegler; Ann Steed; Sophie Steel; Paul Tecklenberg; Fernanda Torrente; Matthew Travers; Robert Travers; Liz Waring and The William Roberts Society.

We could not have brought this ambitious exhibition and accompanying book to fruition without the commitment of the Ben Uri team: Rachel Stratton, Curatorial Assistant; the intern researchers: Lauren Barnes, Monika Keska and Rosie Wardle; Rachel Rotrand and Laura Jones in Operations; Alix Smith and Gaby Edlin in Learning; and Catriona Sinclair, Web Manager.

Special thanks to our 'Preferred Partner', Manya Igel of Manya Igel Fine Arts, for generously sponsoring free entry to 'Uproar!' and to all our exhibitions this year so that there are no financial barriers to entry.

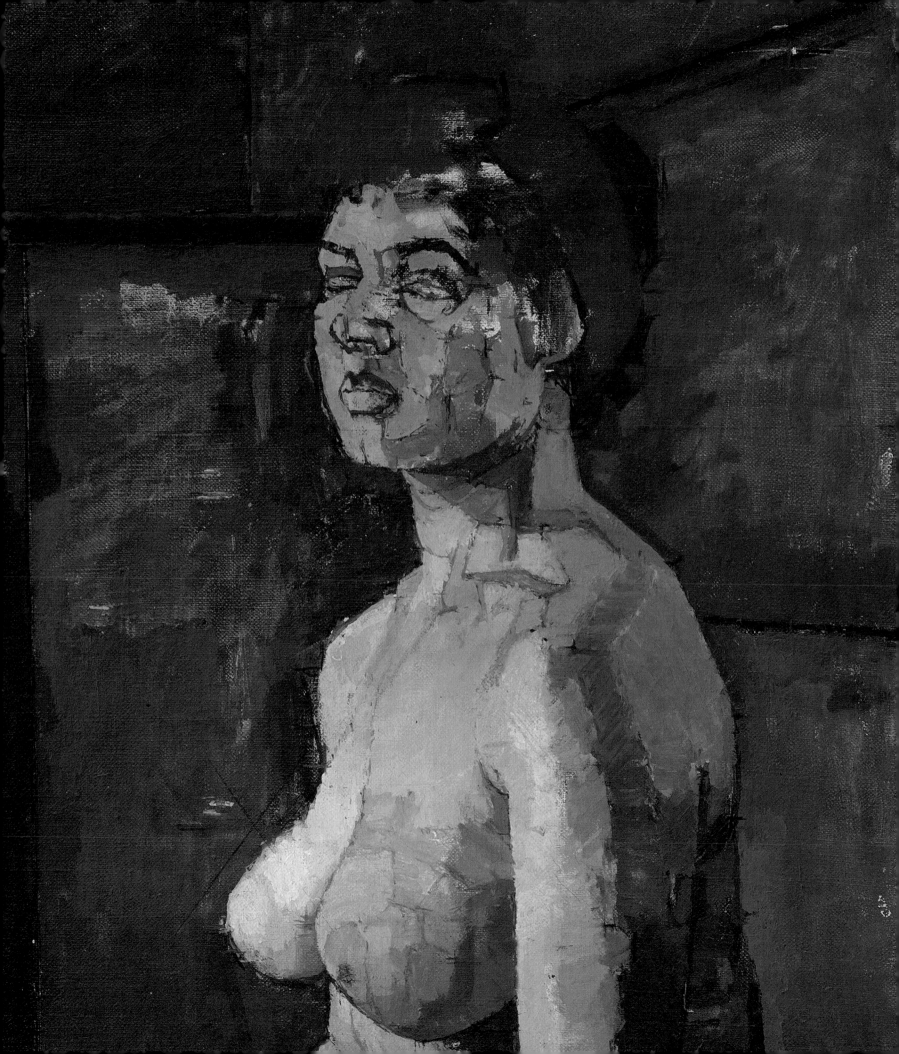

ALLAN WALTON VANESSA BELL

MATTHEW SM

NINA HAMNETT **THE BLOOMSBURY GROUP** DUNCAN GRANT

BERNARD ADENEY ROGER FRY

FREDERICK ETCHELLS

EDW

MARK GERTLER JACOB KRAMER

C R W NEVINS

THE WHITECHAPEL BOYS JACOB EPSTEIN

DAVID BOMBERG HORACE BRODZKY BERNARD MENINSKY

HENRI GAU

HANS FEIBUSCH OSKAR KOKOSCHKA

BORIS ANREP **ÉMIGRÉ ARTISTS** WILLI SOUKOP

T

MORRIS KESTELMAN MARTIN BLOCH

LONDOI

ABRASHA LOZOFF FRITZ KORMIS

1913

GERTRUDE HERMES ELISABETH FRINK FRANK DOBSON

FIGURATIVE SCULPTURE

RUPERT LEE EDNA MANLEY

I

ABS

STANLEY HAYTER

HENRY MOORE CERI RICHARDS

DIRECT CARVING

BARBARA HEPWORTH PETER NORMAN DAWSON

PAUL NASH **SURREALISM** EILEEN AGAR

ROGER HILTON H S WILLIAMSON

ST IVES

PETER LANYON

ROBERT BEVAN

STANISLAWA DE KARLOWSKA CHARLES GINNER

WALTER SICKERT **THE CAMDEN TOWN GROUP** SPENCER GORE

SYLVIA GOSSE ETHEL SANDS HAROLD GILMAN

LUCIEN PISSARRO CICELEY HEY

JOHN PIPER

ABSTRACTION-CRÉATION

...SWORTH

WYNDHAM LEWIS PAULE VÉZELAY

ORTICISM JESSICA DISMORR

...ESKA WILLIAM ROBERTS

RODRIGO MOYNIHAN

EDWARD MCKNIGHT KAUFFER

OBJECTIVE ABSTRACTION

GEOFFREY TIBBLE

WILLIAM COLDSTREAM

GROUP **THE EUSTON ROAD SCHOOL**

963 CLAUDE ROGERS

VICTOR PASMORE

L S LOWRY

...CHENS

JOHN BRATBY

ACTION **SOCIAL REALISM / KITCHEN SINK**

WILLIAM GEAR JACK SMITH

LYNN CHADWCK

KENNETH MARTIN KENNETH ARMITAGE

CONSTRUCTIVISM EUAN UGLOW

MARY MARTIN DOROTHY MEAD

EXPRESSIONISM

FRANK AUERBACH LEON KOSSOFF

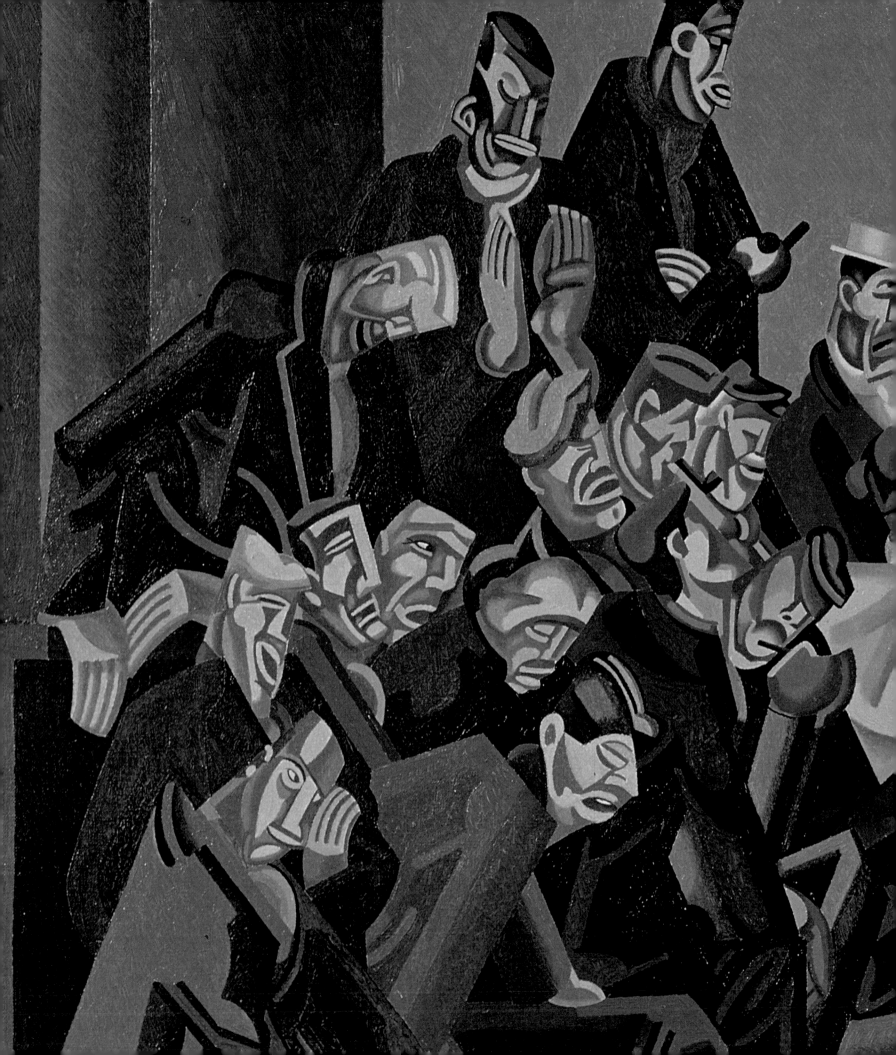

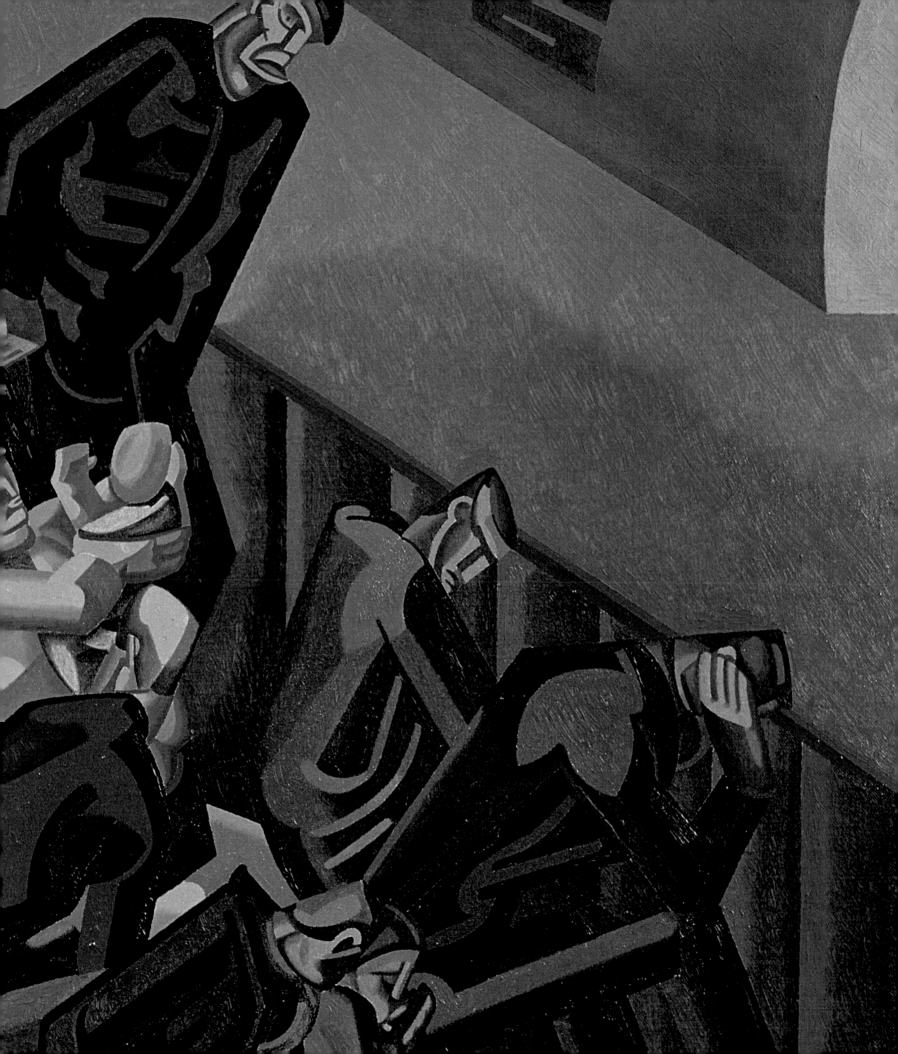

BEN URI CHAIRMAN'S FOREWORD

DAVID J GLASSER

Ben Uri is honoured to present *Uproar! The first 50 Years of The London Group 1913–63*, showcasing 50 works by 50 artists during this half century. The exhibition and this accompanying book mark the Group's centenary and its first minuted meeting on 25 October 1913. Founded as an alternative to the existing art establishment, the Group's turbulent early years reflect the controversial emergence of early British modernism and the experimental work of many of its members. The often inflammatory language of the press is exemplified by the 'uproar' which followed Mark Gertler's exhibition of *The Creation of Eve* at the Group's third show in 1915, which lends its name to our own exhibition exploring the Group's early history.

This partnership between Ben Uri and The London Group is a revealing reflection on both institutions' early and entwined histories. The London Group was founded by fresh-minded and free-spirited artists from the Camden Town Group and others experimenting with Cubism and Futurism. They were determined to embrace the new practice and movements arriving from Europe and from France in particular, to set a new agenda for a new century. However, their exhibiting opportunities in the mainstream were significantly restricted by an establishment dominated by the Royal Academy which was intent on maintaining the status quo. Coming together to form The London Group, it quickly became a magnet and an exhibiting forum for artists who were often considered rebellious by the establishment, and even in some quarters, notorious, during these early seminal decades in Britain.

Ben Uri was founded less than two years later, in July 1915, in the Jewish ghetto in London's East End, also in response to establishment prejudice and exhibiting restrictions. In this instance the artists themselves were 'outsiders' (irrespective of their artistic practice) – Jews, and what was probably considered worse, mostly immigrants or the children of foreign-speaking immigrants. Among them were a number of young Jewish artists committed to pushing artistic boundaries, including David Bomberg, Jacob Epstein, Mark Gertler and Jacob Kramer – now better known as 'The Whitechapel Boys' – who were immediately drawn to the artistic freedom and intellectual vigour of this new milieu. It was Jacob Epstein, the American émigré, who is credited with coining the name 'London Group' at a Group meeting, held on 15 November 1913. These same artists played significant historical roles during the first two decades of both The London Group and Ben Uri, and today, with extraordinary works of national significance, still represent the backbone of Ben Uri's 1300-strong collection. One hundred years later, most of the 50 'radical' artists exhibited in *Uproar!* are cornerstones of twentieth-century British modernism and a benchmark of respectability.

During the 1930s and 1940s, in response to the Group's open submissions policy, many Jewish émigré artists also used its annual exhibitions as their

exhibition platform – much as they did with the Ben Uri, but to a markedly different audience. In the appendix we list 40 artists, mostly émigré, from the Ben Uri collection who exhibited with The London Group in its first 50 years.

Ben Uri and The London Group have many links apart from age and heritage in the shaping of British modernism. Both have always fostered experimental work across a range of media. Both have embraced the involvement of women artists. Ben Uri's collection has 28% women artists and The London Group, under its second woman president, Susan Haire, has almost 25%, compared to around 5% in national galleries.

The centenary is a timely opportunity to reflect on The London Group as one of the most pivotal catalysts for change in twentieth-century British art and modernism.

It is almost 20 years since Denys Wilcox first published his authoritative volume *The London Group 1913–1939: The Artists and their Works*, as part of his PhD research, building on the work of Wendy Baron in her important history of the Camden Town Group (1979). In 2008 London Group archivist David Redfern followed with his sourcebook *The London Group: Origins and Post War History*. However, to date there has been no single volume illustrating visual highlights of the Group's extraordinary exhibition history. We hope that both this exhibition and this companion volume will remedy this omission and provide the first opportunity to see a remarkable range of artworks by some of the most important figures within British modernism situated within the context of The London Group.

The half-century surveyed explores The London Group's inception, its Camden Town Group roots, the controversy of the early (particularly First World War) years and Bloomsbury domination in the 1920s; the strong showing of Jewish and women artists, Official War Artists, avant-garde sculptors, the 'shadow of the right' during the 1930s, and the participation of the newly arrived émigré artists during the 1930s and 1940s; and the contribution of specific artists' groups, ranging from Vorticists to Surrealists, Abstract-Creationists and the Euston Road School.

Wherever possible, we have selected the most debated works, whether from within our own collection or from national, regional or distinguished private collections. These works reflect the new and the daring and those which consistently provoked a sense of 'uproar' at the time, as it was 'uproar' that added to the momentum for the public's appetite for the new. The exhibition, in displaying 50 of these significant and controversial works, brings together a remarkable survey and insight into the development of British modernism and the artists who then were the outsiders but today considered the establishment.

An exhibition of this scale requires partnership from many different quarters, both institutional and individual, and we have many thanks to offer. Firstly, Ben Uri pays tribute to The London Group's current president, Susan Haire, and to committee members Peter Clossick, Philip Crozier and Gillian Ingham for their support and enthusiasm for this project during the many years of its making. Special thanks go to David Redfern, The London Group historian, for access to The London Group archive and his insightful text on The London Group post-1963, to London Group members Moich Abrahams, for raising the initial concept, and Paul Tecklenberg, for his on-going commitment to the vision.

We extend particular thanks to Wendy Baron and Denys Wilcox, who have given generously of their time, knowledge and expertise, and without whose original pioneering work an exhibition of this scope and individual focus would not have been possible.

The exhibition and book would not have been possible without the shared commitment of all our many lenders and contributing scholars listed earlier and I take this opportunity to recognise them again here.

Special thanks to our 'Preferred Partner', Manya Igel of Manya Igel Fine Arts, for generously sponsoring free entry to *Uproar!* and to all our exhibitions this year so that there are no financial barriers to entry.

Finally, I pay the highest tribute possible to the museum's co-curators and editors Sarah MacDougall and Rachel Dickson who have invested some three years of their lives transforming the vision into reality.

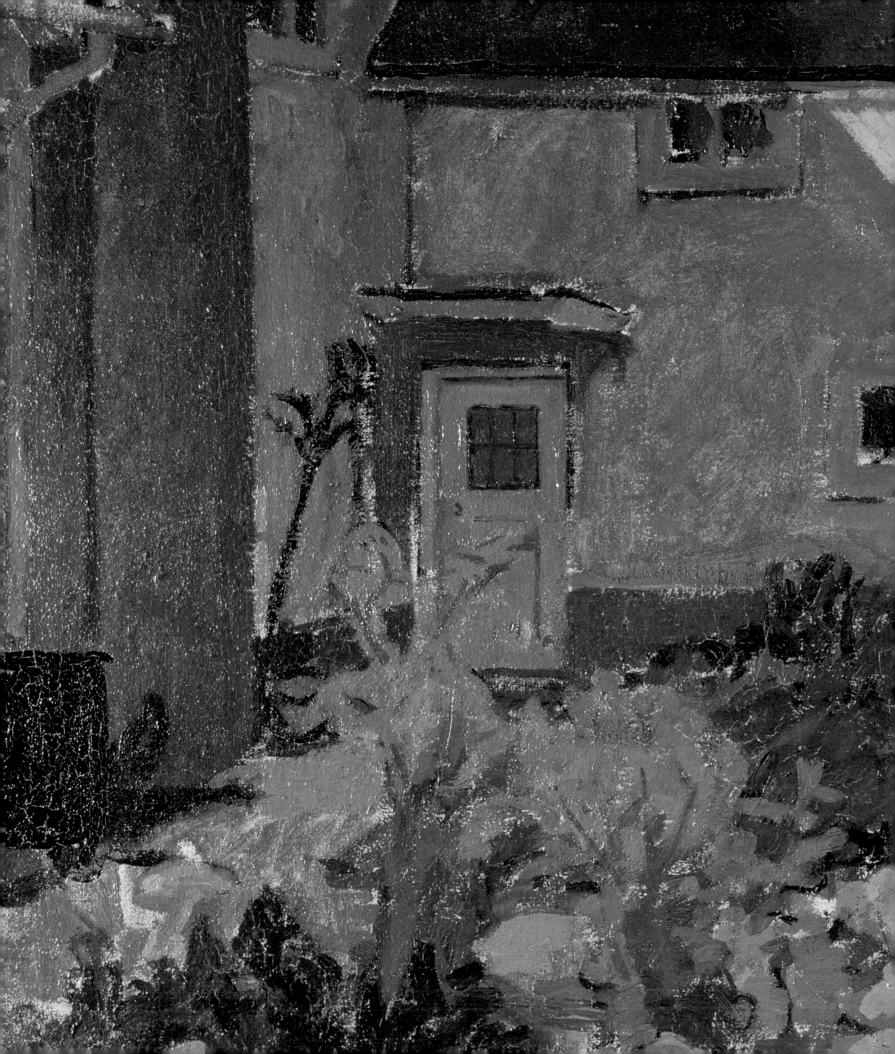

THE LONDON GROUP
PRESIDENT'S FOREWORD

SUSAN HAIRE

There could be no better way of celebrating The London Group centenary than with Ben Uri's exceptional exhibition, *Uproar! The first 50 years of The London Group*, showing 50 London Group artists from its first 50 years. Those members who have worked with Ben Uri's curators Sarah MacDougall and Rachel Dickson have been extremely impressed by their scholarship, thoroughness and dedication and the Group is privileged to be associated with Ben Uri for this important celebration.

The companion show *+100: The London Group Today* at the Cello Factory in Waterloo specifically marks the centenary of the coining of 'The London Group' name by founder member Jacob Epstein on 25 October 1913. In this exhibition current London Group members will be showing works made in response to many of the historic artists showing at Ben Uri. It has meant a great deal to the members to have researched and thought deeply about these works by early London Group artists and to create connections sparked by a personal engagement. In the process our awareness of the Group's illustrious history has been intensified – what an honour it is for us to be a part of their Group.

Today The London Group is a thriving collective of around 90 artists, showing several times a year and proud of the diversity of practices amongst its members which range from painting to performance.

Independent of institutions, the Group is self-funding and artist-run. The London Group has many strengths, presenting large and small exhibitions and opportunities for discussion within the membership and to a wider audience. We are almost like a big family with members giving vital support to each other in friendship and as fellow artists, and this is of great value in our tough careers.

The London Group Open is of major importance to the Group – without it we would just be a showing society, enclosed and inward looking. Since the 1950s the Open was pretty much the only platform available for artists to launch their careers and this was the case right up to 1995 when it was discontinued for 12 years for financial reasons. The Open was successfully re-launched in 2007 as a biennial exhibition and quickly became a hugely popular event in the art calendar, our centenary year having seen the fourth Open since then. The Group is committed to continuing the important tradition of offering young and emerging artists showing opportunities, acting as a springboard to launch careers and being able to award prizes to give a special boost to those of outstanding calibre. The Open does wonders for the Group itself, too, by keeping us in touch with younger artists, some of whom are subsequently elected to the Group benefitting us significantly by their enormous energy, enthusiasm and ideas.

In addition to the full Group exhibitions like the Annual and the Open, in 2001 Small Group Exhibitions were launched, giving opportunities for curated exhibitions where selected members are invited to show. The curators are given the opportunity to have a specific raison d'être, enabling a coherence not achievable in a full Group exhibition and making it possible to showcase particular kinds of work or philosophy in ways that present The London Group in a stimulating and challenging light, contributing insights that have major relevance to the condition of making art today.

We have been celebrating our centenary year with a number of exhibitions but the crowning glory is this collaboration between The London Group and Ben Uri. It is highly appropriate to mark the centenary by bringing together works by historic and current members with the affirmation of the Group's rich history through our responses. Thank you Ben Uri for all you have done to make this possible and for your truly inspiring exhibition.

INTRODUCTION: ORIGINS OF THE LONDON GROUP

WENDY BARON

The achievement of The London Group in reaching its centenary against all odds is beyond remarkable. From the beginning it aimed at inclusivity. Its title, The London Group, as opposed to the neighbourhood inferences conveyed in the terms the Fitzroy Street Group or the Camden Town Group, is in a sense a metaphor for this wider embrace. Created at a time of exceptional ferment in the British art world, it not only brought under its umbrella the cohort of painters and sculptors inspired by Cubism and Futurism, but weathered the ensuing early resignation of its founding fathers, Lucien Pissarro (1863–1944) and Walter Sickert (cat.18). Under the active and principled presidency of Harold Gilman (cat.1) it even managed to withstand the deprivations of the Great War. The 'Cubist' section suffered the most: the sculptor, Henri Gaudier-Brzeska (cat.8), was killed in action in 1915; active service diverted the attention of Wyndham Lewis (cat.6), Edward Wadsworth (cat.24), David Bomberg (cat.16) and William Roberts (cat.17) away from preparing for exhibitions. Some, such as Lewis and Wadsworth, did not return to The London Group except to contribute to the 1928 retrospective. Only the Bloomsbury Group was initially blackballed because of the bitter quarrel between Wyndham Lewis and Roger Fry (cat.13) over the disputed appropriation by Fry of an exciting commission

intended for Lewis and Spencer Gore to design a room for the Ideal Home Exhibition.

However, in 1917, when early passions had cooled and, more crucially, Lewis was no longer active within the Group, Roger Fry was elected. In 1919 he was joined by Duncan Grant (cat.26) and Vanessa Bell (cat.14). In the space of six years, The London Group had succeeded in drawing into its ambit all the prevailing disparate factions to offer a viable alternative to the Royal Academy and the New English Art Club as an artist-led exhibiting society. More eclectic in its membership than the two senior bodies, it had attained a distinct and well-respected place in the yearly cycle of exhibitions.

Its gestation was lengthy.[1] On 27 January 1910, the formation of 'a London Group' had been announced in the *New Age*. However, a glance at the list of members of the Group (Robert Bevan, Harold Gilman, Spencer Gore (cat.5), Lucien Pissarro, Augustus John (1878–1961), Albert Rothenstein (1881–1953), Walter Sickert, Nan Hudson and Ethel Sands (cat.2)) reveals that at the beginning of 1910 this was no more than an alias for the Fitzroy Street Group. In spring 1907, Sickert and seven of his colleagues, among whom were Gore and Gilman, had rented the first floor at 19 Fitzroy Street. Those who contributed to the rent used the premises to store their pictures, display and sell them to an enlightened band

of patrons, and to discuss art and its politics with all who cared to come to the informal Saturday afternoon gatherings hosted by Sickert. Membership of the Group fluctuated over the years as new recruits were talent-spotted: Pissarro joined in autumn 1907, Walter Bayes (1869–1956) and Robert Bevan (cat.4) in 1908, and Charles Ginner (cat.11) in 1910. The *New Age* announcement suggests that the idea of forming a new society was in the air and in due course a new society was indeed formed: the Camden Town Group.

Early in 1911, in the immediate wake of the backlash which followed the exhibition *Manet and the Post-Impressionists* arranged by Roger Fry at the Grafton Gallery, there was an urgent need to find somewhere prepared to exhibit work which demonstrated mildly progressive tendencies. The huge number of exhibits and lack of quality control disqualified the non-jury Allied Artists' Association founded in 1908 from offering a useful shop-window. The relative merits of capturing control of the jury of the conservative New English Art Club, or setting up a rival exhibiting society were hotly debated at Fitzroy Street and at convivial dinners in town. An inner core of Fitzroy Street members decided on a new society and agreed it should be limited to 16 members and exclude women. Sickert wrote to Miss Sands and Miss Hudson: 'As a matter of fact, as you probably know, the Camden Town Group is a male club, and women are not eligible. There are lots of 2 sex clubs, and several one sex clubs, and this is one of them.'[2]

Recruitment followed a random pattern guided more by personal preference than communal ideology. For example, Gore brought in his deaf pupil, John Doman Turner (*c*.1872–1938); Gilman his Letchworth neighbour, William Ratcliffe (1870–1955); Pissarro his disciple J B Manson (1879–1945); Sickert his pupil Malcolm Drummond (1880–1945); Gilman and Gore argued in favour of their Slade contemporary, Wyndham Lewis; and Augustus John recruited his painting companion J D Innes (1887–1914). Sickert persuaded Arthur Clifton of the Carfax Gallery in Bury Street, St James's to lend his basement premises for the Group's exhibitions. There were just three: in June and December 1911 and in

December 1912. Meanwhile the gatherings chaired by Sickert at 19 Fitzroy Street remained a focus where members of the Camden Town Group were joined by visitors drawn from a wider compass. Some, for instance Jacob Epstein (cat.7) in April 1913, became members of The Fitzroy Street Group. At a meeting on 25 October 1913, when the Group reassembled after a summer recess to face decisions about expansion of the Camden Town Group, it was resolved that a 'new society' be formed by amalgamating the two groups. Thus was The London Group born.

Several artists, including C R W Nevinson (cat.10), Cuthbert Hamilton (1884–1958), Edward Wadsworth and Frederick Etchells (cat.22), realised that if they stormed the more flexible defences of Fitzroy Street in advance they could bypass the potentially stringent, although as yet undecided, election procedures to the new society. This invasion from Lewis's Futurist-Cubist camp significantly altered the political and artistic balance of the society.[3] It marked the moment when the two elders of the Fitzroy Street Group, Pissarro and Sickert, lost control of the enterprise.

It is thought that Epstein, at the 15 November meeting, suggested the title 'The London Group' as a fitting banner to embrace the more broadly based membership. Gilman was selected as President of the new Group instead of Gore, who had been President of the Camden Town Group. The first election for new members was held on 6 December. All 14 candidates failed to pass the test. The political complexions represented by both voters and candidates made it impossible to reach the simple majority required under the rules. Epstein therefore proposed that the votes of one-third, rather than one-half, of the total number of members be sufficient to secure election.

On 3 January, the next election date, 26 candidates put themselves forward and nine secured election. The unsuccessful candidates included Mark Gertler (cat.9); the successful included John Nash (1893–1977) (his brother Paul (cat.25) failed) and David Bomberg. On 3 February 1914, ten candidates were proposed for election of whom only Gaudier-Brzeska, at his first attempt, was successful. A significant absentee from this meeting was Sickert,

who until then had always taken the chair. He stayed away from subsequent meetings and resigned his membership of both Fitzroy Street and The London Group before the exhibition opened in March. Stanley Spencer (1891–1959) was the only candidate elected out of six on 7 March, too late to send work to the first London Group exhibition; Horace Brodzky (1885–1969) – a friend of Gaudier-Brzeska – and Alfred Wolmark (1877–1961) were among the failures. In March, Pissarro (who had gone to Eragny in France in January) resigned from The London Group and the Fitzroy Street Group.

The history of resolutions, elections and resignations recorded in the minutes of London Group meetings between October 1913 and March 1914 reflects private reactions to public events. Chief among these events was a large exhibition entitled *English Post-Impressionist, Cubists and Others* held at the Brighton Art Gallery from 16 December 1913 to 14 January 1914. The Camden Town Group under the presidency of Gore was invited to select this exhibition and thus, on paper at least, enjoyed a brief reprieve from extinction. In fact suggestions for selection were probably made by the entire Fitzroy Street Group, in other words by the founder members of The London Group. Because exhibitors did not have to pass the stringent election processes used by The London Group, the Brighton exhibition included many artists who failed on one, more or all of their attempts to be admitted to the new society. It was obviously difficult to find a title appropriate to such a mixed exhibition of contemporary art. As the director of the Art Gallery wrote in an introductory catalogue note, the chosen title, 'Work of English Post-Impressionists and Cubists', was 'hardly sufficiently explanatory, as there are many works exhibited which do not come under either of these titles. It is, however, sufficiently indicative of the general tendency of the exhibition.'

A rift divided these exhibitors from the start. Not only were the exhibits physically separated, but two separate catalogue introductions were found to be necessary, one written by Manson which traced the history of the Fitzroy Street and Camden Town Groups, the other by Wyndham Lewis who wrote about 'The Cubist Room'. Lewis described the work of himself and his colleagues, Nevinson, Etchells, Hamilton and Wadsworth, as 'a vertiginous, but not exotic, island in the placid and respectable archipelago of English art'; Epstein, he declared, was 'the only great sculptor at present working in England'. Sickert had opened the exhibition with a speech which did not reveal his disillusion with the persistent and growing influence of Lewis and his colleagues on the activities of the Fitzroy Street and London Groups. However, a Fitzroy Street 'At Home', probably in February 1914, was too much for him. He wrote to tell Nan Hudson:

> like the lady in bridal attire who bolts at the church door the Epstein-Lewis marriage is too much for me and I have bolted. I have resigned both Fitzroy Street and the London Group. You who have watched the stages will not think me merely frivolous. […] First Gilman forced Epstein on me, as you know against my will. But I was in a minority. At Brighton the Epstein-Lewis-Etchells room made me sick and I publicly disengaged my responsibility. On Saturday Epstein's so-called drawings were put up on easels and Lewis's big Brighton picture. The Epsteins are pure pornography […] and the Lewis is pure impudence […] *never again for an hour* could I be responsible or associated in any way with showing such things. […] I shall not set foot in Fitzroy Street again after my sensations when the Epsteins were on the easels and various charming and delightful people open-mouthed looking to me for explanations or defence.

Like Pissarro, Sickert felt driven out of Fitzroy Street, his own creation, by an alien invasion. Unlike Pissarro, he decided to conduct an active campaign of extermination from the outside. He felt admirably placed to do this because the *New Age*, a periodical which thrived on controversy, gave him a free hand to publish articles on whatever subjects he chose. With great optimism he told Nan Hudson: 'being a weekly I influence all the other critics. I really become the conductor of the critical orchestra in London.' On 26 March, his essay 'On Swiftness' was published, dealing, as he told Nan Hudson, 'delicately but firmly, with the pornometric aspect of Cubism':

We hear a great deal about non-representative art. But while the faces of the persons represented are frequently nil, non-representation is forgotten when it comes to the sexual organs. […] the Pornometric Gospel amounts to this. All visible nature with two exceptions is unworthy of study, and to be considered pudendum. The only things worthy of an artist's attention are what we have hitherto called the *pudenda*!

Sickert was fighting a losing battle. T E Hulme was also employed by the *New Age* and produced avant-garde counterblasts to all Sickert's attacks. For instance, in December 1913 Sickert had been commissioned by the *New Age* to edit a series of illustrations called 'Modern Drawings'. His weekly selection began on 1 January 1914 and included several of his own drawings, one by Ginner, one by Bayes, and many by his little-known pupils. On 19 March, instead of Sickert's choice, Gaudier-Brzeska's geometrical *Red Stone Dancer* (fig. 5), appeared, as the first in a series edited by Hulme and nicely distinguished from Sickert's selection by the title 'Contemporary Drawings'. Hulme's series, including drawings by Bomberg, Roberts, Wadsworth and Nevinson, gradually ousted Sickert's. Similarly, the issue of the *New Age* containing Sickert's 'On Swiftness' also contained Hulme's brilliantly reasoned explanation and appreciation of the works of Lewis, Bomberg, Wadsworth, Hamilton and Epstein then on view at The London Group exhibition.

When Sickert retired, disenchanted, from The London Group in 1914 he could afford to abandon ship. The existence of the new society as an entity, and the factions it stimulated, represented the successful culmination of his ambition, first expressed in Fitzroy Street in 1907, to create an ambience in London wherein young painters could encourage each other towards independence and professional self-confidence.

The Fitzroy Street Group itself petered out with the war. Some of its members went on to establish tighter, mutually congenial groupings. Wyndham Lewis and his colleagues banded together to found the Rebel Art Centre in March 1914. Bevan, Gilman and Ginner founded the Cumberland Market Group in 1914 and were later joined by John Nash, Edward McKnight Kauffer (1890–1954) and Nevinson (after he fell out with his erstwhile Rebel Art Centre colleagues). The close-knit character of the group, their habit of drinking strong tea and of showing pictures to visitors at Saturday 'At Homes', closely reflected the early Fitzroy Street model.

Adaptability and flexibility have remained the keystones of The London Group's survival. J B Manson's messianic vision of what the Group might achieve, as expressed in his introduction to the pivotal Brighton Art Gallery exhibition, has some validity:

it will no longer limit itself to the cultivation of one single school of thought, but will offer hospitality to all manner of artistic expression provided it has the quality of sincere personal conviction. The Group promises to become one of the most influential and most significant art movements in England.

Since its Jubilee Exhibition in 1964 at the Tate Gallery, the Group has had its ups and downs. Without premises of its own, regular open submission exhibitions have been difficult to organise. However, it has never become dormant. During the last 50 years it has provided a first opportunity for many of today's major figures to launch their careers on leaving art school. Its membership has been constantly replenished, its activities reach well beyond the boundaries of London. The events this year are, have been and will be worthy demonstrations not only of the distinguished history of The London Group but also of its continuing relevance to the artistic life of Britain.

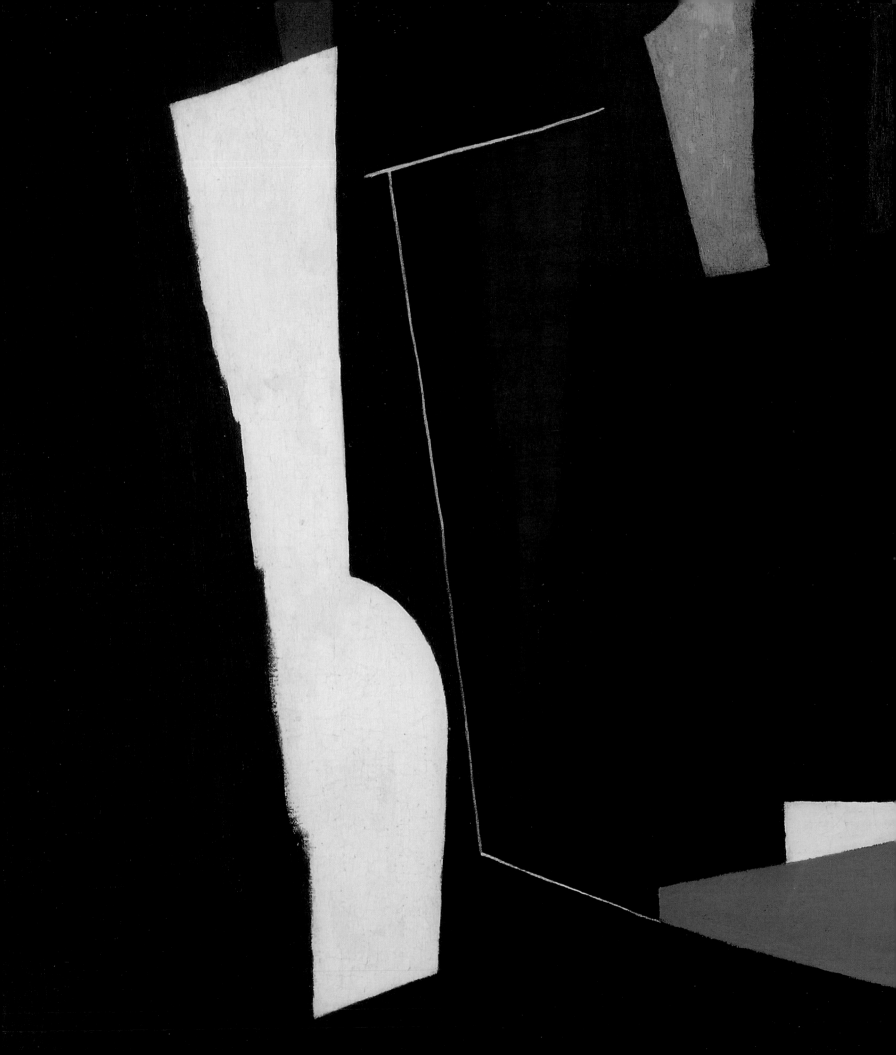

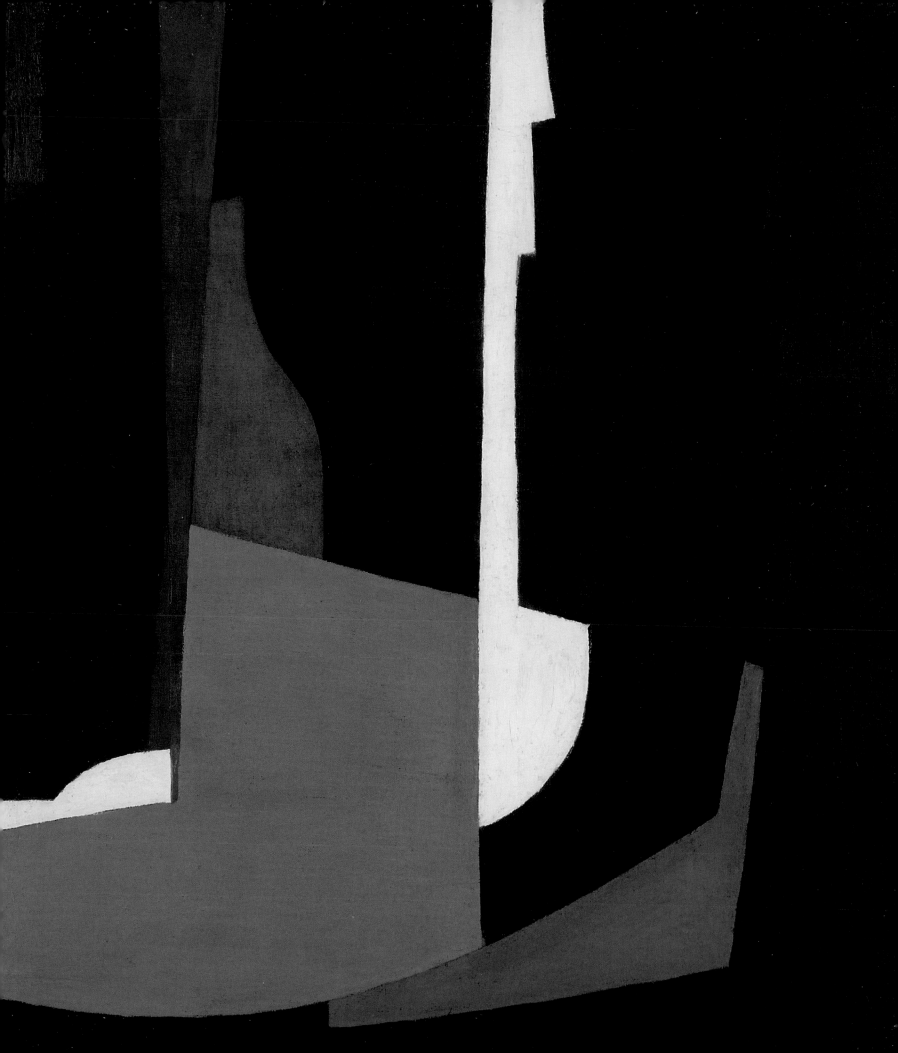

'UPROAR!': THE EARLY YEARS OF THE LONDON GROUP, 1913–28

SARAH MACDOUGALL

From its explosive arrival on the British art scene in 1913 as a radical alternative to the art establishment, the early history of The London Group was one of noisy dissent. Its controversial early years reflect the upheavals associated with the introduction of British modernism and the experimental work of many of its early members. Although its first two exhibitions have been seen with hindsight as 'triumphs of collective action',[1] ironically, the Group's very success in bringing together such disparate artistic factions as the English 'Cubists' and the Camden Town painters only underlined the fragility of their union - a union that was further threatened, even before the end of the first exhibition, by the early death of Spencer Gore (cat.5). Roger Fry (cat.13) observed at the Group's formation how 'almost all artist groups […] breed by division. They show their vitality by the frequency with which they split up.' Predicting the Group would last only two or three years, he also acknowledged how it's members had come 'together for the needs […] of two quite separate organisms' to 'give each other mutual support in an unkindly world.'[2]

In its first five decades this mutual support was, in truth, short-lived as 'Uproar' raged on many fronts both inside and outside the Group. These fronts included the hostile press reception of the ultra-modernists; the rivalry between the Group and contemporary artists' exhibiting societies, such as the New English Art Club in the Group's first decade and the Seven & Five Society (so-called after the nucleus of painters and sculptors it aspired to encompass)[3] in its second; the internecine warfare between different factions (Camden Town and the Vorticists, pro- and anti-Bloomsbury, Surrealists versus realists, figuration versus abstraction); and often warfare between individual members with strong personalities (Walter Sickert and Wyndham Lewis, Lewis and Fry, Fry and C R W Nevinson). Occasionally the battles dwindled into mere point-scoring and wrangling (particularly over Cézanne).

Moreover, the press clearly viewed such a collaboration of progressives to be in itself a deliberate act of provocation. The *Observer*'s art critic, P G Konody, set the tone for early critical reaction when he declared that the 'very aggressive blue' of the inaugural invitation card was an 'indication of the defiant attitude of the members'.[4] The Group's very *raison d'être* was understood to be its capacity to create outrage. Yet a close reading of the Group through its contemporaneous press reception over this important first half-century also reveals how, to a large extent, the press itself perpetuated this 'revolutionary and anarchic image'.[5] Always keen to exploit perceived disputes and controversies, it was unwilling perhaps to lose such a rich source of eye-catching headlines and arresting copy; certainly, later

more widespread press approval reflected a blunting of the Group's radical edge. Nevertheless, the Group's first 50 years not only coincided with a remarkable period in British modernism, but also in its earliest exhibitions acted as an important platform, promoter and disseminator of progressive art and ideas. Many of the works that initially caused the most outrage, including David Bomberg's *In the Hold* (fig. 2), Jacob Epstein's *Rock Drill* (fig. 6) and Mark Gertler's *Merry-Go-Round*, are today regarded as among the most important in the British modernist canon, and the wide range of artistic groups and styles which these years encompassed are a further tribute to the Group's ultimate success in absorbing and reflecting such diversity.

Remarkably, the exact date of the first exhibition, which took place in early March 1914 at William Marchant's Goupil Gallery in Regent Street, is unknown. It contained 116 paintings and drawings by 26 artists, just under a third (seven) of whom were women, with two sculptors (Epstein and Henri Gaudier-Brzeska), each showing four works.[6] The first hanging committee was a model of proportional representation, balancing Camden Town representatives Gore, Harold Gilman (president, 1914–19), J B Manson (1879–1945) and Renée Finch (*fl.*1907–16) against the emerging Vorticists Lewis, Edward Wadsworth and (by association) Epstein. The inclusion of both a sculptor and a female painter were also significant markers of future intentions.[7]

Camden Town exhibits including Gore's Letchworth landscape (cat. 5 is of the same subject),[8] Gilman's striking portrait of fellow member Sylvia Gosse (cat. 1),[9] and both versions of his subtly subversive *Eating House* (fig. 3) were certainly admired, but here the balance ended. Arthur Clutton-Brock headlined his *Times* review 'The Cubists' Error', pointing out that the exhibition contained two groups: one deriving from Sickert, the other from Picasso and that the pictures 'did not agree well with each other'.[10] In their haste to portray the 'new', he argued, the Futurists had obscured their own meaning.[11] Sir Claude Phillips (*Daily Telegraph*)

agreed, protesting against a 'swamping, a drowning of what remains of the original group by the Cubists and their following', insisting that 'their hordes have invaded the society and victoriously appropriated the greater part of the wall-space', making the Camden Town Group look 'serious and almost academic by contrast with the onrushing kaleidoscopes'.[12] The term 'kaleidoscopic' was widely invoked to describe the brilliantly fractured, dynamic compositions of Lewis (see cat. 6 for an earlier work)[13] and Bomberg; the latter's frenetically-charged canvas, *In the Hold*, dramatically reflected the common immigrant experience of travelling steerage and the dramatic dislocation of the newly-arrived. T E Hulme of the *New Age* criticised Lewis but supported Bomberg; Konody criticised both for their 'geometrical obfuscations'.[14] Lewis mischievously fed the flames declaring that 'our object is to bewilder […] we want to shock the senses and get you into a condition of mind in which you'll grasp what our intentions are.'[15]

Critics were annoyed by the lack of representation, the associations with mechanisation and speed, and particularly the obscure titles. It was suggested, for example, that Lewis's titles 'might be indiscriminately transferred from one to the other without anybody being the wiser for it'.[16] Yet Nevinson's *Portrait of a Motorist*, which included glass goggles and a real coat button, while wholly comprehensible, was considered 'childishly crude'.[17] By contrast, Walter Bayes' (1869––1956, founder member 1913) more traditional work, *Flint Rafts of the Somme,* was felt to act 'as a pleasant sedative upon nerves excited by the fierce assaults of the artistic firebrands.'[18]

From the start, the new Group was billed as the opposition not only to the Royal Academy but to the prevailing anti-establishment exhibiting society, the New English Art Club (NEAC).[19] Critics enjoyed speculating over which – to borrow a phrase from Sickert – was 'the newer English Art Club of the two?'.[20] The *Manchester Guardian* shrewdly observed, under the headline 'The Revolutionaries', that the NEAC's jubilee exhibition:

fig. 1
David Bomberg
The Studio
1919

Ben Uri, The London Jewish Museum of Art

fig.2
David Bomberg
In the Hold
*c.*1913–14
Tate

seems to have coincided with the formation of a society to supersede it [...] Everyone will be pleased that such a society has come into existence, the frivolous because it will tend to keep the older societies free of eccentricities, and the serious because they know that if art is a real thing every generation must have its fling and dance to its own piping.[21]

The new Group was seen as a society for the young and contemporary – Konody suggested (sarcastically) that all the other galleries had been 'left miles behind'[22], while Manson, a former NEAC member himself, argued that the older society merely housed 'a whole crowd of reactionaries'.[23] This rivalry, which continued for many years, was frequently cited by critics as they examined the two societies side by side.[24]

Ezra Pound, reviewing the first Group show in the *Egoist*, noted that it deserved 'the attention of everyone interested in either painting or sculpture', drawing attention to the important inclusion of sculptors Epstein and Gaudier. Both had a considerable impact on early shows.[25] Although Konody lost patience with Gaudier's 'affectations in stone',[26] including his innovative semi-abstract *Red Stone Dancer* (fig. 5), Fry recognised that he was 'one of the most interesting sculptors working in England [...] very brilliant and facile, and a master of his craft'.[27] Hulme in his *New Age* review called Epstein 'certainly the greatest sculptor of this generation'.[28]

By the time the second London Group show opened a year later, however, the landscape had changed: the Vorticists had founded their own home at the Rebel Art Centre in spring 1914, followed by the launch of Lewis's iconoclastic journal *Blast: Review of the Great English Vortex* in July. The still ruder blast of war, which succeeded it the following month, profoundly affected not only the character of the Group, but also the work produced, its reception and even its membership. The second exhibition in March 1915 was a smaller show comprising 96 works, including six sculptures by Epstein and Gaudier. Gaudier, having already returned to France and enlisted, also sent drawings including *A Mitrailleuse*

in Action and *One of our Shells is Bursting*, carried out, as the catalogue noted, 'in the trenches at Craonne'. The *Connoisseur* complained that in the work of Epstein, which included his highly simplified relief depicting the act of giving birth, *Carving in Flenite* (cat. 7),[29] and others, 'the aesthetic tendencies of the most advanced school of modern art are leading us back to the primitive instincts of the savage.'[30] Lewis's brilliant depiction of existential alienation in *The Crowd* (fig. 4), clashed with Gosse's 'charming' *New Recruit*;[31] and the *The Times* noted rightly how their pictures seemed 'to belong to different ages and continents.'[32]

Meanwhile the *Englishwoman* derided the Vorticist experiments of Lewis, Wadsworth and William Roberts as those of 'artistic lunatics'; in the climate of war, it was felt, there was 'no time to waste on monkeys on sticks'.[33] Although Lewis wittily rebutted the criticism that they were 'Junkers' or 'Prussians' in art,[34] in his own ambiguous review of the exhibition he also drew attention to the contradictory aims of the Group's two principal sections, and in fact (apart from the 1928 retrospective) this was his final showing within the Group. The increasingly jingoistic and worryingly xenophobic remarks continued, however, and critics noted artists who had attended the private view and were not in uniform, also highlighting distinctly foreign-sounding names – one asking whether 'Gaudier-Brzeska' was simply 'an invention devised by the exhibition committee to impress the public?'.[35]

In this atmosphere, it was hardly surprising that Nevinson and Epstein, with their powerful depictions of dehumanised, highly mechanised modern warfare, dominated press attention. Nevinson, though medically unfit to be a soldier, had hands-on experience as a Red Cross ambulance driver and then a Royal Army Medical Corps nurse. His resulting images, including the painted version of *Returning to the Trenches* (see cat. 10),[36] made him 'one of the most talked about artists in London'.[37] As Frank Rutter noted, his were 'the first war pictures to create a stir. They were topical, they were new things shown in a new way. Nevinson had got his blow in first, and he

capture[d] the imagination of London as no subsequent painter of the War was able to do.'[38]

Critics failed to notice, however, the dystopian prophecy of Epstein's *Rock Drill*, a life-size visored figure carrying its own progeny and mounted on a ready-made drill, but censured it anyway for the 'irreconcilable contradiction between the crude realism of the real machinery (of American make) combined with an abstractly treated figure.'[39] Erstwhile supporter Augustus John advised the American collector John Quinn against buying it, calling it 'altogether the most hideous thing I've seen'.[40] Afterwards, reacting to the carnage of the First World War and perhaps to Gaudier's premature death, Epstein cropped the figure. The resulting wounded torso, shorn of the masculine power associated with the new machine age that had been so much a feature

of the original piece, alluded perhaps to the tragic losses of the conflict.

The Group's third exhibition, in November 1915, was notable for the absence of many radicals, particularly Lewis, Bomberg and Wadsworth, now all involved in the war. In fact, only 18 of the 34 members (largely Camden Towners) chose to exhibit, creating an aesthetic unity at which Gertler, exhibiting for the first time, rebelled, 'What a rubbishy show!', he commented, 'All the pictures, except my own, were composed of washed out purples and greens, and they matched so well that it seemed almost as if the artists all collaborated in order to create harmony [...] In reality it means simply that they all paint alike and equally badly!'[41]. Against this backdrop his colourful, experimental work, including *The Creation of Eve* (cat.9), stood out all the more strongly, but Gertler

fig.3
Harold Gilman
Eating House
c.1914

Museums Sheffield

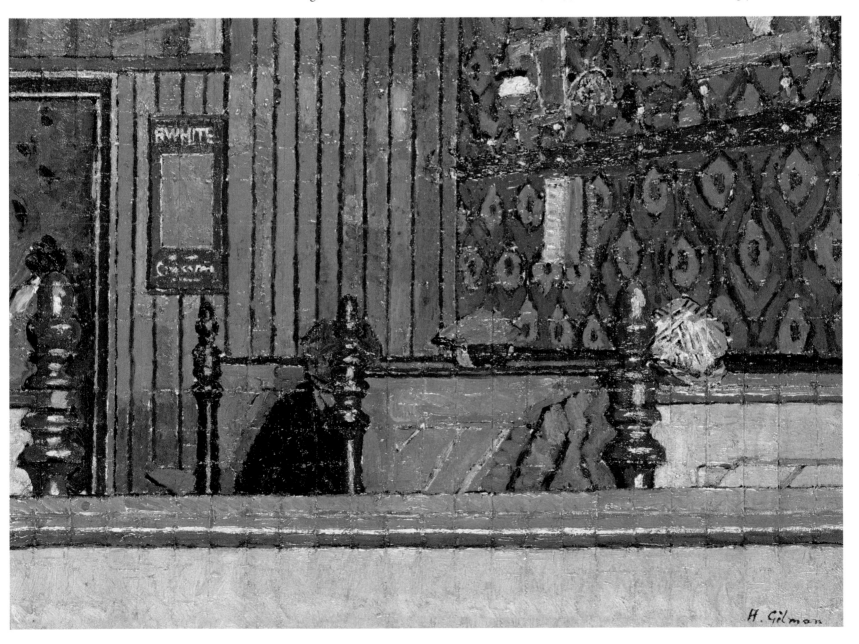

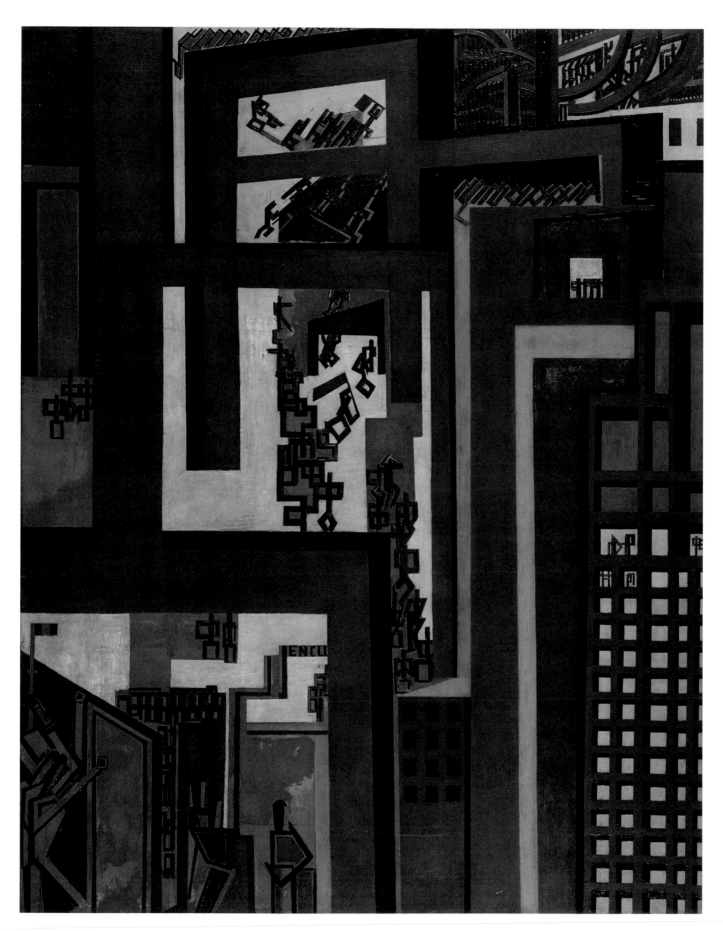

fig.4
Wyndham Lewis
The Crowd
*c.*1915
Tate

was astonished to learn that his pictures had created 'a tremendous uproar!' The critics, he wrote, were 'quite mad with rage. […] One paper said that I had done them simply to shock and create a sensation!'.[42] In the febrile atmosphere of anti-German feeling, such extremes of modernism were seen as unpatriotic and even 'hunnishly indecent'.[43]

Yet the fourth show, in June 1916, despite including Epstein's truncated *Rock Drill* torso (the sole sculpture), attracted the damning comment that there was hardly anything 'that would seem remarkable in the Academy'.[44] Nevinson had now replaced Wadsworth as secretary, a role in which he was perhaps not entirely comfortable. Ethelbert White (1891–1972, elected 1916), later recalled watching Bomberg climb the Goupil's stairs, laboring under 'a canvas of vast proportions', only to be met by Nevinson at the top, who told him, partly in jest, 'that no works could be hung if the member's subscription had not been paid. Bomberg with a good-tempered grin hauled his enormous canvas back down into Regent Street, and although members of the hanging committee ran down to recall him, all they saw was a great sail tacking across Piccadilly.'[45] With Lewis's departure, despite the inclusion among the non-members exhibiting for the first time of Vorticist follower Lawrence Atkinson (1873–1931), the wilder element seemed tamed. Sickert, who showed for the first time as a non-member, was elected soon afterwards and sat on the next hanging committee, but was too late to champion Matthew Smith's boldly provocative *Fitzroy Street Nude, no. 2* (cat.12),[46] submitted at his urging, but, in a move of uncharacteristic censorship, rejected by the committee. Although Smith began to exhibit still lifes as a non-member that autumn, the Group had not proved brave enough to showcase his most experimental work.

The fifth show, in November 1916, included two versions (a drawing and an oil) of Gilman's profoundly humanist portraits of his landlady, *Mrs Mounter,* and Ginner's depiction of war convalescents, *Roberts 8* (cat.11),[47] completed before his appointment as Official War Artist the following year. Compulsory military service (for men aged 16–41) had been introduced in January 1916 and the practice of handing out white feathers to service-aged men not in uniform was then at its height. This was the last London Group exhibition to be held at the Goupil's premises, however, as Marchant's refusal to show work by conscientious objectors led to the Group's courageous decision to leave the space – a move widely interpreted in the press (who were unaware of Marchant's reasons) as an expulsion on the grounds of extreme modernism. The Group was threatened with homelessness until Ambrose Heal offered a welcome alternative space at his Mansard Galleries.

Although at least two members, Gertler and Adrian Allinson (1890–1959, elected 1914), held pacifist views, it is unlikely that Marchant knew this. Yet ironically, it was at the sixth show in April 1917, the first in Heal's premises, that Gertler showed his anti-war masterpiece *Merry-Go-Round* (1916, Tate), greeted by the *Evening News* as 'a shriek, a groan, a hoot, a blare, a tempest of wild rending and most discordant noise'.[48] The painting's pacifist message was clear to Gertler's circle. Lytton Strachey famously wrote that he 'admired it of course, but as for *liking* it, one might as well think of liking a machine-gun',[49] while the lawyer St John Hutchinson, who had already legally represented several conscientious objectors, warned Gertler against exhibiting it at the Group, predicting it would 'raise a tremendous outcry – the old, the wise, the professional critic will go mad with righteous indignation', causing them to 'write all sorts of rubbish about German art and German artists […]'.[50] Yet astonishingly, though Nevinson's *When Harry Tate Comes Down* was criticised as 'a gratuitously unkind caricature of our wounded heroes', critics failed to detect the *Merry-Go-Round*'s anti-military message, concentrating instead on its outrageous modernism. Its positioning opposite Sickert's *Suspense* was also much commented upon. C Lewis Hind in the *Daily Chronicle* called *Merry-Go-Round* 'the best specimen I have ever seen of Frightfulness in Art. […] O, how clever! O, how strident! It shouts across the gallery. I feel that "Suspense" must jump up and scream'.[51] Sickert was welcomed back as the 'Father of the

group' and 'a Master who has strayed wearily, but with resignation into a frolic of youth',[52] yet the *Merry-Go-Round* controversy revitalised the Group confirming its reputation, after the Smith incident, as a platform for extreme modernism.

Edward McKnight Kauffer (1890–1954, elected 1916), who had exhibited as a non-member in the previous exhibition, also came to attention in the same exhibition, not least for the bold graphics and 'pugilistic crème-de-menthe' of his press invitation card. The *Evening News* observed that:

> the figures appear to be either:-Flying buttresses taking a walk. Painters running off with their employers' ladders; or Red Indians in bowler hats joyfully going out to tomahawk some victims. This is interesting, as a picture should always, in fact, be.[53]

McKnight Kauffer, who became best-known as chief poster designer for the London Underground, also designed a number of striking exhibition posters between 1918 and 1919 (fig. 21). In a separate review entitled 'Colour Gone Mad. "The London Group" By Our Own Philistine', the *Star* attacked his painting *Low Tide* as showing 'a purple bridge all out of drawing, with yellow shadows, and red, white and blue barges sailing across a pink and green sky. These colours may not be accurate, but they are all there. The thing is a prismatic mess which might have been hung upside down (and probably is) without damage to its title. This is priced by Mr. Kauffer at 30 guineas.'[54]

With seven female founder members (Finch, Gosse, Jessie Etchells (1892–1933), Anna Hope Hudson (1869–1957), Stanislawa de Karlowska (cat. 3 is a good example of her style),[55] Thérèse Lessore (1884–1945) and Ethel Sands (cat. 2)[56], women were always a vital component of the Group.[57] The majority were part of Sickert's circle but, having been excluded from the Camden Town Group on account of their sex, no doubt realised the importance of retaining their membership in spite of his own erratic participation.[58] Their position was in some ways contradictory. Although their very presence was seen as progressive and they benefited from being allied to

a Group so consistently in the headlines, they also remained a minority within it. While not ignored, generally their exhibits received less press attention or were favourably reviewed only in contrast to the modernist tendencies of their male contemporaries. In the first exhibition, for example, Sands' 'charming interior' was contrasted with Lewis's baffling abstraction *Eisteddfod*. Finch had previously caused a stir at the Allied Artists' Association with a painting of a male nude with blue pubic hair so controversial that she had been forced to withdraw it, but at The London Group her *Jealousy and Indifference* was greeted as trying to be 'dramatic' and failing; and though a later nude was praised for the 'subtlety and beauty of reality',[59] still the most frequent adjective for admired work by the women painters was 'charming'. Nonetheless for the majority The London Group remained their chief exhibiting platform.

During the First World War, however, when many male members were absent, the number of women exhibitors, augmented by the introduction of exhibiting rights for non-members, gradually increased. Nina Hamnett (1890–1956, elected 1917) first exhibited as a non-member in 1916 and, an exception to the rule, established a strong early presence; she was commended for her 'strenuous personalities on canvas and [...] other excellent work'[60] and her 'remarkable gifts'.[61] By the second decade, Lessore and Vanessa Bell (elected 1919, see cat. 14)[62] began to be frequently reviewed. Indeed the *New Witness* (interestingly, the reviewer was also a woman) noted that although by 1921 the most prominent group had formed around Fry, it drew its 'inspiration' from Bell and Duncan Grant, while a second group had formed around Lessore, and a third around Robert Bevan.[63] In this climate, the exhibition-shy Dora Carrington showed once in 1920, and Marjorie Watson-Williams, later better-known as Paule Vézelay, made her exhibiting debut with the Group in 1921, showing her bold, highly-simplified linocut, *Bathers* (cat. 21), in 1923.[64] New York-born Jewish émigré Belle Cramer (1883–1978) also exhibited frequently with the Group during her years in Britain, after meeting Epstein, Ginner and Gilman at the Café Royal (depicted by

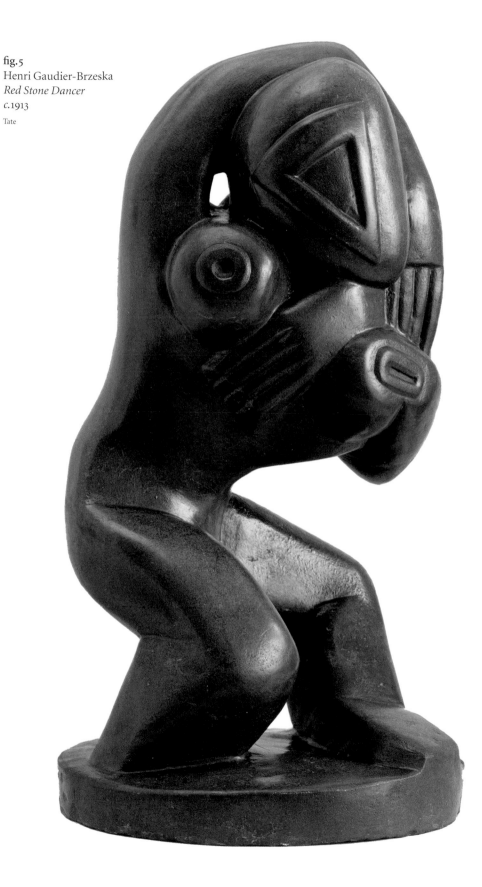

fig.5
Henri Gaudier-Brzeska
Red Stone Dancer
c.1913
Tate

Allinson and shown in the fourth exhibition), an informal network for many of The London Group artists.[65] In the coming decades women including Eileen Agar (cat.31), Jessica Dismorr (cat.33), Gertrude Hermes (cat.35), Barbara Hepworth (cat.28) and Elisabeth Frink (1930–1993, member 1956) emerged from the shadow of the men as distinctive artists in their own right.

Fry's election and place on the hanging committee in 1917 radically changed the character of the Group by accelerating the influence of the Bloomsbury aesthetic. When the *New Witness* observed that Fry's 'angular landscapes' were 'interesting, but […] rather dull', the comments seemed to imply an inherent criticism of Fry's well-known critical role, 'somehow they seem not unlike a treatise on painting written by a learned Professor'.[66] Yet his *Portrait of Nina Hamnett* (cat.13),[67] possibly shown in the same year, is one of his finest. By now *The Times* felt that 'the high spirits and recklessness of the new movements in art seem to have died away'; replaced by 'a rather arid aesthetic Puritanism'.[68] Pound, under the pen name B H Dias, was scathing about the lack of originality, identifying only 'the familiar patchiness, blurriness, [and] stickiness'.[69]

In contrast to the rising Bloomsbury aesthetic was the strong presence of Jewish artists within the Group, united by ties of ethnicity and friendship but not by style, treatment or subject matter. There was no manifesto for these 'Whitechapel Boys' who showed together only once in the so-called 'Jewish Section', of the exhibition *Twentieth Century Art: A Review of Modern Movements* co-curated by Bomberg and Epstein at the Whitechapel Art Gallery in May 1914.[70] Many of them were also involved with the Ben Uri Art Society, formed in Whitechapel in July 1915 by the charismatic Russian-born émigré Lazar Berson. Today work by Epstein, Bomberg and Gertler, Jacob Kramer and Bernard Meninsky is among the highlights of the Ben Uri collection. Kramer and Horace Brodzky (1885–1969, elected 1914) both began exhibiting with the Group as early as the second exhibition and were in due course joined by Meninsky and Edward Wolfe (1897–1982, elected 1923), who also

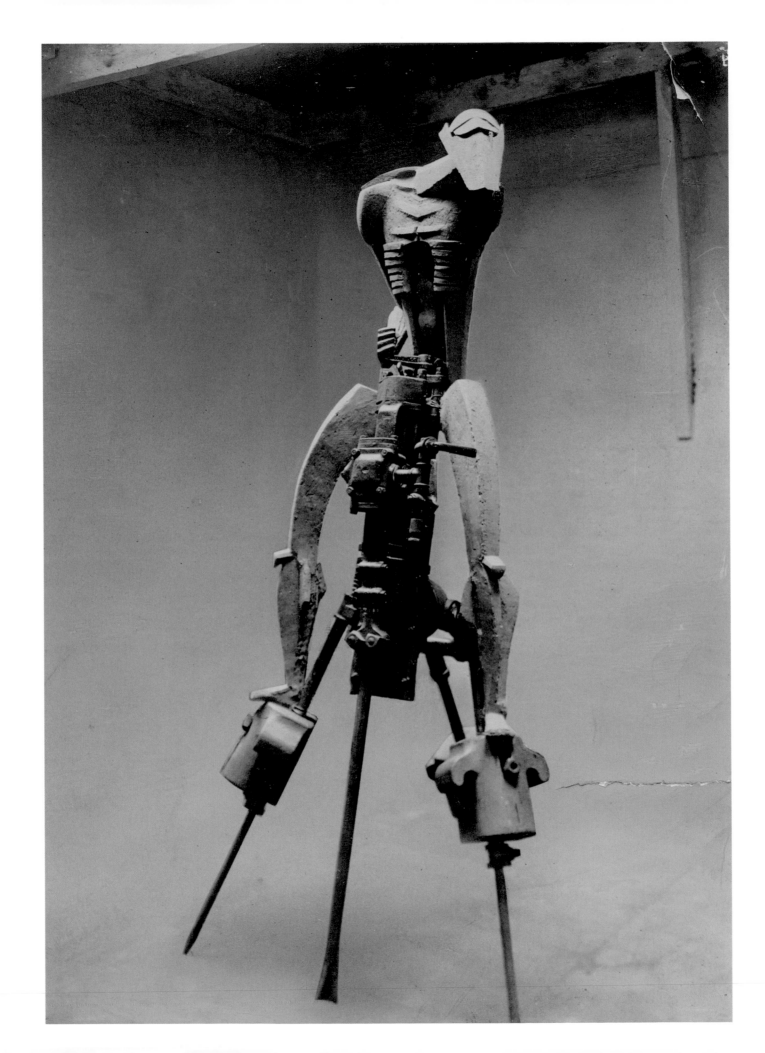

fig.6
Jacob Epstein
Full Rock Drill
1913–15
(archive photograph)

The Henry Moore Foundation

became frequent exhibitors, their work, though less radical was often noticed in the press. Clara Klinghoffer (1900–1970, fig.7), a talented young painter, taught by Meninsky and commended by Epstein, showed once as a non-member in 1919.

These two seemingly disparate groups, the Jewish artists and Bloomsbury, already had exhibiting ties: Bomberg, Gertler, Meninsky and Wolfe all exhibited with the Friday Club,[71] begun in 1905 by Vanessa Bell (as did many other London Group members); and Gertler and Wolfe also exhibited with Fry's Omega Workshops. [72] In 1919 Gertler (who shared Bloomsbury's enthusiasm for Cézanne) found his name coupled with Grant's, and praised by Clive Bell, as 'not only the best of the younger men, but with Mr. Sickert, the best painters in England.'[73] Bell's enthusiasm for Gertler was brief, unlike his widely-resented and consistent championship of Grant and his Bloomsbury colleagues.

In 1920 a distinctly anti-Semitic article in the *Outlook* observed that 'Race will tell in art', ascribing 'some of the characteristics' of the controversial new movements 'to the fact that they are largely in Jewish hands. Possibly I am over-susceptible on this point; but, from internal evidence, I am inclined to believe that more of our younger painters have Jewish blood than is evident in their names.'[74] Yet the modernism of the Jewish painters was equally deplored by the conservative *Jewish Guardian*, which noted in May 1920 that 'Of the inanities and insanities which compose the bulk of the show it is painful to note how woefully large a proportion are by young Jewish painters', in which the author included Gertler, Bomberg and Meninsky,[75] ignoring the Jewish subject matter of both Bomberg's *Ghetto Theatre* (cat.16),[76] and Meninsky's *Jewish Boy*. On the other hand, the *New Witness* commended the latter as 'a brilliant piece of colour', and Meninsky's *Mother and Child* (cat.15)[77] was also praised as 'powerful in design and colour'.[78] Elsewhere, Tatlock drew attention to Bomberg and Gertler as 'serious students of a vital tradition' in contrast to the general 'decorativeness' of English painting.[79] They were sometimes joined by non-member Jewish exhibitors, often émigrés, such as

Moses Kottler (1896–1977), a South African Jewish painter and sculptor, who exhibited in autumn 1922 and in 1930 during fleeting visits to London,[80] demonstrating the Group's continued willingness to show work by non-members and also anticipating the greater numbers of artist refugees (predominantly Jewish) fleeing National Socialism in the 1930s who exhibited with the Group in the following decade.

By 1918 fewer than half the members were exhibiting. Gilman's death in February 1919 brought about the resignation of Etchells, Lewis and Roberts. Ezra Pound penned an openly hostile review of the eleventh exhibition in November 1919, 'The London Group invents nothing whatever; [...] If anything accrues from them it is fortuitous by-product. Here we have a general ecole [*sic*] de goggle-woggle, cream-ice and stucco tonality; the arty, the sloppy.'[81] R H Wilenski's suggestion that in their revolt against tradition London Group members were 'building a new art',[82] sounded a rare note. *The Times'* ambiguous headline – 'High average and serious experiment' – was perhaps more telling. During the hiatus in the presidency over the next two years, Bevan, former Treasurer, became the older statesman figure.

As fissures widened over the growing Bloomsbury presence, a number of rival societies arose including the short-lived Monarro Group,[83] and Lewis's brief resurrection of the Vorticists as Group X. Lewis, as ever, commanded extensive press attention, and it was felt that the Vorticist 'secession' had robbed the Group of much of its vitality.[84] Ultimately the Seven & Five Society, formed in 1919, would become a more lasting rival. Though initially lacking boldness, it became more progressive after Ben Nicholson (who showed only once at The London Group's 'dog's dinner'), joined in 1924 and reorganised the group from within.

When Fry showed Derain around the 1919 annual exhibition it caused friction among other members and after accusations of favouritism Fry withdrew from the hanging committee. The thirteenth exhibition in October 1920 took place without Bloomsbury involvement. Fry's correspondence reveals that he still considered the Group to be 'the freest and least academic group in England', but he

called the replacement hanging committee a group of incompetents. This group included Nevinson who resigned in 1921 and never forgave Fry. The exhibition was a commercial flop, however, and afterwards Bloomsbury returned to the Group with increased support. Though Fry refused the post of president he was widely regarded as the power behind Bernard Adeney's (1878–1966, founder member 1913, president 1921–23) 'throne'.[85] Roberts, a former Official War Artist, who returned to exhibit with the Group in 1922, with his exceptional theatre interior, *At the Hippodrome* (cat.17),[86] was the sole remaining exponent of Vorticism.

In 1921 Bloomsbury dominance was regarded as a mainly positive influence on the group's 'most active and promising members' but a note of warning was sounded that others were becoming 'fascinated – entangled.'[87] It was hoped that Maynard Keynes' preface to the 1921 autumn show, which suggested it was better to sell pictures cheap than not at all, would help to increase sales; however, the preface attracted more press notice than the pictures themselves. D S MacColl (1859–1948), painter and former Keeper of Art at the Tate Gallery, strongly objected to Keynes' assertion that the Group included 'the greater part of what is most honourable and most promising amongst the English painters of to-day'.[88] A flurry of letters to the editor followed, including one from Group member Alfred Thornton (1863–1939, elected 1924), who argued that The London Group's work was 'of serious interest in that it reflects a very deep under-current that is running in life.'[89] This fuelled a further spat between critics MacColl, Tatlock and Hugh Blaker, primarily over the influence of Cézanne.[90] The admiration for French painting led to invitations to Maurice Utrillo (1883–1955), who exhibited with the Group in 1923, and Raoul Dufy (1877–1953), who showed in 1924 and 1926.

Although by 1922 critics noted that the Group was appearing 'far less revolutionary',[91] Konody considered the standard had been 'raised rather than lowered' and that the Group was now 'the most representative body of independent artists in [the] country'.[92] Grant's cityscape *St Paul's* was picked out

as 'akin to the architectural and topographical subjects of Corot's first period, so broadly and solidly handled, and yet so sensitive.'[93] The *Evening Standard* observed however that the Group could still 'count a sense of humour among their virtues. Perhaps the best joke at the Mansard Gallery, […] is, apart from the funny things hanging on the walls, the information in the catalogue that the portrait of Miss Harriet Cohen, by Savo Popovitch [*sic*], is priced at £150, including frame, but without frame eightpence.'[94] Serbian painter Popovic (1887–1955, elected 1922), along with the Italian Mario Bacchelli (b. 1893, elected 1922) and Russian ceramicist Boris Anrep (1883–1969, elected 1919), was part of a growing émigré presence commended, perhaps surprisingly, by the *Daily Mail* in April 1923, which declared that the Group was 'gradually expanding and developing from a narrow coterie into an art society of international importance.'[95] The *Daily Sketch* described it, less flatteringly, as containing 'contributions by artists of as many nationalities as go to make up the average London revue.'[96] Anrep's mosaics and Lessore's ceramics were however welcomed.

During this period sculpture began to have a more articulated presence. After the early strong showing by Gaudier and Epstein, there had been a hiatus when little or no sculpture was shown. This changed with the presidencies of Frank Dobson (1924–26)[96] and Rupert Lee (1926–36, cat. 20)[98]. Lee began exhibiting in 1919: his 'ingenious linear designs',[99] as well as his sculpture were admired; and Dobson in 1922, when his work was praised as 'one of the very best things in the exhibition'.[100] By the following year sculpture was firmly established as a vital component of Group shows and regularly reviewed. Dobson was a former Group X exhibitor and the Vorticist influence lingered in his *Seated Torso* (cat. 19), but his classical *Cornucopia* (exhibited in the 1928 retrospective) is more typical. In 1926 Epstein received rare

fig.7
Clara Klinghoffer
Sleeping Girl
1919

Ben Uri, The London Jewish Museum of Art

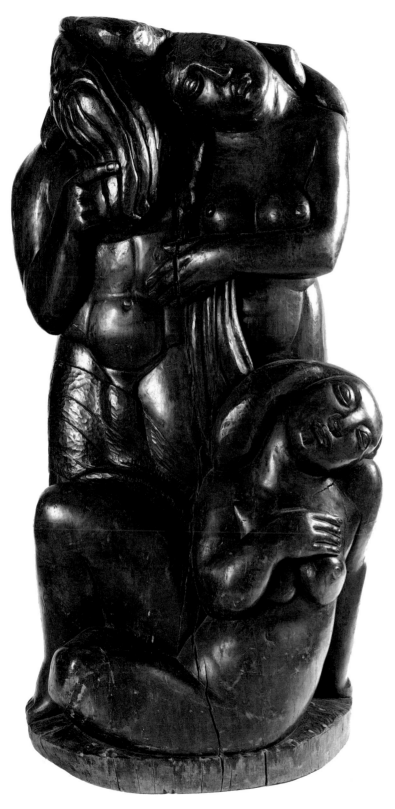

praise for his portrait head of a boy, *Enver*, described as 'the best that native sculpture can do in character and expression',[101] while the Russian-Canadian Jewish sculptor, Abrasha Lozoff (1887–1936), whose work combined the disparate influences of Grinling Gibbons and Gauguin, exhibited for the first and last time. His extraordinary woodcarving *Lot and his two Daughters* (fig.8) later donated by Lord Sieff to the Ben Uri), was judged by the *Times* to be 'not as good as it looks, owing too much to its Far Eastern reference, though it is evidently the work of a man who knows his job';[102] the criticism may have been provoked by the whopping £1,500 price tag. A number of women sculptors also began to become regular exhibitors in this decade including Elizabeth (Betty) Muntz (1894–1977, elected 1927) and non-member Margaret Hayes (exhibited 1923–26).

Although in most camps The London Group continued to be seen as younger and more energetic than the NEAC, the *Times*' critic in May 1926, commenting on the Royal Academy's inability to fill the third gallery of the Summer Exhibition, swept away such divisions when suggesting that 'they […] should call upon the young lions of the New English Art Club and the London Group to splash about in it.'[103] However, having also drawn a clear distinction between the RA and The London Group critics did not like to see this line blurred. Allinson's 'carefully accurate' *Spring in Suburbia* was criticised as being 'too near to the modernity of Burlington House to be encouraging'.[104] Throughout the 1920s, a number of stalwart contributors including the Carline brothers (Richard, 1896–1980, elected 1921; and Sydney, 1888–1929, elected 1922) became members, while individual painters including Paul and John Nash (1889–1946, elected 1914) and Matthew Smith were also consistent and highly individual exhibitors, who added considerably to the vitality of the exhibitions. Yet by the time of its first retrospective in 1928, as the *Evening News* suggested with its damning heading 'Back to Normal in London art, No Futurist Sensations at the New Exhibition',[105] the Group was undoubtedly tired and in need of the boost that it was hoped this important anniversary would deliver.

'NEITHER GOSPEL NOR CREED': THE LONDON GROUP 1928-49

RACHEL DICKSON

fig.9
Allan Walton
Catalogue cover for *The London Group Retrospective Exhibition 1914–1928*, New Burlington Galleries, 1928

The Diana Brinton-Lee Archive

The London Group's *Retrospective Exhibition* in spring 1928[1] at the New Burlington Galleries included 53 current and 25 past members, living and deceased (almost all the members to that date)[2] represented by 266 works; almost a quarter of the exhibitors were women. Efficiently and effectively organised by Rupert Lee and Diana Brinton, the show presented a balanced view of the Group, embracing all its constituent 'tendencies'. Founding and early members were prominent, with Adeney, Bomberg, Fry, Gertler, de Karlowska and Lessore each showing at least five works; the late Spencer Gore's exhibits oddly predated the official founding. Gilman had the greatest number of works (eight) – a fitting tribute to the first president. Among the seven sculptors, Gaudier was represented by five pieces, including the outstanding *Bird Swallowing Fish* (cat.8).

The list of private lenders, including Samuel Courtauld (1876–1947), George Eumorfopoulos (1863–1939), Edward Marsh (1872–1953), Maynard Keynes (1883–1946) and Sir Michael Sadler (1867–1943, one of the earliest supporters of Post-Impressionism in England), indicated how once-controversial works were now forming the backbone of English modernist collections. Sadler's loans included Kramer's *The Jew*, the subject of heated debate in 1917.[3] Artists inevitably loaned their own works – Fry (*Portrait of Miss Nina Hamnett*, cat.13), Wadsworth (*Marseilles*, cat.24),

Kramer (*Clay*, cat.23), Sands and Vézelay – amid much reciprocal lending. Brodzky showed his portrait by Gaudier; Fry lent Etchells' *Nude (Hip Bath*, cat.22) and Hamnett's *Portrait*; Ginner showed McKnight Kauffer's *Poppies* and Epstein lent Matthew Smith's *Femme à l'Eventail*.

Loans from public lenders also confirmed members' acceptance into the art establishment: the Imperial War Museum lent Paul Nash's haunting *We are Making a New World* (1918);[4] the Contemporary Art Society (founded in 1910 to donate art to public institutions) lent works by Adeney and George Barne (1882–1931, elected 1922). From the commercial world, Ernest Brown and Phillips (the Leicester Galleries) lent Epstein's sculpture *Pigeons* and Lucien Pissarro's oil *Quai de Seine, La Frette*.

A sizeable illustrated catalogue, with Allan Walton's[5] striking red Bloomsbury-esque cover design of a vase of flowers (fig.9) included Fry's introduction *The Modern Movement in England*, Thornton's short *History of the London Group* and a foreword by Tatlock, who acknowledged that members had 'so often given us something worth thinking and writing about.'[6] Fry's opening salvo, 'The years covered by the existence of the London Group comprise one of the most eventful episodes in the history of British art',[7] was tempered by his admittance 'that something of the adventurousness of the early years has gone. [...]

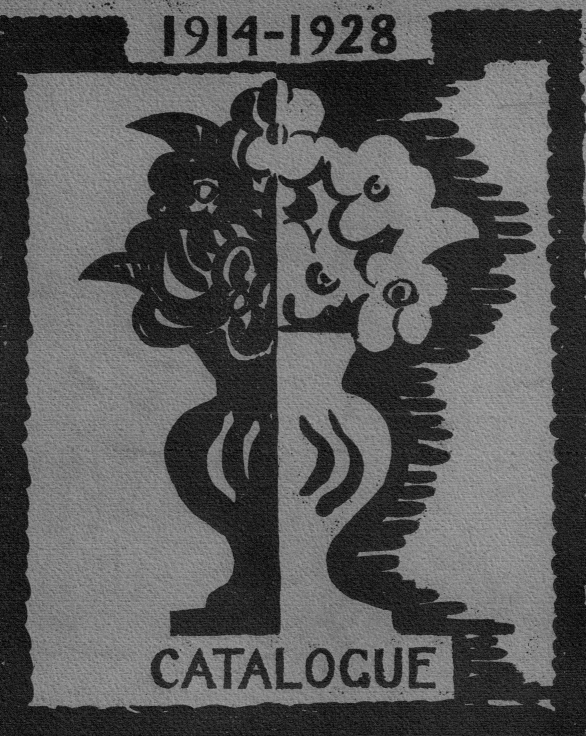

LONDON GROUP
RETROSPECTIVE EXHIBITION
1914-1928

CATALOGUE

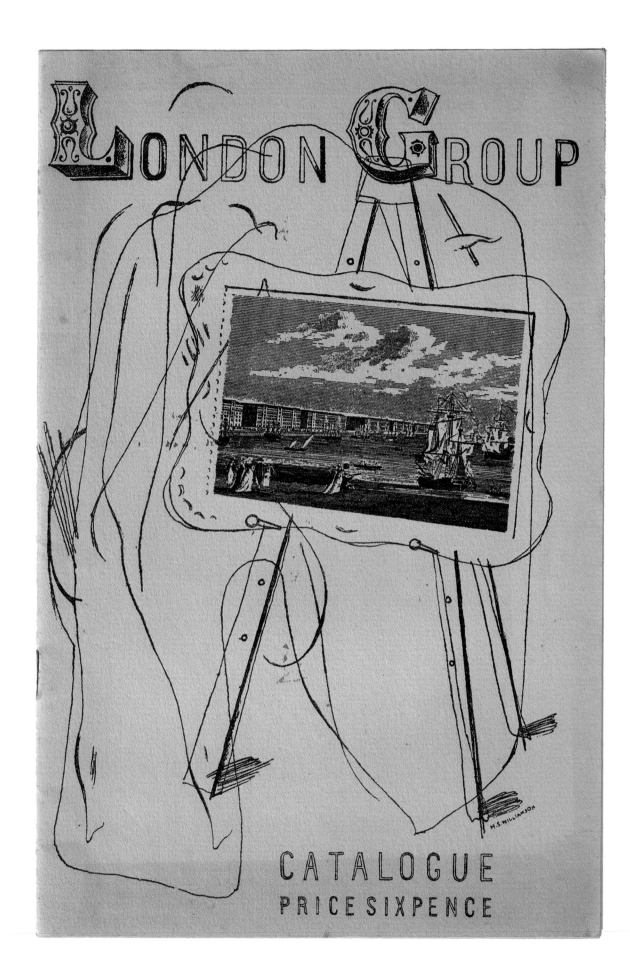

large-scale compositions have given place to works that are more suitable to the exiguity of modern apartments.'[8]

As a vehicle for the Group's finest exhibits to date, the retrospective diffused rather than courted press controversy. *The Times* was 'amazed at the number of serious English artists […] and at the merit of their works […] So catholic is the Group that it is hard to think of any serious artist who is not represented […]'[9] However, a number of critics echoed Fry, bemoaning the Group's current lack of innovation, as well as that of individuals including stalwarts Bomberg, Gertler and Grant. 'It is melancholy to the young, and reassuring to the old', mused the *Scotsman*, 'to reflect on the comparative uniformity in style and absence of experimental fervour'.[10] Nevertheless, Tatlock's sympathetic view concluded that 'members of the London Group were the only English painters who contrived to do more than merely "carry on" during the war period. At a time when others merely rested on their oars they invented and developed.'[11]

With its mood of warm inclusivity, the retrospective marked a sea change in tempo and reinvigorated the Group as a whole; 1929 heralded a record number of applicants for membership and 80 exhibits from non-members. Yet the press remained divided. Smith and Grant (*View from a Window*, cat. 26)[12] were praised for works 'not only larger in scale, but richer in achievement, and […] more important than any previously seen';[13] but *Connoisseur* only saw 'what was more unforgivable, dullness.'[14] Lewis continued Fry-baiting, whilst Rutter declared the 27th Exhibition 'more truly representative of the independent art practiced in London than it has been for some years', noting '[…] the conspicuous' addition of one wall of 'semi-abstract geometrical paintings.'[15]

With the change of decade, the influx of new members and non-members continued (in the early 1930s non-members predominated), bringing provocative experimental influences from Europe. Unwittingly, the Group's democratisation gradually became a double-edged sword, allowing shows to become ever larger and unwieldy, flabby rather than tightly curated, lacking both a defining doctrine and a clear admissions process. The Group also faced new challenges: external political pressures; an influx of European émigré artists following the rise of fascism; and the ascendancy of non-traditional sculpture.

In spring 1930 the Group's modest sculpture exhibition in Selfridges' roof garden (noted for its mini golf course and all-girl gun club), a model for the postwar open air shows curated by the Arts Council in Battersea[16] and Holland Parks, comprised 20 artists, of whom eight were women (the catalogue, now produced by The Women's Printing Society Limited, further demonstrated the Group's continued support for female creative endeavour.[17]) Three significant new members who were elected in 1930, and exhibited at Selfridges, were sculptors Barbara Hepworth, her husband John Skeaping, and Henry Moore. The *Scotsman* rather sniffily described Moore's 'block-like, unalluring "Woman" with triangular eyes'[18] and the *Morning Post* referred to the 'grotesque amplification' and 'aggressive' scale of the works as a whole.[19] Lee nobly rose to defend the medium in print:

> Why should modern sculpture be so much more badly treated than painting or music of a like calibre? At a mixed exhibition this Cinderella of the arts is entirely neglected by the critics, who seem only to have heard of Epstein, which they repeat without intelligent reference to his work, while the paintings, which are no less and no more "advanced," no less and no more "beautiful" in their own sphere, are painstakingly discussed and valued.[20]

As Moore and Hepworth created increasingly abstract work, both withdrew from the Group to other more progressive and tightly focused societies, including the Seven and Five; Unit One (founded by Paul Nash);[21] and Abstraction-Création, a Paris-based, loose association of artists who wished to counter surrealism via abstraction.

Edna Manley, who had emigrated to Jamaica with her husband in 1922[22] and was later known as the Mother of Jamaican Art, exhibited six works in wood and bronze at Selfridges – more than either Hepworth or Moore – including her large-scale carved *Eve*, a daring, non-conventional representation of the female form, subsequently donated by Yorkshire-born

Manley to the Graves Art Gallery, Sheffield in 1937[23] with *The Dance of Life* (cat. 29). The first pieces of 'serious' sculpture acquired by the city, Manley feared they were easy targets for criticism. Councillor Darrell Foxon duly obliged: 'I do not think there has ever been born a woman like any of these. I have never seen such absolute tripe in any other art gallery or anywhere else. […] If anyone wants to see anything far worse than Epstein ever carved they have only to go to the Graves Art Gallery.'[24] Nevertheless, avant-garde sculpture continued to claim a small but potent niche within the Group, with pioneering sculptor-members including Kenneth and Mary Martin (cat. 45 and 44, elected 1949 and 1959 respectively), Lynn Chadwick (cat. 43, elected 1952) and Kenneth Armitage (cat 42, elected 1953) contributing important exhibits throughout the late 1940s and 1950s.

The Group's now annual open exhibitions drew critical disappointment in the early 1930s: the *Spectator* accused the Group of 'Genteel mediocrity'[25] whilst the anonymous author of the 1931 catalogue preface admitted members had 'neither gospel nor creed.'[26] *Apollo* considered this to be a 'confession of weakness worthy of politicians.'[27] Nevinson gloomily saw the Group approaching a stylistic impasse, accusing London Group 'Academicians' of clinging 'to their "pure art" formulas condemning […] all the great masters of the past […]. With the exception of the Sur-realists who are too literary and too obsessed by the science of "idea association"[,] modern artists have chained themselves to one dreary form of production'.[28] When Sir William Llewellyn, President of the RA, attended the 29th exhibition preview (the first time any PRA had been officially invited), the press pounced eagerly on a possible aesthetic rapprochement: not 'foreshadow[ing] a National Government in artistic affairs, but it should be the prelude to more intelligent relations between the two parties.'[29]

The 1932 catalogue, prefaced by Roger Hinks (1903–1963, Assistant Keeper of Greek and Roman Antiquities at the British Museum), prudently advised exhibitors 'to extract aesthetic virtues out of economic necessities'.[30] Although he refrained from the term

'abstract', his reference to clear structure and pictorial surface certainly encouraged such interpretations.[31] After the 31st Exhibition late in 1933[32] devoted an entire wall to abstraction, the *Yorkshire Observer* proclaimed 'A fresh outbreak of "abstract" painting'.[33] As usual, the critics' provocative vocabulary left no doubt as to their distaste for experimentation:

> A marked feature […] is a recrudescence of abstract, cubist and surrealist painting. When we compare the Kaleidoscopic[34] designs of Miss Eileen Agar with the delicate luminism of Miss Lessore's "Do you remember Jem Mace?", or the vague savagery of Mr. Adeney's fauvist "Composition" with the pale distinction of Mr. John Nash's most poetic landscape, "The Stump", we are completely at a loss to know what the London Group stands for.[35]

Illustrating the stylistic breadth embraced by the Group, nine members were elected in 1933 (the largest number in one year to that date), including William Coldstream (cat. 36), Slade graduate and traditional figurative painter; Agar (cat. 31), who would show the most controversial work in 1934; Rodrigo Moynihan (cat. 32), for whom the press would reserve some of their choicest critiques; John Piper (cat. 34); and Peter Norman Dawson (1902–1960, fig. 11), now largely unknown, whose Surrealist-inspired, often collaged, works exceeded even Agar's in terms of press incomprehension.[36] For Dawson, recent RCA graduate and committed Surrealist, the Group provided a much-needed platform for broader exposure, and his reliance on the publicity it generated is evident from the quantity and continuity of his submissions.

If abstraction was viewed with distaste, Surrealism, permeating from Europe, was deplored, with Agar's controversial *The Modern Muse* (cat. 31)[37] attracting stinging criticism, even though the exhibition was tempered by the death of Fry, six of whose works were shown, including *Portrait of Nina Hamnett* (cat. 13), and Lee wrote the catalogue eulogy.

The following year Harold Sandys Williamson (1892–1978, elected 1933), Headmaster of the Central School, was also rebuked for his Surrealist *Woman Seated at a Window*, described as 'a headless woman

in red sitting by a fire.'[38] Nevertheless, his appointment as Chairman (1937–43) and his Surreal 1936 catalogue cover (fig.10) suggest that Surrealism was now embraced by the Group, if not the press. The design, with its swirling embellishments worthy of a magnificent schoolboy doodle, recalled 'Dufy's swift and witty calligraphy', noted the *Sunday Times* 'but when the imitation is neither witty nor swift the charm of Dufy is gone.'[39]

The New Burlington Galleries had hosted the controversial *International Surrealist Exhibition* in summer 1936[40], preceding the Group's autumn show, with Group members McKnight Kauffer, Lee, Moore and Paul Nash among the organisers, and members Agar, John Banting (1902–1972, elected 1927), Diana Brinton and Dawson exhibiting. The critic T W Earp caustically observed 'Perhaps the Surrealist exhibition [...] has left germs of fever.[41] Certainly the 1936 exhibition had a distinctly different mood. Bloomsbury-ites Keith Baynes, Bell and Grant had left the Group, while Gertler, John Nash and Matthew Smith failed to exhibit. 'To create a show so repellent', fumed the *Scotsman*, 'is quite an achievement, and if the success of an exhibition is to be judged by the indignation it excites [...] then this is a triumph'.[42] The *Cork Examiner* criticised Jessica Dismorr's *Study in Dissociated Forms* (see cat.33 for similar work)[43] as 'a collection of articles back from the wash'.[44]

New English Weekly declared:

> The circus has come to town. Several hundred more or less solemn clowns are gathered together in thy name, O father which Art, to crack every kind of old cold chestnut. There is nobody to crack the whip they so richly deserve. There is no semblance of order. Just a nice big anarchists' holiday gathering, such as all societies need to have once in a while, especially when times are bad and the ominous rumble of another apocalypse fills the air with disquiet.[45]

In this mood of agitation, Dawson's work was singled out over three consecutive years. *Unfinished Parachoic Composition* (1936) was simultaneously considered '[...] highly imaginative [...], a study of lost souls in some green horror of their own making'[46] while containing 'slaughtered entire families of

painted figures'.[47] Rutter particularly mocked his 1937 collage, *Blue Mouth of Paradise*: 'I do marvel that anybody should be so simple as to believe that there is anything clever, skilful or wonderful in cutting the print of a human head and torso off an anatomical chart and gumming the paper to a canvas.'[48] In the 1938 show, *Before the New Atlantic State*, a 'shocker'[49], with its actual barbed-wire frame, caused one bemused writer to advise visitors against 'paying 6d. for a catalogue [...] unless they have the mentality of crossword puzzle solvers. It will only increase their already considerable confusion.'[50]

Thus the years 1934–38 were reminiscent of the ferment of the early days, and the rise of Surrealist work in no way diminished certain critics' loathing for abstraction. New member Rodrigo Moynihan's all-white works, including *Painting (Objective Abstraction)* (cat.32), were lambasted as an aesthetic step too far:

> It has happened at last! [...] it was only a matter of time before some daring painter just dabbed a canvas with pigment anyhow and had it hung and solemnly commented on in a gallery. The name of the painter is Rodrigo Moynihan, the place is the New Burlington galleries, and the exhibiting body is the London Group.[51]

As if this insult were a catalyst for retrenchment, in spring 1937[52] the Leicester Galleries hosted a compact members-only show with 63 exhibits, generally greeted favourably, despite a consensus that the Group had lost its avant-garde edge (Dawson, Agar, and Moynihan apart). The *Daily Mail* approved the Group as 'a vital force in contemporary art'.[53] The *Evening News* even detected 'something of the *Blast* spirit'.[54] Nevertheless, traditional painting still had its place, with Coldstream's *Mrs Auden* (cat.36) attracting favourable reviews ('more modern than actual post-impressionism'[55]), and the regional tour of selected works to Wakefield, Sunderland and Hull considered 'one of the most important ever seen in the provinces.'[56]

In autumn 1937, however, the regular open format returned to the New Burlington Galleries where, despite outbursts over individual works, it received

fig.11
Peter Norman Dawson
Blue Mouth of Paradise
1937
Current whereabouts unknown

a more tolerant, even welcoming, press as 'an institution almost Parliamentarian in influence',[57] revitalised by its outing to the provinces 'for fresh blood'.[58] Two newer members, John Piper (cat.34), and Gertrude Hermes (cat.35), both on the hanging committee (Hermes the lone woman among eight men), now consolidated their Group careers.[59]

In the wake of the continued furore of the abstraction versus Surrealism debate, the Euston Road School[60] emerged as a reaction against the extremes of the avant-garde, with a small coterie of artists inspired by Sickert and Cezanne seeking a return to traditional figuration. Three of the four principals – Coldstream, Pasmore and Claude Rogers (cat.37) were all Group members. Moynihan also exhibited.[61] As Graham Bell, the fourth principal, pointed out, not all younger artists looked to the avant-garde, and the principals' work represented 'a return to adult standards of painting, to the tradition of Degas […] The best future of painting lies away from the forced intensity and sterile hilarity of the last few years.'[62]

However, events on the continent continued to seep unbidden into the Group in unforeseen and unexpected ways. In late 1936, Professor Rudolf Hellwag (1867–1942), a German academic painter who had worked in St Ives in the early 1900s, invited the Group to stage an exhibition of British Modernism in Berlin, minus the work of Jewish exhibitors. The episode[63] resulted in uproar and was vehemently opposed by the Jewish members, led by former member Jacob Epstein. The Group ultimately rejected the blatantly anti-Semitic proposal despite the art establishment's embrace of Hellwag, who was welcomed at the Royal Academy and the Royal Society of Portrait Painters. Aware of the real agenda of the Nazi propaganda machine, all members clearly saw the offer as morally reprehensible. Only months later, the infamous *Entartete Kunst* (Degenerate Art exhibition) was held in Munich[64] in which over 650 paintings, sculptures, prints, and books, confiscated from German public collections, were displayed as examples of degenerate or subversive art, with one room wholly devoted to works by Jewish artists.

The foregrounding of political issues inevitably lingered during the build-up to war. Throughout the 1930s, a number of alternative independent exhibition groups emerged with political agendas, whose members also chose to exhibit with the non-aligned London Group. James Fitton (1899–1982, elected 1934) co-founded the left-wing, anti-fascist *Artists International Association* in 1933. Its First Statement of Aims in 1934 was signed by 32 artists, including Group members Agar, Lee, Moore and Paul Nash. Bell, Grant, Pasmore, Coldstream, Julian Trevelyan (elected 1949), Merlyn Evans (elected 1953), Robert Medley (elected 1937) and Ruskin Spear (cat.39) were also active participants. By 1936 the AIA had over 600 members; in the spirit of The London Group it declined to promote one style, but also encouraged commercial art in a way that the Group did not and supported a shift towards realist art with a social function.

Fired by the wider political mood, Bomberg submitted urgent proposals to the Group's 1936 annual meeting, suggesting affiliation with the AIA. Both these and his subsequent plans in 1938 to reorganise the Ben Uri were emphatically rejected, despite his plea that 'The Jewish artists are starving [,] none of us can work, most of us receive one form of charity or another – we can make a market for ourselves if we organise'.[65] Meanwhile Manley used the Group's winter 1938 exhibition[66] to support political protestors in her adopted homeland; *Revelation*, her sculpted head of one of the Jamaican ringleaders, displayed 'an indirect sympathy with the rioters.'[67] Augustus John, recently returned from Jamaica, also engaged with the cause.[68]

With the approaching threat of war, the Group continued to show modestly (130 works) with its first *Special War-time Show* in November 1939, and functioned throughout the war years, despite a lack of members and materials (in contrast, Ben Uri closed completely until 1944). During this period, the Group developed as an important exhibition platform for a number of mainly non-member émigré contributors, who added significantly to the richness and complexity of the Group's narrative.

fig.12
Photograph of Gertrude Hermes with *Butterfly*
1937
The Henry Moore Institute, Leeds

Hitler's rise to the German Chancellorship in 1933 and increasing anti-Semitic legislation led to an influx of mostly Jewish, German and Austrian artists, designers and architects into Britain, escaping political, racial and artistic persecution. By 1945 more than 300 creative individuals had taken refuge, some only pausing briefly before emigrating to a second destination, such as America or Israel.[69] The Group's open submissions policy, in the spirit of continental *Jury Frei* exhibitions, no doubt appealed to these artists. For some, the Group was simply one among the opportunities offered by Ben Uri or other newly formed organisations aligned with particular émigré nationalities, such as the Free German League of Culture, the Free Austrian Movement and the Czech Institute,[70] or British-led organisations such as AIA and CEMA.[71] For other émigrés, the Group was their only platform.

More than 27 émigrés,[72] across a range of nationalities, exhibited with the Group between 1931 and 1948 including 'degenerates' German Henry de Buys Roessingh (1899–1954), who showed a single landscape in 1931,[73] and Hans Feibusch, who became the first émigré Group member in 1934, a year after his arrival from Germany. His *Drummer*, painted in exile and depicting a masked and uniformed musician, drumstick held aloft, was a powerful allegory of the unstoppable force of National Socialism, acclaimed by the *Jewish Chronicle* as 'a surrealist *tour-de-force*'.[74] Feibusch showed consistently with the Group from 1934–43, often attracting press attention. In 1936 his oil *Elijah* was selected as 'outstanding'.[75] In October 1937 he exhibited an early version of *Narcissus* (cat.30) with his *Design for Mural Painting*, indicating his new career as a church muralist following his conversion to Christianity. Naturalised in 1938, he gradually switched his allegiance instead to the Royal Academy, showing regularly in the Summer Exhibitions from 1944–70.

Prior to its praise for Feibusch, it is remarkable that the *Jewish Chronicle* had entirely ignored the Group's activities for more than twenty years, despite the significant number of Jewish founder artists and

early members, until commenting on the 1928 retrospective, under the heading *Jewish Artists and Modern Developments*. The critic 'K' noted the current 'recession from the extreme point of abstraction' and the 'excellent results produced by young men under this indirect stimuli'.[76] However, by 1929 he described the Group's problems as 'Rousseau – Matisse – Chirico – incompetence'.[77] Although at pains to acknowledge the contribution by Jewish exhibitors – 'astoundingly high, both in quantity and in quality'[78] – by October he had virtually written off the Group in view of 'a terribly low proportion of its real masters, no interesting new work whatsoever, and a great deal of tenth rate student work' (though, in his partisan view 'certain consoling reflections may be drawn from the Jewish point of view'[79]).

In 1936 German sculptor Fritz Kormis (1887–1986) exhibited *The Expulsion* and the following year Willi Soukop (1907–1995) showed his progressive concrete *Head of a Girl* (fig.13) – only rarely did titles or imagery suggest the wider and terrible events in Europe). In November 1938 émigré exhibitors included noted Austrian sculptors Siegfried Charoux (1896–1967) and Georg Ehrlich (1897–1966), who began to contribute regularly to the sculpture section; German ceramicist Grete (Margaret) Marks (1898–1990)[80] and Hans Aufseeser (1910–1997), who would adopt a new anglicised surname 'Tisdall' in his subsequent career in Britain as a noted painter, designer and illustrator. Later catalogue entries reveal other changes of name / identity. Both Austrian Heinz Inlander (1925–1983) and Polish émigré Henryk Gotlib (1890–1966, elected between 1940 and 1943) – no individual years of election are recorded during this period – were listed with the first name 'Henry' in 1946 and 1948 catalogues respectively.

The *Special War-time Show* in November 1939 was the first of six wartime exhibitions held at various venues from 1939 to 1944, generally smaller than peacetime displays.[81] The second show during the winter of the Blitz (1940–41) was safely evacuated to Cheltenham.[82] Gotlib exhibited for the first time in the *Third War-Time show* in winter 1941 (the year of his arrival) showing *Landscape in Hampstead* (an area

fig.13
Willi Soukop
Pola Nirenska
*c.*1937
Ben Uri, The London Jewish Museum of Art

settled by many émigrés and which became a recurrent subject). Oskar Kokoschka (1886–1980), as Honorary Member (elected 1940–43), showed 'a rather elaborate "Caricature" of Mussolini.'[83] Hellmuth Weissenborn (1898–1982), also recently arrived, exhibited *Landscape*.[84] The catalogue included a foreword by William Mabane MP, Parliamentary Secretary, Ministry of Home Security, who affirmed the importance of the Group's open-door policy, which '[…] has a new significance in a world in which the regimentation of the individual soul is presented as the greatest good. The London Group rejects such doctrines.'[85]

The *Fifth War-Time Exhibition* in autumn 1943 at the RA saw the height of émigré participation with Feibusch, Gotlib and Fred (Manfred) Uhlman[86] (1901–85) now all listed as members. The *Manchester Guardian* praised 'a welcome infusion of new blood from foreign, particularly Polish, artists'[87] including Tadeasz Piotr Potworowski (1898–1962, elected 1953)[88] and Felix Topolski (1907–89, who exhibited *Refugees*), along with Germans Paul Feiler (1918–2013)[89] and Martin Block [*sic*] (1883–1954).[90] Charoux and Ehrlich continued to bolster the sculpture section, alongside a *Portrait* of émigré artist Kate [*sic*] Wilczynski[91] by Cynthia Drummond.

The *Sixth War-Time Show*[92] in autumn 1944 included Berlin-born Susanne Einzig (1922–2009), her first name still listed with its German spelling.[93] The work of first-timer, Paris-trained Polish painter and sculptor Marek Szwarc (1892–1958) caught the eye of the press: 'In the midst of all this deliberate chromatic understatement the handful of pictures by Polish artists now painting in this country shine like bonfires on an autumn evening […].'[94]

Postwar, Group exhibitor Zdzislaw Ruszkowski (1907–1991) became one of the most successful of the Polish émigré painters in Britain;[95] former German internees Fritz Krämer (1905–?) and Samson Schames (1898–1967) showed one work apiece. The 1947 exhibition included Austrian Ernst Eisenmayer (born 1920),[96] Judith Kerr (born 1923, who became a renowned children's author)[97] and Hungarians Kalman Kemeny (1896–1994) and Laszlo Péri

(1899–1967).[98] The 1948 show at the 'poorly lit' Academy Hall[99] included German refugee Gustav Metzger (born 1926), political activist and founder of auto-destructive art in the late 1950s, exhibiting the enigmatically titled *Hospital Mural 'Wombman'*.

The conflict also provided the opportunity for British artists to make war-related work for the War Artists' Advisory Committee, set up in November 1939, which was well funded by government and chaired by Kenneth Clark. Anthony Gross RA (1905–1984, elected 1948) referred to his subsidised wartime travels as 'a government magic carpet'.[100] 300 artists were supported; 30 were paid a full-time salary for a maximum of six months; 100 were awarded specific commissions and 200 had their work purchased. Group members who worked for the WAAC included Piper, Sutherland, Moore, Stanley Spencer, Edward Ardizzone, Gross, Dobson, Paul Nash, Leonard Rosoman, William Scott, Trevelyan and Keith Vaughan. Coldstream was particularly involved with the *Mass Observation* scheme, an artistic record of ordinary, everyday life in Britain. However, little war-related work permeated to the Group shows, although Ceri Richards (elected 1938) showed *Camouflaged Soldiers* in autumn 1941 in response to the heavy bombing of Cardiff.[101] In 1938 Richards

fig.14
Martin Bloch
Svendborg Harbour, Denmark
1934

Ben Uri, The London Jewish Museum of Art

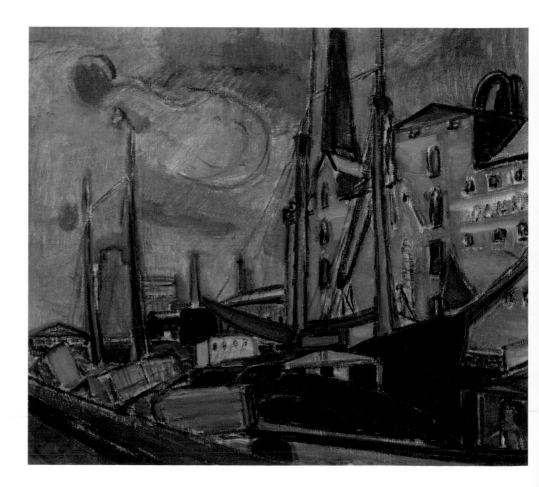

(see cat. 38) had been criticised for 'pretentious and empty' works,[102] but by 1941 writer and critic Jan Gordon considered him '[…] the spear-head of the London Group.'[103] A new exhibitor at this time was Lawrence Gowing (1918–1991, elected 1940–43), who had also joined the Euston Road School and was to become one of the most influential mid-century university art educators.

Ironically, in showing at the RA from 1943–46 (wartime disruption may have made such a prestigious venue readily available) not only were works shown to the greatest advantage, but the Group itself was inevitably seen in alignment with the establishment. The *Manchester Guardian* duly noted:

> one hardly knew whether to regard this as a broad-minded gesture on the part of the Royal Academy – a gracious bow to the Left – or an adventurous step towards respectability on the part of the London Group. Perhaps it was both, and certainly the benefit is mutual, for the London Group has never been so well hung and the walls of Burlington House have seldom looked so dashing.[104]

As the 1940s progressed, the artistic 'uproars' of the previous decade were generally superseded by new, less frenetic visual debates. In a changing postwar climate, much of the work by Spear, Coldstream and John Bratby (cat. 48) became infused with a degree of social realism, its very ordinariness, including 'intimate scenes of daily life – men at a pub, women shopping, the artist's wife bathing the baby or dispensing high tea'[105] contrasting with the grandeur of the Academy's setting. L S Lowry (cat 41, elected 1948), who showed regularly with the Group from 1944 until his death, exemplified this study of the everyday. A notable atypical exhibitor in the winter 1945–46 show was the young Nigerian carver and recent Goldsmiths graduate, Ben Enwonwu (1921–1994).[106]

In spring 1946 *The London Group Exhibition of Paintings* held in David Jones' Art Gallery[107] was accompanied by a small-format illustrated catalogue with a striking geometric cover (unattributed). The foreword by Jan Gordon's widow Cora[108] particularly praised early Group members, whose work had once

been greeted with 'derision or distrust' and were now recipients of '[…] the highest official honour', with Matthew Smith regarded as 'second to none' and Lee's work shown 'in many Galleries.'[109]

The 1947 exhibition, relocated to the RBA with almost 290 exhibits, featured the work of a number of younger painters beginning to carve out successful careers, including Prunella Clough (1919–1999), Roger de Grey (1918–1995, President of the RA 1984–93) and Anthony Eyton RA (born 1923). The following year at the Academy Hall,[110] the joint catalogue foreword by outgoing president Elliott Seabrooke (1886–1950, elected 1920) and Victor Pasmore set out a broad manifesto: '[…] the London Group stands for the best of the past and present, and because of this integrity, for the best of that which is to come.'[111] Pasmore also created the exhibition poster based on his exhibit *Abstract* (cat. 40).

Spear, the newly elected president for the January 1949 *Exhibition of New Work by Members*, was praised for the 'most coherent and satisfying of the paintings', while the Group's reputation was considered 'retrieved' – 'no outsiders being present to lower the average level of accomplishment.'[112] By the end of 1949, Spear had overseen the election of 13 new members, the greatest number in a single year, representing a multitude of responses across postwar British art. Robert Adams, Edward Ardizzone, Robert Buhler, Edward Burra, Morris Kestelman, Kenneth Martin, John Minton, F E McWilliam, Peter Potworowski, William Scott, Julian Trevelyan, Keith Vaughan and Carel Weight, encompassed variously: abstraction, Surrealism, illustration, neo-romanticism and avant-garde sculpture.

Thus, much as it had done twenty years earlier, the Group approached the new decade in robust form.

MANY PERSUASIONS:
THE LONDON GROUP 1950–64

SARAH MACDOUGALL AND RACHEL DICKSON

fig.15
Photograph of Kenneth Martin
holding a screw mobile, 1962
Tate Archive

There was no annual exhibition in autumn 1950 owing to the decoration of the Arts Council-administered New Burlington Galleries. Once re-opened with a restored fourth gallery however, the Group (now with a healthy membership of 83)[1] could again host exhibitions of a size to rival those it had held pre-war and entered perhaps its most successful decade.[2] In 1951, the year of the Festival of Britain,[3] two exhibitions were held under the discriminating eye of new president John Dodgson (1890–1969, elected 1947, president 1951–52).[4] The Working Party for the February 1951 exhibition comprised Gertrude Hermes, Morris Kestelman (elected 1949)[5], Victor Pasmore, H E du Plessis (elected 1929), Ceri Richards, Claude Rogers and Julian Trevelyan (elected 1949); former president Bernard Adeney designed the abstract catalogue cover.[6] Members were allowed to send four works each, thereby greatly reducing exhibits by non-members. This attracted criticism from the *The Times* which argued that the Group was the only large mixed show to give 'a really adequate summary of the more serious painting and sculpture of the year', and that 'the serious young artist […] more anxious to show there than anywhere else', was disadvantaged.[7] However, a few 'serious' non-members including sculptors Eduardo Paolozzi (1924–2005), Bernard Meadows (1915–2005, elected later the same year), Peter Startup (1921–1976, elected

1973), émigré Franta Belsky (1921–2000) and Kenneth Armitage (elected 1953), who showed his witty and inventive sculpture, *People in the Wind* (cat.42),[8] injected new blood.

Old criticisms were also revived, though with far less sting, with the observation that the effect of mixing realistic with 'unrealistic' painting was one of 'bewildering diversity'.[9] Only the abstract paintings of Pasmore, Richards and Bomberg were considered a homogenous group. Although figurative work by Hitchens, Smith, Grant, Hamnett, Dodgson and Sands was noted,[10] L S Lowry's spare Cotswold landscape, *Burford Church* (cat.41), went unremarked. A special section was given over to postwar abstractionists including Mary Martin (elected 1959), who showed her first plaster relief, *Columbarium* (cat.44);[11] the following year her husband and fellow Constructivist, Kenneth Martin (elected 1949), showed his 'ingenious' *Small Screw Mobile* (see cat.45 for a similar work). Both regarded the Group as an important exhibition platform during a period of limited opportunities.[12] By November 1951, the Group's main function was confirmed as its unique ability to offer 'something like an annual report on recent developments in British painting', showcasing both established and emerging artists.[13]

Perhaps building on this, in October 1952, under the new presidency of Claude Rogers (1952–66), the

Group announced that it had halved its membership fee 'in order that young or impecunious artists could afford to belong to it'.[14] This move gained the *The Times'* approval for bridging the 'gulf between the art school and the first one-man show'[15] and in this decade the Group helped to bring several notable young artists to attention early in their careers. These included the painter Euan Uglow (cat. 46), logged as 'an interesting talent',[16] and Elisabeth Frink, whose *Christ at the Column* was immediately acclaimed when exhibited at the Group in 1952. 'She looks like being hailed the first of our women sculptors and as impressive as the best of our men,' *the Scotsman* noted; indeed Lynn Chadwick's arresting iron 'ventilator' (cat. 43), though commended elsewhere, suffered by comparison.[17] Although work by both Uglow and Frink was afterwards seldom absent from press columns this early important membership was later often omitted or excised from both their exhibition histories.

But for Myfanwy Piper the Group remained, as yet, unreformed: 'three hundred pictures hung two and three deep of many persuasions – Realist, Abstract, Expressionist – […] and the rest.' Of this last group, she complained, there were too many '[…] in vaguely post-impressionist (London Group variety) […] gaily swamping the more serious successes and the more interesting failures.'[18]

As the decade progressed, a number of committed older contributors including Richards and Smith (knighted in 1954) continued to be regularly picked out in reviews. Richards designed the 1954 catalogue cover (to celebrate the Group's 40th anniversary) and Smith designed his first poster for the autumn 1955 exhibition at the age of 76, gamely producing 36 designs from which the committee selected one. Pasmore's further journey into abstraction was lamented by Quentin Bell, who admired his 'sincerity of purpose' but felt that his constructions were 'as far from the painter's true bent as are the classical sublimities of Sir Joshua Reynolds' and that he was 'easily distanced' by Mary Martin's 'tasteful and accomplished' work.[19] John Berger, though commending Pasmore's 'superb' design, agreed,

believing his development had the 'quality of a cautionary tale'.[20]

Émigré artists, by now usually settled and often naturalised, continued to be notable contributors including painters Marek,[21] Henry Inlander (1925–1983), Josef Herman (elected 1953), and Henry Sanders (1918–1982); and sculptor Karin Jonzen (elected 1958). Memorials honouring recently deceased past members had by now become a regular feature of the exhibition catalogue and included those for Bernard Meninsky (by Morris Kestelman) and Elliott Seabrooke (by Victor Pasmore, both 1951); Charles Ginner and Stanislawa de Karlowska (both 1952); Geoffrey Tibble (1953); John Buckland Wright (by Gertrude Hermes, 1954); Vera Cunningham (by H E du Plessis, 1955); Nina Hamnett, John Minton, Jack B Yeats, David Bomberg and Anna Hope Hudson (all 1958); and Augustus John and Vanessa Bell (both 1962).

The closure of the New Burlington Galleries in 1955 was a serious blow not only to The London Group but to all independent exhibiting societies, as Claude Rogers (in his presidential role) pointed out in a letter to the *The Times* in June. He was supported by Rodney Burn, Honorary Secretary of the Group's old rival the NEAC, and by representatives of the Women's International Club, Artist's International Association, Royal College of Art, and Department of Fine Art at King's College, University of Durham, as well as prominent Group members Moore, Pasmore, Piper and Smith. Despairing of the difficulties in finding a central London space to exhibit the work of living artists, the group referring to a previous *Times'* recommendation from 1949, re-advocated the building of a new gallery for this purpose.[22] The coming together of these previously disparate factions also indicated how far the original artistic divisions had now healed.

In spite of the loss of the New Burlington, 1955 saw three London Group exhibitions at three different venues: from January to June a selection of 80 paintings and five sculptures from the 1954 exhibition travelled to Southsea and Southampton. The exhibition catalogue foreword lightly drew attention

fig. 16
Catalogue cover for *The London Group Contemporary Painting, Drawing and Sculpture* exhibition, New Burlington Galleries, 1951

The London Group Archive

fig. 17
Catalogue cover for *London Group Prints: The first exhibition of original prints by members of the London Group*, Zwemmer Gallery, 1955

The London Group Archive

to 'the perplexity and controversy' originally created by innovative movements, such as Post-Impressionism and Cubism, and to the Group's success in overcoming them. In March-April the first *London Group Prints* show at the Zwemmer Gallery in March-April included 76 works: linocuts, wood engravings, lithographs, monotypes, acquatints, etchings and silk screen prints (the last by William Gear, elected 1953). The catalogue featured two cover images (fig. 17): the lower by Richards and the upper by Edward Ardizzone (elected 1949), who gently and humorously encouraged purchasers by depicting two collectors examining a print portfolio.

The November 1955 members-only exhibition, held at the Whitechapel Art Gallery, prompted reflection on the 'curious' discovery that more than 40 years on 'much in the present show reflects, indeed repeats the Group's first products and ambitions.'[23] 'B. R.' (probably the Whitechapel's influential director Bryan Robertson) contributed a preface in which he suggested that The London Group was now so well known that like the Boat Race or the Proms, it needed no explanation; that its annual exhibitions were 'part of English life' and that is was held 'in affectionate esteem by a large public seriously interested in the arts' – a description which perhaps invited comparison with another old enemy, the Royal Academy. However, Rogers' introduction by contrast highlighted the Group's continuing experimentalism (even while acknowledging criticism that it was sometimes thought 'too varied to preserve unity') and held up its unique one-member one-vote system as a model.

The work of Grant and Bell, perhaps surprisingly so late in their careers, attracted criticism,[24] but the very different accomplishments of Herman's 'fluent and lyrical' painting,[25] Hitchens' boldly abstract *Red Spring* (cat. 47) and Rogers' spatially innovative *Hornby Train* were praised, alongside the 'considerable quality' of a work by Bomberg,[26] inviting the comment that 'he might have been our English Soutine if the passion of his handling did not so often override the subject'.[27] Yet Bomberg's influence remained strong and by 1962, the Group

had once again divided into recognisable artistic factions, which David Sylvester in the *New Statesman* identified as 'Constructivism, Bombergism and Coldstreamism' as the three 'conspicuous' trends, including 'beautiful objects' by both Martins among the Constructivists and 'outstanding' work from Dorothy Mead among the 'Bombergers'.[28]

In 1956 the exuberant realist painter John Bratby (elected 1957), whose work, along with other 'Kitchen Sink' painters,[29] was later seen to define the decade, first exhibited his characteristic *Kitchen Interior* (cat. 48). He worked, according to John Berger, 'as though he sensed that he only had a day to live. He paints a packet of corn flakes on a littered table as though it were part of a last supper [...] He paints every picture in order to impress the subject so vividly in his consciousness that he will never lose it.'[30] Elsewhere, 'Atticus' of the *Sunday Times* commended Bratby's 'forthright, overcrowded, plain-spoken and rather lugubrious canvases [...] A redoubtable arguer, less naïve than he might seem, Bratby has been known to emphasise a point so violently as to break three bones in his hand.'[31]

1957 saw the biggest intake of the decade with seven new painter members, apart from Bratby: Norman Adams, Alan Davie, Terry Frost, Patrick George, Leonard Rosoman and Jack Smith were all elected to the Group.[32] Non-member exhibitors (numbering 140 in 1958; 188 in 1959) including Michael Rothenstein (1908–1983) and Mario Dubsky (1939–1985, fig. 18), tutored by Mead, and Pop art founder Joe Tilson (b. 1928), continued to strengthen shows; and 1958 included a specially-invited group of ten 'Yugo Slav' painters.

With the new decade the Group exhibitions, several hundred exhibits strong, continued at the RBA Galleries. Dorothy Mead who had exhibited with the Group consistently throughout her student years under Bomberg at the Borough Group,[33] showed her striking *Self-Portrait* (cat. 49).[34] Elected to membership later in 1960 (as were Frank Auerbach, fig. 19, one of the first of the so-called 'School of London' painters, and future Group president Andrew Forge), Mead significantly went on to become the

fig. 18
Mario Dubsky
Figure Study (II)
Ben Uri, The London Jewish Museum of Art

Group's first female president between 1971 and 1973. By 1962, when the RBA Galleries were renamed the Federation Galleries, she had also become the first female artist to design the catalogue cover and exhibition poster. Two new members who strengthened the Group's disparate painterly tendencies in this period were Craigie Aitchison (1926–2009) and Dennis Creffield (b. 1931), also taught by Bomberg at Borough; both developed significant careers as artists and teachers.

1963 was a low point in the Group's history. Headed 'One's a Joke', the *Evening News* declared that 'Apart from a handful of paintings by serious artists like Professor Carel Weight, L. S. Lowry, William Gear and Philip Sutton, the show, surely the worst in the Group's 50-year history, is aptly summed up by the title of one picture, "Study for *What the Hell*"'. Geoffrey Grigson, with his famously vituperative barb, titled his piece 'On a Dying Gladiator' and having first insisted that the Group should be reformed, then corrected himself: 'No, groups or societies cannot be revitalised. So this one shouldn't be allowed to bring any further shame on its members, exhibitors, and the act of painting.' Yet, in the same year, two of the most important English painters of the late twentieth century, Leon Kossoff and David Hockney (b. 1937)

were both elected, implicitly countering Grigson's grim prognosis. Kossoff showed *Seated Woman* (see cat. 50 for a similar portrait study of N M Seedo),[35] displayed again the following year in the Group's 50-year retrospective.

As with the previous retrospective, the 1964 Jubilee Exhibition (subtitled *Fifty Years of British Art at the Tate Gallery*)[36] aimed to showcase the Group's history in all its glory, through 160 exhibits, displayed within the most important public gallery of contemporary art in Britain. Organised by the Arts Council, selected works from the exhibition then toured to Cardiff and Doncaster. The exhibition and accompanying illustrated catalogue provided a chronological account of the Group, with the various schisms and uproars which had characterised the first half-century now ignored and all works accorded equal importance within the display. Post-Impressionism, Bloomsbury, Vorticism, Surrealism and abstraction were all represented. Émigrés were integrated with English-born exhibitors and a strong showing of female artists, while traditional and avant-garde sculpture and construction fully energised the spaces beyond the walls. Within the catalogue decade-by-decade spreads of images allowed works of diverse tendencies to jostle with each other – Gilman's realism against Bomberg's startling fractured early modernism; Kenneth Martin's mobile (cat. 45) against a later, painterly Bomberg; Moore's progressive sculpture against Moynihan's painterly abstraction (cat. 32) and Nash's surrealism (cat. 25); Hitchens (cat. 47) against Mary Martin; Kossoff (cat. 50) against Uglow – all suggesting a breadth and dynamism within the Group, and (re)making powerful visual connections on the page, as much as in the rooms of the Tate itself. As Rogers affirmed in the opening sentence to his foreword, 'The strength of the London Group has always resided in the number and variety of painters and sculptors who have been members.'[37] In its first 50 years the Group had come full circle: embracing and celebrating both innovative and traditional work and earning itself a unique place in the cultural artistic calendar.

fig. 19
Frank Auerbach
Nude
1954

Ben Uri, The London Jewish Museum of Art

VISION AND LEADERSHIP:

THE RECENTLY DISCOVERED DIANA BRINTON-LEE ARCHIVE AND THE CRUCIAL ROLE OF THE INDIVIDUALS WHO SHAPED THE LONDON GROUP'S FORMATIVE YEARS

DENYS J. WILCOX

When I began researching the history of The London Group more than 20 years ago, it was immediately clear that much vital archival material was missing from the Tate Gallery archive. Apart from a full run of exhibition catalogues and several books of press cuttings, there was very little material that shed any intimate light on the day-to-day running of the Group and the conflicting internal politics that shaped the Group's development. Reliable source material relating to the individuals who organised and led the Group during the hardships of the First World War and the subsequent economic slumps that characterised the postwar years was scarce. The discovery of the perfectly preserved Diana Brinton-Lee archive in Spain in 2005 has put flesh on the bones of The London Group's history between the wars, providing a rare insight into the mechanics of running an artists' co-operative that didn't have the backing of the establishment. Although the minutes to the vast majority of the Group meetings still remain at large, the meticulously collated correspondence and administrative papers that make up the Brinton-Lee archive suggest that it was a small number of individuals who can be credited with sustaining The London Group's longevity.

Before assessing the new material which concerns particularly the interwar years, it is important to consider the legacy of The London Group's founding president Harold Gilman (cat.1). It was Gilman who set the tone for the Group's ethos of inclusiveness and tolerance overseen with a fiercely committed leadership style. A dominant and often dogmatic leader, he was unwavering in his desire 'to see a revival of good sound painting in England' and with an iron will to succeed in his mission.[1] He had been centrally involved with the formation of various artists' societies such as the Cumberland Market Group and the Camden Town Group, but these had been short-lived and Gilman understood better than most the difficulties of keeping a group of artists together in one society for any length of time. As Charles Ginner (cat.11) observed, Gilman's motivation for serving The London Group was to ensure that the younger generation of artists should reach their public on a regular basis in the form of twice-yearly exhibitions. Ginner stressed: 'As President of the London Group, Gilman was unceasing in his efforts to keep the Society going and in spite of many difficulties he arrived at setting it on a firm basis.'[2]

The First World War was just one of the strains on the Group's organisation, but Gilman acknowledged, albeit belatedly, the invaluable asset of the women members who had previously been denied membership of the Camden Town Group.[3] Gilman's friend, the American artist Edward Mcknight Kauffer (fig.21), was elected Secretary during the War and the

fig.20
Photograph of Harold Gilman

The Diana Brinton-Lee Archive

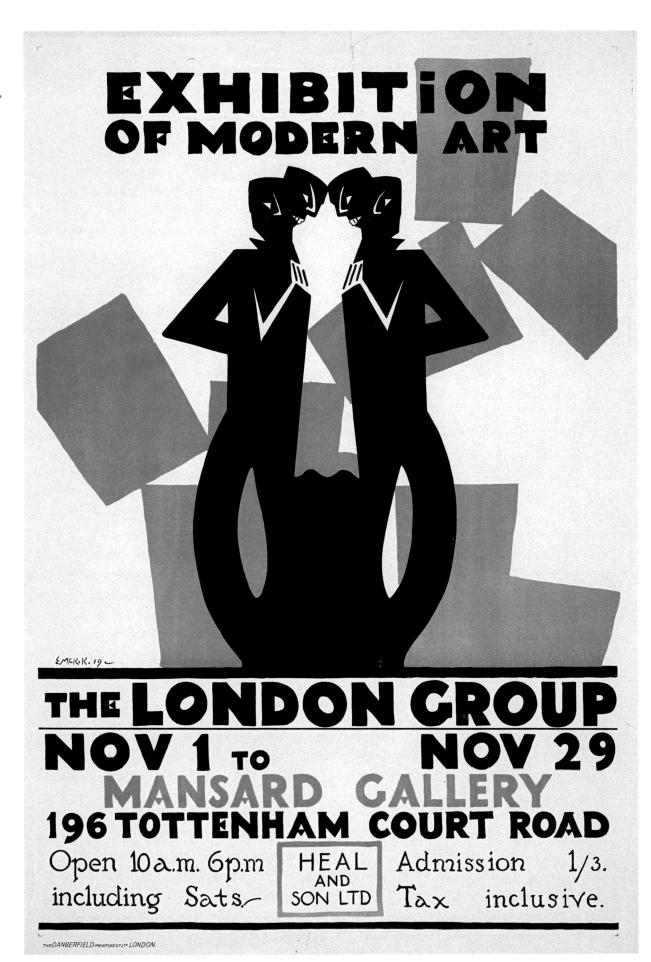

THE LONDON GROUP.

RULES 1925.

President :
F. DOBSON, 14, Trafalgar Studios, Manresa Road, S.W

Vice-President :
FREDERICK J. PORTER, 256, Portsdown Road, Maida Vale.

Hon. Treasurer :
J. WOODGER, c/o Drummonds Bank, 49, Charing Cross Road, S.W.1.

Secretary :
DIANA BRINTON, 84, Richmond Road, W.2.

1. This body of Modern Painters and Sculptors shall be called "THE LONDON GROUP."
2. The membership of the Group is not confined to any nation.
3. The officers of the Group shall be a President, a Vice-President, a Treasurer and a Secretary, who hold office for one year, but are eligible for re-election.
4. The membership subscription shall be £3 yearly, payable in two sums of 30/- before each exhibition, and no work will be hung unless it is paid.
5. If after two warnings a member has failed to pay his membership subscription before the end of the year he shall cease to be a member.
6. There shall be two Exhibitions yearly, one in the Spring and one in the Autumn. The Group accepts no responsibility for loss or damage to works submitted or accepted for Exhibition.
7. Members may exhibit five works at these Exhibitions ; the area of painting in oils exhibited by each member not to exceed 25 square feet, exclusive of the frame.
8. No member or non-member has the right to remove a work when once hung until after the Exhibition closes without permission of the President.
9. The Group shall hold two General Meetings, one in June and one in December when all the members are expected to attend.
10. The business at these General Meetings shall be :—
 (1) To elect new members.
 (2) To discuss and decide any business that may arise affecting the policy, the activity or the constitution of the Group, providing it is on the Agenda of the Meeting.
 In addition the business at the December Meeting shall be :—
 (1) To receive the reports of the retiring officers.
 (2) To nominate and elect officers for the New Year.
 (3) To nominate and elect the working committee for the New Year.
 Members unable to attend are asked to nominate and vote by proxy.
11. A Working Committee of five members working with the officers of the Group shall undertake the organisation and hanging of the Two Annual Exhibitions held in the Spring and the Autumn. The members of this committee shall hold office for one year, but are eligible for re-election.
12. The members of the Group shall at the Annual General Meeting propose eight candidates for this committee on which the meeting shall vote and record votes by proxy. The five candidates receiving most votes shall be elected.
13. New members may be elected half-yearly at the General Meetings. Members are requested to bring to the June and December meetings nominations for membership, and candidates may by application to the President submit their works to these meetings, or, if that is not possible photographs of their works, and it shall be the business of the meeting to discuss the proposed members in turn.
14. Voting for the officers of the Group and for membership at the Annual General Meeting shall be done in the following manner. The members shall receive a list of nominations proposed by the members themselves and they shall after careful consideration and discussion, cross out those names for whom they do not wish to vote, the untouched names counting as votes cast for membership. A candidate shall be elected when he receives more votes than half the number of papers returned. Those members not able to be present may send their votes to the Secretary by post not later than seven days after the meeting, when the President and Secretary will count the votes and notify those who have been elected.
15. Non-members may, if they wish, submit not more than two works for exhibition and should apply to the Secretary for the necessary form which must be filled up and accompany the work sent in.
16. The non-members work shall be judged at the Gallery on the sending-in day by the members in consultation and they shall record their votes by show of hands, the works being judged in the following manner :—
 (a) If half the number of members present are in favour of a work it shall be accepted.
 (b) If a quarter are in favour of a work it shall be hung at the discretion of the Working Commitee.
 (c) If less than a quarter are in favour of a work it shall be rejected.
 The hanging fee for non-members shall be 12/6 for each work accepted.
 Non-members, when submitting work are required to send a cheque to cover the amount of the hanging fee, such amount to be returnable in the event of the work not being accepted.

group benefited hugely from Kauffer's genius for poster design. There was a new, all-encompassing spirit about The London Group which derived from Gilman's determination to adapt, survive and command the respect of such diverse individual personalities as Walter Sickert (cat.18) and Wyndham Lewis (cat.6).

It was not within Wyndham Lewis's nature to offer praise and support to his fellow artists, but he granted this accolade in his little-known memoir of Gilman published in 1919. Wyndham Lewis recognised the rare quality of Gilman's character:

> [W]hether you sympathised with his work or not, he never abated his standards, but pushed on in a logical progression towards his best […] there was a very frigid Anglican core to his make-up as a painter that came into full and useful play in his functionings as President of a Group – an influential character in his circle. [4]

There can be little doubt that without Gilman as President, Wyndham Lewis and his Vorticist collaborators would never have joined The London Group and thus left their strident mark of radicalism on the Group's first two exhibitions.

Perhaps most significant of all, during those first five years, Gilman prevented monopoly of the Group's direction by any one particular individual or clique. During much of Gilman's reign the ever pervasive influence of Roger Fry (cat.13) was kept at bay. Gilman, whilst admiring Fry as a scholar, had always expressed his reservations about the quality of his paintings and there is more than a hint that he detected an affectation in Fry's endeavours which was entirely contrary to his own 'parsonic' honesty and 'moral rectitude in his pursuit of pictorial truth' – to quote Wyndham Lewis. [5] However, towards the end of the First World War, Roger Fry, Duncan Grant (cat.26) and Vanessa Bell (cat.14) did finally infiltrate group proceedings. A war commission sent Gilman to Canada to paint Halifax Harbour and, in his absence, Fry was elected first to the membership and then almost immediately to the hanging committee and thus the era of Bloomsbury influence began. Soon after, Gilman was a victim of the great flu epidemic of 1919 initiating a watershed moment in The London

Group's history. While the Bloomsbury artists embedded themselves, Wyndham Lewis attempted one more rival radical grouping in the form of Group X, which managed only one exhibition in 1920 in a final swan song to Vorticism. Lewis's attempt to weaken The London Group's prominence in the wake of Gilman's death and Fry's emerging dominance failed and The London Group soldiered on through the interwar years of austerity.

Frank Rutter identified Gilman's eventual successor, Bernard Adeney (1878–1966, founder member 1913, President 1921–23), as simply a frontman for Roger Fry who realised it would have been a tactical mistake to take up the official post of president himself. [6] In the few years after Gilman's death, the Group lost members, failed to elect a new president quickly and attracted fewer non-member exhibitors, while the lack of sales at the Group's exhibitions threatened its very survival. Resourceful measures were taken in an attempt to boost The London Group's diminishing profile and fragile finances. Fry invited his friend John Maynard Keynes to write the preface to the Group's exhibition in 1921 which amounted to a forceful plea to the public:

> […] I should like to add that the London Group includes the greater part of what is most honourable and most promising amongst the younger English painters of to-day. It would be rash to name any one of them as being secure of permanent fame. But it is not rash to affirm that it is from amongst their number that posterity will choose those whom it will celebrate as the leaders of English painting in the generation after the War; – which affirmation leads me back to my proper topic and allows me to add that the element of "investment" may not be entirely absent after all, that great masterpieces have often cost their first owner very little, and that the discerning purchaser has a real chance of finding at the London Group a picture which public collections will covet some day […] Without patrons art cannot easily flourish. [7]

Fry's initiative was most effective and he proved very skilful in courting the interest of the press which became a valuable tool in the Group's survival strategy. However, Fry also realised there was a need for the right personnel to manage and organise the

Group's activities on a daily basis and to keep on top of the financial necessities. Fry had been working at *The Burlington Magazine* with a highly educated young woman who he believed possessed all the right qualities to turn The London Group into a superbly organised society to rival in its infrastructure the older establishment exhibiting societies. Diana Brinton (1898–1982), still in her mid-twenties, had worked her way up to being a sub-editor at *The Burlington Magazine* and Fry had relied on her linguistic skills in translating French and Spanish texts, most importantly André Salmon's seminal essay on 'Negro Art' which she translated for the magazine in 1920.[8]

Diana Brinton began working as a gallery secretary for the Group in 1922 and immediately set about reorganising the Group's affairs.[9] An efficient filing system was created, with indexes for exhibitors and purchasers, and up-to-date publicity material about the Group was prepared and sent out to the newly created mailing list. She kept meticulous records of the attendances at the exhibitions and analysed the sales in order to build an accurate picture of the Group's progress or otherwise. In a document dated March 1931 Brinton recorded:

> I became gallery secretary to the London Group in 1922 and secretary in 1924. Before that time the sales had averaged £60 to £120, but at the 1922 show they were more than doubled and rose to over £1,000 in 1929. The 1930 show was the worst for years as regards sales, but the admissions and sale of catalogues, which had also been rising steadily, again created a record.[10]

The mundane and often irksome jobs of collecting membership subscription fees and issuing mail shots was carried out with renewed vigour and, in 1925, an updated list of rules was published which reinforced the Group's democratic structure while clearly outlining economic imperatives. Another obvious way to increase revenue was to gradually enlarge membership and accept more work from non-members, thus staging the larger exhibitions which became a noticeable feature throughout the 1920s and 30s. Despite the economic slumps of the period, Brinton encouraged a degree of pragmatism with her circulars advising members to sell their work at lower

fig. 23
Letter from Roger Fry
26 April 1926
The Diana Brinton-Lee Archive

prices and to be open to price negotiation. In these important elements of detail, The London Group became a more tightly run unit to the envy of other exhibiting societies – even to those like the National Society and London Artists' Association that also attracted the younger generation of artists and had a democratic reputation in common.

However, it was not just in these areas of administrative detail that Diana Brinton excelled. Her formidable intellect and sympathy with the Group's founding principles was also very evident to Roger Fry who observed with admiration her performance at Group meetings:

> Here I noticed her accuracy and fairness in drawing up minutes, her business like exactitude in every detail and, what came out most in such meetings, where rather heated discussions not infrequently occurred, was her admirable tact, patience and firmness in dealing with even the most unreasonable objections. I can only say that I have never met anyone more pleasant to work with or more efficient in any situation. [11]

Brinton's commitment to The London Group was to strengthen further as she became romantically involved with the painter and sculptor Rupert Lee (cat. 20) who was elected President of the Group in

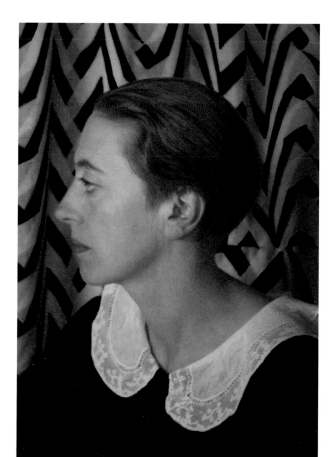

fig. 24
Photograph of Diana Brinton
1922
The Diana Brinton-Lee Archive

1926. Lee had been in the same Slade class as Mark Gertler (cat. 9), C R W Nevinson (cat. 10), Paul Nash (cat. 25) and Edward Wadsworth (cat. 24), had served in the War and was a respected, independent figure who also wrote for the *New Age*. It is clear from Paul Nash's descriptions in *Outline* that Lee was very much his own man, not a member of any cliques and therefore a good choice to lead a diverse group of artists. [12] Lee's relationship with Roger Fry and Bloomsbury was amicable but not too close and he remained distant enough to keep other members like Paul Nash and William Roberts (cat. 17) feeling that they were not exhibiting under the wing of an entirely Bloomsbury-dominated society. The correspondence between Lee and Brinton at this period is peppered with the problem of sorting out squabbles and disagreements between members. Smouldering hostilities and underlying jealousies were commonplace and a great deal of tact was required just to keep the membership content among themselves, quite apart from external forces that were constantly threatening the Group's stability. A recurring cause of discord within the Group during the 1920s and 30s were the high prices asked (and often achieved) for Duncan Grant's pictures. There was a sense that he had been unfairly elevated above other members in the writings of Fry and Clive Bell who famously described him as the best living English painter. [13]

Working very effectively as a team, both Lee and Brinton harboured definite ideas about the Group's direction and were highly motivated in the pursuit of their set goals. Brinton was deeply interested in politics and had been an active suffragette and was passionate about promoting the interests of women. Throughout the 1920s and 30s she encouraged women artists to submit their work to the exhibitions and she worked hard to increase the number of women members although they remained a minority. [14] As a sculptor, Lee's emphasis was always to encourage more young sculptors to join the Group and to raise the profile of sculpture in general, which he described as the 'Cinderella of the arts' and 'entirely neglected by the critics'. [15] His greatest initiative in this regard was

conceiving the idea for an open-air sculpture exhibition in the roof garden of Selfridges in the summer of 1930 (fig. 26). This proved to be one of the first exhibitions of its kind and was perhaps the trigger for the series of open-air shows arranged during the postwar period. Almost as if he anticipated the grand-scale work of Barbara Hepworth (cat. 28) and Henry Moore (cat. 27), Lee had the vision to attract these new young sculptors to The London Group and was one of the earliest champions of their talent and potential.

Diana Brinton recorded that she and Lee worked day and night organising The London Group retrospective in 1928.[16] The handsomely catalogued (fig. 9) show was a major achievement which sparked considerable press coverage and did much to help define the significant role the Group had played in the cultural life of the country. As Fry was involved in the project and wrote the introduction to the catalogue, the task of obtaining loans from disaffected former members proved especially difficult. Wyndham Lewis and Nevinson had both long distanced themselves from The London Group, hostile at the thought of Fry pulling the strings, but Lee managed to secure good examples from both artists. In the event, the show was comprehensive and balanced even prompting Fry to acknowledge, in the introduction, that the Vorticists had left an indelible mark on the modern movement in England noting, 'Evidences of Cubist influence are to be found sporadically throughout most of the period' – which remains one of the very few references he made to Vorticism in print.[17] The 1928 retrospective showed confidently that the Group was

fig. 25
Photograph of Diana Brinton and Rupert Lee

The Diana Brinton-Lee Archive

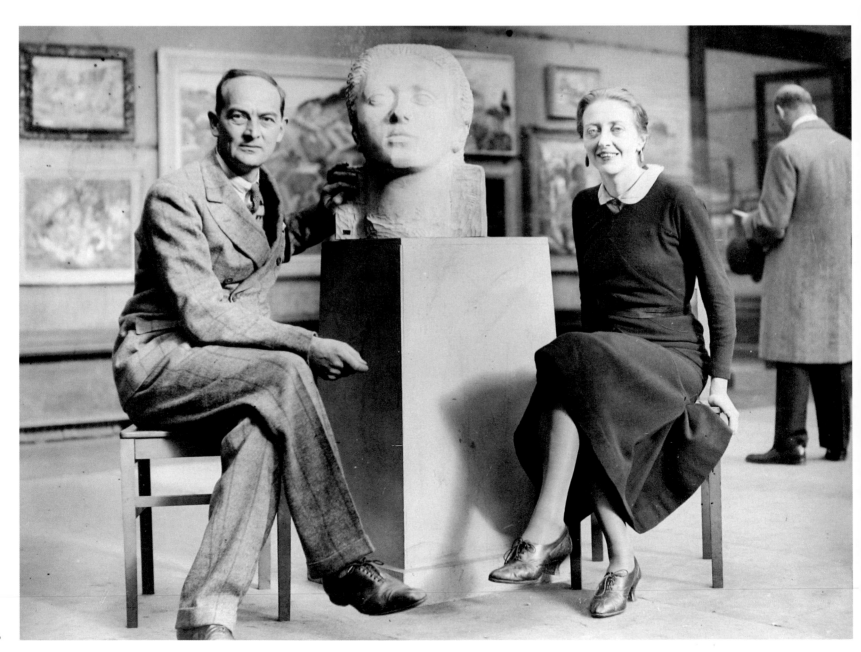

60

very small indeed), went before his scrutiny. I have never seen such conscientiousness in any other group or society. Here we had the Master looking at everything with complete, unbiased, close attention. If he thought there was the slightest flicker of something worthwhile in a picture, he would proclaim his discovery and the picture would be marked 'doubtful', to be re-examined before hanging on the walls. Most juries and judges are less exact in their demands, they make up their minds more quickly. Not so with Roger Fry; no vestige of talent went unrewarded! It was one of the unusual things, as regards the big exhibitions, that the whole membership of the London Group could meet and judge the work of non-members. The number of members who used to come and vote and take part was probably greater than those who get together today. Every member of the London Group felt that he or she had a hand in the whole proceedings. They voted and they helped. It was not a case of electing by votes the same set of people; *every* member was on the job.[18]

proud of its roots and remained true to its founding principle of welcoming all modern methods. It was never the intention of the Group to have a specific modernist agenda, but simply to provide a solid platform for broad experiment.

The retrospective was a huge success in terms of reinvigorating the society and in 1929 there was a record number of applicants wanting to become members and submissions from non-members also increased dramatically. One such new member, elected in 1929, was R O Dunlop (1894–1973) who has left a fascinating account of his impression of the Group at this period:

> I used to look up to the artists of the London Group as expressing all that was really good in painting of that day. The London Group had a fine record and numbered among its membership most of the virile, experimental artists in this country.
>
> I went to the first meeting of the London Group, as a newly elected member, full of trepidation. It was a most interesting experience, for at the head and fountain of all, sat Roger Fry, his white locks in unruly tangle. Every single picture, large or small (and often

The Group's deep-seated spirit of democracy showed itself in another way during the 1930s when fascism and communism became the focus of world politics. Although some members, notably David Bomberg (cat.16), wanted The London Group to adopt an openly left-wing stance this motion was consistently rejected at Group meetings.[19] However, throughout the 1930s The London Group did forcefully oppose fascism – most famously when an official from the Nazi government offered the Group an exhibition in Germany with the stipulation that Jewish members were to be prohibited from showing. This offer was very publicly rejected and the episode has already been published in detail elsewhere.[20] In 1935 the president, Rupert Lee, confided in a letter to Diana Brinton, 'The world seems to me about balanced between Bolshevik propaganda and Fascist propaganda. I find myself definitely on the Bolshevik side because the Fascists are most dangerous and completely without any constructive ideas.'[21] It was Diana Brinton who alerted the British public to Nazi propaganda against Jacob Epstein (cat.7) which appeared in their notorious anti-Semitic publication, *Der Stürmer.* On a visit to Germany she had seen the 'violent attack on "der Jude Epstein"' and wrote about

small group exhibitions in public venues across London, for example, *On My Behalf*, a curated exhibition on the theme of the self-portrait held in the busy foyer of the Cumberland Hotel, Marble Arch (2013).

Changes in London society and commerce have inevitably impacted on The London Group. The explosion of popular culture in the 1960s spawned a large number of commercial galleries interested in promoting and selling young artists which meant that The London Group's role of supporting younger artists was somewhat undermined. Even so, emerging artists such as Stuart Brisley (b. 1933), Tracey Emin (b. 1963) and Gustav Metzger (b. 1926) – who were to create uproar in their times – were all given exhibiting opportunities by The London Group early in their careers. Large, affordable, central venues for exhibitions disappeared as rents and land prices increased in the capital. The Group nimbly

sidestepped these developments by showing in offices, the *Economist's* in 1991 for example, and two exhibitions at Deutsche Bank in 2007–08.

Many London Group members supported their personal art activity by working either full- or part-time in art education. From the 1960s London art schools achieved international recognition for the quality of their 'products' and London Group members held teaching and managerial posts in virtually all of them. Exhibition spaces were often integrated into art school buildings so that contemporary developments could be on hand for students to study. Using their internal contacts The London Group members organised exhibitions in the Royal College of Art, the Royal Academy Diploma Galleries, Central St Martins, Kensington and Chelsea College, the London Institute and Morley College. Furthermore it could be argued that managerial experiences in art school departments equipped London Group members with organisational and administrative skills which kept the Group alive and functioning.

The complexion of The London Group has changed with developments in contemporary visual

fig. 27
Royal College of Art, London
David Redfern

fig. 28
Whitechapel Gallery, London
David Redfern

creativity. Current members' practice is within the fields of installation, photography, video and performance as well as the more conventional two- and three-dimensional areas of work. There are few, if any, 'isms' or 'schools' in contemporary art activity. The individual is to the fore, even the YBAs were not a manifesto group as such. The London Group does not promote any one direction or style and is proud that following election, members are entirely responsible for the work they exhibit without censure from other members. Its guiding star has always been quality and peer approval.

Current London Group member James Faure Walker articulates what being a member of The London Group means to him:

It is a friendly organisation, and like other user-groups – or the Greens – it holds meetings that occasionally get diverted for hours on end to some tiny detail of the constitution that seems of enormous importance to one or two members. Meanwhile the world outside moves on, empires rise, empires fall, oblivious to infringements of The London Group constitution. It is a small price to pay. I like the phrase 'professional artist'. The actual experience of 'being an artist' is not necessarily plain sailing, even for us professionals […] So the opportunity – the guaranteed opportunity – of putting something on show each year is a godsend.

fig. 29
Barbican Centre, London
David Redfern

CATALOGUE

1

EXHIBITED

The First Exhibition of Works by Members of The London Group, March 1914, The Goupil Gallery, as (92) *Miss Silvia Gosse* [*sic*], £30.0.0

Founder member 1913, President 1914–18, exhibited 1914–18 and posthumously 1919, 1928 and 1964 retrospectives

Harold Gilman
Portrait of Sylvia Gosse, 1912–13

Oil on canvas
67 × 49 cm

Southampton City Art Gallery

Harold Gilman was not only a founder member but also one of the most influential voices within the Fitzroy Street, Camden Town and London Groups. From 1901–3 he had visited Spain where he studied Spanish art, copied Velázquez, and married the American Grace Canedy. On his return to England, living outside London with family responsibilities, Gilman's art developed free from the influence of his Slade contemporaries who included Spencer Gore (cat.5) and Wyndham Lewis (cat.6). However, early in 1907 Gore probably introduced Gilman to Walter Sickert (cat.18), and thus to the collaborative studio at 19 Fitzroy Street. After his wife left him in 1909 to return to Chicago with their children, Gilman spent more time in London, adopting a Sickertian vocabulary of subjects and focusing much energy on the politics of art in London. It was Gilman who insisted that women be excluded from the Camden Town Group, Gilman who pressed that Wyndham Lewis (whose art was already leaning towards the angular distortions of Cubism and whose temperament was distinctly uncompromising) be invited as one of the Group's 16 members.

When The London Group was formed from the amalgamation of the Fitzroy Street and Camden Town Groups, Gilman, rather than the more equable Gore, was selected as President. Again it was Gilman who fiercely supported the invasion of Fitzroy Street and The London Group by artists in Wyndham Lewis's camp, in particular Jacob Epstein (cat.7) and Frederick Etchells (cat.22); their 'pornometric' art forced Sickert's resignation from both Groups. Gilman had the ambition, the drive and the dogmatism to lead the new society at a time of upheaval. Meanwhile his own art was becoming more radical as he absorbed the impact of Post-Impressionism. He retained the Sickertian vocabulary but adopted a more broken touch, a more emphatic line and a more highly coloured palette.

Gilman's selection of one of his two portraits of *Sylvia Gosse* (a smaller version is in the Museum of Art, Cleveland, Ohio) for the first London Group exhibition was tactful, in view of his sitter's close identification with Sickert and Sickert's cause. Miss Gosse (1881–1968), was Sickert's most faithful pupil, disciple, helpmeet and friend. From 1910 to 1914 she was Sickert's partner in running Rowlandson House, his private art school at 140 Hampstead Road where Gilman painted this portrait. Elected to The London Group on 3 January 1914, the last meeting Sickert chaired, she exhibited regularly until 1920. As a painter and printmaker she adopted Sickert's subject matter and his working practices. She was modest, shy and self-effacing, aspects of her character brilliantly captured by Gilman in this vivid and sympathetic portrayal. Gilman's portraits of women, whether of his wives, his mother, his friends or his landlady, are always sensitive. The typical Camden Town format he used here, the sitter seated, half-length, facing the spectator, within the shallow space of an interior closed off by patterned wallpaper, continued to underpin the masterly sequence of portraits Gilman painted from 1914 to 1917 in his Maple Street lodgings. Gilman's life and his presidency of The London Group were abruptly ended when he died from influenza in February 1919.

WENDY BARON

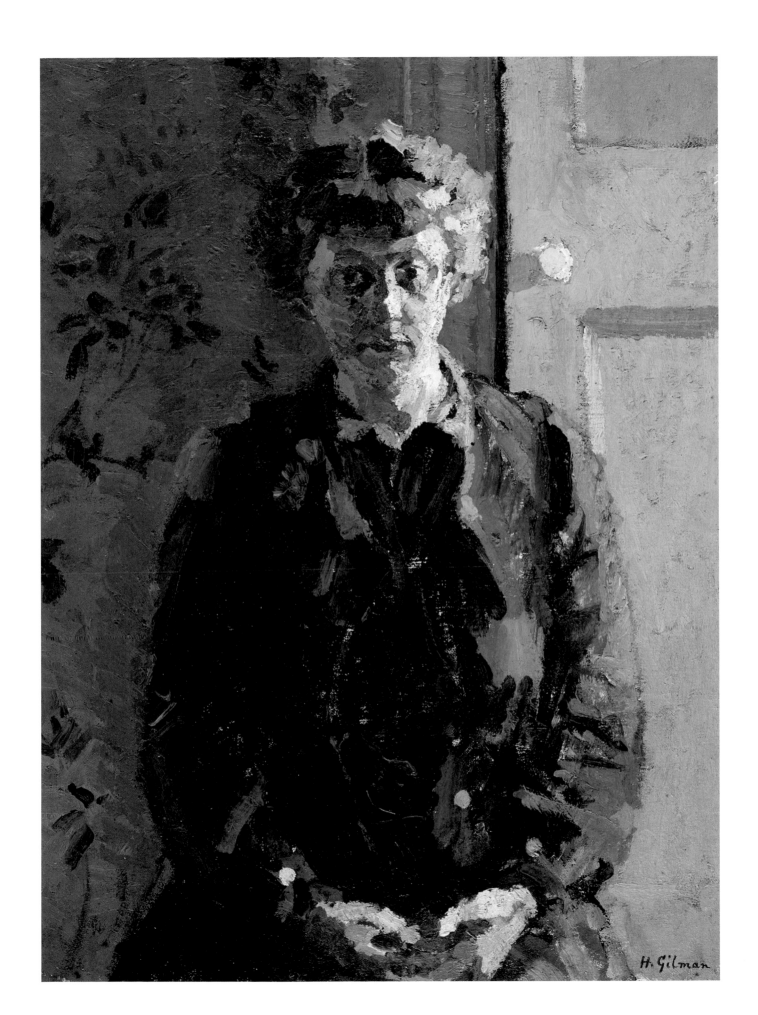

H. Gilman

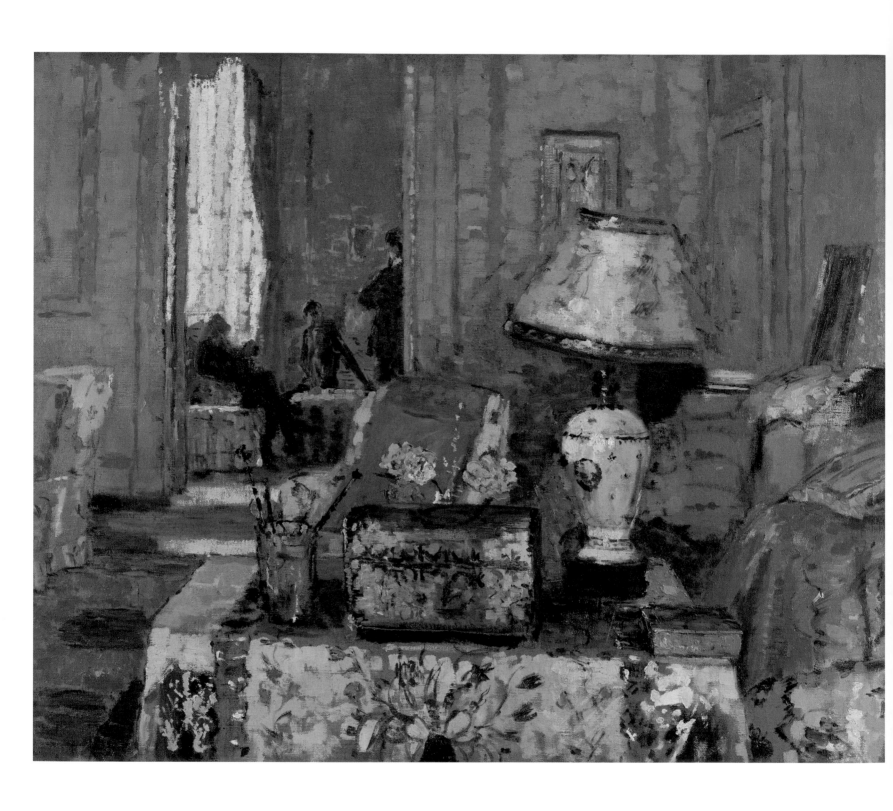

2

EXHIBITED

The First Exhibition of Works by Members of The London Group, March 1914, The Goupil Gallery, as (32) *The Pink Box*, £12.0.0

Founder member 1913, exhibited 1914–24, 1926–29, 1933, 1935–37, 1939, 1948–54

Ethel Sands
*The Pink Box, c.*1913

Oil on canvas
50 × 61 cm
Private Collection

Ethel Sands came to London with her glamorous, wealthy and socially distinguished New York parents when she was a baby. She and her life-long partner, Anna Hope (Nan) Hudson (1869–1957), also an East-Coast American, met in Paris in 1894 where both studied painting in the studios of a succession of artists, including Eugène Carrière and (probably) Edouard Vuillard. For the next 17 years their artistic life centred on Paris. They exhibited regularly at the Salon d'automne where in 1906 Walter Sickert (cat.18) particularly admired a Venetian painting by Nan. In 1907 he sought them out and invited them to join the Fitzroy Street Group as full rent-paying members. For the next ten years he bombarded them with letters packed with his own news, his views on painting and detailed advice on their work.

Meanwhile, Ethel's genius as a hostess matured. Over some 50 years, her legendary house parties at Newington in Oxfordshire and her dinners in London drew together artists and writers of different generations and different circles. She was an enlightened patron of contemporary art, commissioning Sickert, Boris Anrep (1883–1969, elected in 1919), Vanessa Bell (cat.14) and Duncan Grant (cat.26) to decorate her houses. Her paintings reflected her social life: exquisite interiors, artful still lifes, and from the 1920s onwards portraits of her friends at home. Nan's painting (much preferred by Sickert), mainly buildings and townscapes without figures, mirrored her more austere temperament. Both were regarded as his protégés but necessarily excluded from membership of the male-only Camden Town Group. When Camden Town and Fitzroy Street merged, they became *de facto* founder members of The London Group. Nan and Ethel were of independent means; neither needed to make a living by selling their work. However, both took their painting seriously and wanted exhibition opportunities. Ethel had a one-woman show in Paris in 1911; in London, she and Nan shared an exhibition at the Carfax Gallery in 1912; they contributed to the non-jury Allied Artists' Association from its foundation in 1908; Nan exhibited at the NEAC in 1909, 1910 and 1913; their work was displayed at 19 Fitzroy Street; each contributed her full quota of six paintings at the pivotal Brighton exhibition of 'English Post-Impressionists, Cubists and Others' in 1913–14. The London Group provided them with another regular opportunity to demonstrate their accomplishment as painters. Nan showed three paintings at the first exhibition, Ethel two: *The Pink Box* and *The China Swan*. Both were charming interiors, singled out for praise by conservative critics in contrast to the unintelligible offerings of Wyndham Lewis (cat.6) and his Cubist colleagues. *The Pink Box* is typical of Ethel Sands' work: the planar composition, the uncertain perspective, the delight in pretty objects – including the pink lacquer box of the title, and the vibrant colours applied in distinct dabs of paint. The elegant interior, with its interconnecting reception rooms, may represent Lady Ottoline Morrell's house at 44 Bedford Square. The three figures in the further room are indistinct, but one could be Henry James, an old friend of Ethel's, who first met Ottoline at Newington.

WENDY BARON

3

EXHIBITED
2nd London Group Exhibition, March 1915,
The Goupil Gallery, as (3) *Swiss Cottage*, not
priced

Elected 1914, exhibited 1914–49 and
(posthumously) 1953 and 1964 retrospective

Stanislawa de Karlowska
Swiss Cottage, 1914

Oil on canvas
61 × 76.2 cm

Signed (lower right) 'S. de Karlowska'
Tate: Presented by the artist's family 1954

Stanislawa de Karlowska was a Polish artist who trained in Warsaw and Cracow before attending the Académie Julian in Paris in 1896. At the wedding of a fellow student in Jersey she met Robert Bevan (cat.4), and the two were married the following year. Karlowska showed her work first at the Women's International Art Club from 1900, which had a modern and progressive profile. With Bevan she was an exhibitor at the first Allied Artists' Association exhibition at the Albert Hall in 1908, where her contributions gained some critical attention. Here Karlowska and Bevan were taken up by the Fitzroy Street Group of Spencer F Gore (cat.5), Harold Gilman (cat.1) and subsequently Walter Sickert (cat. 18) and became part of the wider London avant-garde surrounding them. However, when the Camden Town Group was formed, discouragingly Karlowska was excluded because of her sex. At their home in Swiss Cottage the Bevans held regular gatherings of friends who included avant-garde proponents such as the sculptor Henri Gaudier-Brzeska (cat.8), Wyndham Lewis (cat.6) and the anarchist philosopher T E Hulme, as well as Sickert, J B Manson (1879–1945, founder member 1913) and Lucien Pissarro (1863–1944, founder member 1913). One of the principal factors in dissolving the Camden Town Group was the desire to bring advanced artists and women into a new, broader configuration that became The London Group. Karlowska was elected to the Group in January 1914 and she remained a member throughout her life. The London Group exhibition in 1953 included a selection of her works as a memorial display.

Karlowska's *Swiss Cottage* was exhibited at the Second Exhibition of The London Group at the Goupil Gallery in March 1915. Both Karlowska and Bevan appear to have wanted to focus on the life of the streets around where they lived to provide the subject

matter for their work. The location of Karlowska's *Swiss Cottage* was close to their house at 14 Adamson Road, and shows the view south down Finchley Road. Ye Olde Swiss Cottage pub has since been demolished and rebuilt, but still occupies the same site and has the same name. The yellow building to the left of the pub in the picture was the Swiss Cottage dairy. Karlowska has populated her canvas with shoppers but appears to have deliberately attenuated their bodies, so they appear taller and thinner than would be normal, lending the picture the exaggerated quality of caricature. The manner in which several figures stare back at the viewer – notably the girl with the hoop – recalls photographs of the period in which subjects return the interest of the photographer and it might be possible the painting was based partly upon photographs or postcards.

ROBERT UPSTONE

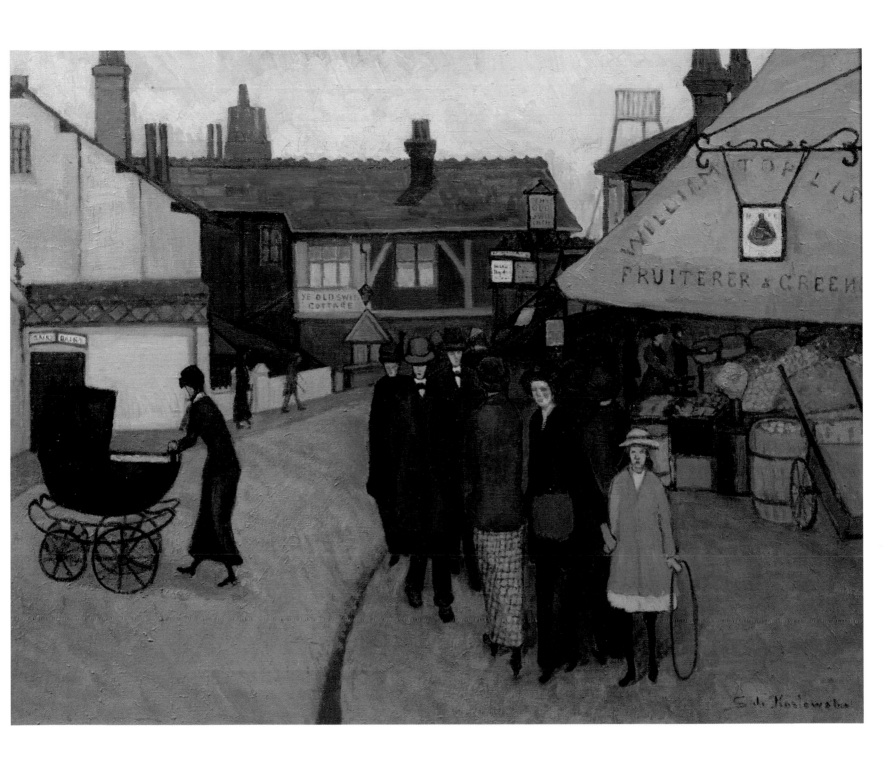

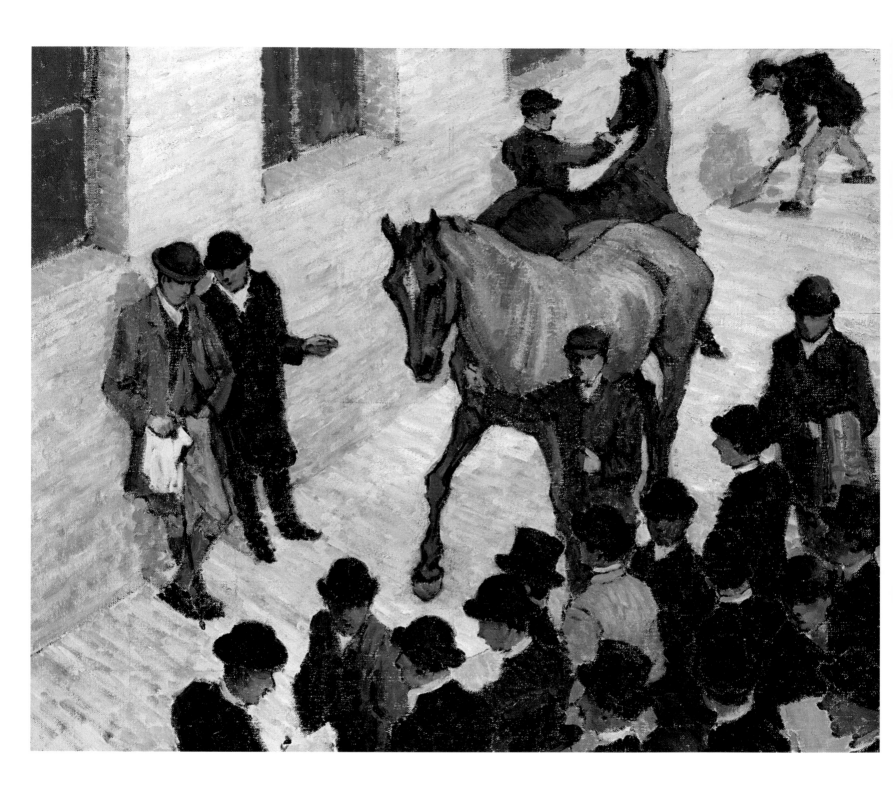

4

EXHIBITED POSTHUMOUSLY
23rd London Group Exhibition, 9–30 January 1926, R. W. S. Gallery, as (45) *A Sale at Tattersalls* (1911) (Lent by Lt.-Col. J. K. McConnel D.S.O., M.C.)

Founder member 1913, exhibited 1914–25, posthumously (1926), and 1928 and 1964 retrospectives

Robert Polhill Bevan
A Sale at Tattersalls, 1911

Oil on canvas
50.8 × 61 cm

Southampton City Art Gallery

Robert Bevan was a founder member of The London Group, and effectively took over its leadership between the years of 1919 and 1921 when no President was elected. At the Group's foundation Bevan was appointed Treasurer, a role he had previously fulfilled for the Camden Town Group. Bevan held an impressive record of exposure to modern French painting having trained at the Académie Julian in Paris and spent 1891 and 1893–94 at Pont Aven, where he met Gauguin and Renoir. In London he became part of the circle around Sickert (cat.18) at Fitzroy Street and was recruited to the Camden Town Group in 1911. In 1914, with Charles Ginner (cat.11) and Harold Gilman (cat.1), Bevan set up the Cumberland Market Group. Bevan was a keen horseman, and his art in this period focused first on the London cab trade and then the city's horse auctions. These were pictures that elevated the everyday working life of London into the realm of art, and rendered it in bright, pulsating Post-Impressionist colour harmonies for which Bevan was taken to task by conservative critics.

This is believed to be the first horse sale picture Bevan painted. Tattersalls was the oldest and best-known horse auctioneers in the country, dating back to the early 1770s. In this period they were based at Knightsbridge Green in purpose-built premises that opened in 1865. Sales were held weekly or, in the season, twice weekly. The auction had a 'long trot' along which horses were displayed by their blue canvas-jacketed grooms, and this is what Bevan portrays. His vantage point was the first-floor gallery popular with spectators and the picture was based on sketches made on the spot. In the painting Bevan uses broken touches of soft pastel colour laid next to each other to suggest the fall of light and the differing tints in the shadows. In such pictures Bevan sought to convey convincingly the individual character of the

horses through the set of their limbs and bodies, and this was extended to the buyers in the horse sale. The colour used for the horses was, however, anti-naturalistic – the brown horse is rendered in pinks and oranges, while the black one combines blue and violet. The composition cuts diagonally across the picture space, a device of visual dynamism that derives from Degas' theatre scenes and recalls certain pictures by Bevan's Camden Town colleague Spencer Gore (cat.5).

Tattersalls was known as a milieu where well-off buyers of hunters mixed with working horsemen, here emphasised by the contrasting bowler and top hats, providing a frisson of social reportage. Bevan's son Bobbie recalled that as children: 'he took us, of course, by horse-bus, and we sat on the front seats on top so that he could talk horses to the driver. At Tattersalls […] there would always be a word or two with dealers and with handlers […] who all seemed rather surprised that anyone should think they were worth drawing.'[1]

ROBERT UPSTONE

5

Not exhibited at The London Group;
a similar work exhibited
*The First Exhibition of Works by
Members of The London Group*, March 1914,
The Goupil Gallery, as (94) *Croft Lane,
Letchworth*, £30.0.0

Founder member 1913, exhibited 1914
and (posthumously) 1928 and 1964
retrospectives

Spencer F Gore
Harold Gilman's House at Letchworth, Hertfordshire, 1912

Oil on canvas
63.5 × 76.2 cm

Stamp signed 'S. F. Gore'
Leicester Arts and Museums Service

The premature death from pneumonia of Spencer Frederick Gore robbed twentieth-century British art of one of its most innovative and promising practitioners. He had trained at the Slade from 1896–99, overlapping with Harold Gilman (cat.1), Wyndham Lewis (cat.6) and Augustus John (1878–1961). He travelled in Spain with Lewis over the winter of 1902–03; in 1904 he visited Dieppe where he met Walter Sickert (cat.18). Their instant rapport helped persuade Sickert to return to London from his self-imposed exile in France. Gore was a founder member of the Fitzroy Street, Camden Town (of which he was also President) and London Groups. His ability to 'set up with every person he met […] a personal relation of the most definite and binding kind' was, as Sickert wrote in his valedictory essay, 'a wonderful gift'. Gore was at ease with Camden Town, Fitzrovia and Bloomsbury. His work was included in the more progressive shows of 1911 to 1914: the 'English Group' section of Roger Fry's (cat.13) *Second Post-Impressionist Exhibition* at the Grafton Gallery from 1912–13 and Frank Rutter's *Post-Impressionists and Futurists* at the Doré Galleries in 1913. In the first half of 1912, he supervised the hedonistic decorative scheme, incorporating murals by himself, Lewis and Charles Ginner (cat.11) together with sculpture by Eric Gill (1882–1940) and Jacob Epstein (cat.7), to adorn Madame Strindberg's Cabaret Theatre Club in Soho.

That summer, while Gilman was in Sweden, Gore borrowed his house at 100 Wilbury Road, Letchworth, designed by the garden city architects Barry Parker and Stanley Unwin and completed in 1909. In his paintings of Letchworth and its surrounding landscape, Gore retained the vigorous hedonism of his Soho murals. The visionary concept of the new garden city evoked a youthful radicalism in his response, encouraged by his recent encounters with European Post-Impressionism and Italian Futurism. In this, the first of his 23 views of Letchworth, and one of two paintings of the house where he was living, he took the natural colours, exaggerated them and grouped them into relatively simple, angular shapes. The red-tiled roof loses its texture and becomes a uniform fierce vermilion; Mollie, Gore's wife, is a schematic three-coloured patch on the pathway behind the brilliant yellow flowers; the light and shade patterns of high summer are rendered in simplified areas of violet and creamy ochre; the sky is an intense blue. This is not the Letchworth painting Gore selected as one of his four contributions to the first London Group exhibition; that was *Croft Lane* (Private Collection), a less exuberant landscape largely painted in a range of greens against a pale blue sky, the trees and clouds portrayed as chunky patterns of simplified tones. The tree-filled motif, the more muted colours, the concentration on the underlying structure of forms, presaged the Cézanne-inspired landscapes Gore painted in Richmond in the last few months of his life. Gore died during the third week of the first London Group exhibition. It is arguable that without his abilities as mediator (in Sickert's absence, Gore had chaired the crucial Fitzroy Street meeting on 3 February) The London Group might have disintegrated before that exhibition.

WENDY BARON

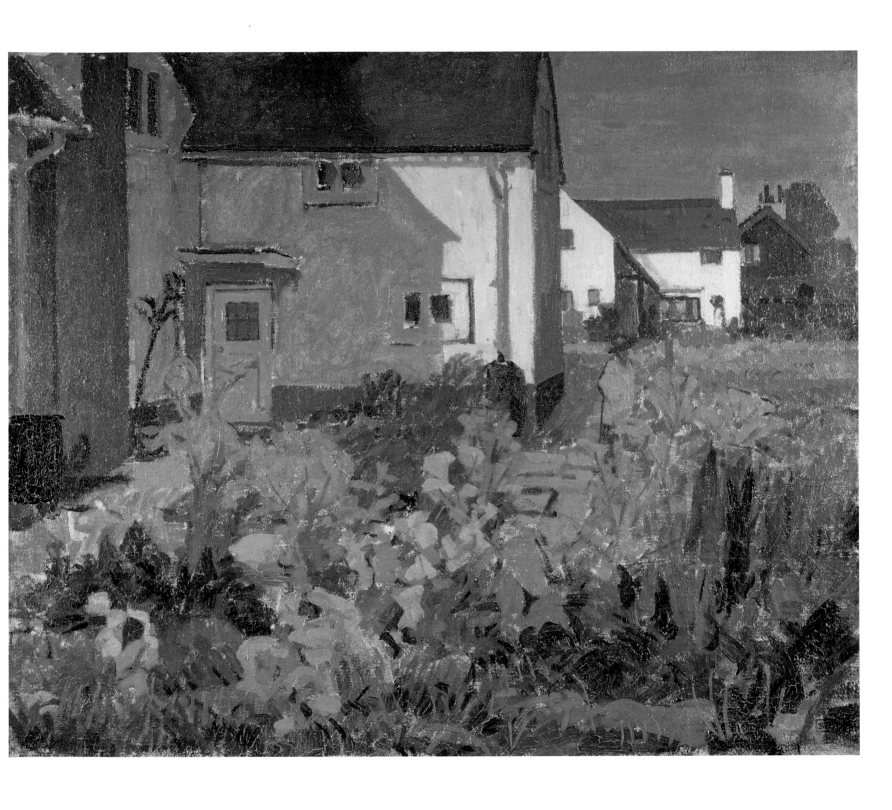

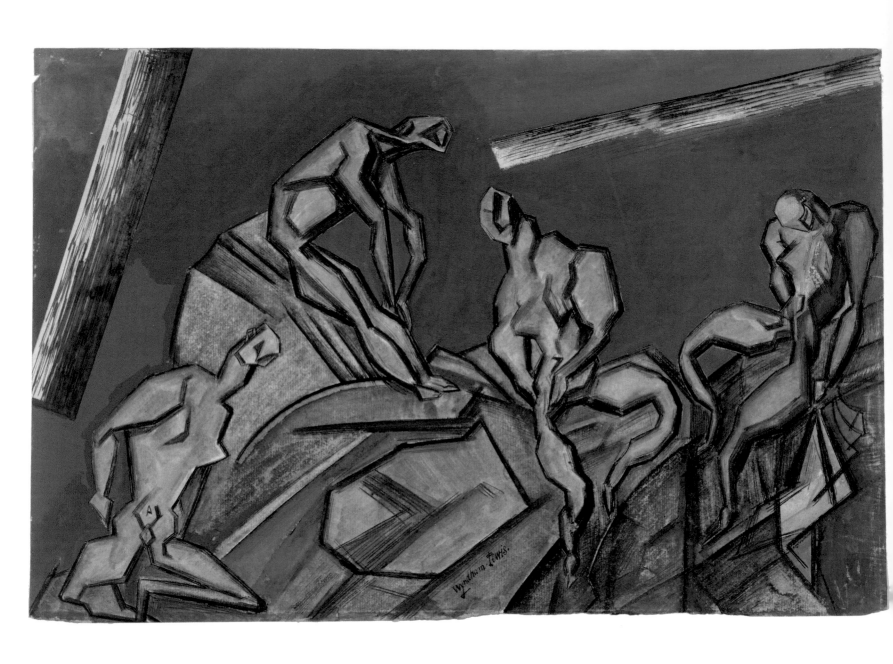

6

Not exhibited at The London Group

Founder member 1913, exhibited 1914–15
and 1928 retrospective and (posthumously)
1964 retrospective

Wyndham Lewis
Sunset among the Michelangelos, c. 1912

Ink and gouache on paper
32.3 × 47.8 cm

Signed (recto) 'Wyndham Lewis'
Victoria and Albert Museum
Given by the family of Captain Lionel Guy Baker

Wyndham Lewis was at the centre of the artistic ferment that brought modernism to London before the First World War and led to the formation of The London Group. An anomalous member of the Camden Town Group, his exhibits were out of character with the realism of the other members. His strongly sculptural quasi-cubist style was received more favourably by Bloomsbury than by Camden Town artists such as Lucien Pissarro (1863–1944, founder member 1913),[1] and his lost painting, *Creation*, at the *Second Post-Impressionist Exhibition* was hailed by Clive Bell as exemplifying Bell's theory of significant form.

Lewis joined the Omega Workshops, but broke with Roger Fry (cat.13) in October 1913, convinced of Fry's duplicity in appropriating a commission of which a part had been intended for Lewis himself. This precipitated a walkout by the core of the future Vorticist Group. Lewis set up the Rebel Art Centre in competition, and formed an anti-Bloomsbury alliance with the Camden Town Painters in an exhibition at Brighton Art Gallery in January 1914: the future London Group. But the old aesthetic differences with other Camden Town painters resurfaced as Lewis insisted on having a special 'Cubist room' for him and his more avant-garde comrades.

In the first exhibition of The London Group itself, besides two drawings, Lewis exhibited two now lost paintings, (68) *Eisteddfod* (£40.0.0) and (78) *Christopher Columbus* (£70.0.0). He was already producing works that would soon be called Vorticist, but how far these paintings exemplified this new abstract style is not clear. T E Hulme judged them to be failures, though containing 'admirable inventions'. By the second London Group show, Lewis was leading the Vorticists, and his exhibits were the Vorticist oils, *The Crowd* (fig.4) and *Workshop* (both Tate). *The Times* critic saw them as 'Prussian in spirit',[2] a kind

of artistic goose-step. When Lewis returned from First World War service he found Bloomsbury dominant over the art scene and withdrew from The London Group. In 1929 he wrote that, except for some individuals' work, the group's exhibition was an 'ugly and untidy kitchen-garden' over which hovered 'the benevolent, cheaply fanatical form of Roger Fry'.[3] He had objected to being represented in the 1928 retrospective show, and two large paintings owned by Richard Wyndham were withdrawn.

In *Sunset among the Michelangelos* Lewis used a version of Cubist style to depict a 'primitive' relationship between figure and ground. Like many modernist artists, he celebrated the stark simplicity of primitives supposedly uncorrupted by urban decadence; yet he was also deeply sceptical. These 'Michelangelos' have declined from heroic forcefulness to enervated lassitude, as the sun sets on the era of Renaissance humanism. The figures (the one on the far right is reminiscent of Michelangelo's *Night* in the Medici Chapel in Florence) have declined to a vegetable existence, hardly distinguishable from the rocky ground on which they sprawl. 'A comic type', Lewis wrote in 1914, 'is a failure of considerable energy'[4]; like many of the figures in Lewis's work, the Michelangelos are both pathetic and slightly ridiculous, but the composition itself is imposing, despite its small size.

PAUL EDWARDS

POSSIBLY EXHIBITED
2nd London Group Exhibition, March 1915,
The Goupil Gallery, as (94) *Carving in Flenite*,
not priced

Founder member 1913, exhibited
1914–16, 1926, 1928, 1930, 1942, 1949 and
(posthumously) 1960 and 1964 retrospective

Jacob Epstein
Flenite Relief, 1913

Serpentine stone
30.5 × 28 × 9 cm

Leeds Museums and Galleries (Leeds Art Gallery)

The dark surface, which absorbs rather than reflects light, seems to invite touch to better read its subtle gradations, a fact that presents a further challenge to the viewer of what would then have been an 'untouchable' subject: the act of birth. Recent study by Jon Wood and others has revealed it not to be a double-sided relief, as was previously thought, but in more revolutionary terms the compressed rendering of a female figure whose body is bent back in the pangs of giving birth. The marked dip in the centre of the distinctive curved upper rim of the work is a belly button and the narrow curved sides are tightly drawn-up thighs, both offering clues to the reading of a sculpture that is extraordinarily modern in its cryptic formal language and profoundly 'primitive' in its totemic treatment of one of life's most elemental experiences.

The conceptualised figure, simplified low relief and incised treatment of the limbs, head and breasts is clearly indebted to Brancusi's *The Kiss*, which Epstein would have known, probably in several versions, from his visits to Paris in late 1912 to early 1913 during the installation of his *Tomb of Oscar Wilde* in Père Lachaise Cemetery. He visited the studios of fellow sculptors Modigliani and Brancusi and met other members of the Paris avant-garde, including Picasso. The work has an almost Egyptian density and polish while the stylisation of the new-born child holding an egg-like shape between its hands reveals his assimilations from the non-European art he had studied in museums and was now beginning to collect; there are affinities both with the angularity and splayed limbs of Kota reliquary figures and with the more rounded splayed figures of Maori tiki, for instance.

Procreation, pregnancy and birth – then subjects treated by artists in respectably coded and symbolic terms – were recurrent themes in Epstein's early work. His Whitmanesque frankness about the human body attracted opprobrium and shocked even Walter Sickert (cat.18), himself no stranger to controversy over the implied sexual undertones in his Camden Town bedroom scenes. On his return from Paris, working both alone and as part of the artistic and literary grouping associated with Wyndham Lewis's (cat.6) Rebel Art Centre and with the philosopher T E Hulme, Epstein began to explore these themes in drawings and in series of carvings. Three were in serpentine which he renamed 'flenite', a word evocative of ancient hard stones – flint and granite. The other two flenites are pregnant female figures (now Tate and Minneapolis Museum of Art). The S-shaped *Female Figure in Flenite* (1913, Tate) was included in the first London Group show in March 1914 (where it was shown alongside equally primitivising carvings by Gaudier-Brzeska (cat.8)) and was commented upon by Ezra Pound and Hulme.

The London Group's standing as the prime exhibition forum for a wide range of the most advanced work was emphasised by the second Group show in March 1915. Epstein showed his most experimental work, the original *Rock Drill* (fig.6) complete with real drill and startling white plaster robotic figure, the Brancusian white marble *Mother and Child* (1913, New York, Museum of Modern Art) and the painted wood *Cursed Be the Day Wherein I was Born*, and another *Carving in Flenite* (no. 94), which may be the piece exhibited here or the *Figure in Flenite* now in Minneapolis.

EVELYN SILBER

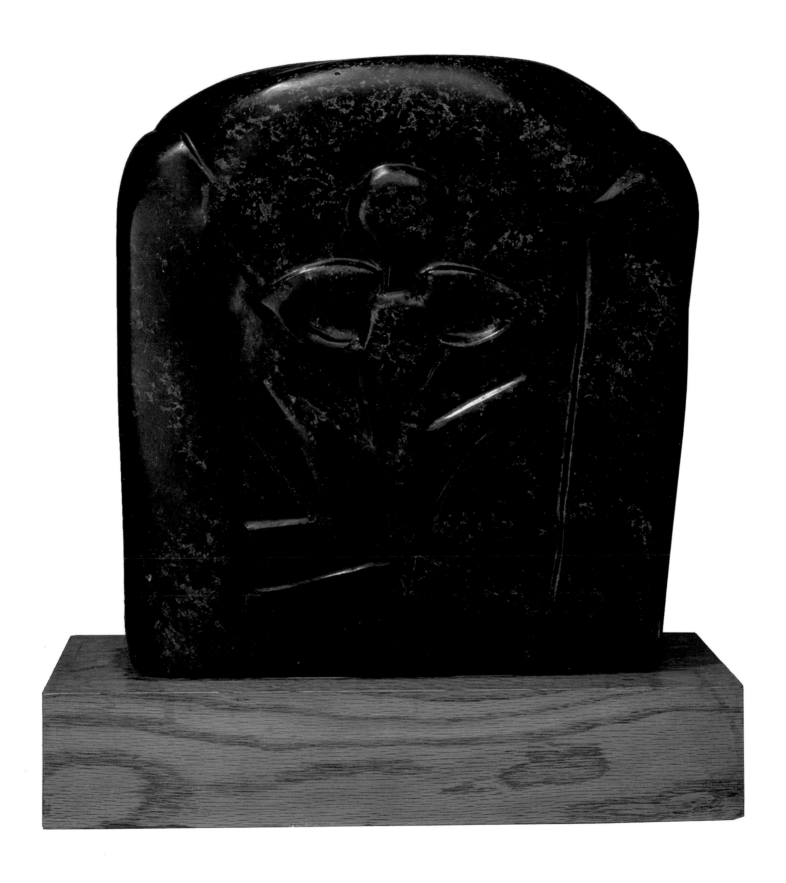

Henri Gaudier-Brzeska
Bird Swallowing a Fish, 1914

Bronze
31 × 60 × 29 cm

Kettle's Yard, University of Cambridge

EXHIBITED
*London Group Retrospective Exhibition
1914–1928*, April–May 1928, New Burlington
Galleries, as (184) *Bird Swallowing a Fish
(bronze)*, 1915, not priced

Founder member 1913, exhibited 1914–15
and (posthumously) 1928 and 1964
retrospectives

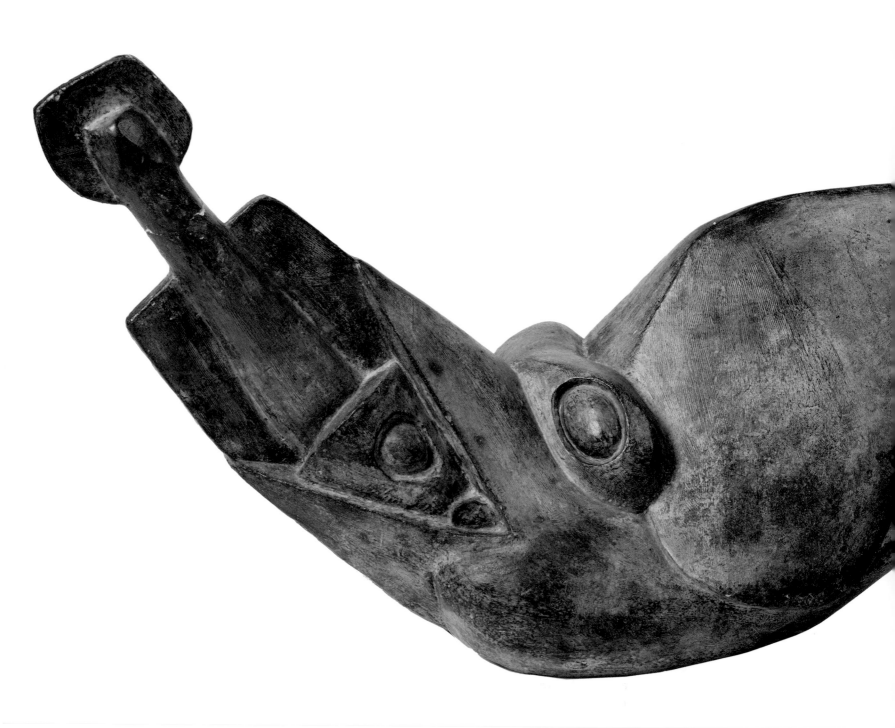

By the time *Bird Swallowing a Fish* was exhibited at The London Group in 1928, Henri Gaudier-Brzeska had been dead for over a decade. This precocious, inventive and restlessly energetic French sculptor was killed by a German machine-gun bullet at the age of 23, after volunteering to serve as a soldier in the First World War. His loss, in June 1915, was reported one month later in the second issue of the Vorticists' magazine, *BLAST*, which published his final statement under the title 'Vortex Gaudier-Brzeska (Written from the Trenches)'.

The tragedy profoundly affected his allies in London, where Gaudier had been based since 1911. He was mourned by The London Group, which had elected him as a founder member before including Gaudier's work in its first two exhibitions, in March 1914 and the following year. An outstanding selection of his carvings was included in the 1914 show, ranging from the relative naturalism of the marble *Maternity* (111) to the purged radicalism of *Red Stone Dancer* (113, fig.113) and two alabaster carvings, *Stags* ((112) as *Alabaster Group*) and *Boy with Coney* (114). Yet he sold nothing at the exhibition, and struggled to continue working as an audacious young artist right up until the moment when the outbreak of war impelled him to join the French army.

Bird Swallowing a Fish, a masterpiece of Vorticist sculpture, is among the final works Gaudier completed. An inveterate draughtsman, he always carried sketchbooks on long walks through his adopted city and probably based this dramatic sculpture on an incident witnessed in a London park. By the time he modelled his plaster version, however, the brutal encounter between predator and victim had undergone an arresting transformation. Although the bird is far larger than its would-be prey, the struggle between them is by no means over. The fish has now become firmly lodged in the bird's gullet, and nobody can predict the outcome.

We can even imagine that the fish, armed with a tail shaped like the butt of a weapon, is ramming the bird with formidable defensive aggression. Far from swallowing its prey, the bird might be choking. Even so, the fish's head appears doomed to remain trapped deep inside the bird's immense and ravenous mouth. As a result, the two combatants seem locked in a stalemate. Although both of them are struggling to survive and prevail, they look strangely paralysed. Here, in the pre-war months of 1914, Gaudier is prescient enough to foresee the profoundly frustrating trauma of a protracted conflict where the opposing armies experienced such difficulties in their search for a decisive military breakthrough. Stalemate prevailed during much of the First World War, killing so many soldiers on both sides.

That is why *Bird Swallowing a Fish*, cast at first in the eerily appropriate medium of gunmetal, now appears prophetic. Gaudier's ability to foretell the essential character of the war is quite uncanny, and his death was deplored by many of his friends. We can understand why a grieving Ezra Pound immediately started work on his eloquent and elegiac book, *Gaudier-Brzeska: A Memoir*, declaring: 'A great spirit has been among us, and a great artist is gone'.

RICHARD CORK

9

EXHIBITED

The Third Exhibition of Works by Members of the London Group, November–December 1915, as (76) *Creation of Eve*, not priced

Elected 1915, exhibited 1915–20, 1922, 1924–25, 1927–31, 1933–35, 1937–38 and (posthumously) 1939 and 1964 retrospective

Mark Gertler (1891–1939)
The Creation of Eve, 1914

Oil on canvas
75 × 60 cm

Signed and dated (verso) 'Creation of Eve by Mark Gertler 1914'
Private Collection

When he was elected to The London Group in February 1915,[1] Mark Gertler was already a seasoned exhibitor with the Friday Group, New English Art Club and Chenil Gallery, Chelsea, and had been included in the 'Jewish Section' co-curated by David Bomberg (cat.16) and Jacob Epstein (cat.7) at the Whitechapel's 1914 exhibition, *Twentieth-century Art: A Review of Modern Movements*. Part of a notable generation that included Bomberg, Dora Carrington (1893–1932), Paul Nash (cat.25), C R W Nevinson (cat.10), William Roberts (cat.17) and Stanley Spencer (1891–1959)[2], Gertler was the first Jewish, working-class student of his generation to enter the Slade School of Art, where he twice won the scholarship and left with another from the British Institute. He was soon followed by further 'Whitechapel Boys' including Jacob Kramer (cat.23) and Bernard Meninsky (cat.15). Following the overwhelming impact of Roger Fry's two seminal post-impressionist exhibitions at the Grafton Gallery in 1910 and 1912, Gertler rejected Slade teaching in favour of modernism. During The London Group's first decade, his work was at its most radical.

Gertler showed three experimental works at his London Group debut in November 1915: *Swing Boats* (lost), *Fruit Stall* (also lost) – which greatly impressed Edward Wadsworth (cat.24), Duncan Grant (cat.26) and Clive Bell – and *Creation of Eve* [*sic*], much admired by D H Lawrence,[3] and already rejected by the NEAC because of Eve's 'indecent' nakedness. Inspired by William Blake, Gertler's imaginative composition shows a bearded God pulling Eve by her hair from the ribs of a sleeping Adam; towering agapanthus, a highly coloured parrot and a tame deer, all compressed into the vertical format, add to the hallucinatory atmosphere. Gertler noted how his work stood out against what he unflatteringly described as the 'washed out purples and greens' of the other painters,[4] but was quite unprepared for the 'uproar!'

he unleashed. With a number of the Group's more radical members (including Bomberg, who had just enlisted) fighting at the Front, Gertler's work was foregrounded. Already primed against modernism, the increasingly jingoistic press considered such artistic experiments during wartime unpatriotic and subversive. He was accused of calculated and unpleasant sensationalism,[5] 'deliberate […] eccentricity'[6] and 'impertinence, with a seasoning of blasphemy'.[7] After the *Morning Post* declared the work 'hunnishly indecent', Gertler discovered to his astonishment that 'Some people in a rage [had] stuck a label on the belly of my poor little "Eve" with "Made in Germany" written on it!'[8] Only Walter Sickert (cat.18), in the *Burlington*, defended the work, scorning the NEAC for rejecting it and calling Gertler, a 'legitimate and sturdy child of the Slade School […] left like a foundling in a copy of *The Times* on Mr. Marchant's doorstep.'[9]

In April 1917 Gertler's London Group exhibits – his only finished sculpture, *The Acrobats* (1917, Tate) and strident, anti-war masterpiece, *Merry-go-Round* (1916, Tate) – attracted further accusations of 'sheer sensationalism' (although the latter's pacifist message remarkably went undetected). Even after beginning his solo career in 1921, Gertler, though remaining independent, exhibited regularly with the Group for the rest of his life.

SARAH MACDOUGALL

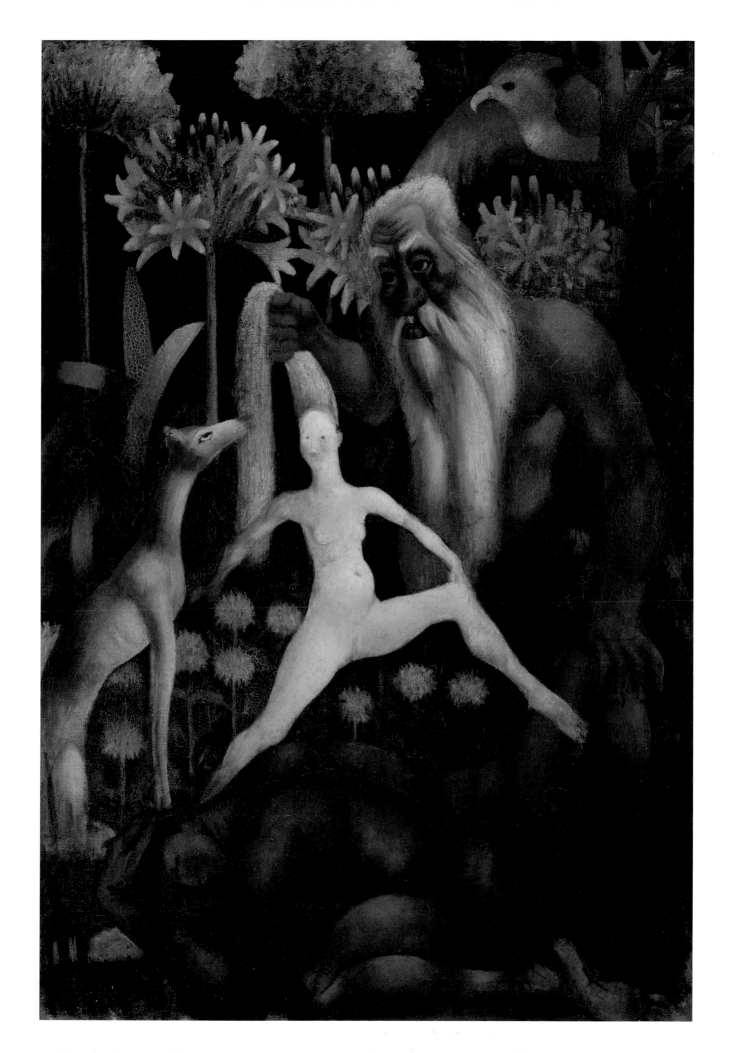

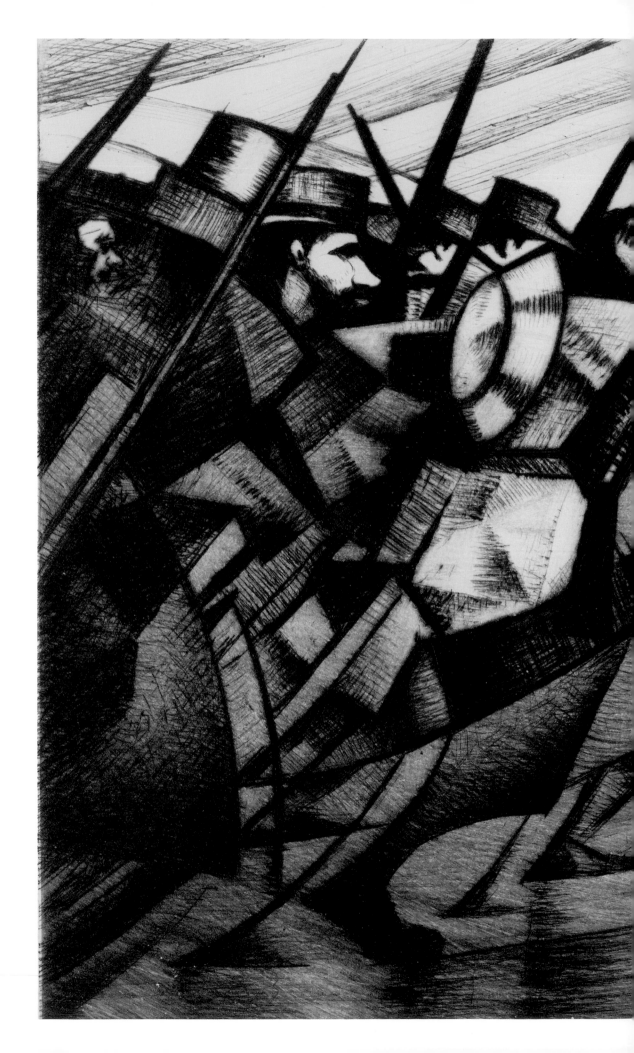

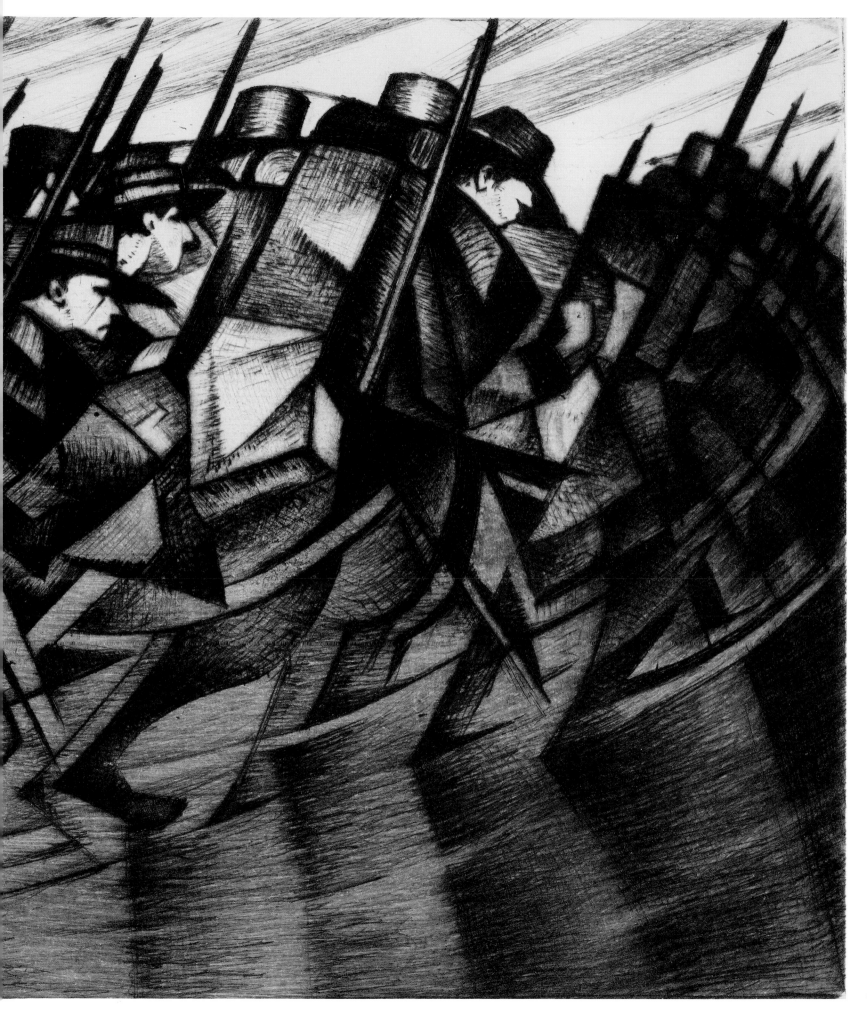

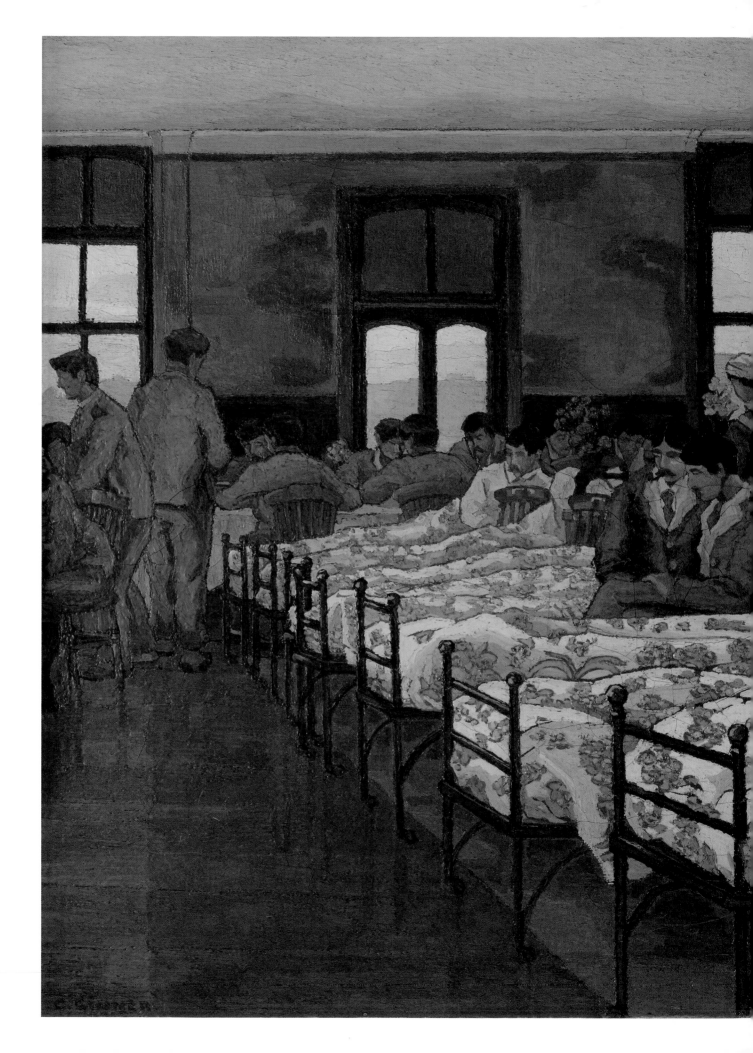

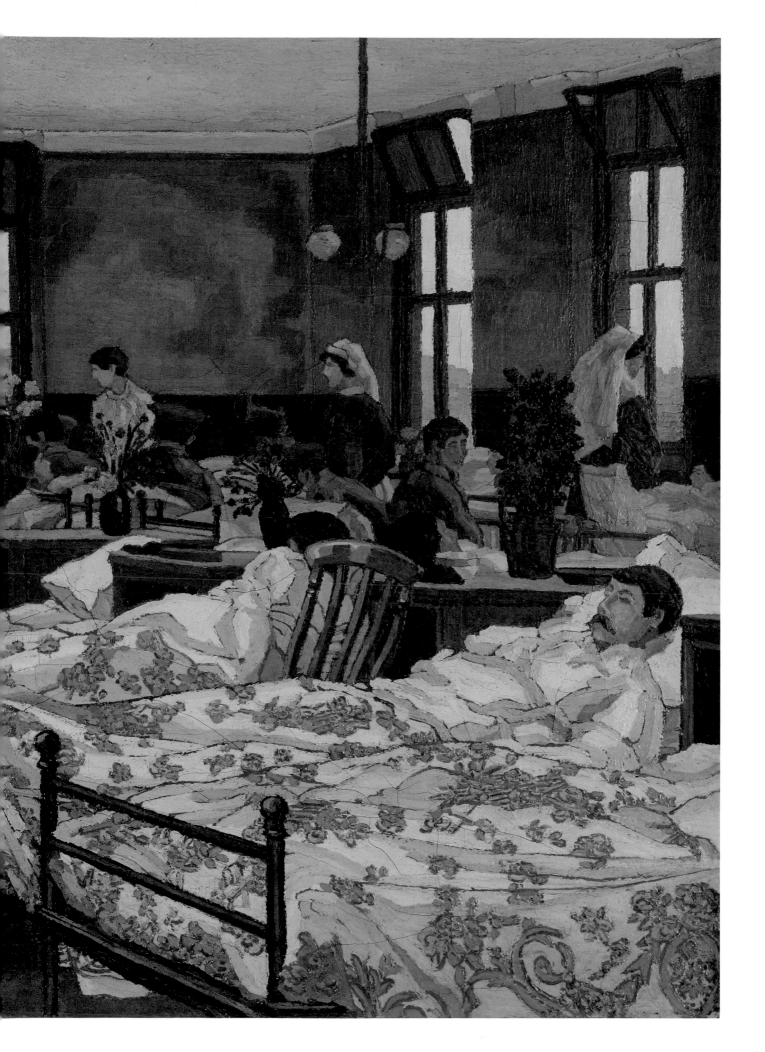

REJECTED
The Fourth Exhibition of Works by Members of the London Group, June 1916, The Goupil Gallery

Elected 1920, exhibited 1916, 1919–20, 1922–31, 1937–38, 1940–44, 1946, 1948–59, and (posthumously) 1960 and 1964 retrospective

Matthew Smith
Fitzroy Street Nude No. 2, 1916

Oil on canvas
101.5 × 76 cm

British Council Collection

Aged 37, Smith heralded his artistic maturity with a pair of bold nudes in vivid primary colours. These Fitzroy Street nudes (1916) are starkly lit and claustrophobic, the figures cropped by the picture frame. In *Fitzroy Street Nude No. 2* the model, posing in a cramped attic room, is thrust towards the viewer. The colours sing: from the yellow and green skin to the inky-blue hair against the billowing pink curtain. The model's arm is raised like a *Venus Anadyomene*, but she is unidealised, her face mask-like. Her powerful body twists forward as the room recedes, resisting any surface pattern. In the smaller *Fitzroy Street Nude No. 1* (Tate) the same model is viewed from behind against an abstracted red plane with bands of green anchoring the composition. Although Smith was already developing an architecture beneath his clamorous colour in these nudes, they earned him the epithet 'the English Fauve'.

After studying art in Manchester and at the Slade without success, Smith had moved to France in 1908. He briefly attended the Atelier Matisse in 1910 and exhibited at the *Société des Artistes Indépendants* in 1911 and 1912. In 1912 Smith began assimilating the techniques of the Fauves, enjoying the liberation of the rapid application of pure colour to the canvas *alla prima*. The outbreak of war in 1914 sent Smith back to England where he rented a studio at 2 Fitzroy Street. Walter Sickert (cat.18), who had a studio at No. 8, befriended Smith and encouraged him in his work, suggesting he submit the two nudes to The London Group's summer show in 1916. In a now notorious decision, The London Group rejected them.

Roger Fry (cat.13) has often been blamed for this outcome but John Gledhill, author of Smith's catalogue raisonné, points out that Fry was not a member of The London Group until 1917 and was not responsible. The chairman of the committee in 1916 was Harold Gilman (cat.1), usually very supportive of avant-garde work, but working under pressure from William Marchant of the Goupil Gallery. Marchant was worried about the press reaction to the exhibition he hosted and keen to avoid controversy. The formal radicalism of Smith's paintings was considered too antagonistic for the wartime public. Epstein (cat.7) had exhibited his *Rock Drill* (fig.6) at The London Group in 1915 but the mood had changed with the increasingly appalling news from the Front.

Under his friend Epstein's encouragement, however, Smith successfully submitted two still lifes to The London Group's winter exhibition the same year. These were the first works Smith exhibited in his native country and included the forceful *Lilies* (1913–14, Leeds). Smith joined The London Group in 1920 and exhibited there until his death.

Gilman's wariness of Smith's nudes was justified a decade later, when Smith had his first solo show at the Mayor Gallery. Critics declared his palette gory and his models ugly while even his supporters considered him too aggressively daring for the general public. As late as 1942, Leeds City Art Gallery and Tate declined to acquire the Fitzroy Street nudes.

ALEXANDRA MACGILP

14

POSSIBLY EXHIBITED
11th London Group Exhibition, 1–29 November
1919, The Mansard Gallery, as (128) *Apples*,
not priced

Elected 1919, exhibited 1918–35, 1942–61
and (posthumously) 1962–3 and 1964
retrospective

Vanessa Bell
Apples, c. 1916–17

Oil on canvas
52 × 44.5 cm

Signed (lower right) 'V B'
Monks House, Rodmell, The Virginia & Leonard Woolf Collection (The National Trust)

Vanessa Bell first exhibited with The London Group in 1918. She was elected in 1919 and showed regularly until her death in 1961 although in the mid-1930s she temporarily resigned her membership in protest over managerial manoeuvrings. Her work was also shown posthumously between 1962 and 1964.

1918–19 was a critical time for Bell, as she moved from the extremes of her experimental period (*c.*1910–17) to a more tempered preoccupation with figuration; from the anxieties of the First World War, during which she endured an isolated life as a pacifist in rural Sussex, to the uncertainties of a post-war world and her return to London; from the Bloomsbury group's beginnings as a radical sub-culture, to its status in the 1920s as a new artistic establishment. Bell herself was emerging as an artist of distinction, although her success was qualified. In her lifetime, she attracted little published comment (her moment of celebrity came 20 years later), and she tended to be seen as one of a group, whether Bloomsbury or of women artists. Her decision to join The London Group registers the shifting politics of the London avant-garde, from the factional dramas of 1913–14, when Vorticists dominated the membership and Bloomsbury was largely excluded, to a less polarised post-war art scene. Election gave Bell an opportunity to show and sell her work regularly, and a voice on the committee.

Her painting *Apples* (*c.*1916–17) was probably exhibited with The London Group in 1919. The linear arrangement of five rosy apples in a bowl tilted almost to the vertical suggests a response to Cézanne, particularly his *Apples* (*c.*1877–78), which Bell's friend John Maynard Keynes acquired in 1917. The reference reaffirms her sense of herself as a European artist at a moment when contact with the continent was severely curtailed by the First World War. When, in 1917, she took part in an exhibition featuring French and English artists together, a reviewer drew attention to the Cézannesque quality of the show.[1] He identified the trend as a new realism, contrasting with recent experiments in abstraction. The work Bell sent to The London Group in the early 1920s met with a similar response. Reviews noted with approval her return to the object and praised her sense of colour.[2] There was a consensus that she had found her voice as 'the most important woman painter in Europe' (woman being the limiting term).[3]

Apples conveys an experiential realism of skewed perspectives, ambiguous spatial relationships, and a homespun irregularity that implies a particular response to the objects of everyday life. The apples are misshapen: elongated, pot-bellied or dwarfed; deviating almost comically from the smooth rotundity of the Cézanne. Neither are the other elements of the painting composed with any sense of deliberation. The bowl is unframed, extending to the edges of the canvas on three sides, while the vessel behind it hovers seemingly without support. It is perhaps a mirrored reflection, an opportunity for the artist to explore the tones and contours of the creamy ceramic from the side.

GRACE BROCKINGTON

16

EXHIBITED
Twelfth Exhibition of The London Group,
10 May–05 June 1920, The Mansard Gallery,
as (42) *Ghetto Theatre*, not priced

Founder member 1913, exhibited 1914,
1919–22, 1928 retrospective, 1936–39, 1943–57
and (posthumously) 1958 and 1964
retrospective

David Bomberg
Ghetto Theatre, 1920

Oil on canvas
74.4 × 62 cm

Signed and dated 'Bomberg 1920'
Ben Uri, The London Jewish Museum of Art
Purchased 1920

David Bomberg was a founder member of The London Group in October 1913 and the inaugural exhibition in March 1914 marked a crucial year in his early career. Though regarded as a 'disturbing influence' at the Slade School of Art, Vanessa Bell (cat.14) noted his progressive exhibits at the Friday Club and he worked briefly for Roger Fry's (cat.13) Omega Workshops before participating, in December 1913, in Wyndham Lewis's (cat.6) *Camden Town Group and Others* Brighton exhibition – The London Group's first unofficial showing. Bomberg's drawing of simplified, hieratic heads, *The London Group*,[1] probably influenced by Jacob Epstein (cat.7) and Modigliani, whose Paris studio he and Epstein had visited in 1913, possibly references the Group's formation.

Bomberg showed five advanced works in March 1914 including *In the Hold* (1913–14, fig.2) a fractured, discordant vision of newly arrived, newly displaced immigrants, and one of the most uproarious exhibits in the show.[2] In May he and Epstein co-curated the 'Jewish Section' at the Whitechapel Art Gallery's *Twentieth-century Art: A Review of Modern Movements*, where Bomberg's radical works were criticised as 'a waste of pigment and wall space'.[3] At his first solo exhibition in July, he hung his severely abstracted *Mud Bath* outside the Chenil Gallery, Chelsea, provocatively festooned with Union Jacks, while his strident exhibition foreword rejected 'everything in painting that is not Pure Form'. He exhibited at the Vorticists' first exhibition in 1915, but refused to join the movement.

Bomberg enlisted in November 1915; his harrowing war experiences, including the death of his brother, resulted in a self-inflicted wound. Escaping court martial and temporarily invalided out, he soon returned to active service. Commissioned by the Canadian War Memorials Fund to produce a painting of *Sappers at Work* (1918–19), his first, severely abstracted version was rejected; a second, more naturalistic version was accepted, but the experience destroyed his early exuberance.

Exhibited at The London Group in spring 1920 and acquired by Ben Uri in the same year, Bomberg's masterly *Ghetto Theatre*, described by the *Sunday Times* as 'a curiously characteristic interior',[4] captures his dismal, postwar vision. Painted on the eve of his departure from the East End, its dark, savage brilliance contrasts vividly with his animated pre-war Whitechapel theatre studies. The composition is boldly bisected by an imposing balcony rail that cleaves the Jewish theatre audience in two, separating them both from each other and the viewer and trapping them in their seats. The sense of unease is increased by the vertiginous, almost vertical diagonal. As in the theatre compositions of Walter Sickert (cat.18), whose Westminster School evening classes Bomberg had attended, it is the spectators, not the actors, who portray the drama. Drably dressed, their mask-like faces and closed body language exude disappointment.

Bomberg showed nothing with the Group between 1922 and 1936, but from 1943 onwards, after his final solo show at the Leger Gallery, it provided a regular exhibition platform which partially countered his scandalous critical neglect.

SARAH MACDOUGALL

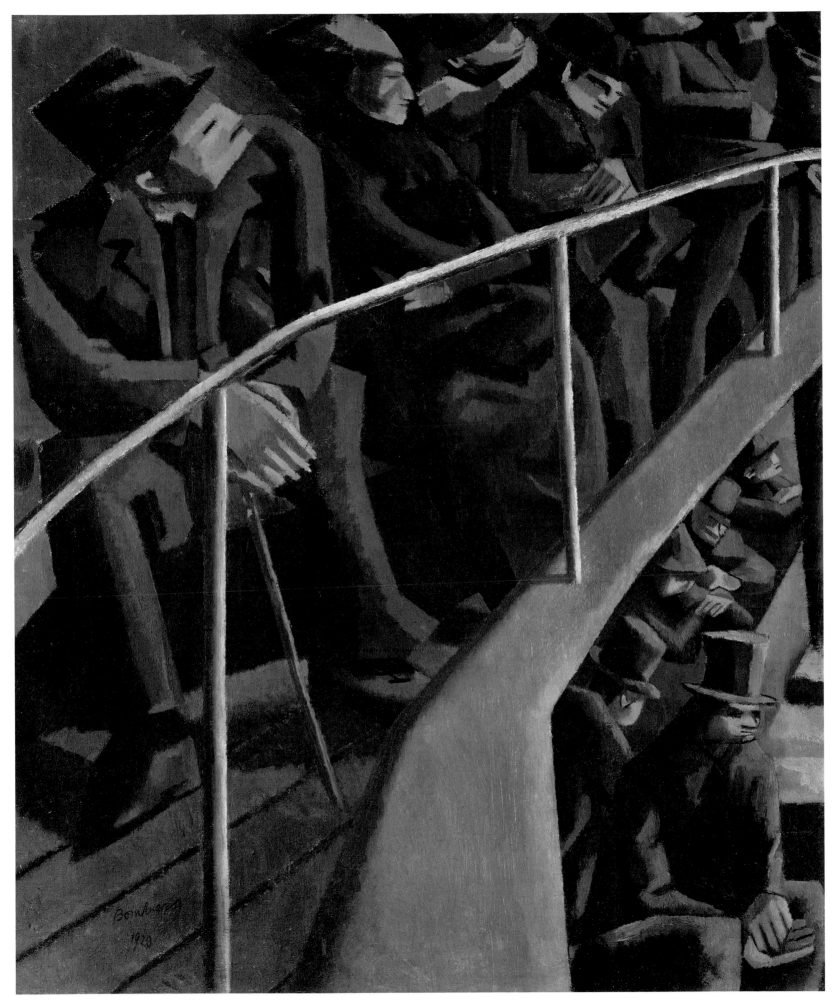

17

EXHIBITED

17th London Group Exhibition, 16 October–
11 November 1922, The Mansard Gallery,
as (66) *The Gods*, £90.0.0

Elected 1914, exhibited 1915, 1922,
1925–26, 1928 retrospective, 1937–38, 1947–50,
1959–60 and 1964 retrospective

William Roberts
At the Hippodrome (aka The Gods), 1920–1

Oil on canvas
95 × 90.6 cm

Signed (lower left) 'Roberts'
Leicester Arts & Museums Service

William Roberts was elected to The London Group in 1914, and showed three radical 'abstract' works at the Goupil Gallery in the March 1915 exhibition. Although only 19 years old, Roberts was already known to the art critic of *The Times*, who declared that 'Messrs. Lewis, Wadsworth, and Roberts are more rigid than ever. Their pictures are not pictures so much as theories illustrated in paint'.[1] Roberts went on to exhibit with the Vorticists in June, and was later called up for military service and then commissioned as an Official War Artist.

Consequently, Roberts did not exhibit with The London Group again until 1922, when his style was still strikingly modernist, but now directed towards paintings of more recognisable, mainly urban, subject matter. In May 1922, *Novices* and *The Last 'Bus* were shown at the 16th London Group exhibition; then, in October, at the 17th exhibition, he exhibited two large oil paintings *The Gods* (aka *At the Hippodrome*) and *Dock Gates*. Edward Wadsworth (cat.24) bought *The Gods* (list price £90) for the Contemporary Art Society, and this purchase was of financial significance to Roberts and his wife Sarah (née Kramer, sister of Jacob Kramer, cat.23), as they were desperately poor and had a three-year-old son. They had been living in Mornington Crescent until recently, and the work's more familiar title, *At the Hippodrome*, may refer to the Camden Hippodrome, a local variety theatre that had become a picture-house in 1913.

At the Hippodrome can be seen as a companion piece to Roberts's *The Cinema*, and his friend David Bomberg tackled a similar subject in *Ghetto Theatre* (cat.16) in the same period, *c.*1920. Roberts eschews both lighting and perspective effects and presents us with a stark, fully lit auditorium. 'The Gods' – the inexpensive wooden benches situated almost in the roof of a theatre – seems also to refer ironically to the dejected and downcast individuals in the audience as unemployment in Britain had begun to rise. The iconography of primitive Oceanic masks is used to express their demoralisation.

The *Daily Mirror*'s art critic was sarcastic about the challenging, modernism on show: 'The exhibition by the London Group at the Mansard Gallery contains the most advanced paintings in England. In fact, if they were a little more advanced they would be out of sight, a consummation devoutly to be wished for by those with old-fashioned ideas about form, beauty and colour'.[2] *The Times* was 'bewildered' by Roberts's *Dock Gates*;[3] but P G Konody in the *Observer* provided a positive endorsement: 'Excellent work is also shown by […] W. Roberts'.[4]

These two London Group exhibitions in 1922 served as useful preparation for Roberts's first one-man show in 1923. Roberts appreciated the no-manifesto approach of The London Group and he usefully exhibited with them in 1925, 1926 and 1928, then occasionally afterwards in the 1930s, 1940s and 1950s; in 1949 he created an affectionate homage in watercolour, *The London Group Gives a Reception*.

DAVID CLEALL

19

EXHIBITED

18th London Group Exhibition, April–May 1923, The Mansard Gallery, as (164) *Seated Torso*, Not for Sale

Elected 1922, President 1924–26, exhibited 1922–25, 1928 retrospective, 1930 and (posthumously) 1964 retrospective

Frank Dobson
Seated Torso, 1923

Ham Hill Stone
20.5 × 26 × 21.5 cm

Aberdeen Art Gallery and Museums Collections

Frank Owen Dobson was born in Acton Street, St. Pancras, London in 1886, the son of a commercial artist. At the age of eleven he won an art scholarship to Leyton Technical School. He left school, aged 14, and became a studio assistant to the sculptor William Reynolds-Stephens (1862–1943). Between 1906 and 1910 he studied at Hospitalfield House art school in Arbroath, Scotland, after which he attended classes at the school in Cornwall run by the painter Stanhope Forbes (1857–1947).[1]

Dobson's visit to Roger Fry's (cat.13) landmark 1911 exhibition *Manet and the Post-Impressionists* was a momentous experience for him: 'The show at the Grafton Galleries was just an explosion – the demolition of all the art-forms I had come to know. I was affronted, even hurt. But what a vista! Anything was possible. Here was something more than just emotion. Here was work for the intelligence.'[2] His first exhibition of paintings took place at the Chenil Galleries in London in 1914. Around this time Dobson tried his hand at sculpture for the first time, but his development was interrupted by the outbreak of the First World War, in which he fought with the Artists' Rifles.

The Arts League of Service was formed in 1919, and Dobson exhibited with them over the next decade. In 1920 he showed in Wyndham Lewis's (cat.6) 'Group X' exhibition at Heals' Mansard Gallery. By 1922 when Dobson was elected a member of The London Group, he was already seen as an important modernist sculptor. In the 1923 London Group exhibition his exhibits included *Seated Torso* which, in its reductive abstraction, clearly shows the influence of the cubist movement, and the portrait bust of Robert Menzies "Bob" McAlmon (1896–1956). In the 1927 London Group exhibition he showed his portrait bronze of the Russian ballerina Lydia Lopokova, together with *Cambria*, a study for the Welsh War Memorial, and the monumental stone-carving *Cornucopia. Cornucopia* formed the centrepiece of Dobson's one-man exhibition at the Leicester Galleries that year and was referred to by the critic Clive Bell as 'a masterpiece […] the finest piece of sculpture produced by an Englishman since – since I don't know when.'[3] Roger Fry wrote that Dobson's work was 'pure sculpture and true sculpture'.[4] Dobson served as President of The London Group from 1924 to 1926, and continued to exhibit with them until 1930.

Aside from his many portrait busts, Dobson's work was invariably based on the female nude. The formalism of his early sculpture gradually gave way to a romantic representation. After the Second World War Dobson became Head of Sculpture at the Royal College of Art, was awarded the CBE in 1947, and became an RA in 1953. At the Festival of Britain in 1951 he exhibited his monumental bronze *London Pride*, which now stands outside the National Theatre. Although Dobson may be considered an establishment figure by the end of his life, in his early years he was one of the first British artists to embrace the influence of the European modernist movement.

NEVILLE JASON

21

EXHIBITED
20th Exhibition of The London Group,
14 April–14 May 1924, The Mansard Gallery as
M. Watson-Williams (94) *The Bathers*, £2.2.0,
signed proof without frame

Elected 1922, exhibited 1921–25, 1927–30
and 1964 retrospective

Paule Vézelay
Bathers, 1923

Linocut on paper
26.7 × 23.5 cm

Signed and dated in pencil (over an erased inscription) 'Paule Vézelay. 1923.'
Inscribed with title and numbered No.10 of 50.
Victoria and Albert Museum

This linocut was produced in 1923, before the artist changed her name from Marjorie Watson-Williams to Paule Vézelay in 1926 (the erased inscription would have been her earlier signature, and she later re-signed the print with her adopted name); another version is in the Tate collection, inscribed 'The Bathers, No.7 of 25', signed 'Paule Vézelay 1923'.[1] This version of *Bathers* was exhibited with The London Group in April 1924, and also in the 1924 Venice Biennale British pavilion under the title *Nudes*.

Paule Vézelay, born Marjorie Watson-Williams in Bristol, went to London to study at the Slade School of Art in 1912, although she soon moved to the London School of Art, where she was taught by the illustrators John Hassall (1868–1948) and George Belcher (1875–1947). Vézelay was interested in printmaking and attended lithography evening classes at Chelsea Polytechnic. Her witty, delicate illustrations, often with an affinity to the work of Aubrey Beardsley (1872–1898), were published regularly in magazines and books as she began to establish a reputation as an illustrator, lithographer and wood engraver.

Vézelay's first visit to Paris in 1920 had an immediate impact. She decided to live and work in France, and began to focus seriously on painting, although she continued to make and exhibit prints. Her style developed in a more modern and simplified way and she first exhibited in Paris in October 1920. At her first one-woman exhibition in London at the Dorien Leigh Galleries in 1921, Vézelay exhibited paintings, drawings, lithographs and woodcuts. Her growing reputation and exhibitions in Brussels, Paris and London led to the invitation in 1922 to become a member of The London Group.

Vézelay was often in France in the early 1920s, spending summers on the Riviera making drawings in her sketchbooks of bathers, cafés, dancers and sailors from which she afterwards made prints. She later recalled that 'The linocut *The Bathers* was made in London after bathing from the rocks of the Château des Enfants and the Hôtel du Cap during a summer at Cap d'Antibes'.[2]

In the summers of 1923 and 1924, Vézelay was part of the expatriate circle that formed around the Cap d'Antibes school run by the dancer Margaret Morris (1891–1980) and her husband, the Scottish painter J D Fergusson (1874–1961). As art editor of the pre-war art and literary magazine *Rhythm*, Fergusson had published his own black and white illustrations influenced by Fauvism, together with designs by other artists, including his previous partner Anne Estelle Rice (1877–1959). Rice knew Vézelay in France, and they exchanged prints of similar stylised figure subjects around this time. Vézelay's *Bathers* is very much a product of this period around Morris and Fergusson and their associates – an influence evidenced by the bold outlines and the simplification of her rhythmic arrangement of graceful, dancing, naked women.

Vézelay continued to exhibit figurative paintings and prints regularly with The London Group, remaining a member until 1933. By 1934, she had totally committed herself to abstraction, and was elected a member of the group *Abstraction-Création* in France.

JANE ENGLAND

22

EXHIBITED

London Group Retrospective Exhibition 1914–1928, April-May 1928, New Burlington Galleries, as (51) *Nude*, lent by Roger Fry, Esq. and *London Group 1914–64 Jubilee Exhibition Fifty Years of British Art*, 15 July–16 August 1964, Tate Gallery, as (13) *Nude (The hip bath)*, 1913, lent by the Courtauld Institute of Art (Roger Fry Collection)

Founder member 1913, exhibited 1914, 1928 retrospective and 1964 retrospective

Frederick Etchells
Hip Bath, 1911–12

Oil on canvas
62.3 × 52 cm

Signed (lower left) 'F. E.'
The Samuel Courtauld Trust, The Courtauld Gallery, London

Frederick Etchells was a founder member of The London Group, showing five works – the prices suggest they were all on paper – in the first exhibition: (58) *Head* (£6.6.0), (60) *On Board Ship* (£6.6.0), (69) *Still-Life* (£6.6.0, possibly the 1913 gouache in the Tate collection), (79) *Houses at Dieppe* (£12.12.0) and (80) *Head of a Man* (£8.8.0). Etchells had worked closely with the Bloomsbury Group, along with his sister Jessie (1893–1933, founder member 1913), contributing to the 1911 Borough Polytechnic murals with Roger Fry (cat.13), Duncan Grant (cat.26) and others and joining the Omega Workshops. Despite his previous closeness to Fry, Etchells sided with Wyndham Lewis (cat.6) in October 1913 on discovering that Fry, without consulting him, had informed Frank Rutter that Etchells would have no paintings to exhibit until the following year. He signed Lewis's round robin denouncing Fry and the Omega, explaining to John Maynard Keynes that he 'went pretty carefully into the thing, & every fact in the circular is borne out.'[1]

Etchells was one of the exhibitors at the pre-London Group Brighton exhibition, and joined the Vorticists (though he did not sign their manifesto). He was represented in *Blast* no. 1 by four reproductions: two Cubist heads clearly inspired by Picasso, and two semi-Cubist townscapes in black ink, awkwardly synthesised from naturalistic details warped into an almost folded space including a view of Dieppe, possibly exhibited as *Houses at Dieppe* in the first London Group exhibition. T E Hulme called Etchells' exhibits 'admirably firm and hard in character', but remarked that he seemed to be 'holding himself back, in a search for a new method of expression', which Hulme found in 'the fine "Drawing of a Head" '.[2] In fact Etchells' work from 1911–14 is almost a compendium of the various styles available to modern English artists during the period, and arguably only when he adopted a full-blooded

Vorticist style did he produce completely assured work.[3]

Etchells did not exhibit at The London Group again, except in the 1928 Retrospective. He abandoned painting after the First World War and became one of the pioneers of modernist architecture in London; later translating Le Corbusier. He was represented in the 1928 exhibition by works from his Bloomsbury period: *The Molecatcher*, *Nude*, and *Head of a Woman*, lent by Roger Fry and Maynard Keynes. *Nude*, or *The Hip Bath* is clearly related to Duncan Grant's *The Tub* (*c*.1913, Tate) and the later Charleston decoration, also called *The Tub* by Vanessa Bell. The picture is dominated by the massive, sculptural figure of the bather, her stooped head suggesting that her monumental presence is greater than the available space can contain. This emphasis accords with Clive Bell's preoccupation with 'significant form', while Bell's enthusiasm for Giotto possibly influenced the painting's chromatic restraint. Perhaps most remarkable, and contradicting the emphasis on volumes, is the 'distressed' surface of the paint, drawing attention to the flatness of the picture plane and giving the work something of the air of a weathered fresco.

PAUL EDWARDS

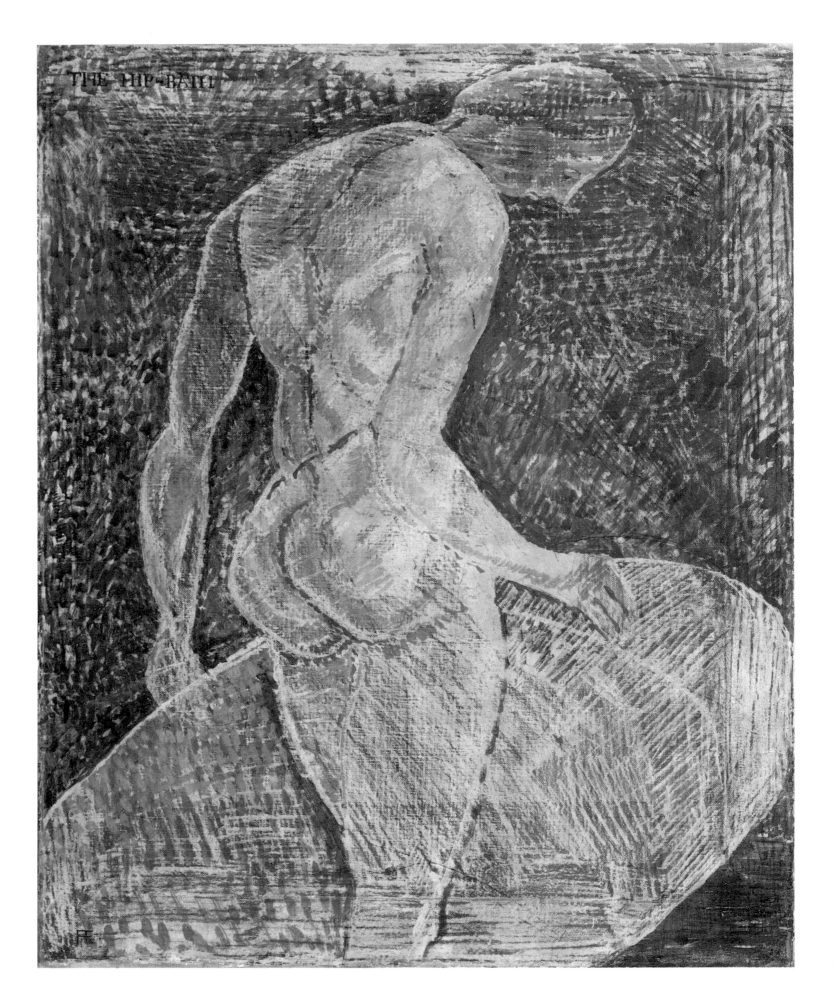

THE HIP-BATH

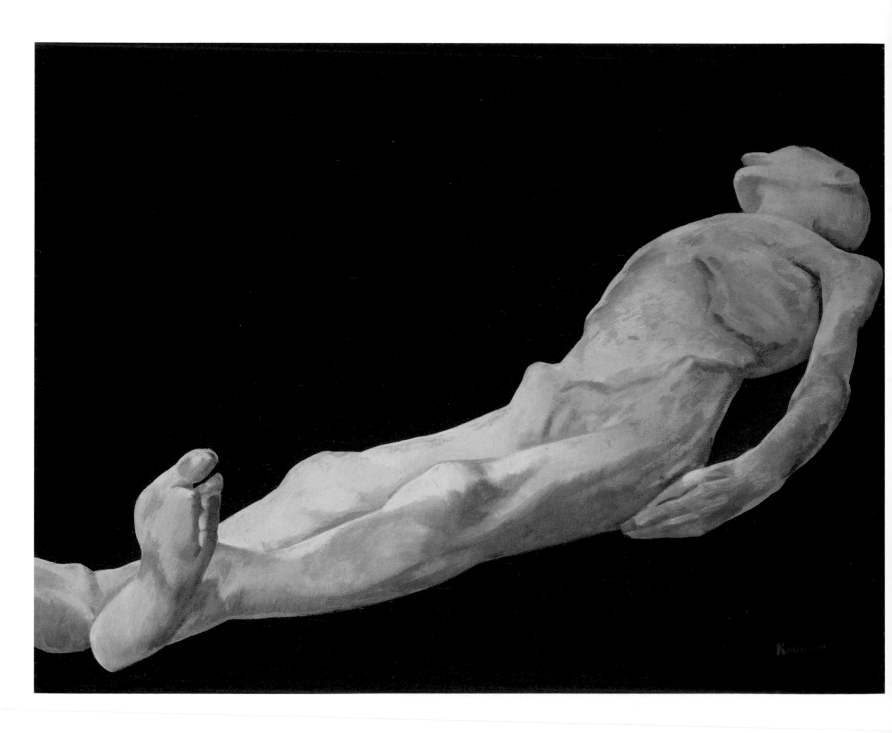

23

EXHIBITED

*London Group Retrospective Exhibition 1914
1928*, April–May 1928, New Burlington
Galleries, as (108) *The Anatomy Lesson, 1927*
[*sic*], £75.0.0 and *London Group 1914–1964
Jubilee Exhibition Fifty Years of British Art*, 15
July–16 August 1964, Tate Gallery, as (31)
The Anatomy Lesson [Clay], 1927, Lent by the
City Art Gallery, Leeds

Elected 1915, exhibited 1915–17, 1922–23,
1928 retrospective and (posthumously) 1964
retrospective

Jacob Kramer
Clay / The Anatomy Lesson, 1928

Oil on canvas
71.7 × 91.4 cm

Signed in red (lower right) 'Kramer'
Leeds Museums and Galleries (Leeds Art Gallery)

Jacob Kramer was notified of his election to the Group by Edward Wadsworth's (cat.24) postcard of 22 February 1915. For the Yiddish-speaking, Russian-Jewish émigré, initially trained in Leeds, this affirmed his arrival among the modernists. Kramer had left Leeds in 1913, attending the Slade School of Art for a year, supported by collector and Leeds University Vice-Chancellor, Michael Sadler, and (somewhat half-hearted) funding from the Jewish Educational Aid Society. There he gained entry to London's bohemian circles and co-curators David Bomberg (cat.16) and Jacob Epstein (cat.7) included his work in the 'Jewish Section' of the 1914 Whitechapel Gallery exhibition *Twentieth Century Art: A Review of Modern Movements.*

Kramer's London Group exhibits were mostly figurative subjects, influenced by Vorticist geometry and expressionist colour. His first exhibit in spring 1915, *Earth*, (now lost) was noticed by Wyndham Lewis (cat.6) in *Blast* and by Frank Rutter, the controversial, pro-modernist Curator of Leeds City Art Gallery. Kramer's exhibits divided critics: in June 1916 with *Death of My Father* (his father had died in May), he was accused of insensitivity.[1] The following spring McKnight Kauffer praised the '*big* simplicity' of *Crucifixion* and *Portrait of Anna Pavlova*, but *The Globe* lamented: 'Poor Pavlova! […] surely deserves a better fate'; in autumn 1917, Rutter called *Ruhala* 'the most arresting of the figure paintings', whilst conceding that 'many people would dislike it'.[2]

Owing to his Russian birth, Kramer was only conscripted at the end of the War (serving as a regimental librarian). Exhibiting again with the Group in October 1922, the *Evening News* caustically described *Drink Deep or Touch Not* as 'something between a woman and a ghost with beetroot-coloured hair, wearing a dress of transparent sea-green gauze and looking from a shapeless eye down a nebulous nose set in a formless, bloodless face.'[3] He participated in the spring 1923 exhibition but following Sadler's appointment to Oxford University, Kramer cast adrift without his mentor, gravitated home.

Invited by Rupert Lee (cat.20), despite lapsed membership, Kramer showed his last works with the Group at the 1928 retrospective: *Death of My Father* and *The Jew* (from Sadler's collection), and *Clay* (titled *Post-Mortem* and priced £100 in his notes). 'I found in the corpse […] a reflection of great tranquillity', Kramer noted.[4] Yet despite recalling Rembrandt's work of similar subject-matter, the painting caused considerable controversy - whether a post-mortem was a legitimate subject for a work of art.v Observed from sketches, it depicts a sickly-coloured cadaver in the medical school dissecting room at Leeds General Infirmary. Kramer was familiar with the hospital, commissioned to make portraits of its benefactor Charles Brotherton and Head of School Dr W H Maxwell Telling. Fittingly, *Clay* was subsequently purchased by Leeds medical graduate Dr (later Sir) Barnett Stross.[5]

RACHEL DICKSON

POSSIBLY EXHIBITED
*London Group Retrospective Exhibition
1914–1928*, April–May 1928, New Burlington
Galleries, as (171) *Marseille* (Lent by the
Artist), (262) *Street in Marseilles*, or (263)
Street in Marseilles

Founder member 1913, exhibited 1914–15
and 1928 retrospective

Edward Wadsworth

Rue Fontaine de Caylus, Marseilles, France , 1924

Tempera on panel
94 × 45.3 cm

Leicester Arts & Museums Service

Trained at the Bradford and Slade Schools of Art, Wadsworth was a founder member of The London Group, probably working alongside his close friend and fellow future Vorticist, Wyndham Lewis (cat.6), early in 1914 to secure the election of like-minded artists. These included Frederick Etchells (cat.22), David Bomberg (cat.16) and painter-critic R H 'Reggie' Wilenksi, who would become one of Britain's leading inter-war art critics and remained sympathetic to The London Group.[1]

By the end of the First World War Wadsworth had moved away from Vorticism's challenging geometric abstraction to emerge as a leading proponent of 'the New Realism', adopting egg tempera as his principal medium after an Italian motor tour in spring 1923. He had briefly visited Marseilles the previous February, but only truly experienced the beguiling nature of the Cote d'Azur coastline in 1924. The following summer (and every summer thereafter until 1930) Wadsworth and his wife returned to further explore the city and nearby small fishing ports of St Tropez and Antibes, in the vanguard of a group of artists and writers, including Picasso, Raoul Dufy, Francis Picabia, Gerald Murphy, F Scott Fitzgerald, Somerset Maugham and Aldous Huxley.[2]

Wadsworth was fascinated by the narrow winding streets and picturesque shabbiness of Marseilles' 'Vieux Port', an allure only heightened by its reputation as the city's 'Quartier Réservé' or red-light district. Evelyn Waugh described this 'labyrinth of sin'[3] in his 1928 novel *Decline and Fall* as 'too narrow and crowded for traffic […] The houses overhung perilously on each side, gaily alight from cellar to garret; between then swung lanterns; a shallow gutter ran down the centre of the path.'[4]

In 1924–25 Wadsworth executed a series of meticulous charcoal drawings focusing on the elaborate lines of washing slung between the buildings of the Vieux Port's narrow streets, preparatory to a series of tempera paintings exhibited in his 1926 Leicester Galleries solo show: *Rue Fontaine de Caylus* (1924), *Rue Bompart* (1925) and *Rue de la Reynarde* (1926). In 1941, when the latter was acquired by Manchester City Art Gallery, Wadsworth wondered if the respectable purchasers realised the notoriety of the location. Had they been so hypnotised by the hanging washing that they had overlooked the women loitering in the doorways?[5]

Wadsworth delighted in the elaborate Neo-Baroque arabesques created by the folds of drying drapery which relate to the hyper-realism of everyday life discernible in the 1925 Mannheim *Neue Sachlichkeit* ('New Objectivity') exhibition. In 1932 a German curator and *Neue Sachlichkeit* champion sought to include *Rue Fontaine du Caylus* in the Hamburg Kunsthalle exhibition as an example of the British contribution to the movement.[6] It was also included in Wadsworth's 1951 memorial exhibition at Tate.

The majority of Wadsworth's views of Marseilles' atmospheric 'Vieux Port' were executed in charcoal and tempera between 1924 and 1926; by autumn 1926 he was producing carefully rendered tempera still lifes, which possess a disturbing quasi-Surrealist quality. An area of French Resistance activity, the Vieux Port Wadsworth had known was almost entirely demolished by German occupation forces in January 1943.[7]

JONATHAN BLACK

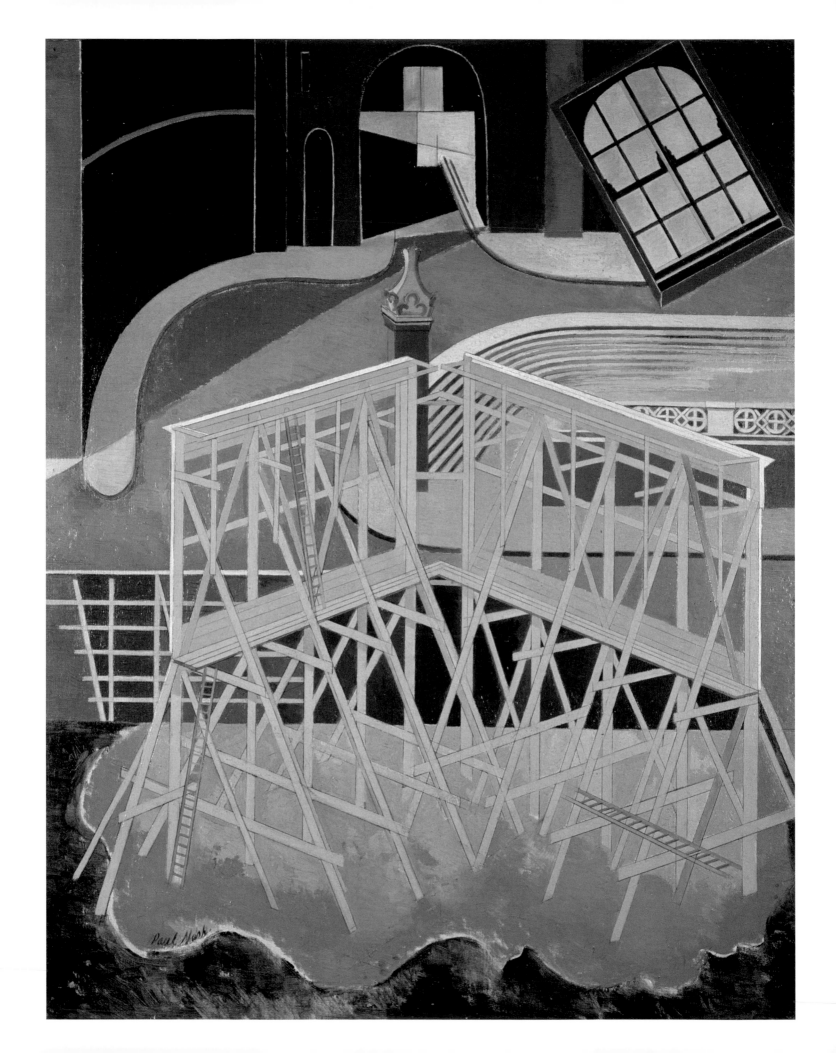

25

EXHIBITED

27th London Group Exhibition,
14 October–01 November 1929, New
Burlington Galleries, as (155) *Northern
Adventure,* £100.0.0 and *London Group
1914–64 Jubilee Exhibition: Fifty years of
British Art,* 15 July–16 August 1964, Tate
Gallery, as (33) *Northern Adventure*

Elected 1914, exhibited 1915–20, 1922–26,
1928–30 and (posthumously) 1964
retrospective

Paul Nash
Northern Adventure, 1929

Oil on canvas
92.7 × 71.6 cm

Signed (lower left) 'Paul Nash'
Aberdeen Art Gallery and Museums Collections

Paul Nash left the Slade School of Art in 1911, aged 22. He enjoyed a modest success with his first solo exhibition the following year, and Roger Fry (cat.13) stated that Nash's watercolours were 'the only things he liked' at the May 1913 New English Art Club exhibition.[1] Nash was first proposed for The London Group in January 1914; while his brother John was elected, Paul was narrowly unsuccessful, but was admitted later the same year. Joining the Group was probably opportunistic: an ambitious young artist, he was keen to exhibit as widely as possible. Though landscape was his chief subject, he was well aware that London was where he would best advance his career. Indeed, by the time of his first exhibition with the Group, in March 1915, he was living in London, having enlisted for home service with the Artists' Rifles.

From 1917 Nash enjoyed considerable success as an Official War Artist, and was a regular exhibitor with The London Group until 1930. His Great War painting *We Are Making a New World* (1918, Imperial War Museum) was exhibited in The London Group's 1928 retrospective exhibition. As Charles Marriott observed in his review of the show in *The Times*, Nash 'is always a mannerist, but he has worked on his manner and improved it out of all knowledge […] But as a designer Mr. Nash has remained the same'.[2] As Nash told his wife, Marriott's review 'hits the nail on the head again when […] he emphasizes the strength which is the weakness of the modern English mind, underlining our national label, Safety First […] The French appeal to me more. They have reached out, they have real mental daring.' He added that Marriott was also probably right 'when he remarks that as a designer I have remained stationary […] This is the result of unenterprise, of a subconscious playing for safety'. But with a show of his new work forthcoming, Nash felt 'caught at present. It is no time to experiment overmuch just now.'[3]

That same year there was an extensive Giorgio de Chirico exhibition in London, and the Italian's work – and the Surrealist movement in general – gave Nash an important new direction: 1929 would mark a key change in his work, as he moved towards Surrealism.

There was much in de Chirico's work that naturally appealed to him, in particular the use of architectural structures, which was sympathetic to Nash's long interest in theatre design. There had also long been more than a hint of the uncanny in his work.

Northern Adventure is one of Nash's earliest intentionally Surreal paintings and depicts the view from his flat overlooking the entrance to St Pancras Station (the London terminus of trains to the north) crossed by scaffolding during the building of Camden Town Hall. The painting was widely exhibited including at the International Surrealist Exhibition in Paris in 1938 and twice at The London Group: in October 1929, and at the Group's 50th Jubilee Exhibition in 1964.

DAVID BOYD HAYCOCK

26

EXHIBITED
The London Group 26th Exhibition,
05–26 January 1929, as (8) *View from a
Window,* £157.10.0 and *London Group 1914–64
Jubilee Exhibition Fifty Years of British Art,* 15
July–16 August 1964, Tate Gallery, as (50) *View
from a Window (Window, South of France),*
1928, lent by the City Art Gallery, Manchester

Present at founding meeting 1913,
elected 1919, exhibited 1919–22, 1924–32,
1934–5, 1939, 1942–45, 1947–1961 and 1964
retrospective

Duncan Grant
Window, South of France, 1928

Oil on canvas
100 × 81.1 cm

Signed and dated (lower left) 'D. Grant 1928'
Manchester City Gallery. Gift of the Contemporary Art Society, 1930

Unlike some of his well-known contemporaries such as Wyndham Lewis (cat.6), Edward Wadsworth (cat.24) or Matthew Smith (cat.12), Duncan Grant had no private income. Sales of his work were therefore crucial and he exhibited widely between the wars. He had single-artist exhibitions with various commercial galleries, exhibited with the London Artists' Association and regularly with The London Group which had a comparatively high rate of sales. In the 1920s Grant was one of the Group's best-known exhibitors and took part in some of its deliberations, particularly the recruiting of new members. He showed several important works with the Group until the mid-1930s. The present painting, shown at the January 1929 exhibition, was critically acclaimed, purchased by the Contemporary Art Society and given in 1930 to Manchester City Art Gallery, with its substantial and growing collection of recent British art.

At the time when Grant was working on this painting, May 1928, in France, several of his early paintings were on view at The London Group Retrospective Exhibition at the New Burlington Galleries. They all dated to the years before he became a member of the Group in 1919 and demonstrated his most adventurous period. Such works (including the large, controversial *Adam and Eve* of 1913) came as a surprise to the post-War generation who knew only the more contained representational works that brought him a high reputation in the 1920s. *Window, South of France* enhanced his standing.

The work was painted in Grant's first-floor studio at La Bergère, a small house he and Vanessa Bell (cat.14) rented for several years, two kilometres north of Cassis. It had (and still has) extensive views over vineyards and olive trees sloping towards the town and the sea. Grant recorded the landscape in many paintings and pastels from 1928 to 1932. Of all these works, the present one is perhaps the most elaborate, at the same time capturing the artist's surprise and delight in opening his new studio's windows onto a radiant landscape. The firm delineation of the window demarcates the private, interior world of the studio from the sunlit panorama beyond. The view unfolds through fields and trees towards the sea whose strip of colour is returned to the interior through the electric blue of the window frame; the landscape is reflected in the panes on the left; the sill, with its urn of anemones, in those on the right. In their turn, the flowers, gathered from outside, are echoed in the printed roses of the old-fashioned wallpaper. The unchanging permanence of the classic Mediterranean landscape is contrasted with the palpable materials of still life painting, the window reflections acting as a synthesis of the two.

RICHARD SHONE

EXHIBIT

The London Group Exhibition of Open-
Sculpture, 02 June–30 August 1930, The Ro
Gardens of Selfridge & Co., as (56) *He*
(concrete), £31.10.0 (probably) and *Lona*
Group 1914–64 Jubilee Exhibition Fifty Year.
British Art, 15 July–16 August 1964, T
Gallery, as (70) *Head of a Woman,* 1928, [:
lent by the City Art Gallery and Museu
Wakefi

Elected 1930, exhibited 1930, 19
1937–38, 1949 and 1964 retrospect

fig. 30
Hoa Hakananai'a ('lost or stolen
friend')/ Moai (ancestor figure)
*c.*1200
The British Museum, London

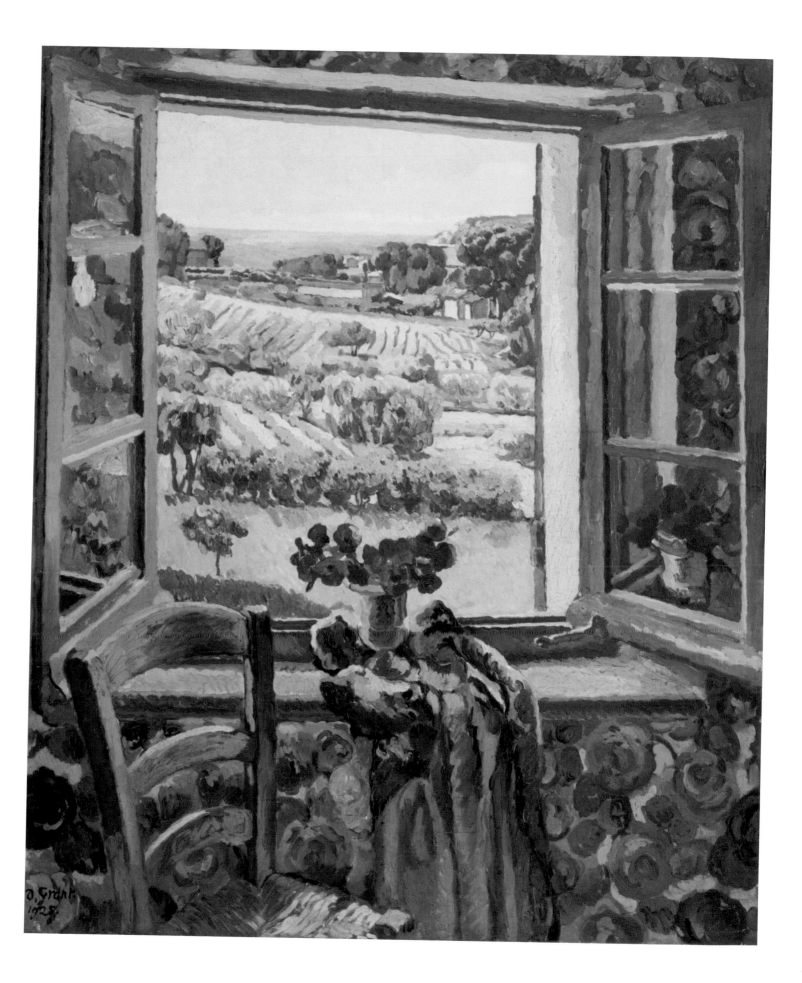

30

An earlier version of this work was exhibited at *The London Group Thirty-Sixth Exhibition of Painting & Sculpture*, 30 October–20 November 1937, New Burlington Galleries, as (196) *Narcissus*, £21.0.0

Elected 1934, exhibited 1934–43, 1945–46, 1948–55 and 1960–62

Hans Feibusch
Narcissus, 1946

Oil on canvas
61 × 91.5 cm

Signed and dated (lower left) 'HF 46'
Pallant House Gallery, Chichester (Presented by the Artist, 1998)

Born into a wealthy Jewish family in Frankfurt am Main, Hans Feibusch was a key figure in the city's art scene during the Weimar Republic. A member of the progressive art group the *Frankfurter Künstlerbund* and winner of the Prussian State Prize in 1930 for his painting, *The Fishmonger*, Feibusch was commissioned by the city mayor, Ludwig Landmann, to paint portraits of local politicians, religious leaders, artists and musicians. Landmann operated at the core of networks of patronage in Weimar Frankfurt and, through his connections, Feibusch gained significant commissions.

The rise of Nazism signalled the end of this period of artistic productivity. In September 1933, the *Reichskulturkammer* was formed, which prohibited Jews from holding professional positions within the arts. Feibusch was dismissed from the *Frankfurter Künstlerbund* and all commissions were suspended with immediate effect. The loss of his profession, and the rising threat of anti-Semitism, forced him to immigrate to Britain, where he settled in London, the home of his fiancée Sidonie Gestetner.

While Feibusch's once celebrated work was seized, ridiculed and destroyed by the Nazis (who included his painting *Zwei Schwebende Figuren* in the infamous exhibition *Entartete Kunst*), he found safety and artistic freedom, yet also obscurity, in Britain. Working tirelessly to make a name for himself in his adopted country, Feibusch took on diverse projects including poster design and book illustration, while organising (and partially funding) exhibitions of his work at the Lefevre Gallery. Following a year of intense productivity, Hans Feibusch was offered membership of The London Group in October 1934. Just weeks later, at the Group's November exhibition, his work gained glowing reviews, as critics praised his expressive brushwork and adventurous use of colour, with one reporter insisting that Feibusch's paintings

were the highlight of the show (even claiming that the visitor could 'forget all the rest').

Narcissus (1946), an earlier version of which was included in The London Group's 1937 exhibition, embodies this tendency for bold colour and illustrates Feibusch's fascination with the classical world, a product of his Greco-Roman education in Frankfurt. The 1937 version of this work was also included in the exhibition, *Twentieth Century German Art*, at the New Burlington Galleries in 1938, most likely on the recommendation of Augustus John (1878–1961), an honorary member of The London Group, and the president of the exhibition committee. John and Feibusch formed a professional working relationship resulting in the Society of Mural Painters in 1950, alongside fellow London Group members Stanley Spencer (1891–1959),[1] Victor Pasmore (cat. 40) and John Piper (cat. 34), among others.

Feibusch went on to create more than 40 murals in British churches, restaurants and civic buildings and frequently collaborated with London Group members, including Phyllis Bray (1911–1991, elected 1933) and Graham Sutherland (1903–1980, elected 1937). Membership of The London Group allowed Feibusch, an outsider in exile, access to the art establishment in Britain and through his involvement he made close friendships and professional contacts which he maintained throughout his lifetime. These connections fuelled his career and gave him a vital sense of belonging in his adopted country.

JOANNA CHEETHAM

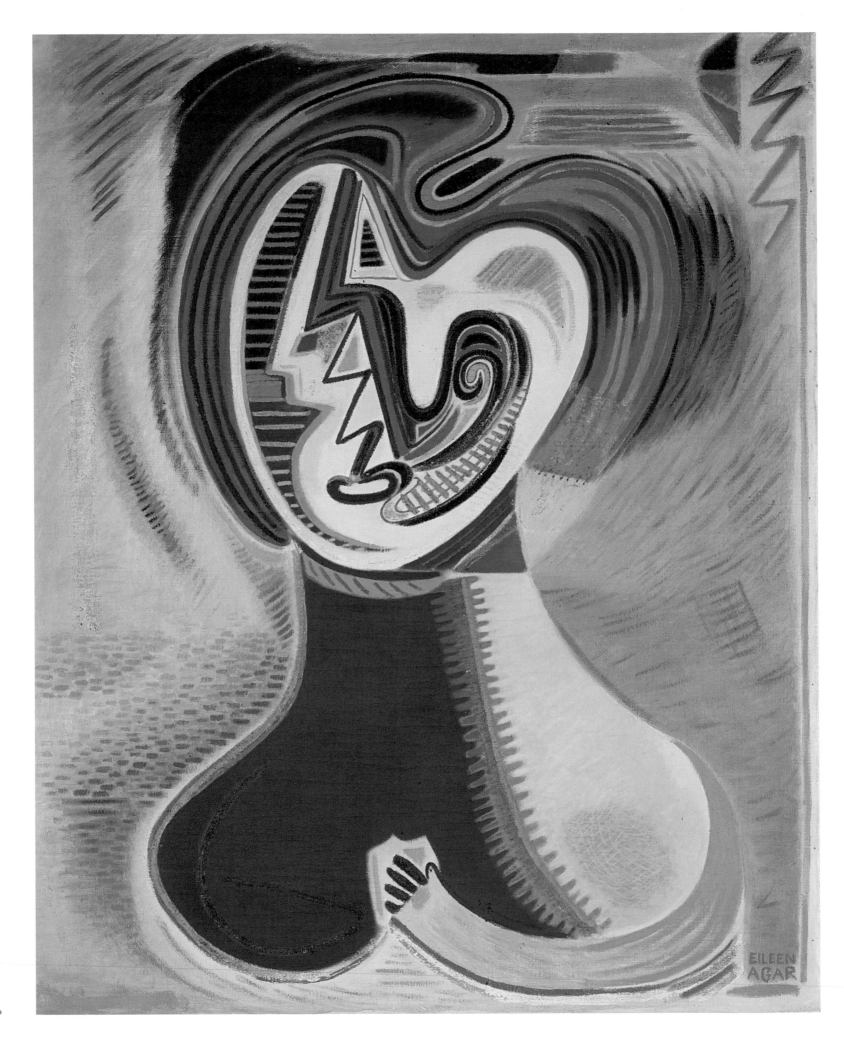

31

A version of this work was exhibited at the *32nd London Group Exhibition*, 12–30 November 1934, New Burlington Galleries, as (127) *The Modern Muse*, £25

Elected 1933, exhibited 1933–34, 1936–39, 1941–43, 1945–64 including 1964 retrospective

Eileen Agar
*The Modern Muse, c.*1931–34

Oil on canvas
102 × 81 cm

Private Collection

Henry Moore (cat. 27) suggested that Eileen Agar join The London Group in 1933, around the time of her first solo show – a retrospective of seven years' work mounted by the Bloomsbury Gallery in London, ranging from forthright realism to cubist-derived abstraction. Agar was a rising star and welcomed the idea, recounting in her autobiography, *A Look at My Life* (1988), that The London Group had the reputation for showing exciting new work.

In 1934, Agar's mixed media construction, *The Modern Muse*, was the most discussed work in the exhibition, with another exhibit, entitled *Daffodils*, also earning the adjective 'bizarre' from the *Western Mail*. Like conflicting witnesses at the scene of an accident, different critics saw different things. The *Western Mail* maintained that affixed to *The Modern Muse* was 'a pulley contraption, a set square, and a ruler and cardboard cigarette holder'. Frank Rutter in the *Sunday Times* wrote: 'This is not so much a painting as a mixture of woolwork and *appliqué*, with various objects stuck on the surface of the composition. A wooden foot-rule is attached, so that we may measure for ourselves the perfection of the Muse's proportions. A length of black cotton, daintily stretched across the centre, reminds us how much of worth may hang upon a thread.'[1]

These three-dimensional extras would have had to be properly mounted onto the surface of the picture and there is no real evidence of this in the painting exhibited here. The London Group picture sounds altogether more playful and unexpected, and this may explain the fact that there are traditionally two dates ascribed to *The Modern Muse* – 1931 and 1934. Perhaps the painting we have today was an earlier try-out of the muse theme, and the later mixed media work has simply disappeared from view, either lost or destroyed. Certainly the contemporary descriptions of the 1934 incarnation make it sound distinctly surreal, which would confirm that Agar was working in a surrealistic spirit before she was formally identified as a Surrealist in the spring of 1936. It should, of course, be no surprise that Agar was in the vanguard of English Surrealism: she had lived in Paris in the late 1920s, and knew French Surrealists including André Breton and Paul Eluard.

The exhibited painting is a striking Picasso-influenced rendition of a female head, wonderfully stylised in a sophisticated version of a primitive mask. The double row of decorative tooth-like stitches up the neck prefigures the African bark cloth patterning on Agar's second version of her *Angel of Anarchy* (1936–40, Tate). In *The Modern Muse*, the pattern is painted in exaggerated form to look like the toothed bill of a swordfish (Agar had one of these in her studio). Here we have a vigorous meeting of the archaic and the advanced: tough and declarative, *The Modern Muse* is geometric and tribal in her striated features, yet her heart-shaped face and elaborate coiffure bear a marked resemblance to an artist's palette. The effect is disturbing and confrontational and seems to suggest a more primeval force behind the ancient source of creative inspiration.

ANDREW LAMBIRTH

32

EXHIBITED
The London Group 34th Exhibition,
12–28 November 1936 as (146) *Painting*, £25;
and *London Group 1914-64 Jubilee Exhibition
Fifty Years of British Art*, 15 July–16 August
1964, Tate Gallery as (82) *Painting: Objective
Abstraction*, 1936, lent by the Trustees of the
Tate Gallery

Elected 1933, exhibited 1930–38, 1943–44,
1947–50, 1953, 1962 and 1964 retrospective

Rodrigo Moynihan
Objective Abstraction ('Painting'), 1935–36

Oil on canvas
44.7 × 35.6 cm

Tate: Purchased 1958

Born in the Canary Islands, Moynihan had an itinerant early life, attending high school in New Jersey, then living in Europe and studying at the Slade School of Fine Art, London, under Professor Tonks (1928–31).[1] He came to public attention with his work in the *Objective Abstractions* exhibition at Zwemmer's Gallery, March–April 1934, alongside Geoffrey Tibble (1909–1952) and Graham Bell (1910–1943), with whom he joined in rejecting the geometrical abstraction of the European avant-garde. Thomas Carr (1909–1999), Ivon Hitchens (cat.47), Victor Pasmore (cat.40) and Ceri Richards (cat.38) also exhibited but showed largely representational works.

Tibble was allegedly the first of the group to embrace non-figuration, circa September 1933, but Moynihan soon followed suit; his densely impastoed abstractions in a limited palette were influenced by the Impressionists, particularly Monet, as well as by Cézanne and Turner. These works aroused considerable press attention, but little support, and Moynihan returned to representational painting in the 1940s–50s. Between 1937 and 1939 he was associated with, though not a member of, the Euston Road School through his friendship with Pasmore and William Coldstream (cat.36). His first solo exhibition was at the Redfern Gallery in 1940. During the Second World War Moynihan trained as a gunner and joined the camouflage section, but was invalided out after two years, becoming an Official War Artist (1943–44) and an ARA (1944). After the war, he became Professor of Painting at the Royal College of Art (1948–57) and was appointed CBE (1953) and RA (1954). He resigned from the RA in 1957, returning to abstraction until 1971 then re-embraced figurative painting executing many portraits and a series of notable mature still lifes.

Moynihan began exhibiting with The London Group in 1930, was elected in 1933 and showed intermittently thereafter. *Objective Abstraction*, exhibited under the title 'Painting', was the most controversial work in the 1936 exhibition, described by the *Cork Examiner* as 'just a mass of creamy white paint, with pink incarnations, placed on canvass [*sic*] without any idea of outline or character'.[2] The previous year, Moynihan and Tibble had shown similar works, appreciated by Frank Rutter in the *Sunday Times* as 'the most honest paintings I have ever seen; because they do not claim to be anything more than their titles indicate. They *are* paintings – and nothing else. They do not appeal by colour or design or any kind of representation, but plead for admiration solely by reason of the material beauty of their corrugated impasto'.[3] However, in language evoking London Group controversies of the first decade, the critic of the *Daily Independent*, claimed to be 'entirely flabbergasted'[4] by *Objective Abstraction*, while the *Artist* described its 'smeared' surface as 'sheer affrontary' [*sic*],[5] and the *Observer* compared Moynihan's 'vague impastoes' to the 'bottom of parrots' half-cleaned cages'.[6] Although Moynihan exhibited a number of non-representational works between 1934 and 1937, all with the title 'Painting' or 'Drawing'; an old photograph of the painting in a frame bearing the number '146' confirms that (although later partly repainted) this is the work shown in 1936.[7]

SARAH MACDOUGALL

33

POSSIBLY EXHIBITED
34th London Group Exhibition,
12–28 November 1936, New Burlington
Galleries, as (96) *Study in Associated Forms II,*
10 guineas or (112) *Study in Associated Forms I,*
15 guineas

Elected 1926, exhibited 1924–38

Jessica Dismorr
Untitled (Two Forms), 1936

Oil on prepared gesso board
46 × 61 cm

Gillian Jason, Modern & Contemporary Art

In October 1925 Freddie Mayor opened his gallery at 18 Cork Street, London, and its second exhibition was *Drawings by Jessica Dismorr.* The works shown were in fact all watercolours and, with the exception of two still lifes, were of buildings and bridges and landscapes painted on her travels or, near her home and studio, in Hampstead.

That R H Wilenski was willing to write the introduction to the catalogue should be seen less as a stroke of luck than as a tribute to a growing reputation: 'In selecting the members of the "Vorticist" and "X" Groups on her return from France as her artistic mentors she showed courage, discrimination, and a sense of her ability to play a part in the typical artistic experiments of her generation.' The exhibition was warmly welcomed by Frank Rutter in *The Sunday Times.* He points to her 'keen interest in the big things […] To this artist the major fact about a house is that it is rectangular and solid, that it has windows and doors are minor details that can be accepted or rejected as convenient […] The exhibition should be seen by all interested in the modern movement.'

Dismorr had shown with The London Group in 1924 and 1925 and in 1926 a happy result of her exhibition's critical success was her election both to The London Group and to the Seven & Five Society. In that year she showed with The London Group nine watercolours, some already shown at The Mayor Gallery, and a pencil drawing of her mother with her nurse. In successive years, from 1924, her father, her eldest sister and her mother died and in 1927 Dismorr suffered one of her recurring breakdowns. She was not represented in 1927 and showed only one watercolour in 1928. In 1929 she received a letter from George Clausen (1852–1944) discussing the merits of painting on a gesso ground. Between 1929 and 1934 Dismorr showed 25 figurative paintings, most of them painted on commercially prepared 'gesso board'.

In November 1935 Dismorr exhibited four *Compositions,* 'not portraits more decorative subjects', still lifes in part inspired by an archaeological expedition of R H Frankfort's to Iraq and the pottery vessels excavated there. These were again painted in oil on gesso board, as is the painting in the present exhibition, one of the earliest of Dismorr's 1930s abstracts. It is possible, but by no means certain, that this is one of the two *Associated Forms* exhibited in November 1936.

The abstracts shown in 1937 would have been of the kind referred to affectionately by her friends as 'Jessica's dress patterns'. With two exceptions they are painted in gouache on board in shades of putty and grey. Her last four paintings are all *Superposed Forms,* with one exhibited at The London Group in 1938 (November–December 1938 (no. 186), £20). Three of the four are versions of the same painting. One is painted in tempera. She did not paint in the last year of her life.

QUENTIN STEVENSON

EXHIBITED
The London Group Thirty-sixth Exhibition of Painting & Sculpture, 30 October–20 November 1937, New Burlington Galleries as (134) *Painting: 1937*, 9 guineas

Elected 1933, exhibited 1931–38, 1953, 1955, 1962 and 1964 retrospective

John Piper
Abstract, 1937 (aka *painting: 1937*)

Oil on canvas
90 × 106 cm

Hugh Fowler-Wright

fig. 31
John Piper
Foreshore with Boats, South Coast
1933
Private Collection

John Piper left the Royal College of Art in 1929, without graduating, eager to be a working artist, having gained supportive artistic friendships and having recently married painter Eileen Holding (1909–1984). Piper supplemented his income by reviewing the arts for *The Nation and Athenaeum* and *The Listener*, later broadcasting about modern art for radio (1935) and television (1936 and 1937), and compiling the innovative magazine *Axis* (1935–37) with his second wife, Myfanwy Evans (1911–1997). *Axis* began by extolling the merits of abstraction but segued into also supporting surrealism.

As an unknown artist in 1929, any opportunity to exhibit was attractive. Piper watched his friends Raymond Coxon (1896–1997) and Henry Moore (cat. 27) successfully enter the 1929 and 1930 London Group exhibitions respectively. Subsequently, Piper and Ivon Hitchens (cat. 47) each submitted two pictures in 1931. Piper's *Cotswold Village* and *Bognor Regis* exemplified the transition in his interest and outlook. His early admiration of the illustrator F L Griggs (1876–1938) had led to many charming Cotswold vistas but now he explored the south coast for subjects. Of his two coastal pictures in the 1932 exhibition, *The Times* favourably noted *The Square*. By 1933, when Piper was elected to The London Group, his art was on the cusp of full abstraction, as his entries displayed. Three were essentially representational showing strong pictorial understanding; one, *Foreshore*, utilised a meandering line fragmenting the picture into blocks of colour.

For the next three shows (1936 and two in 1937) Piper was on the hanging committee and continued displaying his latest totally abstract compositions, originating from the observed nautical environment and filtered and structured by his life-long passion for medieval stained glass. He experimented with the interplay and limitations of using a finite number of colours and shapes. Hence in *Painting: 1937* elements of boats, beach and the female form float on a 'sea' of maroon. Abstract art was not widely appreciated in the 1930s and Piper did not help the viewers with his use of non-descriptive titles. In 1937 he wrote of the 'lost object' in art and of each artist's own 'sketching grounds'. Piper always needed real objects in mind when painting and just as he had abstracted objects into his pictures during 1933, they now re-emerged in *Painting: 1937*.

Being elected to join the 7&5 Group in January 1934 was far more prestigious as a mark of acceptance by fellow artists, yet it was the relatively unchallenging ethos of The London Group in the 1930s that gave Piper a display window which helped build his confidence in developing his art. By 1938 Piper had his first solo show at the London Gallery, followed by the publishing of *The Brighton Aquatints* (1939), which brought him to wide public attention and financial success. Piper stayed involved with The London Group committee and exhibited with the Group occasionally in the 1950s and 60s. Yet already by 1939 he described himself as 'a cubist, abstract, constructivist, surrealist independent' – a statement facilitated by the rich mix and strength of his exhibits with The London Group.

HUGH FOWLER-WRIGHT

36

EXHIBITED
London Group Exhibition of works by Members, March 1937, The Leicester Galleries as (2) *Mrs G. A. Auden*, not priced and *London Group 1914-64 Jubilee Exhibition Fifty Years of British Art*, 15 July–16 August 1964, Tate Gallery as (80) *Mrs G. A. Auden*, 1937, lent by the City of Stoke-on-Trent Museum and Art Gallery

Elected 1933, exhibited 1929–30, 1936–38, 1949 and 1964 retrospective

William Coldstream
Mrs Auden, 1936–37

Oil on canvas
76 × 56 cm

Courtesy of The Potteries Museum & Art Gallery

'A white-faced little rat of a boy who seemed so cocksure and full of himself, and did such absurd drawings' was the judgement of a fellow student when William Coldstream arrived at the Slade School of Art in the summer of 1926.[1] Yet in no time he became the dominant member of a group which included Claude Rogers – who became a lifelong friend and colleague. Like Rogers, Coldstream started exhibiting early, with the London Artists' Association, and with The London Group throughout the 1930s, becoming a member in 1933. After the Second World War his dual roles in teaching and arts administration took up most of his time, and he exhibited only once more with the Group, in 1949.

Coldstream met the poet W H Auden while the latter was up at Oxford, and their friendship was renewed when they both worked for the General Post Office Film Unit. It was Auden who encouraged him to start painting portraits. After hearing Walter Sickert (cat.18) lecture on drawing, Coldstream longed to abandon filming and return to painting to try out Sickert's suggestion of identifying a point on the canvas and plotting the angles and the distances outwards from that point. He was egged on by his friend Victor Pasmore (cat.40), who suggested that each should paint the other using a documentary approach similar to film work. 'We tossed up who should sit and who should start painting. I sat, and Bill produced a third-rate picture, rather like something by Sargent. We thought, there's no future here, we'll have another try and start again next Sunday. By that time Bill had a plumb line and ruler and started measuring. We had a look at that one. It was a bit rum but a little better – the first Euston Road picture.'[2]

In 1936 Coldstream was invited by his friend Igor Anrep to stay at his mother's house in Suffolk. Rogers was also staying, and the two painters were working on portraits. It was here that the idea of starting a

School of Drawing and Painting, with Rogers, Pasmore and Coldstream as the teachers, was first mooted. When it became a reality in 1937, all three regularly painted alongside their students. However, it was Coldstream's punctilious measuring that was to become the school's hallmark.

In 1936 Coldstream painted Anastasia Anrep in his new-found manner, using thinly painted parallel brushstrokes applied with fine sable brushes. Later that year Auden's mother surprisingly offered to sit for him, perhaps hoping to glean news of her son, from whom she had become estranged.[3] Her statuesque head and shoulders were constructed around a vertical running through the left eye and the knot of her tie, and proceeding with tiny tonal shifts to the outer edges. Coldstream considered these two paintings, of Baba Anrep and Mrs Auden, to be his first 'Euston Road' paintings. *Mrs Auden* was exhibited with The London Group in 1937 and bought by Kenneth Clark, then Director of the National Gallery. Coldstream continued to use this method of plotting, working with fine hatched brushstrokes, throughout his life.

JENNY PERY

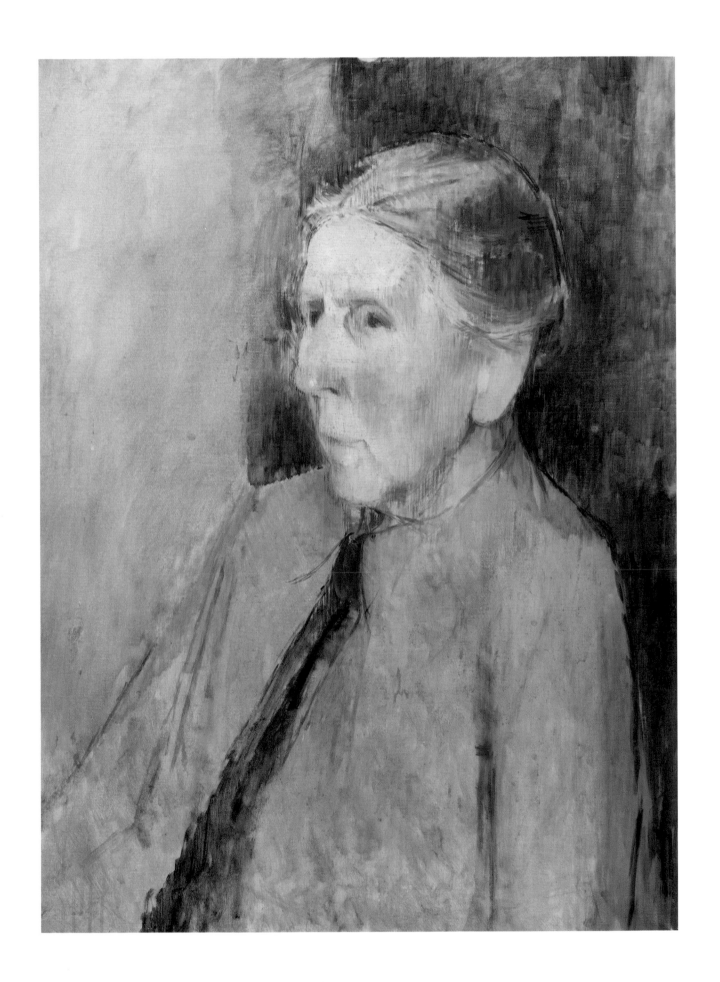

38

Not exhibited at The London Group

Elected 1938, exhibited 1931–32, 1936–39
1941–43, 1947–59 and 1964 retrospective

Ceri Richards
Two Costers in a Pub, 1942

Ink, watercolour and pastel on paper
30.6 × 24.1 cm

Jonathan Clark Fine Art, representatives of the Artist's Estate

Swansea-born Ceri Richards was apprenticed as an electrician before studying at Swansea School of Art (1920–24) and winning a scholarship to the Royal College of Art (1924–27), where he met his future wife, the painter and printmaker Frances Clayton (1903–1985), as well as Henry Moore (cat. 27) and Paul Nash (cat. 25). He also attended evening life classes under Bernard Meninsky (cat. 15) and was acclaimed as a brilliant draughtsman. Richards exhibited two non-abstract works (as part of a more representational section including Ivon Hitchens (cat. 47) and Victor Pasmore (cat. 40)) at Zwemmer's *Objective Abstractions* exhibition in 1934. Sympathetic to the international moderns, he was influenced by Picasso and Kandinsky, particularly in his series of semi-abstract relief constructions, including notable, occasionally Surreal, *Coster* works; and participated in the 1936 London International Surrealist Exhibition. In 1937 Richards became a teacher at Chelsea College of Art (later teaching at the Slade and Royal College). During the war he taught at Cardiff School of Art and was commissioned by the Ministry of Information to record South Wales tin-plate workers (his father's occupation) in a series of black and white ink drawings.

Richards first exhibited with The London Group in 1931, participating regularly in the late thirties, forties and fifties, his works including his spectacular variations on the *Beekeeper* theme and *Trafalgar Square: Movement of Light* (1951), acclaimed as 'a dazzling vision of sunlight pouring on to a diamond flagged pavement', which anticipates the spectacular *Sunlight in the Room* (1952, private collection), shown in 1953.[1] His vividly coloured work, often inspired by music and poetry (particularly by Dylan Thomas), was executed in a variety of media.

The circumstances surrounding the beginnings of Richards' exhilarating fantasia on the theme of the Pearly Kings and Queens was described by his wife, Frances:

> During the early part of 1939, Ceri saw the Pearly King of Hampstead, Mr Bert Mathews, in the street, and was very excited by the splendour and design of his clothes. He spoke to Mr Mathews about the possibility of doing a drawing of him in costume and Mr Mathews was delighted by the suggestion. He came to our house in St Peter's Square, Hammersmith, together with his wife, the Pearly Queen, and drawings were made from them both, in full regalia. They were delightful people, but I am sure they have never been aware of all the works of art which eventually resulted from the sittings. Later that year, Ceri visited the fair on Hampstead Heath and saw costers at the coconut shies there. He loved the combination of the throwing movements and the patterns of their costumes.

It was on this trip to the fair that Richards saw, at a pub table, a coster with a sewn-up eye socket: it was a convulsive image he could not forget. In 1939 he made at least two linocut images of the subject. The pearly costers appealed to Richards' (Surrealist) love of the marvellous in the everyday: in the London street markets and at the fair he encountered the fantastic and the phantasmagoric, material for fabulous invention and fanciful exaggeration.

MEL GOODING

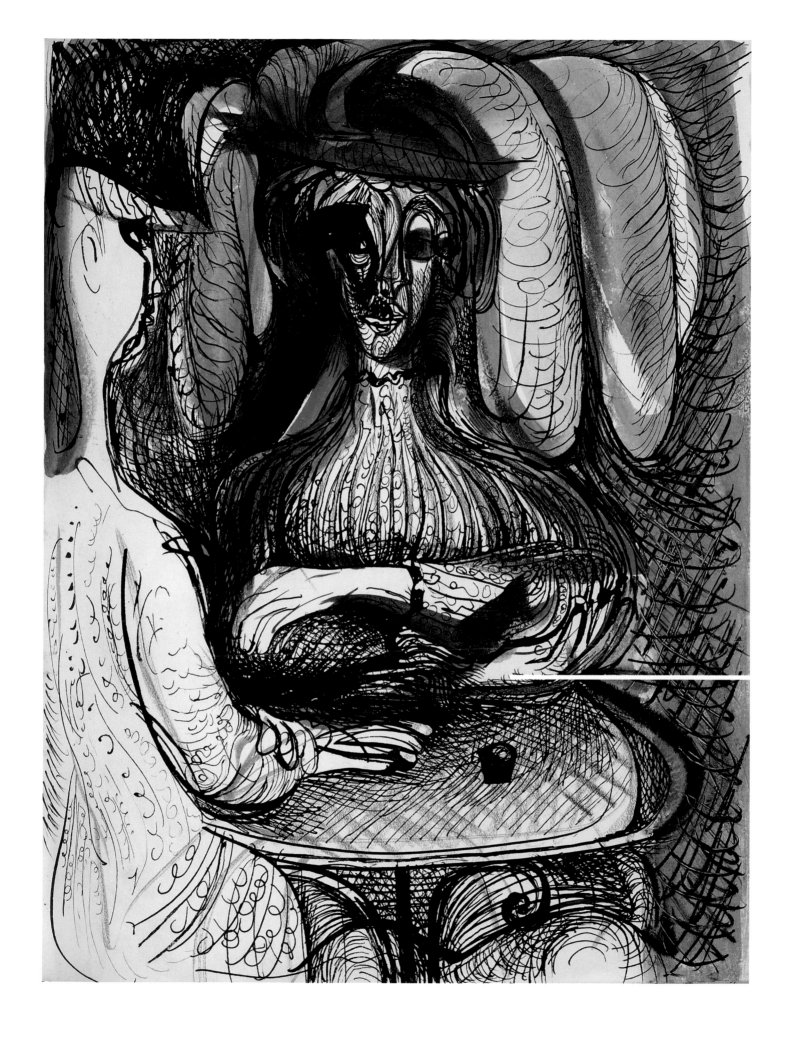

40

Reproduced as poster for *London Group Annual Exhibition*, 21 May–06 June 1948, The Academy Hall

Elected 1934, exhibited 1930, 1932, 1934–40, 1943–45, 1947–52, 1955–59 and 1964 retrospective

Victor Pasmore
Abstract, 1948

Lithograph on paper
68.5 × 49 cm

British Council Collection

Victor Pasmore attended art classes at the Central School of Art for three years at the end of the 1920s. A local government officer, he modestly characterised himself as 'a weekend painter with no academic training' until, with Kenneth Clark's financial support, he was able to paint and teach full-time at the later-named 'Euston Road School' in 1938. He had co-founded this informal school of drawing and painting with Claude Rogers (cat.37) and William Coldstream (cat.36) the previous year.

Pasmore was elected to the London Artists' Association in 1932, holding an exhibition of his early, post-impressionist paintings at its Cooling Galleries. On its dissolution in 1934, he was fortunately elected to The London Group, which absorbed many of the LAA's members. He also joined a group of artists, including Rogers and Coldstream, who were experimenting with *tachisme avant la lettre*, in an exhibition entitled 'Objective Abstractions', a style which used 'only the brush as its module'. Pasmore found this looseness unfulfilling and, inspired by the abstract paintings of Ben Nicholson (1894–1982) at a 7&5 Society exhibition, tried a more rigorous form of geometric abstraction, before returning to his earlier style. He later characterised the work of the Euston Road School as involved with 'a dialectic of pure painting based on the old visual model and a new social consciousness of art as a whole'. In reality there were already two tendencies: Coldstream and Graham Bell worked in the spirit of 'social realism', while Pasmore and Rodrigo Moynihan (cat.32) looked back to the French masters: Degas, Cézanne and Bonnard.

Andrew Forge (writing retrospectively in the 1960s), considered The London Group's vitality as 'always [...] a fluctuating thing, dependent on the needs that its members have had for the Group at any given time'[1]; observing elsewhere, 'What has been special about the London Group is the wide range of styles it has embraced – it has been a neutral vehicle for whoever needed it most'. Although Forge singled out Pasmore (by then highly successful and exclusively contracted to the prestigious Marlborough Fine Art gallery) as one of its most distinguished members, in reality post-war Pasmore had yet to find his own artistic truth.

As a registered conscientious objector during the Second World War, Pasmore had reluctantly consented to military training in 1940, then recanted, and after six months' imprisonment settled in Hammersmith by the river. In 1941–47, he experimented with the dissolution of reality into patterns of lines, dots and circles and at times, monochromes. His teaching, first at Camberwell School of Arts and Crafts (1943–49), and afterwards at the Central School, became more erratic, as he experimented further eventually producing abstract geometric reliefs. Pasmore held solo exhibitions at the Redfern Gallery in 1943, 1948 and 1949.

By 1945 The London Group resembled an empty vessel, to be filled opportunistically by artists seeking extra exposure and sales. The flourishing School of St Ives, centred around Ben Nicholson and Hepworth (cat.28), drew many London artists, Pasmore included, and further encouraged his definitive move towards a language of abstraction, independent of the work he exhibited with The London Group.

PHILIP WRIGHT

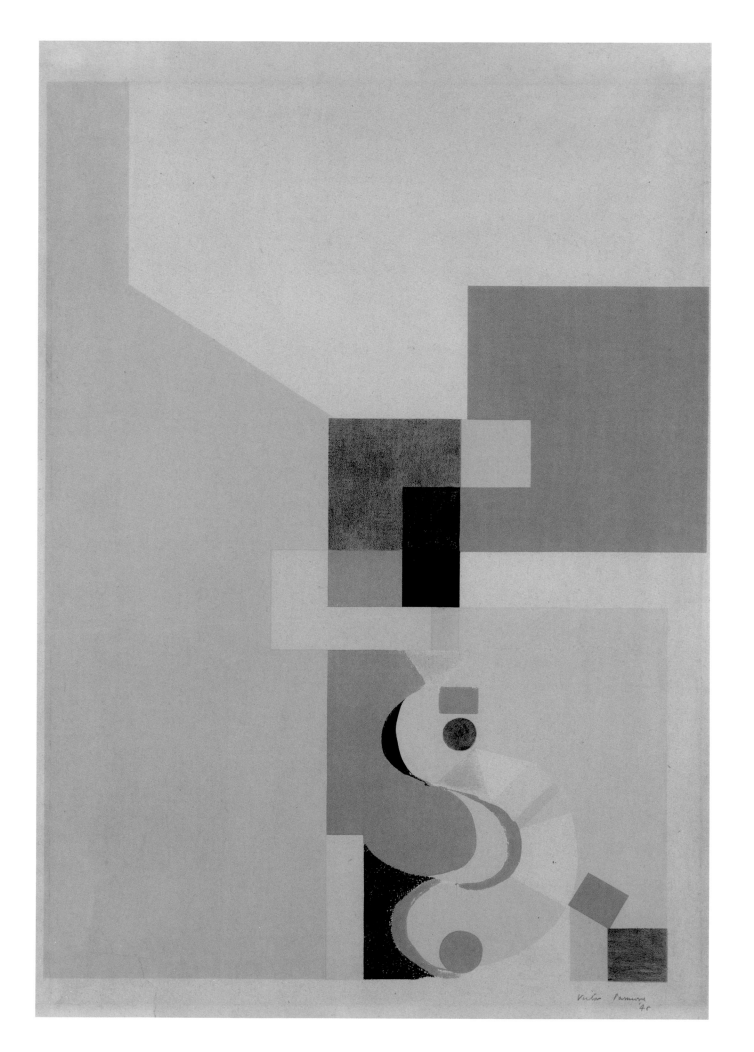

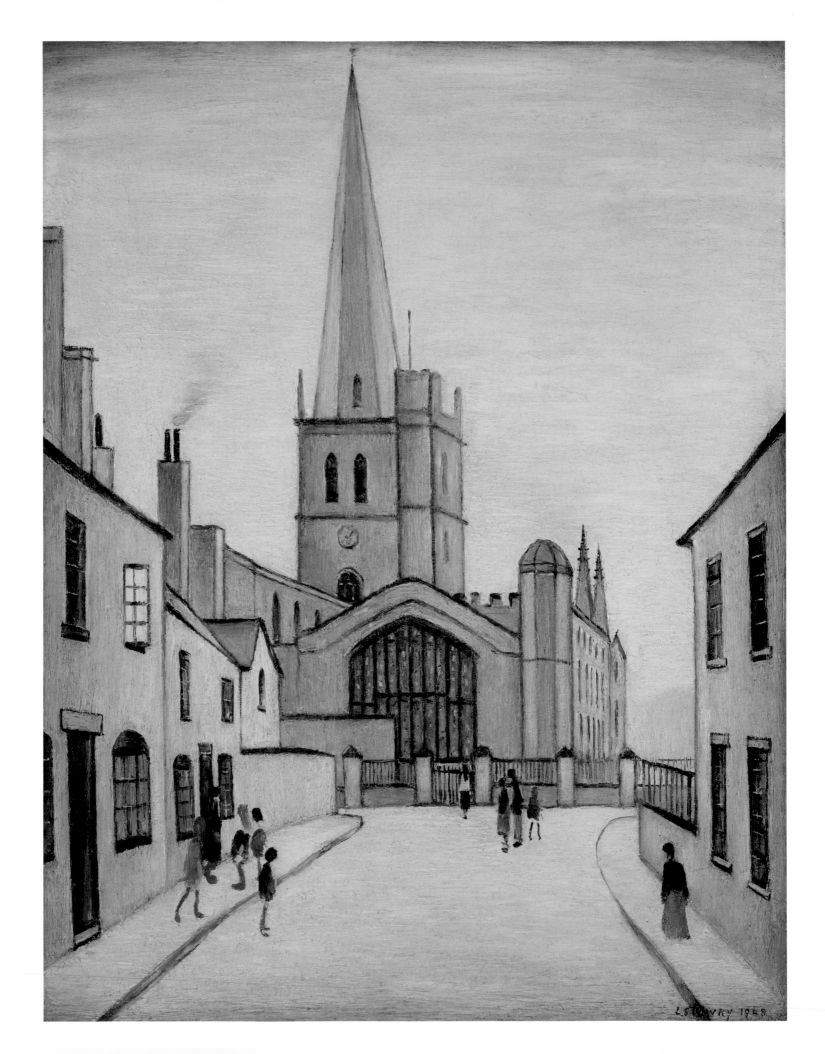

41

EXHIBITED
49th London Group Exhibition,
February–March 1951, New Burlington
Galleries, as (13) *Burford Church*, £63.0.0

Elected 1948, exhibited 1944–45, 1947–52,
1954–59, 1961 and 1963–64

Laurence Stephen Lowry
Burford Church, 1948

Oil on canvas
59.5 × 44.5 cm

Private Collection on loan to The Lowry Collection, Salford

Lowry first exhibited with The London Group in 1944, relatively late in his career. It is not clear why he waited so long as he had exhibited regularly with other groups from the 1920s onwards. These ranged from the Manchester Academy of Fine Art to the Paris Salon, the New English Art Club and the Artists' International Association, to whom he gave a lecture in 1939. By the mid-1930s Lowry was exhibiting at the Royal Academy, and in 1939 his first solo exhibition in London took place at the Lefevre Gallery. By this time his work was selling to both public and private collections (although it was 1945 before he was able to say he was making a small profit from sales).

Burford Church, painted in 1948, was shown with The London Group in 1951. In the following year, Lowry retired from the Pall Mall Property Company where he had been a clerk and rent collector since 1910. It was after retirement that his work became increasingly successful commercially and more widely known. In practice, this almost invariably meant his industrial landscapes, the subject matter he had developed in the 1920s. Less familiar to viewers were the portraits, empty landscapes and seascapes he had produced concurrently. Although some of his largest, most iconic industrial scenes date from the 1950s, Lowry was nevertheless beginning to tire of the subject matter by this time.

In contrast to the titles of some of the other works Lowry exhibited with The London Group – *Iron Works*; *Loading at Queen's Dock, Glasgow*; *Outside a Lodging House* – in *Burford Church* he was exhibiting a more traditionally picturesque subject. Church buildings attracted Lowry's interest repeatedly over the years. Often depicted as dark, isolated structures looming over their surroundings, he included few people near them, certainly not the crowds which often flock to his mills or football matches. Although Lowry represents the Cotswold village's landmark in a fairly stark, minimal style, *Burford Church* remains a more picturesque scene than many of its urban equivalents. The painting does not seem to have been particularly singled out by the press on its exhibition in 1951 but, a few years later at the Royal Academy, his painting *Portrait of Ann* caused a stir among reviewers as its subject matter was similarly surprising to those more familiar with his industrial scenes.

Lowry continued to exhibit with The London Group until the early 1960s. In 1962 he became a Royal Academician and he continued to be involved in exhibitions of his work until the end of his life, including planning for the major retrospective of his work at the Royal Academy, which took place only a few months after his death in 1976.

CLAIRE STEWART

42

EXHIBITED
*London Group Contemporary Painting,
Drawing and Sculpture,* February–March 1951,
New Burlington Galleries (354), £126

Elected 1953, exhibited 1951, 1954–55 and
1964 retrospective

Kenneth Armitage
People in the Wind, 1950

Bronze
64.8 × 40 × 34.3 cm

Tate: Purchased from the artist (Grant-in-Aid) 1960

Leeds-born, Armitage studied locally at the College of Art before winning a scholarship to the Slade School of Art in 1937. His early influences included antique sculpture in the British Museum and neolithic remains, which first stirred his interest after he discovered the landscape of his mother's Irish heritage, further reinforced by his wartime training on Salisbury Plain. His love of the West Country landscape deepened during 1946–56 when he was Head of Sculpture at the newly-founded Bath Academy of Art at Corsham Court in Wiltshire.

Armitage recalled that he modelled the sculpture at Corsham in 1950, inspired by a real-life incident on a gusty day in London, when he saw a woman struggling to carry two children against the wind. She appeared as some strange, flailing, multi-limbed creature, which he then conflated with his interest in long-stemmed plants. The work is characteristic of his 1950s' style, defined by figures with squat, flattened bodies, small heads and sprouting, attenuated limbs. In the mid-1950s Armitage began to work in clay; in the 1960s he employed wax, resins and aluminium, his pieces becoming darker in mood and increasingly abstract in form. From the mid-1970s to 1980s he abandoned the figure in favour of nature, inspired by oaks in Richmond Park, south west London.

In a televised interview 'The Artist Speaks' Armitage commented: 'We live in a world of verticals and horizontals […] Although it is mainly for movement it is also for this reason that I like sometimes to make my figures, my sculpture, on a slant, so that they run across this rather rigid pattern.'[1]

As with his contemporary Lynn Chadwick (cat. 43), Armitage represented Britain in the 1952 Venice Biennale, alongside fellow sculptors including Reg Butler (1913–1981) and Bernard Meadows (1915–2005). In the catalogue essay, the critic Herbert Read associated their works with Cold War anxieties, giving rise to the phrase 'Geometry of Fear', a description by which much groundbreaking sculpture of the period would subsequently be defined: 'These new images belong to the iconography of despair, or of defiance […] Here are images of flight […] of excoriated flesh, frustrated sex, the geometry of fear.' At the entrance to the exhibition was a sculpture by Henry Moore (cat. 27), whom Read described as the 'parent of them all'.

Armitage exhibited *People in a Wind* in the spring 1951 London Group show prior to his membership. Elected in 1953 in the wake of the Biennale, when British sculpture was in the ascendancy, he exhibited in 1954–55 and in the 1964 retrospective (when he showed the work again). It was cast in an edition of six: the first acquired by Peggy Guggenheim following the Biennale; others subsequently purchased for MoMA, New York, and the Museum von der Heydt, Wuppertal. Two smaller studies and a second full-scale, almost identical version, lacking only the protruding hands, were also produced.

In the Group show of 1954 Armitage, Chadwick, Kenneth Martin (cat. 45) and William Turnbull (1922–2012) stood out among a motley selection of 17 sculptors, as a small but important group who were making a significant contribution to mid-century British sculpture in an international context.

RACHEL DICKSON

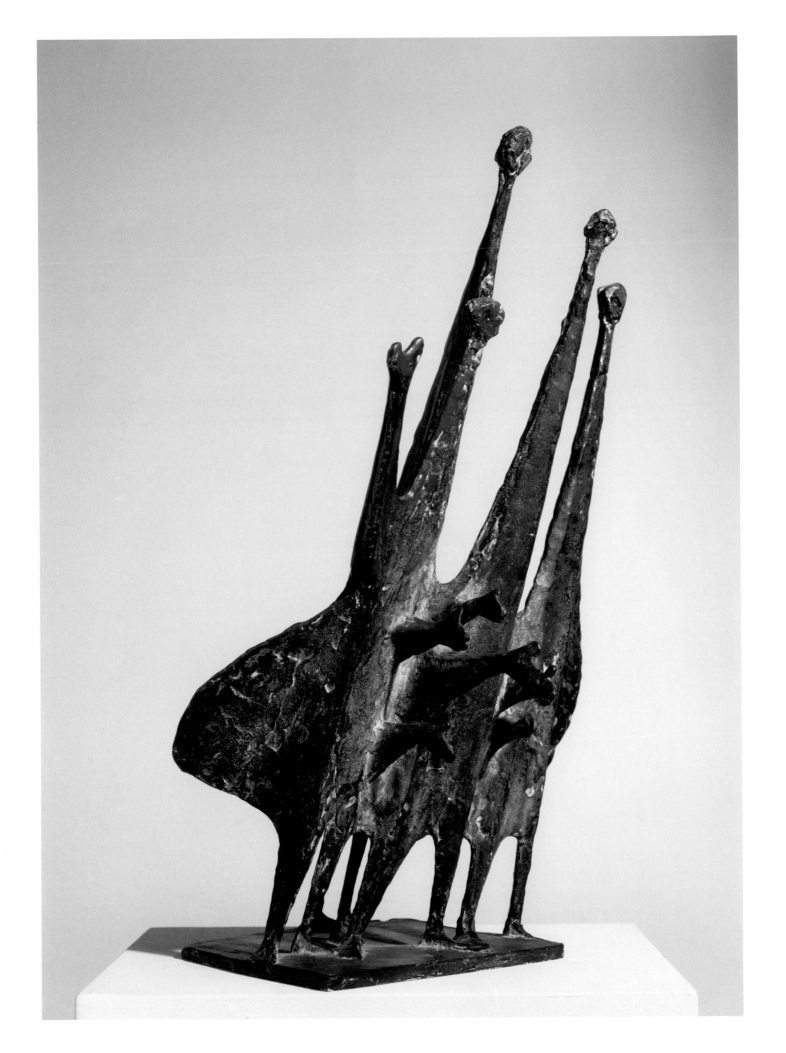

43

EXHIBITED
London Group Annual Exhibition,
25 October–22 November 1952, New
Burlington Gallery, as (264) *Iron Sculpture,*
not priced

Elected 1952, exhibited 1951–56 and 1964
retrospective

Lynn Chadwick
Untitled (Iron Sculpture), 1951

Iron and coloured glass
51 × 59 × 42 cm

Estate of Lynn Chadwick

Born in 1914, Lynn Chadwick trained initially as an architectural draughtsman and worked at various firms in London after leaving school in 1932. He began creating sculpture after the Second World War while working for the architect Rodney Thomas (1902–1996) who introduced Chadwick to Modernist architecture and artworks. The London gallery Gimpel Fils gave Chadwick his first solo exhibition in 1950 and he exhibited with The London Group for the first time in the same year. Chadwick was a member of the Group from 1952 to 1963, and also showed in the 1964 retrospective.

Chadwick's name appeared on the international art stage as part of the British Council's *New Aspects of British Sculpture* exhibition in 1952 at the XXVI Venice Biennale with contemporary artists Kenneth Armitage (cat.42), Reg Butler (1913–1981), Eduardo Paolozzi (1924–2005) and William Turnbull (1922–2012). In the introduction to the catalogue the critic Herbert Read famously described the work as representative of 'the iconography of despair, or of defiance […] of frustrated sex, the geometry of fear'. Read's analysis of the exhibition is particularly fitting for Chadwick's early work of which *Iron Sculpture* is one example.

Untitled (Iron Sculpture) was exhibited in 1952 in The London Group exhibition at the New Burlington Gallery in London from October to November. The work is an example of Chadwick's 'balance structures' of the early 1950s and demonstrates how the artist experimented with balance, form and composition. The sculpture is an animalistic structure, almost a creature from science fiction with three spiky limbs resembling legs and a single sharp arm clutching a jewel-like fragment of glass. The absence of a form resembling a head emphasises the abnormal and ominous aesthetic. This iconography was developed further in Chadwick's sculptures of beasts. Made of welded iron the work is characteristic of the artistic

principles of the 'geometry of fear' group: it is perplexing, menacing and striking.

The reaction to the piece was mixed. On 1 November 1952 a critic with *The Scotsman* commented, 'I tried hard to appreciate the "Iron Sculpture" by Lynn Chadwick but found the iron ventilator on which it was placed more interesting and understandable.' In contrast, Max Chapman in his article 'Art and Artists' for *What's On* (November 15, 1952) said, 'Perhaps the most arresting [sculptures] are Lynn Chadwick's iron and coloured glass affairs, that suggest jewellery seen through an enormously [*sic*] magnifying glass.'

The London Group exhibitions were crucial at the beginning of Chadwick's career, allowing his work to be exposed to a wide audience within the art world. He had been a sculptor for only six years when, in 1956, he won the prestigious International Prize for Sculpture at the XXVIII Venice Biennale, the highest award to which a modern sculptor at the time could aspire, triumphing over the more established artist Alberto Giacometti (1901–1966). From that point in the mid-1950s Chadwick was regarded as one of the most important sculptors of his generation.

ALICE WIGGETT

EXHIBITED
London Group Contemporary Painting, Drawing and Sculpture, November 1951, New Burlington Galleries, as (160) *Columbarium*, £20.0.0
Elected 1959, exhibited 1933, 1938, 1948–1949, 1951–54, 1946–64 (including 1964 retrospective)

Mary Martin
Columbarium, 1951

Painted plaster mounted on wood
23 × 23.5 × 5 cm

Signed and dated (verso) 'Mary Martin 51'
Courtesy of Annely Juda Fine Art

Mary Martin (née Balmford) was awarded a scholarship to Goldsmiths School of Art (1925–29) and a Royal Exhibition to the Royal College of Art (1929–32), where she met fellow artist and future husband Kenneth Martin; they were married in 1930.

Noted as a landscape painter, she also designed and made rugs and taught drawing, painting and design (1936–40), afterwards becoming Head of the Weaving Department at Chelmsford School of Art until 1943. When she resumed painting in 1948, she was versed in the theories of pictorial construction; together the Martins worked within the conventions of Constructivism to create a new type of constructed abstract art.

Mary Martin exhibited in The London Group on and off from 1933, becoming a member in 1959. Both Martins presented their latest work at the Group shows which over the years documented their move away from Post-Impressionism and into postwar British Constructivism. In 1949 Mary showed a painting of Primrose Hill, *Houses and Trees,* using the same enquiries into abstraction as Kenneth in his *Approach to Euston* and *Chalk Farm* series. In the summer of 1951 Kenneth went to visit the photographer Nigel Henderson, which proved to be a turning point for them both: 'Eduardo Paolozzi was there and we went to his studio nearby. Told me about killed plaster – gave me some aluminium and said "Make a mobile Kenneth." Told Mary about all this. Mary made Columbarium in a baking tin as instructed, and never looked back.'[1]

The *Relief* Mary exhibited at The London Group in 1952 was described as 'ingenious' by the *The Times*,[2] and by Quentin Bell in the *Listener* as 'a tasteful and accomplished abstraction'.[3] In 1954 the *The Times* described her *Square Motif* as 'noble',[4] while *Art News* called it 'austerely beautiful'.[5] In 1960 John Russell in the *Sunday Times* noted that 'the painted reliefs of

Mr. and Mrs. Kenneth Martin prove, likewise, that an effect of felicity can be achieved without recourse to the acknowledged currency of high spirits'.[6] Mary described Kenneth and herself as being 'misunderstood' in the 1950s, but the Martins came into their own in the 1960s with interest from young galleries and young abstract artists. The Martins continued to show with The London Group until 1964 by which time they had both held individual solo shows and had work acquired by the Tate Gallery.

Columbarium was shown in the second of The London Group's two exhibitions in 1951. Carved out of plaster, it was Martin's first work in relief; nearly all her subsequent works were constructed. The work relates to her previous abstract paintings showing the movement of a 'format'[7] through positive to negative areas. Instead of using colour to denote the changes, she could now use actual space with the directions and changes of movements expressed in the half-excavated incisions. She was obviously excited by the move into three dimensions. The work was later cast in bronze in an edition of six.

PAUL MARTIN

45

Another *Screw Mobile* was exhibited at *London Group Annual Exhibition*, 03–28 November 1953 New Burlington Galleries, as (221) *Screw Mobile*, £52.0.0 and *London Group 1914–64 Jubilee Exhibition Fifty Years of British Art*, 15 July–16 August 1964, Tate Gallery, as (121) *Screw Mobile*, 1953, lent by S. H. Picker Esq., London

Elected 1949, exhibited 1931, 1933, 1936–42, 1945–64 (including 1964 retrospective)

Kenneth Martin
Small Screw Mobile, 1953

Metal
63.5 × 22.9 cm

Tate: Purchased 1962

Kenneth Martin became a member of The London Group in 1949 at the invitation of fellow member Victor Pasmore (cat.40), although he had already been showing work in the Group's exhibitions on and off since 1931. Martin had already gained recognition as an artist and was included in a list drawn up in 1939 of promising artists who should be given 'safe jobs' during the Second World War. Martin continued exhibiting representational work until 1949 (in contrast to Pasmore who had shown abstract works as early as 1948), when he exhibited one of his *Chalk Farm* series in which he had abstracted the image. He regarded The London Group as an important exhibiting platform, particularly when other opportunities were scarce.

The organisers welcomed the postwar abstract artists who were exhibited together in a special sub-section for the first Group show of 1951.[1] In reviews the *The Times* described Martin's *Abstract, Black and White* as 'severe';[2] two years later the same paper wrote of *Screw Mobile*: 'Mr. Kenneth Martin has invented a new kind of mobile sculpture which certainly makes a nice change; it was high time the intelligentsia had a new try'.[3] Martin's work was also noticed by the Whitechapel Art Gallery's influential director, Bryan Robertson, as 'a charming mobile on a screw principle […] swamped by a great wave of vigorous mediocrity',[4] and by Quentin Bell, as 'a most pleasing and ingenious toy'.[5] In 1954 Martin's work was again singled out, this time by the *Guardian*, who declared 'one mobile with polished discs will please those whom mobiles please'.[6] It was also called 'worthy of any good-class public collection' by John Russell in the *Sunday Times*;[7] and commended by John Berger in the *New Statesman*, who wrote that 'there is Kenneth Martin's abstract mobile behind which one feels there is true calculation, not just improvisation'.[8]

Screw Mobile (1953, Stanley Picker Collection) was shown at The London Group in 1953. This work, *Small Screw Mobile*, a similar but smaller work, is one of Martin's earliest *Screw Mobiles* and demonstrates his first use of an ordering system for the horizontal lengths. He was a regular visitor to the Science Museum; becoming fascinated with how movement can create form as demonstrated by the beating of a bird's wings during flight, he 'attempted to render the revolution of an ellipse by the means of a brass rod'.[9] He had previously used the ellipse in a series of paintings and would continue to use this motif. A similar design was used for *Screw Mobile (multiple)* published by Unlimited in 1969.

PAUL MARTIN

46

POSSIBLY EXHIBITED
London Group Annual Exhibition,
06 November–04 December 1954,
New Burlington Galleries,
as (200) *Nude,* £63.0.0

Elected 1958, exhibited 1951, 1953–54,
1956–64 including 1964 retrospective

Euan Uglow
Big Bertha, 1953

Oil on canvas
96.5 × 71.1 cm

Private Collection

Euan Uglow was schooled at the Camberwell and
Slade Schools of Art, training under Euston Road
painters Victor Pasmore (cat.40), Claude Rogers
(cat.37) and William Coldstream (cat.36), whose
important influence he acknowledged. Uglow began
exhibiting at The London Group in 1951, the year he
followed Coldstream to the Slade, where he was
a prize-winning student much encouraged by his
teachers. He continued to exhibit with the Group until
1964 (he was elected in 1958) even after his first solo
exhibition at Helen Lessore's Beaux Art Gallery
in 1961, and critics soon singled him out as an
'interesting talent'.[1]

More than 60 years after the controversy over
Matthew Smith's (cat.12) *Fitzroy Street Nude, No. 2,*
Uglow's *Nude* (1962–63, Tate), originally included
in the Royal Academy's Summer Exhibition and
subsequently purchased by the Chantrey Bequest,
caused a row when it was included in the 1974 Arts
Council touring exhibition of his work. Bradford City
Councillors objected to the 'ungainly posture' of the
model, captured in the act of rising from or lowering
herself into a chair, while a press report suggested that
her lowered head resulted from her embarrassment
from 'a menstrual stain'.[2] Although the work's
inclusion was stoutly defended by Cartwright Hall's
Peter Bird, later Deputy Director of Visual Arts at the
Arts Council, Uglow never again submitted work to
the Royal Academy, afterwards avoiding competitions
and juried exhibitions.

His London Group exhibits, though
predominantly of similarly solidly painted nudes,
were less controversial. *Big Bertha* (the work's
nickname and not the model's), a seated nude
against a green background, is one of four possibilities
for the *Nude* he showed in November 1954. Catherine
Lampert has observed how 'The volume of the body is
built from clearly defined facets and crisp changes in
local colour using natural light',[3] and it may be the
same work noticed by the *Times* for its 'solid, compact
but uncompromisingly harsh design'.[4] Uglow also
participated in the 1955 AIA show, *Measurement and
Proportion,* curated by Andrew Forge and Adrian
Heath, where his 'passion for measurements'[5] was
pronounced. Geometrical precision within a precisely
structured composition continued to be a notable
feature of Uglow's rigorous, meticulously constructed
and slowly executed work; he typically completed no
more than three paintings a year. Despite two
retrospectives and a number of other exhibitions,
Uglow always maintained a lower exhibiting profile
than his reputation might suggest, and his early
presence at The London Group is often overlooked.

SARAH MACDOUGALL

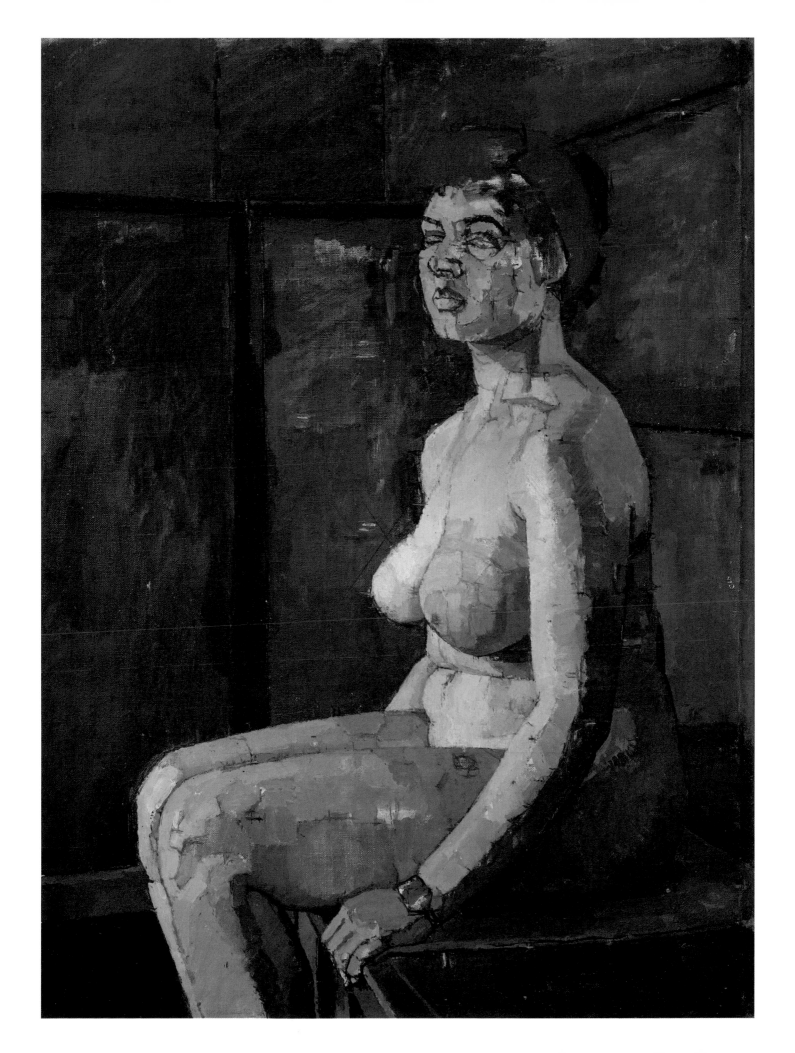

EXHIBITED
London Group Members' Exhibition,
10 November–09 December 1955,
Whitechapel Art Gallery, as (55) *Red Spring*,
£130 and *London Group 1914–64 Jubilee
Exhibition Fifty Years of British Art*, 15 July–16
August 1964, Tate Gallery, as (74) *Red Spring*,
1955, lent by the City of Norwich Museums

Elected 1931, exhibited 1931–39, 1941,
1943–45, 1947, 1949–1952 1955, 1958, 1960 and
1964 retrospective

Ivon Hitchens
Red Spring, 1955

Oil on canvas
51.4 × 105.4 cm

Signed (lower left) 'Ivon Hitchens'
Norwich Museum and Archaeology Service (Norwich Castle Museum & Art Gallery)

Born in 1893, the son of a landscape painter, Ivon Hitchens' career mirrors the myriad cross-currents in art at the beginning of the twentieth century. The influence of Fauvism, Cubism, Cézanne and abstraction can all be discerned in his early work. However, after his move in 1940 to the countryside near Petworth (after his London home was destroyed), he settled into his mature style echoing the general move towards post-war 'English' painting and its resonance with the Neo-Romantic movement.

Hitchens' interrogation of continental modernisms and development from a conservative style is reflected in his membership of the Seven & Five Society.[1] He was the only founding member to last until its demise, instigating and weathering the schism of the 1920s, after Ben Nicholson's rallying call to modernise. Hitchens became a member of The London Group in 1931 and in 1934 exhibited with fellow members Victor Pasmore (cat. 40) and Rodrigo Moynihan (cat. 32) in the seminal Zwemmer Gallery show, *Objective Abstractions*. Proud of his connection to the Group, on hearing that the Tate wanted to include this work in the 1964 Jubilee Exhibition Hitchens wrote to Norwich urging its loan.

Red Spring was painted in 1955 (the year Patrick Heron published a monograph on Hitchens) and exhibited in The London Group's Whitechapel Gallery exhibition the same year. Purchased by the Contemporary Art Society, it was allocated to Norwich Castle Museum and Art Gallery; given the latter's collection of British landscape painting (particularly the Norwich School), they petitioned hard for the work of an artist with such an innovative approach.

Hitchens' landscapes are often described as a translation of the experience of place into paint, but their rigorous structure reflects not only nature but also art and music. His foray into geometric abstraction suggests an interest in order, but his awareness of Renaissance art is perhaps more telling. *Red Spring*'s composition shares a striking similarity with passages of Piero della Francesca's Arezzo fresco cycles (1452–66): both are cleft by prominent partitions which delineate differing spaces. The previous year, when completing his expansive mural for Cecil Sharp House, London, Hitchens also drew attention to the way in which his narrow, horizontal canvases allowed for such progression.

Much has been made of Hitchens' immersion in landscape at the time of his relocation, but his abstraction only evolved gradually. The mythic quality of this work is entirely accounted for by topography. The wooded landscape undoubtedly contained dark passages, yet for a painting with 'spring' in its title there is a conspicuous absence of green. The two halves are unified corresponding passages of yellow and blue; but most arresting is the dark red of the title overlaid with blues and blacks. It would be tempting to read a symbolist meaning into the colours or the title, *Red Spring*, which could evoke a Crucifixion triptych rather than a narrative fresco, but such interpretations may do the work a disservice. Hitchens has boldly captured a landscape, an emotion, without recourse to a socio-political agenda.

HANNAH HIGHAM

48

EXHIBITED

London Group Annual Exhibition, 14 April–04 May 1956, RBA Galleries as (80) *Kitchen Interior*, £100.0.0

Elected 1957, exhibited 1952, 1954, 1956–59, 1961–64 including 1964 retrospective

John Bratby
Kitchen Interior, 1955–56

Oil on board
119.3 × 86.3 cm

Signed (top left) 'Bratby'
Williamson Art Gallery and Museum, Birkenhead; Wirral Museums Service
Presented by the Contemporary Art Society, 1960

John Bratby consistently perpetuated the 'Uproar!' aroused by Mark Gertler's *Creation of Eve* (cat.9), especially with his almost annual controversies in the Royal Academy Summer Exhibitions. In this typical early work Bratby records the torpor and squalor of postwar British life, but his concentrated details and strongly coloured impasto release a latent energy. Even as a student at the Royal College of Art he sloshed on paint as if there were no dole or rations. When Helen Lessore gave him his first solo show in 1954 his critics began their continuing complaints about his mundane settings, brand-name objects, slapdash brushstrokes and overall crudeness. Lessore promoted him as 'the poet of the commonplace'.

Critic David Sylvester named Bratby and three RCA classmates at Lessore's Beaux Arts Gallery – Jack Smith (1928–2011), Edward Middleditch (1923–1987) and Derrick Greaves (b.1927) – the Kitchen Sink Realists. All four rejected any such categorisation. Bratby was elected to The London Group in 1957 and exhibited with them throughout the remainder of the 1950s and early 1960s, including the 1964 retrospective. He acknowledged RCA teachers (and London Group members) John Minton (1917–1957), Carel Weight (1908–1997) and Ruskin Spear (cat.39) as his major influences. Later he wondered if he might be part Jewish, given his compulsive outsiderness and the effulgent palette he shared with David Bomberg (cat. 16), Chaïm Soutine (1893–1943), Oskar Kokoschka (1886–1980), Marc Chagall (1887–1985) and other Jewish exiles. He also had a tendency to deploy the Jewish comic stereotype.

Later Bratby implicitly defended The London Group tradition when he inveighed against the invasion of American and French abstraction. He even found himself defending the staid Royal Academy as Britain's last bastion against non-figuration. Even when Lessore's quartet represented Britain at the 1956 Venice Biennale (and Bratby won a $1,000 Guggenheim National Prize, a feat he repeated at the next Biennale) British art was split between the abstraction of Lynn Chadwick (cat.43), Victor Pasmore (cat.40) and Ben Nicholson (1894–1982), and the London traditionalists, whose realism and social concern also found voice in the 'Angry Young Man' theatre and film scene.

Kitchen Interior is crammed with objects and colour. The woman at the sink is probably Bratby's young wife Jean, with the suited critic on the margin her disapproving (ex-military, grocer) father. Jean said that when the impetuous elopers moved into her father's third floor, Bratby did not come down to meet him for three weeks. The apparent chaos belies a careful structure. The Lux soapbox may pun on the skeleton of white light that supports the scene. Jean's chin marks the composition's centre point. She seems immersed in her new married world, no longer attentive to her father's. The tilted brown chair balances the Lux; the grey hanging pan the father, linked by the curved kettle-handle. The thick layers of paint and expressionist liberty in colour give this sad scene vitality. Clearly Bratby had a hunger to depict his physical world, discovering richness in the mundane, poetry in the prosaic. Even when he was churning out sunflowers and portraits he would always return to such teeming interiors, which in their clog and frenzy seemingly reflect the artist himself.

MAURICE YACOWAR

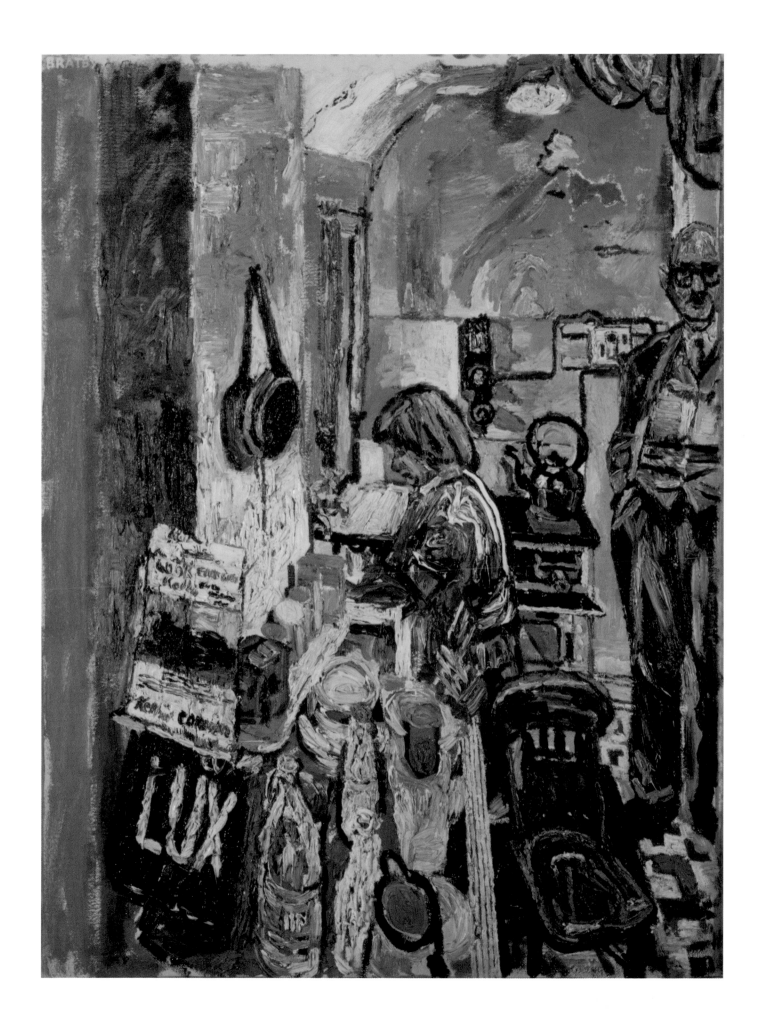

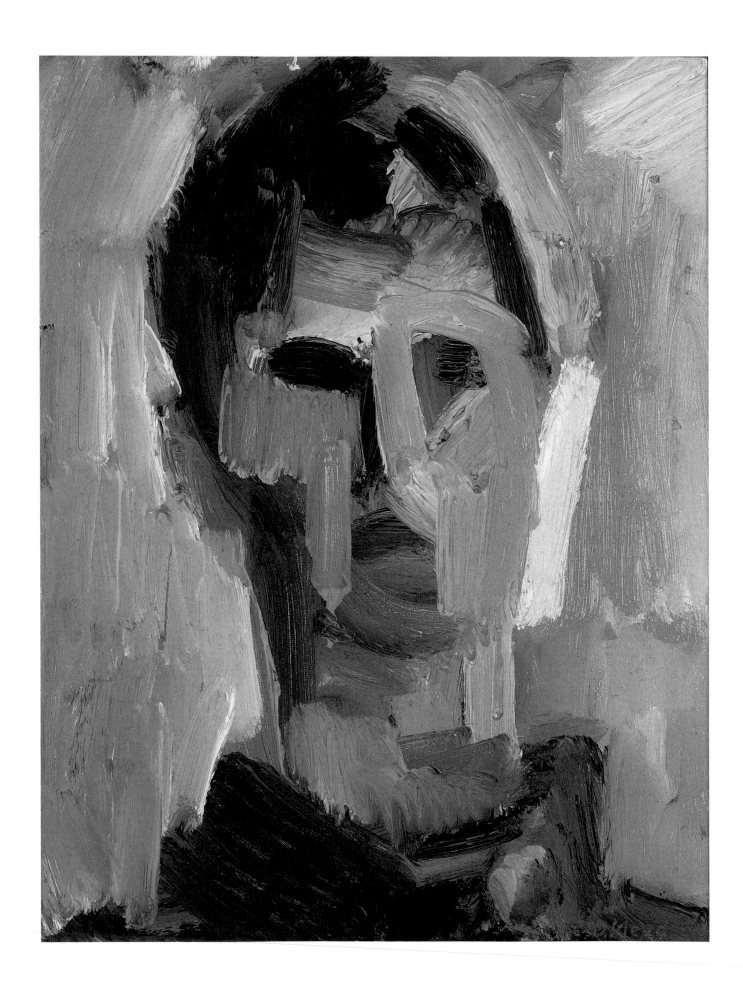

49

EXHIBITED

London Group Annual Exhibition, 15
January–05 February 1960,
R. B. A. Galleries, as (61) *Self-Portrait*,
£52.10.0.

Elected 1960, President 1971–73,
exhibited 1948, 1951, 1953, 1956–64

Dorothy Mead
Self-portrait, 1960

Oil on Canvas
61 × 46 cm

Signed and dated (lower right) 'D. Mead 1960'
Ruth Borchard Collection c/o Robert Travers Work of Art Ltd, Piano Nobile, London

In 1959, Dorothy Mead wrote to Sir William Coldstream (cat.36), Head of the Slade School of Fine Art, defending her decision not to sit the core examination on perspective:

> I feel that perspective is completely alien to me in my work as a painter [...] scientific method, academic attitude, or scholarship [...] are types of activities which, as the names imply are antipathetic to creation. As a painter I cannot profess to know – I can only search for meaning [...] Feeling as I do [...] I cannot see any other course to adopt in conscience and I am obliged to abide by the consequences.[1]

Coldstream, though sympathetic, was unwilling to make an exception for Mead and she left without a diploma. This was no small decision for an aspirational artist and illustrates the strong artistic principles and determination that Mead maintained throughout her career.

Arguably, her early teacher David Bomberg (cat.16) instilled these strong artistic beliefs. Mead met Bomberg in 1944, followed him to Borough Polytechnic (today, London South Bank University) and attended his now legendary classes (1945–51). Here she became a founding member of the artists' collective, the Borough Group. These formative years had a lasting impact and she remained a vocal champion of Bomberg, influencing other painters including Mario Dubsky (1939–1985) and Patrick Procktor (1936–2003).

This bold self-portrait was painted a year after Mead left the Slade and around the time she joined The London Group, a period when she was probably feeling at once disappointed and defiant. Despite having Mead's elegant, distinctive long neck and sloping shoulders, it is an androgynous image. She stares out from behind thick brushstrokes that both frame and partially mask her left eye, eclipsing half of her mouth. The use of vivid colour around the dark eyes is unsettling, as is the predominance of muted violets and greys. The deep orange around her left eye is almost bloodshot; the yellow beneath her right evokes warpaint. Yet the use of colour also creates balance, with the yellow picked up in her hair and behind her head. This, together with the strong brushstrokes, demonstrates a compositional skill and an interest in structure and form that reflect her reservations on perspective.

Mead won prizes at the Slade (1958 and 1959), was President of the Young Contemporaries (1958–59), and exhibited alongside David Hockney (b. 1937) and Bridget Riley (b. 1931) in the Arts Council's 1964 exhibition *6 Young Painters*. Her 1971 nomination as the first female President of The London Group was an accolade acknowledging her commitment to the Group and demonstrating the high regard in which she was held by her peers. After her death in 1975, fellow Borough Group artist Dennis Creffield (b. 1931) selected ten paintings to honour Mead in the Group's annual show, and Neville Boden (1929–1996, then President), wrote a short text, noting 'what a fine painter she was'.1 Yet, despite maintaining a strong artistic practice, and actively supporting other artists (including through teaching posts at Goldsmiths and Morley College), Mead struggled to gain the proper recognition that is now coming with her rediscovery.

RACHEL FLEMING-MULFORD

50

A similar work exhibited at *London Group*, 07–29 March 1963, Art Federation Galleries, as (76) *Seated Woman*, £125.0 and *London Group 1914–64 Jubilee Exhibition Fifty Years of British Art*, as (158) *Seated Woman*, 1960, lent by the Artist
Elected 1963, exhibited 1956, 1963 and 1964 retrospective

Leon Kossoff
*Portrait of N M Seedo, c.*1957

Charcoal on paper
103 × 71 cm

Ben Uri, The London Jewish Museum of Art

fig.32
Leon Kossoff
Portrait of N M Seedo
1957
Private Collection

Initially trained at St Martin's School of Art, Kossoff attended evening classes at Borough Polytechnic (1950–52) under David Bomberg (cat.16), whose work he recalls seeing in London Group exhibitions during this period. In 1956, the year that Kossoff graduated from the Royal College of Art, both artists exhibited in the Group's annual exhibition at the RBA Galleries, where Kossoff showed an untitled drawing. This is his earliest recorded exhibition and demonstrates how, in addition to Helen Lessore's Beaux Arts Gallery, the Group helped Kossoff gain early recognition. While never an active member, he credits the Group with the 'possibility [it gave him] to show' his work more widely in this period.[1] Through it Kossoff made significant contacts with other artists, including Euan Uglow (cat.46).

Kossoff was elected a London Group member in 1963, exhibiting for the third and final time in 1964, by which time he had already achieved considerable success, with the Arts Council and Tate both acquiring work. He also received recognition from critics including John Berger, who was impressed by Kossoff's 'shockingly thick' pigment and his '[…] equally heavily worked and very black' drawings,[2] observing that his 'brooding hunched up figures […] fit as tensely in their panels as mediaeval figures in their niches'.[3] Their shock value also exemplifies how artists associated with The London Group continued to challenge conventional artistic means of representation.

Portrait of N M Seedo bears a striking resemblance to the charcoal and conté drawing *Seated Woman*, exhibited in Kossoff's second and third London Group exhibitions, and the 1957 oil painting of the same title.[4] Berger's comments could easily refer to these works in which the chair and the female figure, heavily delineated with fluent thick black marks, occupy the majority of the space. The woman is similarly dressed, depicted in three-quarters profile, adopting a pose with her hands together, head turned towards the viewer and eyes downcast or closed. The tubular arm-rest that portions off the bottom left corner is a compositional device that features in later works of both clothed and nude sitters.

These three associated works are portraits of Sonia Husid, known by her *nom de plume* N M Seedo, an important model for the artist in these years. Kossoff exhibited a further *Head of Seedo* in the 1963 Group exhibition. Seedo refers to her friendship with the artist in her autobiography, *In the Beginning was Fear* (1964),[5] also movingly describing her experiences of pogroms, fear and loss in Romania. In the empathic work, *Portrait of N M Seedo*, Kossoff clearly conveys her strength through suffering.

STEPHANIE FARMER

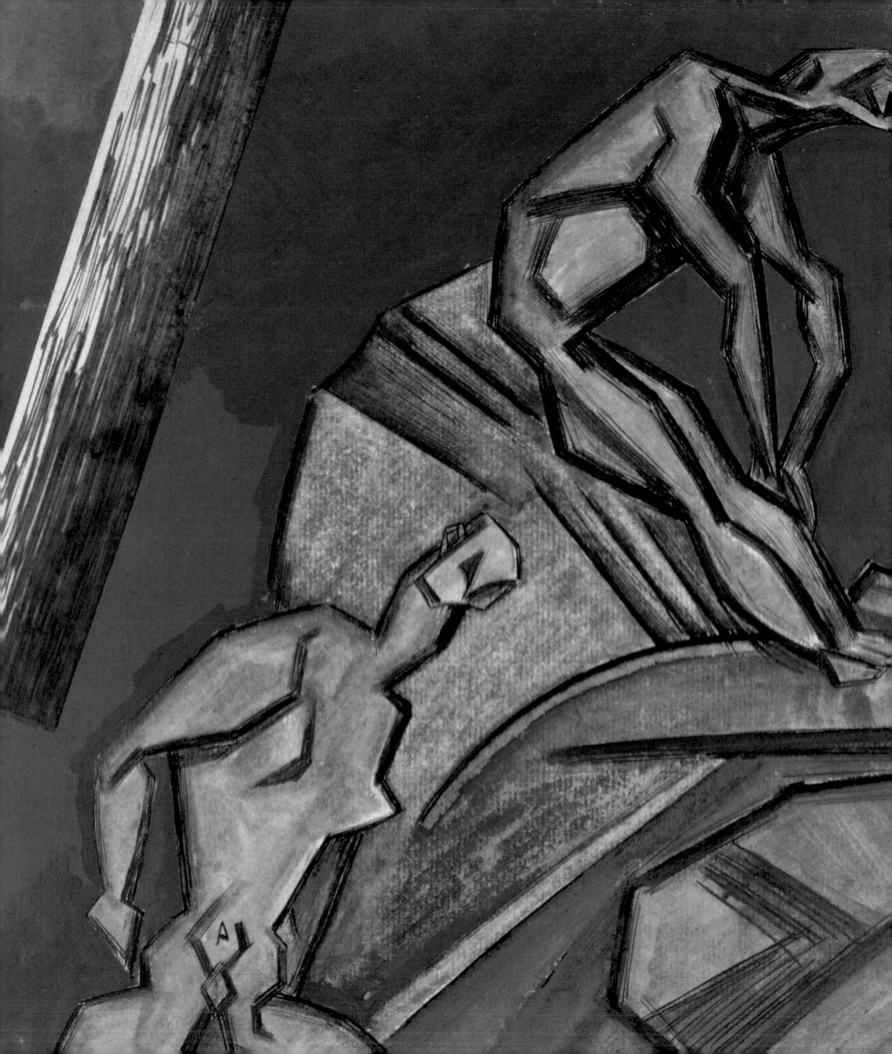

ARTISTS' BIOGRAPHIES

EILEEN AGAR

1899–1991, ELECTED 1933

Mixed media painter, draughtsman and maker of objects, born in Buenos Aires to British parents, moved to England with her family in 1906. She attended weekly classes at the Byam Shaw School of Art (1918–20), studied sculpture under Leon Underwood (1920–21), alongside Henry Moore and Gertrude Hermes, and attended the Slade School of Fine Art part-time (1921–24). Between 1928 and 1930 she lived and studied in Paris, meeting André Breton and Paul Éluard, who introduced her to Surrealism. Her first solo exhibition was at the Bloomsbury Gallery, London in 1933. In 1936 Roland Penrose and Herbert Read invited her to exhibit at the first International Exhibition of Surrealism at the New Burlington Galleries with other English artists including Moore and Paul Nash. She exhibited with the Surrealists throughout her career, experimenting with automatic techniques and new materials. In 1940 Agar married her long-term partner Joseph Bard. She published her autobiography *A Look at My Life* with Andrew Lambirth in 1988. Agar died at her London home in 1991.

KENNETH ARMITAGE

1916–2002, ELECTED 1953

Leeds-born sculptor, studied at Leeds College of Art (1934–37) and the Slade (1937–39). He served in the British Army during the Second World War, afterwards heading the sculpture department at the Bath Academy of Art, Wiltshire (1946–56) and holding a Gregory Fellowship in sculpture at Leeds University (1953–55). His first works, inspired by Henry Moore and Barbara Hepworth, were carved in stone, but postwar he worked with a variety of materials including plaster, bronze, wax and aluminium. In 1952 he attracted international attention at the 26th Venice Biennale as one of the so-called 'Geometry of Fear' sculptors, and held his first solo exhibition at Gimpel Fils Gallery, London. At the 1958 Biennale he won the award for the best sculptor under 45 and held his first retrospective at the Whitechapel Art Gallery in 1959. Armitage experimented with media throughout his career, later producing drawn, screen-printed and photographic images on three-dimensional surfaces. He was appointed CBE in 1969 and elected a Royal Academician in 1994.

VANESSA BELL

1879–1961, ELECTED 1919

London-born painter and designer Bell (*née* Stephen) trained as a painter at Arthur Cope's School of Art, South Kensington (1896–1901) and the Royal Academy of Arts (1901–04). She established 'The Friday Club' (1905–22), inspired by Parisian café life, as a platform for the exchange of ideas between artists and other friends. Bell resigned in 1913, but annual exhibitions featuring progressive young artists were held 1910–14. She married Clive Heward Bell (1881–1964) in 1907 and their Gordon Square home became a focal point for members of the Bloomsbury Group, including her sister, the novelist Virginia Woolf, and Roger Fry. Fry included Bell in his *Second Post-Impressionist Exhibition* at the Grafton Galleries (1912) and she became a leading designer in the Omega Workshops (1913–19), collaborating with Duncan Grant, with whom she formed a life-long professional and romantic relationship. The painted interior of their country home, Charleston, East Sussex, is a tribute to their combined creativity. Bell was a member of the London Artists' Association and, from the 1950s, the Royal West of England Academies. She died in Charleston after a brief illness in 1961.

ROBERT BEVAN

1865–1925, FOUNDER MEMBER 1913

Painter and lithographer, born Hove, near Brighton to a Quaker family closely associated with Barclays Bank; studied painting at the Westminster School of Art and at the Académie Julian in Paris. He travelled to Brittany for the first time in 1890–91, coming into contact with the Pont-Aven group. On a second visit (1893–94) he met Gauguin, who greatly influenced him. He initially developed a pointillist style, though his paint became thicker and more textural in later years, and he often depicted scenes of London life, particularly horses. He held his first solo exhibition in 1905 at the Baillie Gallery, London. Bevan was a founder member of the Camden Town Group and contributed to the formation of The London Group. In 1914 he set up the Cumberland Market Group with Charles Ginner and Harold Gilman. He was elected to the New English Art Club in 1922. In 1897 Bevan married the Polish painter Stanislawa de Karlowska. They travelled to Poland on numerous occasions, where Bevan painted brightly coloured landscapes.

DAVID BOMBERG

1890–1957, FOUNDER MEMBER 1913

Painter and lithographer, born Birmingham to Polish-Jewish parents and brought up in London's East End; attended evening classes at Westminster under Sickert (1908–11), then studied at the Slade (1911–13). In 1913 he visited Paris with Jacob Epstein, meeting Picasso, Derain and Modigliani and was introduced to Cubism and Futurism. Exhibiting with the Vorticists he rejected Lewis's invitation to join the group. In May 1914, he co-curated with Epstein the 'Jewish Section' of *Twentieth Century Art: A Review of Modern Movements* at the Whitechapel Art Gallery. His first solo show at the Chenil Gallery, Chelsea in July 1914, was critically acclaimed. Bomberg enlisted in November 1915; he was later commissioned to produce a work for the Canadian War Memorials Fund. Disillusioned by his wartime experiences, in 1923–27 he travelled to Palestine, painting topographical landscapes which became increasingly freer and more expressive. In his final decades he travelled widely, developing a vigorous, characteristic handling of paint. An Official War Artist during the Second World War, he was commissioned to paint a bomb store. A highly influential teacher at Borough Polytechnic, his students included Frank Auerbach and Leon Kossoff; others, including Dorothy Mead, steeped in his principles, exhibited as the Borough Group (1946–51). In 1954 he settled in Ronda, Spain, but died in London.

JOHN BRATBY

1928–1992, ELECTED 1957

Wimbledon-born painter, writer and teacher, studied at Kingston School of Art (1947–50) and the Royal College of Art (1951–54); held the first of a series of solo exhibitions at the Beaux Arts Gallery in 1954, when he also first exhibited at the Royal Academy. He became an RA Associate (1959) and a Royal Academician (1971). Bratby's realistic paintings often focus on his family and their surroundings in a portrayal of urban domestic life, known as the 'kitchen sink' style, also associated with Jack Smith, Edward Middleditch and Derrick Greaves. Bratby frequently exhibited with The London Group postwar and taught at Carlisle College of Art (1956) and then at the Royal College (1957–58). He was also a successful novelist.

LYNN CHADWICK

1914–2003, ELECTED 1952

Sculptor, born London; trained as an architectural draughtsman in London (1933–39). After serving as a pilot in the Second World War, he began to construct his first works – mobiles – c.1946, and exhibited at his first solo show at the Gimpel Fils Gallery (1950). He received three commissions for the 1951 Festival of Britain, first attending a welding school in 1950, which enabled him to create large-scale works. Together with Kenneth Armitage and others, Chadwick exhibited at the 'New Aspects of British Sculpture' show at the 26th Venice Biennale in 1952, one of the so-called 'Geometry of Fear' sculptors. He won the 1956 International Sculpture Prize at the Venice Biennale, which firmly established his reputation, and was later influenced by the Minimalist movement. He was appointed CBE in 1964 and was created an *Officier de l'Ordre des Arts et des Lettres* in 1985.

WILLIAM COLDSTREAM

1908–1987, ELECTED 1933

Painter, born in Belford, Northumberland and raised in North London; studied at the Slade (1926–29), where he met Claude Rogers and Rodrigo Moynihan. He first exhibited with The London Group in 1929 and was elected to the Group in 1933; he also showed regularly with the London Artists' Association in the 1930s. He always worked directly from the model using a system of punctilious measurements. In 1934 he joined the GPO Film Unit under John Grierson, where he worked with W H Auden and Benjamin Britten. In 1937 he formed the Euston Road School with Rogers and Victor Pasmore, which closed upon the outbreak of the Second World War in 1939. He enlisted in the army in 1940 and became an Official War Artist in 1943. Postwar he was an influential teacher of painting at Camberwell School of Art and the Slade. A trustee of the National and Tate galleries, Director of the Royal Opera House and Chairman of the BFI and the Arts Council, in 1960 he produced the first 'Coldstream Report', which had a deep impact on fine art education in Britain. Coldstream was knighted in 1956. He died in Camden in 1987.

JESSICA DISMORR

1885–1939, ELECTED 1926

Kent-born painter and illustrator, studied at the Slade (1902-03), at Étaples under Max Bohm, and later at the Académie de La Palette, Paris (1910-13), developing a fauvist technique. She exhibited at the Allied Artists' Association (1912–13) and the Stafford Gallery (1912), radically altering her work after meeting Wyndham Lewis in 1913. She became a member of the Rebel Art Centre and signed the Vorticist manifesto. Dismorr contributed writing and artwork to *Blast* (1915) and exhibited in the Vorticist exhibitions at the Doré Gallery, London (1915) and at the Penguin Club, New York (1917). During the First World War she carried out volunteer work in France. Dismorr held her first solo exhibition at the Mayor Gallery, London in 1925 and was elected to both The London Group and the Seven & Five Society in 1926. In the 1930s Dismorr's work moved towards abstraction. She exhibited with the Association Abstraction-Création and in 1937 contributed to Myfanwy Piper's *Axis* magazine. Dismorr committed suicide in London in 1939.

FRANK DOBSON

1886–1963, ELECTED 1922,
PRESIDENT 1924–26

London-born sculptor, painter and
designer; moved to Hastings in 1900,
attending evening classes at Hastings
School of Art. He became studio assistant
to the painter, William Reynolds-Stephens
(1900–01), later sharing a studio with
Cedric L Morris in Devon. Awarded a
scholarship to Hospitalfield Art Institute,
Arbroath (1906), he also attended the City
and Guilds Art School (1910). His first solo
exhibition at the Chenil Galleries, London
(1914) was on the recommendation of his
friend, Augustus John. During the First
World War Dobson served in the Artists
Rifles (1915) and as lieutenant in the 5th
Border regiment (1916-17) but was sent
home due to illness. From 1914 Dobson
turned entirely to sculpture, the only
sculptor to exhibit in Wyndham Lewis's
1920 Group X exhibition. He afterwards
abandoned Vorticism in favour of a more
classical style influenced by Aristide
Maillol. Dobson was president of
The London Group 1924–27, a founder
member of the London Artists'
Association, and Head of Sculpture at
the Royal College (1947–53). He was
appointed CBE in 1947 and elected a
Royal Academician (1951).

JACOB EPSTEIN

1880–1959, FOUNDER MEMBER 1913

New York-born sculptor, painter and
draughtsman of Russian-Polish Jewish
descent; studied in New York and Paris,
where he became interested in 'primitive'
art. He settled in London in 1905. His,
often highly controversial, public
commissions included the façade of the
British Medical Association Building,
London (1907–08); the tomb for Oscar
Wilde at Pére-Lachaise cemetery, Paris
(1911); the carved relief *Rima*, Hyde Park,
London (1924–25); and *Night* and *Day* for
London Underground's headquarters
(1928–29). Often challenging prevailing
notions of sexuality and beauty, he
championed direct carving and favoured
non-European models. In 1914, with David
Bomberg, he co-curated the 'Jewish
Section' of *Twentieth Century Art: A
Review of Modern Movements* at the
Whitechapel Art Gallery. Associated with,
but never a member of the Vorticists, he
contributed to Wyndham Lewis's journal,
Blast. He was an honorary member of The
London Group (credited with coining its
name), sitting on the hanging committee
1915–17. Conscripted as a private in the
Jewish 38th battalion of the Royal Fusiliers
in autumn 1917, he was discharged after a
breakdown in 1918. During the Second
World War he carried out portrait
commissions for the War Artists' Advisory
Committee. He received eight major
commissions in his last decade, including
Social Consciousness, Philadelphia
(1951–53). Epstein was knighted in 1954.

FREDERICK ETCHELLS

1886–1973, FOUNDER MEMBER 1913

Newcastle-born painter, architect and
writer; studied at the Royal College
(1908–11) and in Paris (1911–14), where he
encountered Cubism and Fauvism and was
influenced by Braque and Picasso. He
contributed to the 1911 Borough
Polytechnic murals with Roger Fry,
participated in the *Second Post-
Impressionist Exhibition* at the Grafton
Galleries (1912) and worked closely with
the Omega Workshops. Together with his
sister Jessie (1893–1933), Etchells was a
founder member of The London Group,
but resigned when Fry joined in 1917
having sided with Wyndham Lewis in the
'Ideal Home' dispute. He exhibited in the
Vorticist exhibitions (1915 and 1920). He
was called up in 1916 but discharged due to
illness in 1917. After the First World War he
abandoned painting and dedicated himself
almost completely to architecture and
writing.

HANS FEIBUSCH

1898–1998, ELECTED 1934

Painter, poster designer and sculptor, born Frankfurt, to a Jewish family. Following service in the German army in the First World War, he studied painting in Munich, Berlin, and Italy between 1918–23. During 1923–1924, he studied in Paris with André Lhote and Otho Friesz, exhibiting in the Salon d'Automne and the Salon des Indépendants. Afterwards he returned to Frankfurt, and was awarded the Prussian Great State Prize for painting in 1931, but was forced to flee Germany in 1933 when Hitler came to power. His work was shown in the Nazi degenerate art exhibition, *Entartete Kunst* (1937). He was invited to join The London Group after his first one-man show in England in 1933, and was elected in 1934. His work, often concerned with religious themes and influenced by the experience of exile, became increasingly expressionistic. He also produced book illustrations and poster designs, but is best known for his many Church of England murals. He bequeathed the contents of his studio to Pallant House Gallery, Chichester.

ROGER FRY

1866–1934, ELECTED 1917

Born in London to a Quaker family; art historian, critic and painter; studied Natural Sciences at Cambridge (1884–89); trained as a painter under Francis Bate (1889–91), then at the Académie Julian, Paris (1892), and at evening classes under Walter Sickert (1893). He was curator and then European Advisor to the Metropolitan Museum of Art in New York (1907–10) and declined the Tate Gallery directorship in 1911. Fry championed modern French painting, organising the two seminal exhibitions at the Grafton Galleries in 1910 and 1912, which introduced Post-Impressionism to the British public for the first time. In 1913 Fry founded the Omega Workshops (closed 1919), to give artists employment designing and decorating furniture and textiles, while maintaining their individual careers. Fry's influential publications included *Vision and Design* (1920) and *Cézanne* (1928); he contributed frequently to *The Burlington Magazine*. Fry was awarded an honorary fellowship of King's College, Cambridge (1927), an honorary LDD of Aberdeen University (1929), and the Cambridge Slade professorship (1933). He died in London in 1934.

HENRI GAUDIER-BRZESKA

1891–1915, FOUNDER MEMBER 1913

Sculptor and draughtsman, born in Saint-Jean-de Braye, near Orléans, France. At fourteen he studied in Bristol on a fellowship, afterwards moving to Germany and then Paris, where he began to sculpt. In 1911 he moved to London with the Polish writer Sophie Brzeska, who was twenty years his senior, adding her surname to his. By 1913 he was part of a circle which included T E Hulme, Ezra Pound and Jacob Epstein. He was a founder member of The London Group and a member of the Vorticists, publishing work in its journal *Blast*. His sculptures, predominantly of the human head, figures and animals, closely based on observations from nature, became radically simplified and geometrical. In 1915 he volunteered for the army, sending Edward Wadsworth drawings from the trenches for exhibition at The London Group. He died in action the same year in Neuville-Saint-Vaast, at the age of 24.

MARK GERTLER

1891–1939, ELECTED 1915

Born in Spitalfields, London to Austrian-Jewish immigrant parents; spent early childhood in Galicia, Austria, returning to the East End in 1896. He studied at Regent Street Polytechnic (1906–08) and the Slade (1908–11). He exhibited with the Friday Club (*c*.1910–22), the New English Art Club (1911–16), the Chenil Gallery (1912–13) and with Roger Fry's Omega Workshops (1917–18). Bomberg included him in the 'Jewish Section' of *Twentieth-Century Art: A Review of Modern Movements* at the Whitechapel in 1914. Profoundly influenced by Fry's Post-Impressionist exhibitions, Gertler's work was highly experimental between 1913 and 1920. During the First World War, he was initially rejected for military service because of his Austrian parentage; then declared medically unfit when called up in 1918. Suffering from depression, he left an Official War Artists' commission unfulfilled. He had five one-man shows at the Goupil Gallery (1921–26) and was a leading member of The London Group, but tuberculosis confined him to sanatoria (1920, 1925, 1929 and 1936). He held five shows at the Leicester Galleries (1932–29) and taught part-time at the Westminster (1931–39). He committed suicide in 1939.

HAROLD GILMAN

1876–1919, FOUNDER MEMBER 1913

Somerset-born painter; studied at the Hastings School of Art (1896) and the Slade (1897–1901), where he met Spencer Gore, who introduced him to Sickert. Gilman travelled to Spain, where he studied and copied works of Velázquez and Goya. He became a founder member of a number of important artists' collectives including the Fitzroy Street Group, the Camden Town Group, the Cumberland Market Group and The London Group – of which he became the first president (1914–18). Around 1910, inspired by Roger Fry, Gilman started using thicker impasto, brighter colours and more rigid compositions. He exhibited with Charles Ginner as a 'Neo-Realist' in 1914. In the same year he joined the Cumberland Market Group with Robert Bevan and participated in their only exhibition in 1915. Gilman was married to the American painter Grace Cornelia Canedy and died during the influenza epidemic in 1919.

CHARLES GINNER

1878–1952, FOUNDER MEMBER 1913

Painter and wood engraver, born to British parents in Cannes, France; studied painting at the Académie Vitti (1904) and the École des Beaux-Arts in Paris (1905). Influenced by the works of Paul Cézanne, Vincent van Gogh and Paul Gauguin, Ginner's technique was characterised by small regular touches of thick paint. In 1909 he exhibited at the Salón Costa, Buenos Aires with the Danish painter Dora Erichsen, then returned to England in 1910 where he met Spencer Gore and Harold Gilman. He became a regular attendee at Sickert's 'Saturdays' in Fitzroy Street. He exhibited at the Allied Artists' Association (1910) and was a founder member of the Camden Town Group, The London Group, and the Cumberland Market Group. In his essay, 'Neo-Realism', he disassociated himself and Harold Gilman from Sickert's Post-Impressionism. In 1920 he had his first solo exhibition at the Birmingham Repertory Theatre. He served as an Official War Artist in both the First and Second World Wars.

SPENCER F GORE

1878–1914, FOUNDER MEMBER 1913

Epsom-born painter; studied at Harrow and then at the Slade (1896–99), where he met Harold Gilman. He was friendly with Wyndham Lewis, with whom he travelled to Spain in 1902. In 1905 he visited Gauguin's exhibition at the Salon d'Automne, Paris, which had a lasting impact on his work. In London he accompanied Walter Sickert to the London music halls, which became a recurrent theme in his work. He exhibited with and became a member of the New English Art Club in 1909. He was a founder member of the Fitzroy Street Group, the Allied Artists' Association and the Camden Town Group, of which he was also the first president in 1911. He was one of the organisers of the Camden Group exhibition in Brighton in 1913 and participated in the first London Group show at the Goupil Gallery in 1914, where he was a pivotal figure in bringing together the Group's disparate artistic factions. He died of pneumonia the same year.

DUNCAN GRANT

1885–1978, ELECTED 1919

Scottish born painter and designer; Grant spent his early years in Burma and India, where his father served as a soldier (1887–94). He studied at the Westminster (1902–05) and then at the Académie La Palette, Paris (1906–07) under Jacques-Émile Blanche. Grant was greatly influenced by Roger Fry's two seminal Post-Impressionist exhibitions at the Grafton Galleries in 1910–13. In 1913 he became co-director of Fry's Omega Workshops with Vanessa Bell, with whom he formed a life-long professional and romantic partnership. In 1915 Grant exhibited with the Vorticist group as a non-member. In 1916 he and Bell set up home in Charleston, East Sussex. Grant had his first solo exhibition at the Carfax Gallery, London in 1919, and was elected to The London Group the same year. During the First World War Grant was a conscientious objector and carried out farm work. He was appointed an Official War Artist during the Second World War. Grant's major commissions included Berwick Church, near Charleston, with Bell (1940–43), and a series of decorative panels for the Russell Chantry in Lincoln Cathedral (1959). He died in Berkshire in 1978.

BARBARA HEPWORTH

1903–1975, ELECTED 1930

Wakefield-born sculptor, studied at Leeds School of Art (1920–21) and the Royal Academy (1921-24), where she met Henry Moore. She was runner-up for the 1924 Rome Prize, marrying the prizewinner John Skeaping in 1924 in Florence. In England, they settled at the Mall Studios, Hampstead (1928–31), where their son was born, but separated in 1931. Hepworth married Ben Nicholson in 1932, giving birth to triplets in 1934; their marriage lasted until 1951. Along with fellow sculptors Bedford and Moore, Hepworth and Nicholson became leaders of direct carving. During the 1930s they frequently visited Paris, meeting Picasso, Braque and Arp. Hepworth was a member of the Seven & Five Society (1931–36) and instrumental in its move towards abstraction. In 1937 she contributed to the publication *Circle: International Survey of Constructivist Art*. In 1939 Hepworth and Nicholson moved to St Ives, Cornwall, becoming founding members of Penwith Society of Art in 1943, along with Naum Gabo, Adrian Stokes, Peter Lanyon and Bernard Leach. In 1949 she bought a studio in St Ives (now the Barbara Hepworth Museum and Sculpture Garden). She won many prizes including the São Paulo Biennial Grand Prize (1958) and was appointed CBE in 1959. She died in a fire at her St Ives studio-home in 1975.

GERTRUDE HERMES

1901–1983, ELECTED 1935

Sculptor and wood engraver, born in Kent to German parents; studied at Beckenham School of Art (1921) and under Leon Underwood (1922–26) with Henry Moore, Eileen Agar and Blair Hughes-Stanton, whom she married in 1926; they divorced in 1933. Hermes was a member of the English Wood Engraving Society (1925–31) and exhibited with the Society of Wood Engravers, the Royal Academy and The London Group during the 1930s. She contributed to the short-lived publication, *Island* (1931), edited by Joseph Bard, and was a commissioned illustrator for Penguin Books. She lived in the USA and Canada (1940–45). On her return to England she taught wood engraving, lino block cutting and printing at Camberwell (1945–60), St Martin's (1945–60), the Central (1945–65) and the Royal Academy (1966–69). She was elected an associate of the Royal Society of Painter-Etchers and Engravers (1949), Associate RA (1963) and RA (1971). In 1961 she was awarded first prize in the Giles Bequest competition at the Victoria and Albert Museum for her linocut *Stonehenge*. Hermes suffered a severe stroke in 1969, which left her unable to work. She died in Bristol in 1983.

IVON HITCHENS

1893–1979, ELECTED 1931

London-born painter; studied at St John's Wood and the Royal Academy Schools of Art intermittently between 1911 and 1919. Hitchens was an active member of the Seven & Five Society (1920–35). He had his first one-man exhibition at the Mayor Gallery, London in 1932, and was elected to in 1931 The London Group, where he became a frequent exhibitor. Hitchens' art before 1939 was heterogeneous and influenced, particularly in his landscapes, by Cézanne. In the 1930s he experimented with pure abstraction and in 1934 took part in the *Objective Abstractions* exhibition at the Zwemmer Gallery. After the Second World War, he continued to use strong, pure colour and distinctive open, loose brushwork, but turned to more representative subjects, largely landscapes, becoming associated with the British Neo-Romanticist movement. He exhibited at the 1956 Venice Biennale and was appointed CBE in 1958.

STANISLAWA DE KARLOWSKA

1876–1952, FOUNDER MEMBER 1913

Polish painter, born near Łowicz; studied in Warsaw, Cracow and at the Académie Julian, Paris. She married Robert Bevan in 1897 and they moved to England in 1898, first to the family estate Horsgate, in Sussex, where their children were born, then to Brighton before eventually settling in London's Swiss Cottage. She exhibited with the Women's International Art Club and the New English Art Club, but was ineligible for membership of the Fitzroy Street and Camden Town Groups from which women were barred. She was a founder member of The London Group. Karlowska held her first solo exhibition at the Adams Gallery in 1935. Her style combined that of her Camden Town contemporaries with elements of Polish folk art.

LEON KOSSOFF

BORN 1926, ELECTED 1963

Painter; born in Islington, London to Jewish Eastern-European parents and grew up in East London. His early interest in art was encouraged by the family he lived with after being evacuated to King's Lynn, Norfolk, during the Second World War. After returning to London in 1943, he attended life-drawing classes at Toynbee Hall, later studying at St Martin's (1949–53) and the Royal College (1953–56). Between 1950 and 1952 he also attended evening classes under David Bomberg at the Borough Polytechnic with Frank Auerbach. From 1959–69 he taught at Regent Street Polytechnic, Chelsea School of Art, and St Martin's. He exhibited at the Whitechapel Gallery in 1972, represented Britain at the 1995 Venice Biennale and had a retrospective at Tate in 1996. He lives and works in London.

JACOB KRAMER

1892–1962, ELECTED 1915

Ukraine-born to artistic Jewish parents; a painter and lithographer who immigrated to Leeds with his family in 1900. He was awarded scholarships to Leeds School of Art. Associated with Herbert Read and the progressive Leeds Arts Club, he was influenced by expressionism, particularly the work of Kandinsky. Encouraged by his patron Michael Sadler, Vice-Chancellor of Leeds University, and funded by the Jewish Education Aid Society, he attended the Slade from 1913–14. His London circle included Bomberg, Epstein, Gertler, Nevinson, Roberts (who later married Kramer's sister, Sarah) and Wadsworth. Bomberg and Epstein included his work in the 'Jewish Section' of the 1914 Whitechapel Gallery exhibition *Twentieth Century Art: A Review of Modern Movements*. He exhibited with the Allied Artists' Association, New English Art Club and Glasgow Society of Painters and Sculptors. In 1915 he showed with the Vorticists, and Lewis included his work in *Blast*. His postwar career dissipated; returning to Leeds in the 1920s, he developed a local reputation as a portraitist. Leeds City Art Gallery hosted a retrospective in 1960.

RUPERT LEE

1887–1959, ELECTED 1922, PRESIDENT 1926–36

Indian-born painter, sculptor and printmaker, moved to England in 1892. A talented musician, Lee was unable to afford tuition, instead studying at the Slade (1911–12) and Royal College (1912–13). During the First World War he served in the Queen's Westminster Rifles, returning to England in 1918 with shell shock. From 1922 he taught sculpture at the Westminster, the year he was elected to The London Group. His presidency of the Group terminated in 1936, when he was ousted with the Group's Secretary – and his partner – Diana Brinton (his first wife, Madge Pemberton, refused to grant him a divorce). In 1936 Lee was Chairman of the *International Surrealist Exhibition* at the New Burlington Galleries. In the Second World War Lee and Brinton moved to Hedgerley, near Denham, after their London home was bombed, eventually settling in Spain and from 1949 –56 in Gibraltar. Lee died in a road accident while visiting England in 1959.

PERCY WYNDHAM LEWIS

1882–1957, FOUNDER MEMBER 1913

Painter, novelist and critic, born in Nova Scotia, Canada; attended the Slade (1898 1901), then travelled in Europe until 1909 (accompanied in 1902 by Spencer Gore). On his return to England he co-founded the Camden Town Group and, through his involvement with the *Second Post-Impressionist Exhibition*, began working with Roger Fry at the Omega Workshops. In October 1913, after quarrelling with Fry, he founded the rival Rebel Art Centre, home to the Vorticist movement. Strongly politicised in both his writing and visual work, Lewis was present at the inaugural meeting of The London Group. Dissatisfied with the heterogeneous nature of the Group he left in 1917 when Fry was elected. An artillery officer in France during the First World War, the experience made him vehemently anti-military and influenced his philosophical theories. He attempted to revive the Vorticists as the short-lived Group X in 1920. During the Second World War he lived in America, becoming blind from a brain tumour. He wrote art criticism for *The Listener* (1946–51) and died in 1957.

LAURENCE STEPHEN LOWRY

1887–1976, ELECTED 1948

Lancashire-born painter, Lowry worked as a clerk at a Manchester accountancy firm (1904–10), became rent collector for the Pall Mall Property Company in 1910 until his retirement in 1952, painting in his spare time. Despite attending art evening classes at the Municipal College of Art (1905–25) and Salford School of Art (1915–25), he considered himself self-taught, taking inspiration from his surroundings, particularly Pendlebury, near Manchester, where he lived 1909– 48. Most famous for his northern industrial views and street scenes, he also painted landscapes, seascapes and portraits. Despite exhibiting sporadically from 1918 at the Manchester Academy of Fine Art, New English Art Club (1927–36) and Royal Academy (1932), Lowry's reputation was established slowly. It was not until 1938, when his work was seen by the dealer A J McNeil Reid, that Lowry was offered a solo show at the Lefevre Gallery for 1939, and began to receive public recognition. He was elected a Royal Academician in 1962.

EDNA MANLEY

1900–1987, ELECTED 1930

English-born sculptor and painter of Jamaican, Irish and English descent. Manley studied at Regent Street Polytechnic (1918–20), St Martin's (1920), the Royal Academy (1920–21) and Sir John Cass Technical Institute (1921). In 1921 she married her cousin, Norman Manley, and in 1922 they emigrated to Jamaica, where he became Chief Minister (1955–62). Manley's early Jamaican work looked to Vorticist and Neo-Classical trends in British sculpture and she often controversially used black models. Her first solo show in Jamaica was culturally significant, as little 'local' work had been previously exhibited. In the 1930s her work, which reflected the difficult political situation, became an icon of the Jamaican anti-colonial movement. Manley was an important cultural pioneer in Jamaica, founding the journal *Focus* (1940) and the Jamaica School of Art (1950) was later renamed in her honour. During the last years of her life she returned to painting.

KENNETH MARTIN

1905–1984, ELECTED 1949

Born in Sheffield; studied at the Sheffield School of Art (1927–29) and the Royal College (1929–32). Martin later taught at Camberwell and Goldsmiths. He married the abstract artist Mary Martin (née Balmford) in 1930. He exhibited with the Artists' International Association from 1934, and with The London Group from 1936, although he only joined in 1949. His first solo show was with the Leicester Galleries in 1943. In 1948 he began to produce abstract work. Martin is now considered a leading figure in the revival of the constructivist tradition in sculpture and painting in Britain and he was awarded an OBE in 1971, an honorary doctorate from the Royal College of Art, and the Midsummer Prize of the City of London in 1976.

MARY MARTIN

1907-1969, ELECTED 1959

Abstract painter, mixed-media artist and sculptor, Mary Martin (née Balmford) was born in Folkestone. She attended Goldsmiths (1925-29), and the Royal College (1929-32). She married Kenneth Martin in 1930 after they met at the RCA. With her husband she exhibited still life and landscape paintings with the Artists' International Association from 1934 (under her maiden name). She taught at Chelmsford School of Art 1941-44. In 1950 she made her first abstract painting, moving to abstract relief work in 1951, and her first free-standing construction in 1956. Martin's first major exhibition was in 1954, with her husband, at the Heffer Gallery, Cambridge, where she showed ten reliefs. A prolific exhibitor with The London Group from 1932, she was not elected until 1959. Her work is considered a significant contribution to the development of postwar British constructivism.

BERNARD MENINSKY

1891–1950, ELECTED 1919

Painter and draughtsman born in Ukraine to Jewish parents and brought up in Liverpool; briefly studied at Liverpool Art School, then in Paris in 1911. On his return, Meninsky attended the Slade, before teaching drawing in Florence while working for the avant-garde theatre director Edward Gordon Craig. In 1914 he returned to England and began teaching at the Central School. David Bomberg and Jacob Epstein included him in the 'Jewish Section' of *Twentieth-Century Art: A Review of Modern Movements* at the Whitechapel in 1914. He exhibited with the New English Art Club from 1914 (joining in 1923) and with The London Group from 1916. His first solo exhibition was in 1919 at the Goupil Gallery. During the First World War Meninsky was an Official War Artist and afterwards taught at the Westminster. From 1922-27 he spent much of his time in the South of France; living briefly in Spain in 1936. In 1940 he returned to England to teach at Oxford City Art School until 1945. Suffering from depression, Meninsky committed suicide in 1950.

HENRY MOORE

1898–1986, ELECTED 1930

Yorkshire-born, trained as a teacher (1915–16) before serving with the Civil Service Rifles (1917–19) during the First World War. Moore studied at Leeds (1919-21) and the Royal College (1921–24), where he held the first of two positions as sculpture assistant (RCA, 1924–31); Chelsea (1932-40). His first solo show was at the Warren Gallery in 1928, the year of his first public commission for St James's Park. underground station. In 1929 he married Irina Radetsky, an RCA student. A pioneer of direct carving, Moore exhibited in the early 1930s with the Seven & Five Society and in 1933 joined Paul Nash's Unit One. He showed at both *International Surrealist Exhibitions* in London (1936) and Paris (1938). After his London home was bombed in 1940 Moore moved to Perry Green, Hertfordshire. As Official War Artist, he produced celebrated drawings of bomb shelters. He was awarded numerous Honorary degrees; the Companion of Honour (1955), Order of Merit (1963), West German Grand Cross of the Order of Merit (1980) and *Légion d'honneur*. He declined a knighthood in 1950.

RODRIGO MOYNIHAN

1910–1990, ELECTED 1933

British painter; born in Tenerife, lived in Wisconsin and Rome before enrolling at the Slade. In the early 1930s Moynihan gained critical attention as part of the 'Objective Abstraction' group. Joining The London Group in 1933, he sat on the hanging committee (1936–37). He had his first solo exhibition at the Redfern Gallery in 1940. Progressively abandoning abstraction, he became closely associated with the Euston Road School. During the Second World War he was an Official War Artist; his commissions included portraits of Princess Elizabeth and Clement Attlee. He taught painting at the Royal College (1948–57). In the mid-1950s he briefly returned to abstraction, swapping his richly impastoed style for larger smooth surfaces of saturated colour. In the 1970s, returning to figuration, he received numerous portrait commissions, including one of Margaret Thatcher (National Portrait Gallery). Moynihan married the painter Elinor Bellingham-Smith in 1931 (divorced 1960) and Ann Dunn in 1960.

PAUL NASH

1889–1946, ELECTED 1914

London-born painter, printmaker, photographer, designer and writer; attended Chelsea Polytechnic (1906–08) and Bolt Court, the London County Council School of Photo-Engraving and Photography, before enrolling at the Slade (1910–11). Nash held his first solo exhibition at the Carfax Gallery in 1912. In 1914 he worked for Fry's Omega Workshops and married Margaret Theodosia. He enlisted in the Artists Rifles in 1916 and was appointed an Official War Artist in 1917. Nash joined Vanessa Bell's Friday Club (elected 1913), New English Art Club (elected 1919), and the Society of Wood Engravers (elected 1922). In 1933 he founded Unit One, an experimental artists' group, which included Barbara Hepworth, Ben Nicholson and Henry Moore. The group disbanded after one show due to differences between the Abstractionists and Surrealists. Nash served on the committee for the 1936 London *International Surrealist Exhibition*. During the Second World War, he was again appointed Official War Artist, mainly for the Air Ministry. He taught at the University of Oxford (1920–23) and the Royal College (1924–25 and 1938–40). He died at Boscombe, Hampshire.

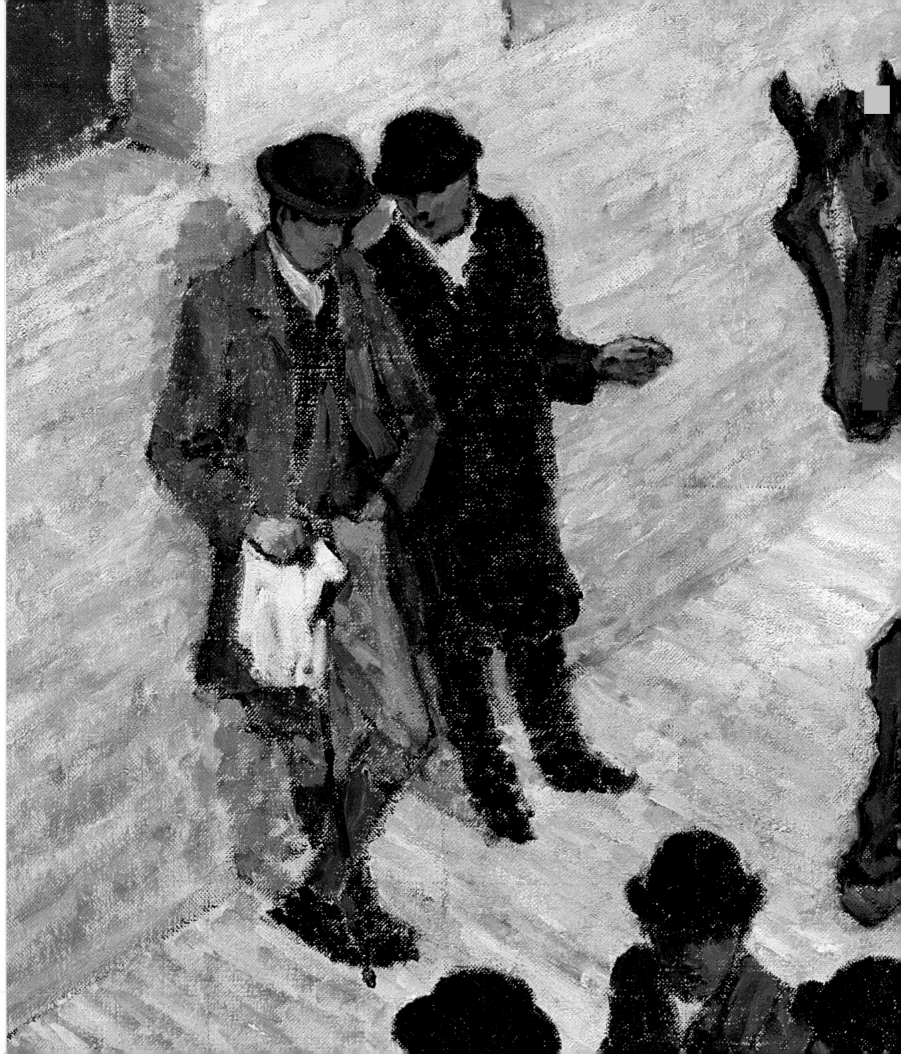

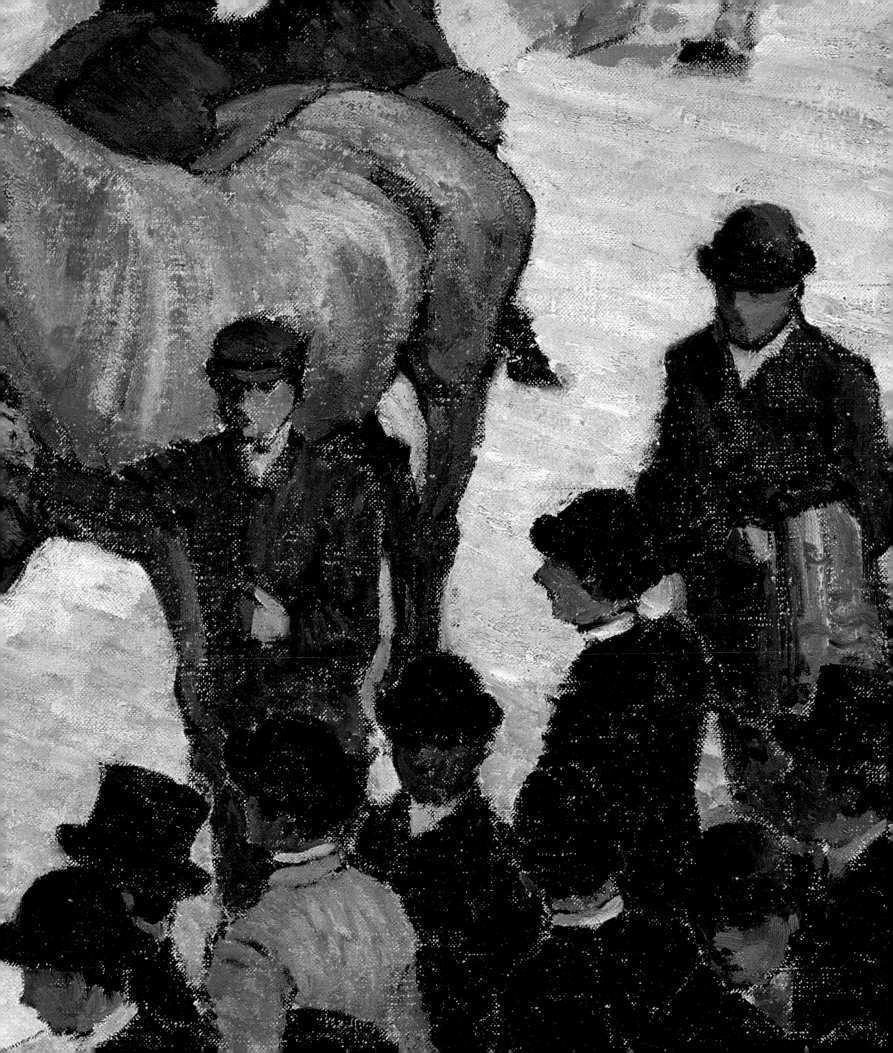

TIMELINE OF THE LONDON GROUP

COMPILED BY RACHEL STRATTON

1913

25 Oct: first meeting of The London Group (TLG), Harold Gilman elected president.
Nov: Constitution drawn up.

1914

June: first issue of Vorticist journal, *Blast*, published.
28 July: First World War declared.
Death of Spencer Gore.
Paul Nash and William Roberts elected to TLG.

1915

June: First (and only) Vorticist Exhibition held at Doré Gallery.
July: Second and final issue of *Blast* published.
Henri Gaudier-Brzeska killed in action.
Mark Gertler and Jacob Kramer elected to TLG.

1916

After Nov exhibition, William Marchant, owner of Goupil Gallery, refuses to exhibit 'enemy aliens, conscientious objectors or sympathisers with the enemy'.
TLG move exhibitions to Mansard Gallery in defiance.
Walter Sickert elected to TLG.
Matthew Smith's *Fitzroy Street Nude No. 2* rejected by TLG selection committee.

1917

Roger Fry elected to TLG.

1918

11 Nov: First World War ends.

1919

The Seven & Five Society is founded (1919–35).
Death of TLG president, Harold Gilman.
Vorticists refuse to take part in TLG exhibitions in protest at Bloomsbury dominance.
Duncan Grant, Bernard Meninsky and Vanessa Bell elected to TLG.

1920

Nov: *Group X* break away from TLG.
Bloomsbury artists refuse to exhibit.
Matthew Smith elected to TLG.

1921

Clive Bell publishes *Since Cézanne*, claiming Duncan Grant is best English painter.
Frank Dobson, Rupert Lee and Paule Vézelay (M Watson-Williams) elected to TLG.

1924

Frank Dobson elected president of TLG (1924–26).

1925

Death of Robert Bevan.

1926

Rupert Lee elected president of TLG (1926–36).
Jessica Dismorr elected to TLG.

1928

TLG Retrospective Exhibition.

1930

Barbara Hepworth, Edna Manley and Henry Moore elected to TLG.

1931

Oct: Rupert Lee calls for end of antagonism between TLG and RA.
Some members of TLG resign.
President of RA attends TLG exhibition private view.
Ivon Hitchens elected to TLG.

1933

30 Jan: Adolf Hitler elected German Chancellor.
Beginning of Objective Abstraction movement (ends 1936).
The Artists' International Association (AIA) set up as radical left-wing political organisation.
Eileen Agar, Rodrigo Moynihan, John Piper and William Coldstream elected to TLG.

1934

March–April: *Objective Abstraction* exhibition at Zwemmer Gallery. Death of Roger Fry.
Hans Feibusch and Victor Pasmore elected to TLG.

1935

Sep 1935: anti-semitic Nuremberg Laws in Germany lead to wave of enforced emigration.
Gertrude Hermes elected to TLG.

1936

June: *First International Exhibition of Surrealism* organised by André Breton, Roland Penrose and Herbert Read, New Burlington Galleries, London.
July: Spanish Civil War begins.
Rudolf Hellwag invites TLG to show in exhibition of British Modernism in Berlin. Many members speak out against supporting Nazi endeavours.
At annual meeting David Bomberg suggests TLG merge with AIA and Surrealists in support of anti-fascist movement but motion rejected.

1937

Ben Nicholson publishes journal *Circle* championing abstract art.
July: *Entartete Kunst (Degenerative Art)* exhibition opens in Munich, Germany.
Harold Sandys Williamson elected chairman of TLG (1937–43).

1938

Ceri Richards and Claude Rogers elected to TLG.

1939

3 Sep: Second World War declared.
Deaths of Jessica Dismorr and Mark Gertler.

1940

7 Sep: Battle of Britain begins. London is bombed for 57 days.
Ruskin Spear elected to TLG (1940–43).

1941

Foreword to third wartime exhibition written by William Mabane M P, Parliamentary Secretary, Ministry of Home Security.
He writes that the freedom of expression in TLG represents the spirit with which Britain fights fascism.

1942

Death of Walter Sickert.

1943

Elliot Seabrooke elected president of TLG (1943–48).

1945

8 May: VE Day.
14 August: VJ Day.

1946

The Borough Group is formed (disbanded 1951). Members include David Bomberg and Dorothy Mead. Deaths of Paul Nash and C R W Nevinson.

1948

L S Lowry elected to TLG.

1949

June: Penwith Society formed. Herbert Read is president. Members include Barbara Hepworth, Peter Lanyon and Ben Nicholson.
Death of Edward Wadsworth.
Ruskin Spear elected president (1949–50).
Kenneth Martin elected to TLG.

1950

John Dodgson elected president of TLG (1950–51).
Death of Bernard Meninsky.
No annual exhibition.

1952

Herbert Read writes introduction to catalogue for Venice Biennale British Pavilion, in which he coins phrase 'geometry of fear'. Claude Rogers elected president of TLG (1952–65). Deaths of Charles Ginner and Stanislawa de Karlowska. Lynn Chadwick elected to TLG.

1953

Kenneth Armitage elected to TLG.

1957

Deaths of David Bomberg and Wyndham Lewis.
No annual exhibition.

1958

Euan Uglow elected to TLG.

1959

Jacob Epstein, Rupert Lee and Matthew Smith die. Mary Martin elected to TLG.

1960

'Situation' exhibitions held at R B A Galleries and New London Galleries. John Bratby and Dorothy Mead elected to TLG.
Deaths of Vanessa Bell and Augustus John.

1962

Death of Ethel Sands.

1963

Death of Frank Dobson.

1964

TLG Jubilee Exhibition, Tate Gallery, London.

APPENDIX

MEMBERS AND EXHIBITORS OF THE LONDON GROUP IN THE BEN URI COLLECTION

MEMBERS:

Frank Auerbach

David Bomberg

Horace Brodzky

Jacob Epstein

Hans Feibusch

Mark Gertler

Julie Held

Josef Herman

Leon Kossoff

Jacob Kramer

Bernard Meninsky

Hyam Myer

Lucien Pissarro

Claude Rogers

Anthony Whishae

Edward Wolfe

NON-MEMBER EXHIBITORS:

Martin Bloch

Bernard Cohen

Ruth Collet

Mario Dubsky

Ernst Eisenmayer

Charles Fleiss

Patrick Hayman

Lilian Holt

Henry Inlander

Kalman Kemeny

Clara Klinghoffer

Fred Kormis

Ben Levene

Abrasha Lozoff

David Maccoby

Gerald Marks

Moshe Maurer

Michael Rothenstein

Michael Salaman

Freda Salvendy

Henry Sanders

Gilbert Solomon

Willi Soukop

Phillip Sutton

Scottie Wilson

Marek Zulawski

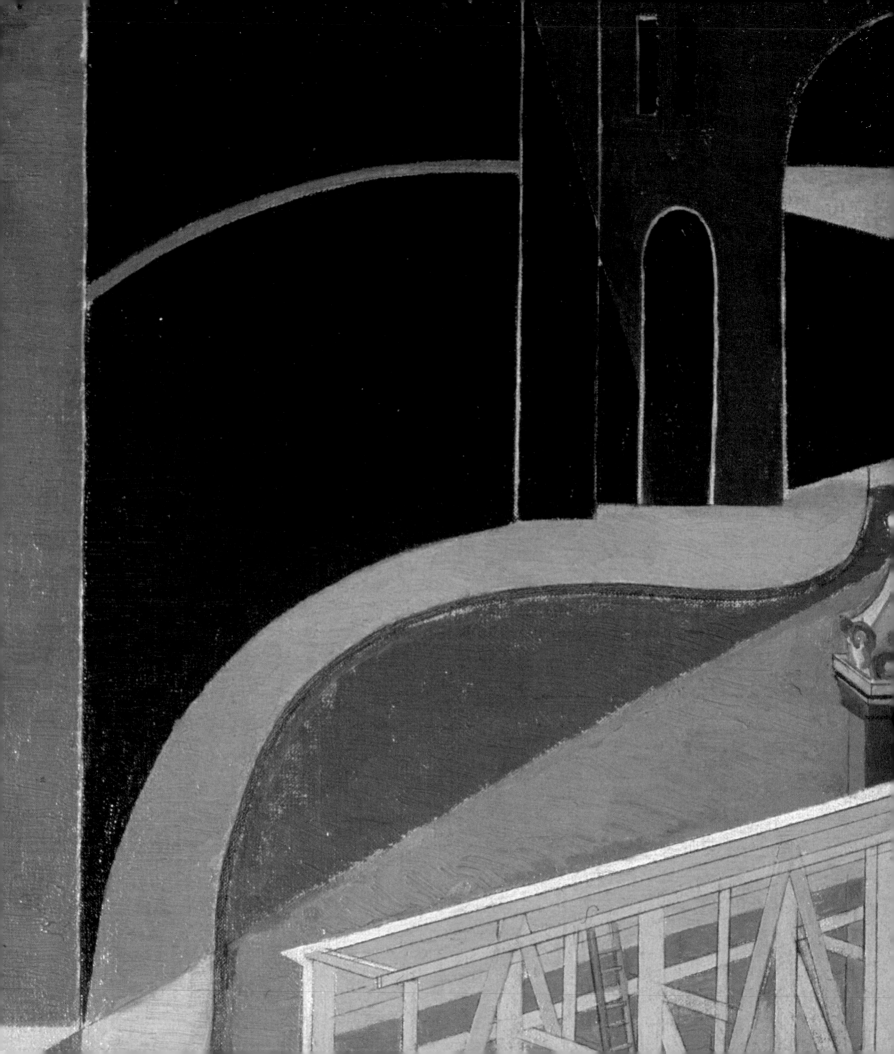

NOTES

INTRODUCTION: ORIGINS OF THE LONDON GROUP

1 A fuller account of the formation of the London Group is given in Wendy Baron, *Perfect Moderns: A History of the Camden Town Group* (Aldershot: Ashgate, 2000), pp.62–76.

2 All Sickert's letters to Ethel Sands and Nan Hudson quoted in this essay are in Tate Archive, London; TGA 9125.5.

3 A chart detailing the succssful and unsuccessful attempts to be elected to the London Group between October 1913 and 14th March 1914 is given in *Perfect Moderns*, op.cit, p.14

'UPROAR!': THE EARLY YEARS OF THE LONDON GROUP 1913–28

1 Denys J Wilcox, 'The London Group 1913–1939: Part One' (Ph.D. thesis, University of Bristol, 1997), p.23.

2 Roger Fry, 'Two Views of The London Group, I.', *The Nation* (14 March 1914), pp.998-9.

3 The Seven and Five Society – later Seven & Five (1919–1935) was founded as an alternative to The London Group during the period of rising Bloomsbury influence. Ivon Hitchens was both a founder member and still a member at its demise. At the first exhibition at Walker's Art Galleries in April 1920, the group printed a brief manifesto, but only became more influential with the influx of a new membership including Ben Nicholson (joined 1924, Chairman 1926), who reformed it from within, steering it towards abstraction. During 1926–30 Jessica Dismorr, Winifred Nicholson, Christopher Wood, Cedric Morris, David Jones and Frances Hodgkins all became members. Its most dynamic period was in the 1930s with four shows at the Leicester galleries; its last exhibition in 1935 at The Zwemmer Gallery has been described as 'the first all-abstract show in England' with a strong presence by Hepworth, Moore, Nicholson, Piper and Penrose.

4 P G Konody, *Observer* (8 March 1914), p.7.

5 See Denys J Wilcox, op.cit., p. 11.

6 Robert Bevan, Renée Finch, Harold Gilman, Edward Wadsworth, Harold Squire, W B Adeney, W Ratcliffe, Spencer Gore, Sylvia Gosse, J B Manson, Charles Ginner, Thérèse Lessore, Walter Bayes, C R W Nevinson, S de Karlowska, M C Drummond, Harald Sund, Ethel Sands, Edward Wadsworth, Spencer Gore, A H Hudson, Percy Wyndham Lewis, David Bomberg, Jessie Etchells, John Nash, C F Hamilton, Jacob Epstein and Henri Gaudier-Brzeska.

7 See: The Modernist Journals Projects, a joint project of Brown University and The University of Tulsa: www.dl.lib.brown.edu/mjp.

8 See Wendy Baron on Spencer Gore in this volume.

9 See Wendy Baron on Harold Gilman in this volume.

10 Even Fry, though concluding that the first exhibition justified the Group's formation, considered that the public would find these strange bedfellows 'puzzling' (*The Nation*, op. cit).

11 Arthur Clutton-Brock 'The Cubists' Error. Exhibition of The London Group', *The Times* (7 March 1914), p.6.

12 Sir Claude Phillips, 'Goupil Gallery. The London Group', *Daily Telegraph* (10 March 1914), p.5.

13 See Paul Edwards on Wyndham Lewis in this volume.

14 P G Konody, op.cit.

15 Unknown author, 'Shocking Art. Pictures Designed to Jolt the Senses', *Star* (1914, day and month unknown), cited Dominika Buchowska 'Around the galleries: art exhibtions in London in 1914' in *London, Modernism and 1914*, ed. M. Walsh (Cambridge: Cambridge University Press, 2010), p.219.

16 Cited ibid., p.221.

17 Ibid., p.222.

18 P G Konody, op. cit.

19 The New English Art Club had been formed in 1886 in direct opposition to the Royal Academy. Run by artists for artists, all matters of membership and the selection of exhibits were decided by a majority vote. There was a membership fee and the Honorary Secretary and Honorary Treasurer positions, members of the executive committee and the selecting and hanging juries were re-elected annually. See Kenneth McConkey, *The New English: A History of the New English Art Club* (London: Royal Academy of Arts, 2006).

20 Walter Sickert, 'A Monthly Chronicle. The London Group', *Burlington Magazine* (January 1916), in *Walter Sickert: The Complete Writings on Art*, ed. A Gruetzner Robins (Oxford: Oxford University Press, 2000), pp.400-401.

21 Unknown author, 'London Letters: "The Revolutionaries"', *Manchester Daily Guardian* (20 January 1914), not paginated.

22 P G Konody, op. cit.

23 Wendy Baron, *Perfect Moderns: A History of the Camden Town Group* (Aldershot: Ashgate, 2000), p.65.

24 'The typical New Englander and the typical London Grouper would each be likely to accuse the other of caring nothing about colour; the simple explanation being that, with a common eye to decorative possibilities, one is thinking of colour in its atmospheric and the other in its constructive values', the *Spectator* observed as late as 1935. ('Art Exhibitions of the Year', *Art Review – A survey of British Art in all its Branches – during the year 1935*, the Artist Publishing Company, London, 1935), p.22, cited McConkey, op.cit., p.170.

25 Epstein and Gaudier exhibited sculpture in March 1915; only Nevinson in November 1915; and only Epstein in June 1916. No sculpture was shown in the following exhibitions: 5th exhibition November–December 1916; 6th exhibition April–May 1917; 7th exhibition in November 1917; 8th exhibition May–June 1918; 9th exhibition in November 1918; 10th exhibition April–May 1919. Epstein then showed nothing until 1926; work by both Gaudier and Epstein was shown in the 1928 retrospective. Rupert Lee showed sculpture in the 11th exhibition in November 1919.

26 P G Konody, op. cit.

27 Fry, 'Two Views of The London Group, I.', op. cit.

28 T E Hulme, 'Modern Art. III, The London Group', *The New Age*, Vol XIV, no. 21 (26 March 1914), p. 661.

29 Now known as *Flenite Relief*, see Evelyn Silber on Jacob Epstein in this volume.

30 *The Connoisseur*, Vol. 40 (May 1915), p.56.

31 '"Junkerism in Art", The London Group at the Goupil Gallery', *The Times* (10 March 1915), p.8.

32 Ibid.

33 St John Irvine, 'The War and Literature', *The Englishwoman* (October 1915).

34 'Junkerism in Art', op. cit.

35 Author unknown, *Manchester Guardian* (13 March 1915), cited Jonathan Black 'Touching Civilisation in its tender mood', in *London, Modernism and 1914*, ed. M Walsh, op. cit., p.195, n. 94.

36 See Michael Walsh on C R W Nevinson in this volume.

37 Frank Rutter, *Some Contemporary Painters* (London: Leonard Parson, 1922), pp.195-6

38 Ibid.

39 P G Konody, *Observer* (14 March 1915), cited Richard Cork, *Wild Thing: Epstein, Gaudier-Brzeska, Gill* (London: Royal Academy of Arts, 2009), p.171.

40 Augustus John to John Quinn, cited Stephen Gardiner, *Epstein: Artist Against the Establishment* (London: Michael Joseph, 1992), p.140.

41 Mark Gertler to Dora Carrington, Friday morning, November 1915, in ed. N. Carrington *Mark Gertler: Selected Letters* (London: Rupert Hart-Davis, 1965), p.104.

42 Mark Gertler to Dora Carrington, Sunday, December, 1915, ibid., p. 106.

43 See Sarah MacDougall on Mark Gertler in this volume.

44 'Puritanism in Art, The London Group', *The Times* (2 June 1916), p.11.

45 Cited Jenny Pery, *The Affectionate Eye: the life of Claude Rogers* (Bristol: Sansom and Company, 1995), p.42.

46 See Alexandra MacGilp on Matthew Smith in this volume.

47 See Robert Upstone on Charles Ginner in this volume.

48 *Evening News* (24 April 1917), London Group Press Cuttings, Tate Archive, London, TGA 7713.11.1.1.28.

49 Lytton Strachey to Lady Ottoline Morrell, 3 July 1916, cited Michael Holroyd, *Lytton Strachey* (London: Chatto and Windus, 1994), p.369.

50 St John Hutchinson to Mark Gertler, [*c.* November 1916], in *Mark Gertler: Selected Letters*, pp. 128-9.

51 *Daily Chronicle* (10 August 1917), p.31.

52 C Lewis Hind, 'A New Picture Gallery – What Youth is Painting', *Daily Chronicle* (10 May 1917), TGA 7713.11.1.1.31.

53 *Evening News*, op. cit.

54 *Star* (26 April 1917), TGA 7713.11.1.1.27.

55 See Robert Upstone on Stanislawa de Karlowska and Robert Bevan in this volume.

56 See Wendy Baron on Ethel Sands in this volume.

57 Six of the seven were connected to Sickert and the Camden Town Group; only Jessie Etchells was associated with Roger Fry and Bloomsbury.

58 They were joined by Mary Godwin (1887–1960), who had also studied under Sickert and Gilman; and in the fourth exhibition by Phyllis Barron.

59 *The Times* (10 November 1917), p.9.

60 'The London Group', *Globe* (12 November 1917), TGA 7713.11.1.1.41.

61 P G Konody, '"Arts and Artists", the London Group', *The Observer* (12 May 1918), p.3.

62 See Grace Brockington on Vanessa Bell in this volume.

63 Bernadette Murphy, 'The Art of Today. The London Group', *The New Witness* (27 May 1921), TGA 7713.11.1.1.81.

64 See Jane England on Paule Vézelay in this volume.

65 Born in New York, Belle Cramer (1883–1978) moved to Edinburgh in 1906 upon her marriage to Dr William Cramer in 1906, studying at the Edinburgh College of Art. They moved to London at the outbreak of the First World War because of her husband's German citizenship. Among the artistic set at the Café Royal, the Cramers met Ginner, Gilman and Epstein, commissioning the latter to create a bust of Dr Cramer; he also sculpted Belle. She exhibited with The London Group in 1917, 1918, 1920, 1925, 1926, 1929, 1931, 1932, 1934, 1937 and 1938. She also exhibited with the Royal Institute, the Royal Portrait Society, and the NEAC. Frank Rutter gave Cramer her first solo show in his own gallery and she had six solo shows during her time in London. The majority of her London work was either destroyed during the war or abandoned when she returned to the States with her husband at the onset of the Second World War.

66 John Salis, 'The Art of Today, The London Group', *New Witness* (15 November 1917), TGA 7713.11.1.1.43.

67 See Anna Gruetzner Robins on Roger Fry in this volume.

68 *The Times* (10 November 1917), p.9.

69 He continued, '[…] No. 52 is a sticky blur; No. 53 is a blur (greasy); 54, a blur (muddy); 55, blur (pure and simple); 56, blur (sticky); 57 is a sectionised blur leaning to the left next to Picasso; 58, a still muddier blur; 59, a blur with a glare on it; 60, patches; 62, a poster effort for Chu Chin Chow [a musical comedy], inexcusable, but tempered by the kindly chiaroscuro of the alcove. And in this manner we might continue.' B H Dias (Ezra Pound), 'Art Notes: At Heals', *The New Age*, Vol 22, no. 4 (22 November 1917), pp. 74-5.

70 For further discussion, see Juliet Steyn, 'Inside Out: Assumptions of "English" Modernism in the Whitechapel Art Gallery, London, 1914' in *Art Apart: Art Instituions and Ideology across England and North America*, ed. M. Pointon (Manchester: Manchester University Press, 1994), pp. 212-30; Lisa Tickner *Modern Life and Modern Subjects* (New Haven and London: Yale University Press, 2000), p. 146; and Sarah MacDougall 'Something is Happening There': Early British Modernism, the Great War and the Whitechapel Boys' in *London, Modernism and 1914*, ed. M Walsh, op. cit., pp.122-147.

71 The Friday Club (1905-22) initially provided a platform for the artist members of the Bloomsbury Group to exchange ideas, but soon widened to include many non-Bloomsbury exhibitors, including many members of The London Group: Allinson, Baynes, Bevan, Sydney Carline, Malcolm Drummond, Frederick Etchells, Jessie Etchells, Gilman, Ginner, Hamnett, McKnight Kauffer, John Nash, Paul Nash, Nevinson and Roberts, also among them. Its exhibitions were held at a number of small venues but primarily at the Alpine Club Gallery, Mill Street. See Richard Shone, *The Friday Club, 1905-1922* (London: Michael Parkin Gallery, 1996), unpaginated.

72 Gertler exhibited with the Omega Workshops in 1917 and 1918. Wolfe was one of the last artists to be associated with the Omega before it closed in 1919.

73 Clive Bell, 'Fine Arts: The London Group', *Athenaeum* (25 April 1919), pp.241-2.

74 *Outlook*, 15 May 1920, cited Denys J Wilcox, *The London Group 1913–1939: The Artists and Their Works* (Aldershot, Hants: Scolar Press, 1995) p. 22.

75 *Jewish Guardian* (21 May 1920), TGA 7713.11.1.1./5.

76 See Sarah MacDougall on David Bomberg in this volume.

77 See Irving Grose on Bernard Meninsky in this volume.

78 Ivor Byrne, 'Reviews. The Art of Today. Royal Academy and London Group', *New Witness* (14 May 1920).

79 R R Tatlock, 'Contemporary Art at the Hampstead Art Gallery', *Burlington* 37 (September 1920), p.165.

80 He passed briefly through London and Paris between April 1922 and January 1923. His lack of a UK reputation and the fleetingness of his visit is perhaps the reason for the omission of his given name. Kottler's bust of the South African Prime Minister Jan Christian Smuts (1949) is in the National Portrait Gallery, London.

81 B H Dias [Ezra Pound], 'Art Notes', *The New Age* (April 1919).

82 R H W [Wilenski], 'Exhibitions of the Week: Mansard Gallery: Eleventh Exhibition of the London Group', *Athenaeum* (7 November 1919), p.1158.

83 Its name a conflation of Monet and Pissarro, it held its first, well-received exhibition in 1919.

84 See Wilcox, 1995, pp. 15-16, for further discussion.

85 Ibid.

86 See David Cleall on William Roberts in this volume.

87 Bernadette Murphy, 'The Art of Today, The London Group', *The New Witness* (27 May 1921), TGA 7713.11.1.1.81.

88 D S MacColl, *Saturday Review* (29 October 1921), cited Maureen Borland, *D. S. MacColl: Painter, poet, art critic* (Harpenden: Lennard Publishing, 1995), p.249.

89 Cited Wilcox, 1995, p.238.

90 MacColl responded with an article called 'The Nonsense About Cézanne'; R R Tatlock retaliated in the *Burlington Magazine*; and Hugh Blaker weighed in to the *Saturday Review* (17 December 1921).

91 *Sunday Times* (14 May 1922), TGA 7713.11.1.1.81.105.

92 P G Konody, 'The London Group', *Observer* (14 May 1922), TGA 7713.11.1.1.105.

93 *Saturday Review* (21 November 1922), TGA 7713.11.1.1.132.

94 *Evening Standard* (6 May 1922), TGA 7713.11.1.1.81.107.

95 'Modernism in Art. Exhibition of The London Group', *Daily Mail* (24 April 1923), TGA 7713.11.2.

96 'Patriotism', *Daily Sketch* (25 April 1923), TGA 7713.11.2.

97 See Neville Jason on Frank Dobson in this volume.

98 See Denys J Wilcox on Rupert Lee in this volume.

99 'The London Group', *Manchester Guardian* (10 October 1923), TGA 7713.11.2.

100 'Contemporary Art, The London Group', *Architect's Journal* (24 May 1922), TGA 7713.11.1.1.115.

101 'Pictures', *Daily Express* (9 January 1926), TGA 7713.11.2.

102 Art Exhibition: The London Group, *The Times* (4 June 1926), p. 12.

103 Anon., 'The Royal Academy Exhibition – The Oil Paintings – Some Successes and a Limitation', *The Times* (3 May 1926), p.8, cited McConkey, op. cit., p.159, n. 91.

104 M T H S, 'The London Group: XIIth Exhibition', *Westminster Gazette* (20 May 1920), TGA 7713.11.1.1.72.

105 'Back to Normal in London Art, No Futurist Sensations at the New Exhibition, *Evening News* (7 January 1926), TGA 7713.11.2.

'NEITHER GOSPEL NOR CREED': THE LONDON GROUP 1928-49

1 The catalogue gives dates only as April–May 1928.

2 Of the then current members only William Ratcliffe failed to exhibit; all past members except Boris Anrep, Mario Bacchelli, Jessie Etchells, Renée Finch, Chantal Quenneville and Harold Sund were represented.

3 *The Jew* caused uproar in the daily, art and Jewish press alike during 1917. See ed. John Roberts *The Kramer Documents* (Valencia, privately published 1983), pp.20-28. The original documents are held in the Kramer archives, Special Collections, Brotherton Library, University of Leeds.

4 Exhibit no.132, 1918, though misdated in the catalogue to 1917. The title was heavily ironic

5 Allan Walton (1892–1948) studied at the Slade, Académie de la Grande Chaumière in Paris, and at Westminster School of Art under Sickert. He showed with the Group from the early 1920s and was elected in 1925. With his brother Roger he founded Allan Walton Textiles in 1931, promoting designs by his London Group colleagues, notably Duncan Grant and Vanessa Bell, and supplied all textiles for Maynard Keynes's rooms at Cambridge. Walton was one of the first Royal Designers for Industry, was Director of Glasgow School of Art 1943–45 and was appointed Professor of Textile Art, Royal College of Art in 1948.

6 Catalogue for *The London Group Retrospective Exhibition 1928*, unpaginated.

7 Ibid.

8 Ibid.

9 'Art Exhibition. The London Group', *The Times* (28 April 1928), p.16.

10 'London News, London Group Retrospect', *The Scotsman* (30 April 1928), p.8.

11 R R Tatlock, 'London Group. A Retrospective Exhibition. 15th Birthday', *Daily Telegraph* (28 April 1928), p.10.

12 See Richard Shone on Duncan Grant in this volume.

13 'Advanced Ideas in Art, Winter Exhibition of London Group. Yorkshire Successes', *Yorkshire Post* (4 January 1929), p.3.

14 Stephen Reid, 'Current Art Notes. Essays in Rotundity', *Connoisseur* (Vol.83, February 1929), p.124.

15 Wyndham Lewis, February 1929, London, TGA 7713.11.2.

16 An 'open-air' exhibition of sculpture staged in Battersea Park in London in 1948 pioneered the idea of taking sculpture to 'the people'. It gave ordinary citizens as opposed to regular gallery-goers the opportunity to freely experience contemporary sculpture.

17 The Society, founded in 1874 and located off Piccadilly, provided employment for women, and continued to print the Group catalogues throughout the 1930s and 1940s.

18 'Modern Sculpture. Passing of the Traditional. London Group Exhibits,' *The Scotsman* (3 June 1930), TGA 7713.11.2.

19 '"The London Group." Over Emphasis in Form and Movement. 28th Exhibition.' *The Morning Post* (14 October 1930), p.5.

20 Rupert Lee, 'Answering a Critic', *Daily Express* (6 June 1930), TGA 7713.11.2.

21 Unit One also included founder London Group member Wadsworth and later member Edward Burra (1905–76, elected 1949). Together with architect Wells Coates and critic Herbert Read, they envisaged revitalising British art by embracing the dual continental developments of abstraction and surrealism.

22 Her cousin Norman Manley, founder of the Jamaican People's National Party, who served as Chief Minister and Premier of the island.

23 Through Manley's friendship with the gallery's founder, John Rothenstein.

24 See Wayne Brown, *Edna Manley: The Private Years 1900–1938* (London: Deutch 1975), p.231.

25 David Fincham, 'Art', *The Spectator* (18 October 1930), p.532.

26 Catalogue for *The London Group Twenty-Ninth Exhibition*, 12–30 October 1931, p.3.

27 Herbert Furst, 'Art News and Notes. The London Group – Twenty-Ninth Exhibition – at the New Burlington Galleries. Also the R.O.I. Piccadilly', *Apollo* (Vol.14, 26 October 1931), p.301.

28 C R W Nevinson, 'The London Group', *New Statesman and Nation* (31 October 1931), TGA 7713.11.2.

29 'Art Exhibition. The London Group', *The Times* (13 October 1931), p.10.

30 Catalogue for *30th Exhibition*, 10–28 October 1932, p.3.

31 A natural progression from Hinks's suggestions towards successful selling was the *Modern Room Exhibition*, held at the Adams Gallery (Maurice Adams Ltd) in October 1933. The exhibition integrated painting and sculpture by members of the Group, including Sickert, John Nash, Fry and Gertler, in room-sets furnished with modernist pieces designed by interior designer Adams, who had abandoned a more traditional aesthetic style in favour of the sleeker, and hopefully more lucrative modernist lines.

32 13 November–1 December 1933.

33 'Our London Correspondents, 'Our London Letter. Cubist Revival', *The Yorkshire Observer* (11 November 1933), p.8.

34 The description 'kaleidoscopic' had been used to criticise earlier modernist works. See Sarah MacDougall in this volume.

35 Frank Rutter, 'The Galleries. One Thing At A Time. The London Group', *The Sunday Times* (19 November 1935), p.5.

36 Peter Norman Dawson (1902–1960). Elected in 1933, Dawson began exhibiting with the Group in 1931, only six years after graduating from the Royal College of Art. Peter and Cicely Dawson lived in Hampstead and actively socialised with the local

artistic community which included Henry Moore and Roland Penrose. Dawson was therefore at the vanguard of the Surrealist movement in Britain when Penrose and Herbert Read formally launched it in 1936, and he exhibited at the *First International Exhibition of Surrealism* at the New Burlington Galleries in the same year. Dawson emerged as one of the more controversial and divisive members of The London Group. In 1938, *Before the New Atlantic State*, framed with barbed wire, was described by one critic as 'picture of the year', depicting 'St George in full suit of armour with a spear behind him impaling the Union Jack, a crucifix and two writhing bodies.' *The Evening News* branded the painting a 'shocker', whilst The *New Statesman* professed it to be 'awful'. The explicitly political subject was characteristic of the work Dawson submitted to Group exhibitions at the time and, as the threat of war loomed, he became increasingly politicised, involved in the Artists' International Association and the International Peace Campaign. However, Dawson subsequently faded from public attention and was largely forgotten at the time of his death. New research for this volume has been compiled by Rachel Stratton, Curatorial Assistant.

37 See Andrew Lambirth on Eileen Agar in this volume.

38 'Portrait on Wallpaper. They cut if off and framed it.' *Sunday Dispatch* [Irish Edition] (10 November 1935), TGA 7713.11.2.

39 Frank Rutter, 'The Galleries. Light on Darkness. "Little Two-Eyes". A New Theory of Painting. The London Group', *Sunday Times* (15 November 1936), p.7.

40 11 June–4 July 1936.

41 T W Earp, 'The London Group Exhibition', *Daily Telegraph* (17 November 1936), TGA 7713.11.1.2.4.

42 'Our London Art Critic, 'Art in London. Turbulent London Group', *The Scotsman* (18 November 1936), p.15.

43 See Quentin Stevenson on Jessica Dismorr in this volume.

44 'London Letter. London Group's Modernity', *Cork Examiner* (11 November 1936), p.6.

45 'Art. Exhibtions', *New English Weekly* (19 November 1936), TGA 7713.11.1.2.3.

46 *Catholic Herald* (November 1936).

47 Pierre Jeannerat, 'Art Crimes in Liberty's Name', *Daily Mail* (12 November 1936), TGA 7713.11.1.2.6.

48 Frank Rutter, 'The Galleries. History as it is Written. The London Group. Origin and Provenance, *The Sunday Times* (14 March 1937), p.7. The work also became *News Review's* 'Most discussed item […] a large oil-painting with stuck-on paper additions. Surrealist Dawson spent a year on it, got the basic idea from a game in which one person writes an adjective, another independently a noun and so on, thus making thought-provoking sentences. Dawson wrote "vein" and the complete sentence became "rhythmic blue vein" which he here depicts, trailing from the skull. The pasted additions, roses, cobra, diaphragm muscles, lung, were taken from a book on anatomy.' 'Art. Advance-Guard's Come-Back', *News Review* (18 March 1937), TGA 7713.11.1.2.21.

49 'What's In A Name? Barbed Wire Frame', *Shields Evening News* (11 November 1938), TGA 7713.11.1.2.51.

50 'What's In A Name?' *Nottingham Journal* [and] *Birmingham Gazette* (12 November 1938), TGA 7713.11.1.2.50.

51 *Artist* (January 1937), TGA 7713.11.1.2.13.

52 Catalogue cover only states March 1937.

53 Pierre Jeannerat, 'Modern Art For the Man in the Street', *The Daily Mail* (10 March 1937), p.8.

54 'Anti-Acadmey. Subconcious, Is It?', *Evening News* (5 March 1937), TGA 7713.11.1.2.21.

55 T W Earp, 'Modern Art Tendencies. Exhibition by the London Group', *Daily Telegraph* (9 March 1937), TGA 7713.11.1.2.22.

56 'City Art Gallery. Exhibition of Contemporary British Art', *Wakefield Express* (10 April 1937), TGA 7713.11.1.2.27.

57 'Art. The London Group', *The Daily Sketch* (29 October 1937), TGA7713.11.1.2.36.

58 'Northern Artists' Work. Exhibits in the London Group. From Our Own Correspondence', *Yorkshire Observer* (30 October 1937), TGA 7713.11.1.2.36.

59 Full list of Working Committee: Bernard Adeney, R P Bedford, Alan Durst, R O Dunlop, John Farleigh, Gertrude Hermes, Rupert Lee, John Piper.

60 Named after the address of the School at 314 Euston Road, London NW1.

61 Latterly, their influence impacted significantly on English art school education, particularly through the presence of Rogers and Coldstream at the Slade School of Fine Art.

62 Graham Bell, 'The Intelligent Man's Royal Academy' *New Statesman and Nation* (21 November 1936), p.810.

63 See Denys J Wilcox, *The London Group 1913–39: The Artists and their Works* (Aldershot: Scolar Press, 1997), pp.25-27.

64 19 July–30 November 1937, subsequently touring to eleven other cities in Germany and Austria.

65 See ed. John Roberts, *The Kramer Documents* (Valencia: private publisher, 2003), pp.144-45.

66 After an interlude at the Leicester Galleries, the winter Group show returned to the New Burlington Galleries, which had just hosted the controversial July 1938 *Exhibition of Twentieth Century German Art*, staged to demonstrate solidarity with many of the continental artists who had been declared degenerate by the Nazi regime.

67 'Artists Look at Jamaica', *Evening Standard* (11 November 1938), TGA 7713.11.1.2.50.

68 Ibid. 'Mr Augustus John recently visited Jamaica and held an exhibition of his Jamaican pictures in London. Since then he has actively interested himself in the conditions of the West Indian native, with especial reference to the recent riots. Other artists are supporting him.'

69 See Jennifer Powell and Jutta Vinzent, *Art and Migration* (Birmingham: George Bell Institute, 2005), pp.1-16.

70 Ibid, pp.24-32.

71 CEMA (The Committee for the Encouragement of Music and the Arts) predecessor to The Arts Council of Great Britain was formed informally in 1939.

72 As a counter to the breadth of émigré involvement with the Group, it is notable that in 1937 Berlin-born artist Hans Jaenisch (1907–1989), a German national who would become an American prisoner of war, showed a single work *Composition*.

73 Roessingh created a range of artworks which recorded his internment in Onchan camp, Isle of Man. See exhibition leaflet to accompany *Forced Journeys*, Sayle Gallery, Douglas, Isle of Man, 2010.

74 Julius Juno, Art Notes. Hans Feibusch in The London Group', *Jewish Chronicle* (16 November 1934), p.30.

75 Herbert Furst, ' Art Notes by The Editor. Round the Galleries. The London Group and the New English Art Club', *Apollo*, 'The London Group' (Vol.24, no.144December 1936), p.371.

76 'Jewish Artists and Modern Developments', *Jewish Chronicle* (14 September 1928), pp.24–25.

77 K., 'The London Group of To-day. Modern "Emotionalism" at the Mansard Gallery', *Jewish Chronicle* (21 June 1929), p.35.

78 K., 'The London Group Exhibition. Worth-while Works by Jewish Artists', *Jewish Chronicle* (18 October 1929), p.24.

79 Ibid.

80 As a refugee in Stoke-on-Trent from 1936, Bauhaus-trained Marks found work in the Midlands pottery industry, eventually establishing an independent ceramics studio.

81 The 1939 show included one work by German émigré painter Ernst Dreyfuss (1903–1977), briefly in England following his recent release from Buchenwald.

82 13 December–1 February 1941.

83 Jan Gordon, 'Art and Artists', *The Observer* (26 October 1941), p.7.

84 Also interned in Hutchinson camp.

85 Catalogue for *Third War-Time Exhibition*, 22 October–19 November 1941, p.3.

86 Uhlman had been interned in Hutchinson camp on the Isle of Man, the so-called 'artists' camp as it had housed renowned figures including Kurt Schwitters and Ludwig Meidner.

87 E. N., 'Burlington House. Four Picture Exhibitions', *Manchester Guardian* (9 November 1943), p.3.

88 He escaped to Scotland in 1943 before settling in London, becoming a member of the Group in 1953 prior to returning to Poland in 1958. From 1948 onwards he exhibited with Gimpel Fils. In 1960 he represented Poland at the Venice Biennale.

89 Schooled in England from 1933 and a Slade graduate, he had recently returned from internment in Canada.

90 Martin Bloch, also interned in Hutchinson camp.

91 Katerina Wilczynski, German painter and illustrator, 1894–1978.

92 12 October–9 November 1944.

93 Arriving in Britain on one of the last *kindertransports*, Einzig faced difficult early years as a young refugee art student evacuated from London. A number of her later tutors at the Central School included Group members Hermes, John Farleigh (elected 1927), Meninsky and Roberts. As the anglicised 'Susan' she became known as illustrator of the children's classic *Tom's Midnight Garden* by Philippa Pearce published in 1958.

94 'Our London Correspondence. The London Group', *Manchester Guardian*, (16 October 1944), p.4.

95 See Douglas Hall, *Art in Exile Polish Painters in Post-War Britain* (Bristol: Sansom & Co., 2009), pp.149-89.

96 See Fran Lloyd 'Ernst Eisenmayer: A Modern Babel' in *Forced Journey: Artists in Exile in Britain c 1933-1945*, eds. Sarah MacDougall and Rachel Dickson (London: Ben Uri, 2009), pp.64–73.

97 Author of childrens' classics *The Tiger Who Came to Tea* and *When Hitler Stole Pink Rabbit*.

98 Born Ladislas Weisz, he took on the less Jewish name Laszlo Péri on moving to Germany. In 1935, he and his wife moved to Hampstead. Although he had become a British citizen in 1939 and had taken the anglicised first name 'Peter', the Group catalogue still referred to him as 'L. Peri'.

100 David Redfern, *The London Group Origins and Post-War History* (London: Croydon College, 2008), p.2.

101 *Third War-Time Exhibition*, 22 October–19 November 1941.

102 *New Statesman and Nation* (26 November 1938), pp.873–4, TGA 7713.11.1.2.61.

103 *The Observer* (26 October 1941), p.7.

104 *Manchester Guardian* (1 November 1943), p.4.

105 *Manchester Guardian* (1 May 1948), p.4.

106 Enwonwu continued his studies at Ruskin College, Oxford.

107 19 March –2 April 1946.

108 Widow of the writer and art critic Jan Gordon, who had been a particular supporter of émigré artist and gallery owner Jack Bilbo, Cora had studied at the Slade.

109 Foreword to catalogue for *The London Group Exhibition of Paintings*, unpaginated.

110 21 May – 6 June 1948.

111 Foreword to catalogue for *The London Group*, unpaginated.

112 A D B Sylvester, 'Arts and Entertainment. Round the Galleries', *New Statesman* (Vol.37, no.933, 22 January 1949), p.78.

MANY PERSUASIONS: THE LONDON GROUP 1950-64

1 This had increased to 84 by November 1951.

2 According to David Redfern (*The London Group: Origins and Post War History* (Privately printed: 2008, unpaginated) over the two 1951 exhibitions, a total of 728 works were shown – the largest postwar showing by the Group in one year.

3 The Festival of Britain was a showcase of British culture designed to demonstrate the quality of modern architecture and its aesthetic unity with painting and sculpture. Work by artists included murals by Josef Herman, Victor Pasmore, John Tunnard, Feliks Topolski and John Piper and sculptures by Barbara Hepworth, Henry Moore, Lynn Chadwick, Frank Dobson, Jacob Epstein and Reg Butler, as well as émigrés Lazlo Peri and Siegfried Charoux. In summer 1951, as part of the Festival of Britain, Ben Uri hosted an *Art Section*, in addition to the main *Anglo-Jewish Exhibition 1851–1951* featuring émigrés including Jankel Adler, Alva, Martin Bloch, Benno Elkan, Hermann Fechenbach, Hans Feibusch, Else Fraenkel, Josef Herman, Kalman Kemeny, Fred Kormis, Max Sokol and Fred Uhlman.

4 See Jenny Pery, 'Painting a Dream World from Life' in *John Dodgson: Paintings and Drawings* (London: The Fine Art Society, 1995), p. 20.

5 Morris Kestelman's archival history of the Group was donated to the Tate.

6 Andrew Forge wrote of this period, 'however receptive to novelty we may be now, or wise to the dialectic of style, we can be certain that good painting does not get exhibited by some ineluctable process. There are more ways than one for an artist to escape attention. It is the claim of the London Group that it tries to take account of this fact.' Cited Pery, op. cit.

7 'The London Group: Large Exhibition', *The Times* (14 February 1951), p. 6.

8 See Rachel Dickson on Kenneth Armitage in this volume.

9 *The Times* (14 February 1951), op. cit.

10 Ibid.

11 See Philip Martin on Mary Martin in this volume.

12 See Philip Martin on Kenneth Martin in this volume.

13 'The London Group: Recent Developments in British Painting', *The Times* (6 November 1951), p.8.

14 'The London Group: Encouraging the Young Painter', *The Times* (27 October 1952), p.8. Readers were also reminded of the egalitarian nature of the system in that there was no selection committee and that all members simply voted on whether a work should be included.

15 Ibid.

16 'The Arts: London Group. Works by Young Artists', *The Times* (3 November 1953), p.3. See Sarah MacDougall on Euan Uglow in this volume.

17 'Around the London Art Shows. Fine Loan Collection from Durham', *The Scotsman* (1 November 1952). See Alice Wiggett on Lynn Chadwick in this volume.

18 Myfanwy Piper, *Time and Tide* (1 November 1952).

19 Quentin Bell, 'Around the London Art Galleries', *The Listener* (20 November 1952), p.856.

20 John Berger, *New Statesman and Nation* (17 May 1952), p.586.

21 Émigré painter and graphic artist Marek Zulawski (1908–1985), known as 'Marek', was born in Rome and studied art in Warsaw and Paris before moving to London in 1936. In 1959 he exhibited alongside Oscar Kokoschka, Josef Herman and Tadeasz Piotr (Peter) Potworowski as part of a touring exhibition of Continental painters working in Britain. His work is in the Ben Uri collection.

22 Rogers et al, 'Art Gallery for Central London', letter to the Editor, *The Times* (28 June 1955), p.9. The other signatories were: Mary Fedden, Chairman, Women's International Club; Adrian Heath, Chairman, the Artists International Association; Robin Darwin, Principal, The Royal College of Art; and Lawrence Gowing, Professor of Fine Art, King's College, University of Durham.

23 'The Arts: London Group's Exhibition, "Members Only"', *The Times* (18 November 1955), p.3.

24 'Mr Grant's method of making a picture seems now to be almost automatic, and the three ducks swimming in his *Farm Pond* have a comic unreality which suggests how much he has lost touch with the visual fact, while Mrs. Bell's neon-lit dummy of a bather is singularly devoid of that essential Bloomsbury quality, taste.' (Ibid.)

25 Though Herman's drawings were criticized as recalling 'Guerin's comment upon the young Géricault, […] to the effect that *his* forms were closer to violin cases than to violins.' (Ibid.)

26 Bomberg showed *Rising Wind, Ronda, Andalusia* (1954) and *Vigilante, España* (1954).

27 Ibid.

28 David Sylvester, 'The London Group', *New Statesman* (9 March 1962).

29 See Maurice Yacowar on John Bratby in this volume.

30 John Berger, 'John Bratby', *New Statesman and Nation* (25 September 1954), p.358.

31 Atticus, *The Sunday Times* (23 October 1955).

32 No surviving catalogue has been traced for the February 1957 exhibition.

33 Leslie Marr and Dennis Creffield, both Borough Group members, would be elected to The London Group in 1961 and 1962 respectively, strengthening the presence of the 'Bombergers'.

34 See Rachel Fleming-Mulford on Dorothy Mead in this volume.

35 See Stephanie Farmer on Leon Kossoff in this volume.

36 15 July – 16 August 1964.

37 Claude Rogers, foreword to *London Group 1914-1964 Jubilee Exhibition: Fifty Years of British Art Tate Gallery* (London: Tate Gallery, 1964), unpaginated.

VISION AND LEADERSHIP

1 Charles Ginner, 'Harold Gilman: An Appreciation', *Art & Letters*, vol. II. no. 3 (summer 1919): p.134.

2 Ibid.

3 During the First World War Mary Godwin, Sylvia Gosse, Stanislawa de Karlowska and Thérèse Lessore served regularly on the Group's hanging committee and were instrumental in maintaining the Group's survival. These artists had previously been denied membership of the male-only Camden Town Group.

4 Percy Wyndham Lewis and Louis F. Ferguson, *Harold Gilman* (London: Chatto & Windus, 1919), p.12.

5 Ibid.

6 Frank Rutter described Adeney thus: 'a blameless echoer in biscuit and pale-green tints of Cézanne's less successful nudes and landscapes – succeeded Gilman in the presidency. His approach to Cézanne made him worthy of the Chair: but Mr. Fry remained the power behind his throne.' *Art in My Time* (London: Rich & Cowan Ltd., 1933), p.187.

7 John Maynard Keynes, 'The London Group' (the Mansard Gallery, London, 1921).

8 André Salmon, 'Negro Art', *The Burlington Magazine*, no. CCV, vol. XXXVI, (April 1920): pp.164-172. Translated by Diana Brinton.

9 Diana Brinton records the date in her curriculum vitae (Diana Brinton-Lee Archive, private collection).

10 Diana Brinton, typescript dated 24 March 1931 (Diana Brinton-Lee Archive, private collection).

11 Roger Fry, handwritten letter dated 26 April 1926 (Diana Brinton-Lee Archive, private collection).

12 Writing about Rupert Lee, Paul Nash noted, 'He was not, however, a person to stand for ridicule as the Slade wits soon found out. He had a power of caustic reprisal and was capable of aggression.' *Outline* (London: Faber & Faber, 1949), p.102.

13 Clive Bell wrote, 'Duncan Grant is the best English painter alive.' *Since Cézanne* (London: Chatto & Windus, 1922), p.106.

14 For more discussion of the women members of The London Group see Katy Deepwell, *Women Artists Between the Wars* (Manchester: Manchester University Press, 2010).

15 Rupert Lee, 'Answering a Critic', *Daily Express* (6 June 1930), London Group press cuttings 1929–32, Tate Archives, London, TGA 7713.11.2.

16 Op.cit., p.9.

17 Roger Fry, *London Group Retrospective Exhibition 1914-1928* (London: The Favil Press, 1928) p.13.

18 R. O. Dunlop, *Struggling with Paint* (London: Phoenix House Ltd, 1956), pp.77–78.

19 William Lipke, *David Bomberg* (London: Evelyn, Adams & Mackay Ltd, 1967), pp.81–82.

20 Denys J. Wilcox, 'British art, Nazi Germany and the London Group', *Apollo*, vol. CXLII, no. 404 (date October 1995): pp.14–17.

21 Letter from Rupert Lee to Diana Brinton, 1935 (Diana Brinton-Lee Archive, private collection).

22 Diana Brinton-Lee, 'The Uniform State', *Time and Tide* (23 April 1938), pp.566–67.

23 For further discussion of John Cooper's intentions see David Buckman, *From Bow to Biennale: Artists of the East London Group* (London: Francis Boutle Publishers, 2012) pp. 185-9.

24 Rupert Lee was accused by John Cooper and John Farleigh of deliberately hiding two works by Edward O'Rourke Dickey in a cupboard in the gallery so that they couldn't be hung in an exhibition. Lee suspected it was Cooper and Farleigh who hid the pictures so that he would get the blame. Undated letter from Rupert Lee to Diana Brinton. (Diana Brinton-Lee Archive, private collection).

25 Undated letter from Rupert Lee to Diana Brinton (Diana Brinton-Lee Archive, private collection).

26 Telegram from Rupert Lee to Diana Brinton, 18 January 1936 (Diana Brinton-Lee Archive, private collection).

27 Letter from Rupert Lee to Diana Brinton, 23 January 1936 (Diana Brinton-Lee Archive, private collection).

CATALOGUE

CAT. 3

1 He resigned before the first exhibition, showing only in the 1928 retrospective. See Wendy Baron's foreword in this volume.

2 '"Junkerism in Art", The London Group at the Goupil Gallery", *The Times* (10 March 1915), p. 8.

3 Wyndham Lewis, 'A World Art and Tradition', *Drawing and Design* (February 1929), rpt. in eds., C. J. Fox and Walter Michel *Wyndham Lewis on Art: Collected Writings 1913–1956* (London: Thames and Hudson, 1969), pp.256–57.

4 Wyndham Lewis, 'Inferior Religions', *The Little Review* (September 1917), rpt. in ed. Bernard Lafourcade *The Complete Wild Body* (Santa Barbara: Black Sparrow Press, 1982), p.316.

CAT. 4

1 R.A. Bevan, *Robert Bevan 1865–1925: A Memoir by his Son* (London: Studio Vista, 1965), p.20.

CAT. 8

1 Ezra Pound, *Gaudier-Brzeska: A Memoir* (London: John Lane, 1916), p.3.

CAT. 9

1 Mark Gertler to Carrington, Friday, February 1915 in ed. N. Carrington *Mark Gertler: Selected Letters* (London: Rupert Hart-Davis, 1965), p.83. He chose not to exhibit in March 1915.

2 See Joanna Cheetham in this volume, n.1.

3 Lawrence visited Gertler's studio when he was working on the painting in autumn 1914. Afterwards Lawrence included the following description of a low-relief carving in his novel, *The Rainbow*: 'Adam lay asleep as if suffering, and God, a dim, large figure, stooped towards him, stretching forward His unveiled hand; an Eve, a small, vivid, naked female she, was issuing, like a flame towards the hand of God, from the torn side of Adam', while '[…] a bird on a bough overhead, lift[ed] its wings for flight.' See S. Sillars: '"Terrible and Dreadful": Lawrence, Gertler and the Visual Imagination', in ed. G. Donaldson *D H Lawrence in Italy and England* (London: Macmillan, 1998), pp.193–209.

4 Adrian Allinson showed an oil entitled *Mauve and Green*.

5 Mark Gertler to Carrington, Sunday, December 1915, *Mark Gertler: Selected Letters*, pp.106–8.

6 Sir Claude Phillips, 'The London Group at Marchant's Goupil Gallery', *Daily Telegraph* (21 November 1915) p.5.

7 *Pall Mall Gazette*, cited John Woodeson, *Mark Gertler: Biography of a Painter, 1891-1939* (London: Sidgwick & Jackson, 1972), p.185.

8 Mark Gertler to Carrington, Sunday, December 1915, *Mark Gertler: Selected Letters*, p.106.

9 Walter Sickert, 'A Monthly chronicle: The London Group', *Burlington Magazine* (January 1916), p.400.

CAT 10

1 G.R.S.T. 'Reflections', *The Limit* (9 March, 1914).

2 'Cubist Masters. Works of Art That Look Like Meaningless Daubs', *Star* (6 March 1915).

3 *Daily Express* (25 February 1915).

4 P. G. Konody, 'Art and Artists: The London Group', *Observer* (14 March 1915).

5 P. W. Lewis, *Blast 2: The War Issue* (London, 1915), p.77.

6 'The Unconscious Humorists. The Art of Coloured Stripes and Mining Tolls,' *Evening News* (13 March 1915).

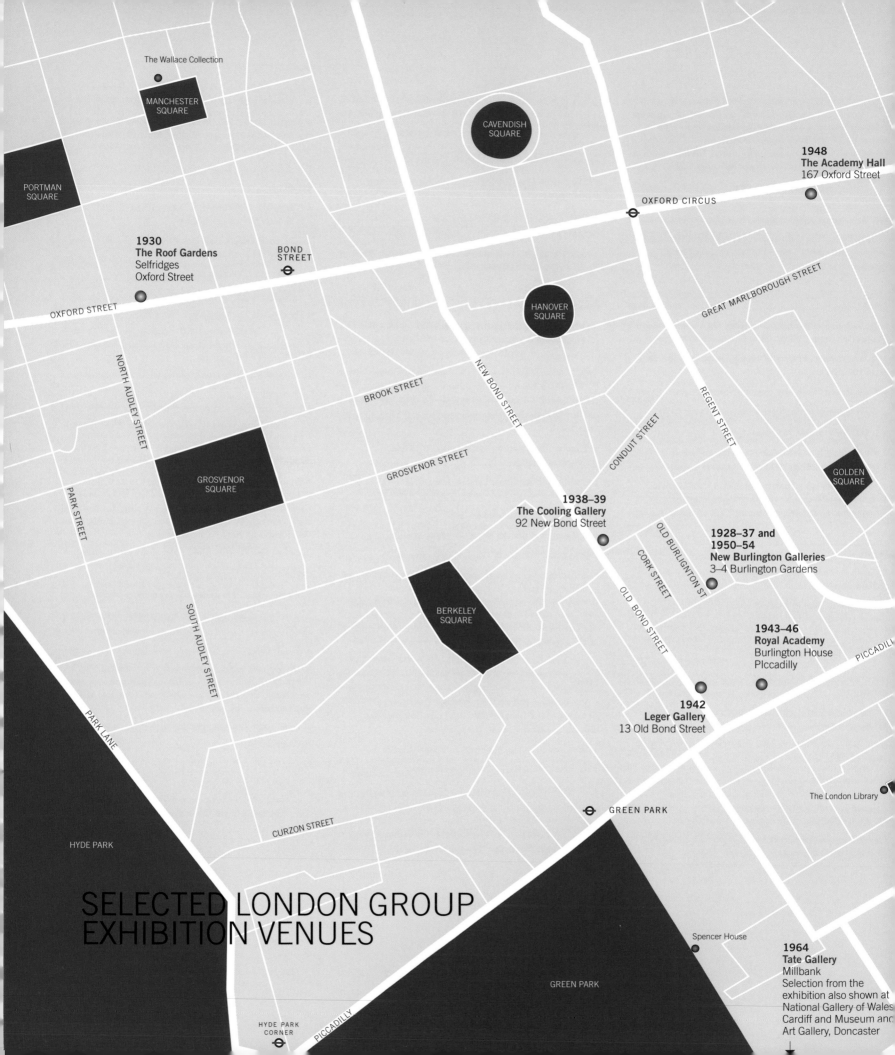

The Wallace Collection

MANCHESTER SQUARE

PORTMAN SQUARE

CAVENDISH SQUARE

1948
The Academy Hall
167 Oxford Street

OXFORD CIRCUS

1930
The Roof Gardens
Selfridges
Oxford Street

BOND STREET

OXFORD STREET

GREAT MARLBOROUGH STREET

HANOVER SQUARE

NORTH AUDLEY STREET

BROOK STREET

NEW BOND STREET

CONDUIT STREET

REGENT STREET

GOLDEN SQUARE

PARK STREET

GROSVENOR SQUARE

GROSVENOR STREET

1938–39
The Cooling Gallery
92 New Bond Street

OLD BURLINGTON ST

CORK STREET

**1928–37 and
1950–54**
New Burlington Galleries
3–4 Burlington Gardens

SOUTH AUDLEY STREET

BERKELEY SQUARE

OLD BOND STREET

1943–46
Royal Academy
Burlington House
PIccadilly

PICCADILL

PARK LANE

1942
Leger Gallery
13 Old Bond Street

The London Library

HYDE PARK

CURZON STREET

GREEN PARK

SELECTED LONDON GROUP
EXHIBITION VENUES

Spencer House

1964
Tate Gallery
Millbank
Selection from the
exhibition also shown at
National Gallery of Wales
Cardiff and Museum and
Art Gallery, Doncaster

HYDE PARK
CORNER

PICCADILLY

GREEN PARK

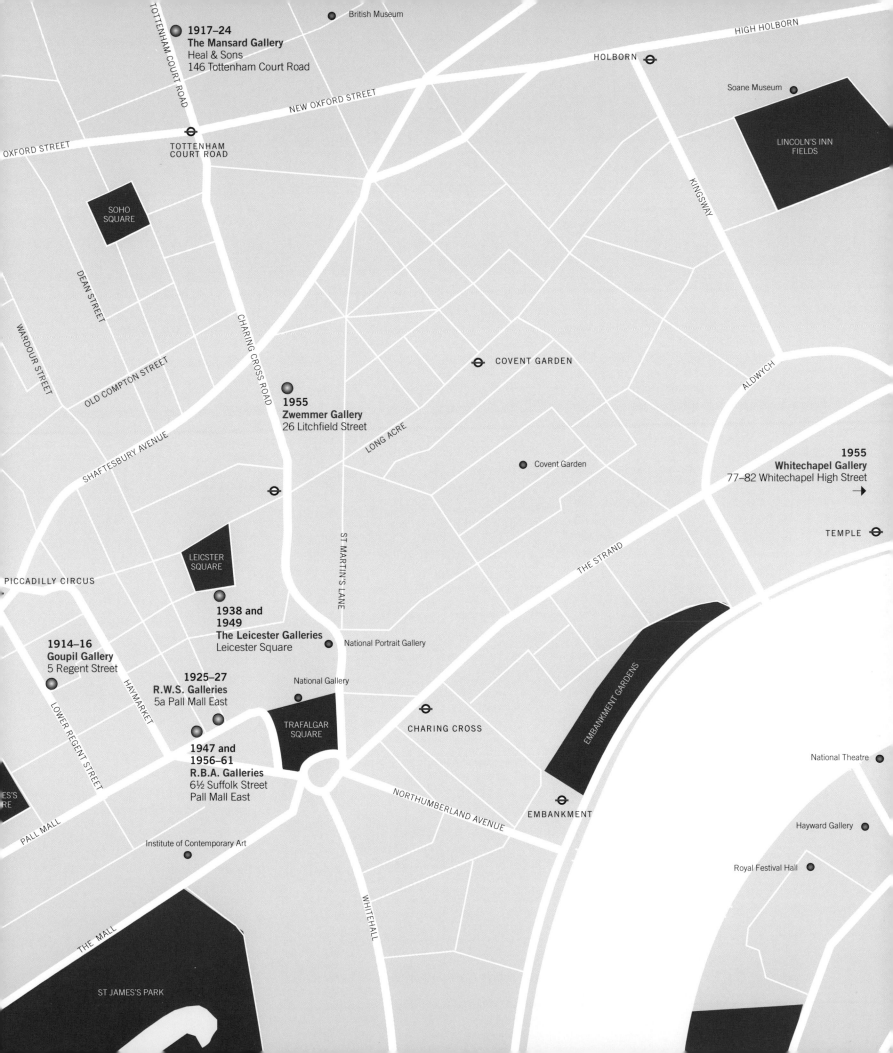

British Museum

HIGH HOLBORN

HOLBORN

Soane Museum

1917–24
The Mansard Gallery
Heal & Sons
146 Tottenham Court Road

NEW OXFORD STREET

LINCOLN'S INN
FIELDS

OXFORD STREET

TOTTENHAM
COURT ROAD

TOTTENHAM COURT ROAD

KINGSWAY

SOHO
SQUARE

DEAN STREET

CHARING CROSS ROAD

WARDOUR STREET

OLD COMPTON STREET

COVENT GARDEN

SHAFTESBURY AVENUE

ALDWYCH

1955
Zwemmer Gallery
26 Litchfield Street

LONG ACRE

Covent Garden

1955
Whitechapel Gallery
77–82 Whitechapel High Street
→

ST MARTIN'S LANE

TEMPLE

LEICESTER
SQUARE

THE STRAND

PICCADILLY CIRCUS

**1938 and
1949**
The Leicester Galleries
Leicester Square

National Portrait Gallery

EMBANKMENT GARDENS

1914–16
Goupil Gallery
5 Regent Street

National Gallery

National Theatre

1925–27
R.W.S. Galleries
5a Pall Mall East

HAYMARKET

TRAFALGAR
SQUARE

CHARING CROSS

**1947 and
1956–61**
R.B.A. Galleries
6½ Suffolk Street
Pall Mall East

LOWER REGENT STREET

ES'S
RE

NORTHUMBERLAND AVENUE

EMBANKMENT

Hayward Gallery

PALL MALL

Institute of Contemporary Art

Royal Festival Hall

THE MALL

WHITEHALL

ST JAMES'S PARK

SELECT BIBLIOGRAPHY

BOOKS AND EXHIBITION CATALOGUES

LAWRENCE ALLOWAY, *Nine Abstract Artists, Their Work and Theory: Robert Adams, Terry Frost, Adrian Heath, Anthony Hill, Roger Hilton, Kenneth Martin, Mary Martin, Victor Pasmore [and] William Scott* (London: A Tiranti, 1954)

MARK ANTIV AND VIVIEN GREENE eds., *The Vorticists: Manifesto for a Modern World* (London: Tate Britain, 2011)

WENDY BARON et al., *The Camden Town Group* (New Haven: Yale Center for British Art, 1980)
——— *Perfect Moderns: A History of the Camden Town Group* (Aldershot: Ashgate, 2000)
——— *The Camden Town Group* (London: Scolar Press, 1979)

DAVID BOYD HAYCOCK, *A Crisis of Brilliance: Five Young British Artis and the Great War* (London: Old Street Publishing, 2009)
——— *Nash, Nevinson, Spencer, Gertler, Carrington, Bomberg: A Crisis of Brilliance, 1908–1922* (London: Dulwich Picture Gallery, 2013)

GRACE BROCKINGTON, *Above the Battlefield: Modernism and the Peace Movement in Britain, 1900–1918* (New Haven: Yale University Press, 2010)

MARY ANN CAWS, *Surrealist Painters and Poets: An Anthology* (Cambridge, MA: MIT Press, 2002)

WHITNEY CHADWICK, *Women Artists and the Surrealist Movement* (London: Thames and Hudson, 1985)

SUSAN COMPTON ed., *British Art in the 20th Century: the Modern Movement* (London: The Royal Academy of Arts, 1987)

MAUREEN CONNETT, *Walter Sickert and the Camden Town Group* (Newton Abbot: David & Charles, 1992)

RICHARD CORK, *A Bitter Truth: Avant-garde Art and the Great War* (New Haven and London: Yale University Press in association with Barbican Art Gallery, London, 1994)

——— *Art Beyond the Gallery in Early 20th Century England* (New Haven and London: Yale University Press, 1985)
——— ed., *Wild Thing: Epstein, Gaudier-Brzeska, Gill* (London: Royal Academy of Arts, 2010)
——— *The School of London and their Friends: The Collection of Elaine and Melvin Merians* (New Haven: Yale Center for British Art, 2001)
——— *Vorticism and Abstract Art in the First Machine Age* (London: Gordon Fraser Gallery, 1976)

PENELOPE CURTIS AND KEITH WILSON, *Modern British Sculpture* (London: Royal Academy of Arts, 2011)

KATY DEEPWELL ed., *Women Artists and Modernism* (Manchester: Manchester University Press, 1998)

RACHEL DICKSON AND SARAH MACDOUGALL eds., *Whitechapel at War: Isaac Rosenberg & his Circle* (London: Ben Uri, The London Jewish Museum of Art, 2008)
——— eds., *Forced Journeys: Artists in Exile in Britain c.1933–45* (London: Ben Uri, The London Jewish Museum of Art, 2009)

PAUL EDWARDS ed., *Blast: Vorticism, 1914–1918* (Aldershot: Ashgate, 1998)

PAMELA FLETCHER AND ANNE HELMREICH eds., *The Rise of the Modern Art Market in London, 1850–1939* (Manchester: Manchester University Press, 2011)

MARGARET GARLAKE, *New Art, New World: British Art in Postwar Society* (New Haven and London: Yale University Press, 1998)

PAUL GOUGH, *A Terrible Beauty: British Artists in the First World War* (Bristol: Sansom & Co., 2010)

ANNA GRUETZNER ROBINS ed., *Modern Art in Britain 1910–1914* (London: Merrell Holberton, 1997)

DOUGLAS HALL, *Art in Exile: Polish Painters in Post-War Britain* (Bristol: Sansom & Co., 2009)

CHARLES HARRISON, *English Art and Modernism, 1900–1939* (New Haven: published for the Paul Mellon Centre for Studies in British Art by Yale University Press, 1994)

MICHAEL HARRISON, *Carving Mountains: Modern Stone in England 1907–37* (Cambridge: Kettle's Yard and Bexhill-on-Sea: De La Warr Pavilion, 1998)

JANE HUMPHREY, *The London Group: Visual Arts from 1913: Celebrating 90 Years' Commitment to the Visual Arts* (London: The London Group, 2003)

BRUCE LAUGHTON, *The Euston Road School: A Study in Objective Painting* (Aldershot: Scolar Press, 1986)

KENNETH MCCONKEY, *The New English: A History of the New English Art Club* (London: Royal Academy of Arts, 2006)

DAVID PETERS CORBETT et al., *The Geographies of Englishness: Landscape and the National Past, 1880–1940* (New Haven and London: Yale University Press, 2002)
——— *The Modernity of English Art, 1914–30* (Manchester and New York: Manchester University Press, 1997)

LYNDA MORRIS, ed., *The Story of the Artists International Association, 1933–1955* (Oxford: Museum of Modern Art, 1983)

ALEX POTTS, *The Sculptural Imagination* (New Haven and London: Yale University Press, 2000)

DAVID REDFERN, *The London Group Origins and Post-War History* (London: Croydon College, 2008)

CHRISTOPHER REED, *Bloomsbury Rooms: Modernism, Subcultures and Domesticity* (New Haven and London: Yale University Press, 2004)

MICHEL REMY, *Surrealism in Britain* (Aldershot: Ashgate, 1999)

FRANK RUTTER, *Some Contemporary Painters* (London: Leonard Parsons, 1922)

MICHAEL T SALER, *The Avant-Garde in Interwar England: Medieval Modernism and the London Underground* (New York and Oxford: Oxford University Press, 1999)

RICHARD SHONE, *Bloomsbury Portraits* (London: Phaidon, 1993)
———— *The Art of Bloomsbury: Roger Fry, Vanessa Bell and Duncan Grant* (London: Tate Gallery, 1999)
———— *The Century of Change: British Painting Since 1900* (Oxford: Phaidon, 1977)

CHARLES SPENCER AND VIVIAN D LIPMAN eds., *The Immigrant Generations: Jewish Artists in Britain, 1900–1945* (New York: Jewish Museum, c. 1982)

STEFAN VAN RAAY, Frances Guy and Simon Martin, *Modern British Art at Pallant House Gallery* (London: Scala, 2004)

JULIET STEYN, 'Inside Out: Assumptions of "English" Modernism in the Whitechapel Art Gallery, London, 1914', in *Art Apart: Institutions and Ideology across England and North America*, ed. M Pointon (Manchester: Manchester University Press, 1994)

ALICE STRANG ed., *From Sickert to Gertler: Modern British Art from Boxted House* (Edinburgh: National Galleries of Scotland, 2008; Sudbury: Gainsborough's House, 2008; Brighton Art Gallery and Museums, 2010)

LISA TICKNER, *Modern Life and Modern Subjects: British Art in the Early Twentieth Century* (New Haven and London: Yale University Press, 2000)

ROBERT UPSTONE ed., *Modern Painters: The Camden Town Group* (London: Tate, 2008)

ANNE WAGNER, *Mother Stone: The Vitality of Modern British Sculpture* (New Haven and London: published for the Paul Mellon Centre for Studies in British Art by Yale University Press, 2005)

MICHAEL J K WALSH ed., *London, Modernism, and 1914* (Cambridge: Cambridge University Press, 2010)

DENYS J WILCOX, *The London Group 1913–1939* (PhD thesis, University of Bristol, 1997)
———— *The London Group, 1913–1939: The Artists and their Works* (Aldershot, England and Brookfield, Vt., USA: Scolar Press, 1995)

PHILIP WRIGHT, *Painting the Visible World: Painters at the Euston Road School and at Camberwell School of Arts and Crafts, 1930–1960* (London: Austin/Desmond Fine Art, 1990)

ARTICLES AND WEBSITES

The Modernist Journals Projects, a joint project of Brown University and the University of Tulsa: www.dl.lib.brown.edu/mjp

DENYS J WILCOX, 'British Art, Nazi Germany and the London Group', *Apollo* CXLII, no. 404 (October 1995)

BIBLIOGRAPHY BY ARTIST

EILEEN AGAR

EILEEN AGAR AND ANDREW LAMBIRTH, *A Look at my Life* (London: Methuen, 1988)

ANDREW LAMBIRTH ed., *Eileen Agar: An Eye for Collage* (Chichester: Pallant House Gallery, 2009)
———— *Eileen Agar: A Retrospective* (London: Birch & Conran, 1987)

ANN SIMPSON et al., *Eileen Agar, 1899–1991* (Edinburgh: National Gallery of Scotland, 1999)

KENNETH ARMITAGE

Kenneth Armitage: An Arts Council Exhibition (London: Arts Council of Great Britain. Held at Norwich: Castle Museum; Bolton: Bolton Museum and Art Gallery; Northamptonshire: Kettering Art Gallery; Nottingham: Victoria Street Gallery; Portsmouth: Portsmouth Museum and Art Gallery; Plymouth: City Art Gallery, 1973)

NORBERT LYNTON, *Kenneth Armitage* (London: Taylor & Francis, 1962)

BRYAN ROBERTSON, *Kenneth Armitage: A Retrospective Exhibition of Sculpture and Drawings* (London: Whitechapel Art Gallery, 1959)

CHARLES SPENCER, *Kenneth Armitage* (London: Academy Editions [for] Editions Electo Ltd., 1973)

TAMSYN WOOLLCOMBE ed., *Kenneth Armitage: Life and Work* (Hertfordshire: Henry Moore Foundation in association with Lund Humphries, 1997)

VANESSA BELL

JANE DUNN, *Vanessa Bell and Virginia Woolf: A Very Close Conspiracy* (London: Virago, [1991], 2000)

DAVID ALAN MELLOR ed, *Radical Bloomsbury: The Art of Duncan Grant and Vanessa Bell, 1905–1925* (Brighton: Royal Pavilion and Museums, 2011)

FRANCES SPALDING, *Vanessa Bell* (London: Weidenfeld & Nicolson, 1983)

RACHEL TRANTER, *Vanessa Bell: A Life of Painting* (London: Cecil Woolf, 1998)

ROBERT BEVAN

R A BEVAN, *Robert Bevan 1865–1925: A Memoir by his Son* (London: Studio Vista, 1965)

GRAHAM DRY, *Robert Bevan, 1865–1925: Catalogue Raisonné of the Lithographs and other Prints* (London: Maltzahn Gallery, 1968)

Robert Bevan, 1865–1925: the Complete Graphic Works (London: P & D Colnaghi & Co., 1974)

FRANCES STENLAKE, *From Cuckfield to Camden Town: The Story of Artist Robert Bevan (1865–1925)* (Cuckfield: Cuckfield Museum, 1999)
———— *Robert Bevan: from Gauguin to Camden Town* (London: Unicorn Press, 2008)

DAVID BOMBERG

Jennifer Brooks and Nicholas Serota eds., *David Bomberg: The Later Years* (London: Whitechapel Art Gallery, 1979)

RICHARD CORK, *David Bomberg* (London: Tate Gallery, 1988)
———— *David Bomberg* (New Haven and London: Yale University Press, 1987)
———— *In Celebration of David Bomberg, 1890–1957* (London: Daniel Katz Gallery, 2007)

W LIPKE, *David Bomberg: A Critical Study of his Life and Work* (London: Evelyn, Adams & Mackay, 1967)

GILL POLONSKY, *David Bomberg* (London: Bernard Jacobson Gallery, 1990)

JOHN BRATBY

ROBIN GIBSON, ed, *John Bratby: Portraits* (London: National Portrait Gallery, 1991)

John Bratby: 30 Years Retrospective (London: Sandford Gallery, 1980)

FRANCES SPALDING ed., *The Kitchen Sink Painters: John Bratby, Peter Coker, Derrick Greaves, Edward Middlemarch, Jack Smith* (London: Mayor Gallery, 1991)

MAURICE YACOWAR, *The Great Bratby: A Portrait of John Bratby RA* (London: Middlesex University Press, 2008)

LYNN CHADWICK

5 British Sculptors (Work and Talk): Henry Moore, Reg Butler, Barbara Hepworth, Lynn Chadwick [and] Kenneth Armitage (New York: Grossman Publishers, 1964)

ALAN BOWNESS, *Lynn Chadwick* (London: Taylor and Francis, 1962)

DENIS FARR AND ÉVA CHADWICK, *Lynn Chadwick, Sculptor: With a Complete Illustrated Catalogue 1947–2005* (London: Lund Humphries, 2006)

Edward Lucie-Smith, *Chadwick* (Stroud, Gloucestershire: Lypiatt Studio, 1997)

WILLIAM COLDSTREAM

LAWRENCE GOWING AND DAVID SYLVESTER, *The Paintings of William Coldstream, 1908–1987* (London: Tate Gallery Publications, 1990)

BRUCE LAUGHTON, *William Coldstream* (London: published for the Paul Mellon Centre for Studies in British Art by Yale University Press, 2004)

COLIN ST JOHN WILSON, *The Artist at Work: On the Working Methods of William Coldstream and Michael Andrews* (Aldershot: Lund Humphries, 1999)

JESSICA DISMORR

CATHERINE ELIZABETH HEATHCOCK, *Jessica Dismorr (1885–1939): Artist, Writer, Vorticist* (Birmingham: Birmingham University Press, 1999)

QUENTIN STEVENSON, *Jessica Dismorr and Catherine Giles* (London: Fine Art Society, 2000)
——— *Jessica Dismorr and Her Circle* (London: Archer Gallery, 1972)
——— *Jessica Dismorr: Oils, Watercolours, Drawings* (London: Mercury Gallery, 1974)

FRANK DOBSON

T W EARP, *Frank Dobson: Sculptor* (London: A Tiranti, 1945)

NEVILLE JASON AND LISA THOMPSON-PHAROAH eds., *The Sculpture of Frank Dobson* (London: Henry Moore Foundation in association with Lund Humphries, 1994)

NEVILLE JASON, *Frank Dobson: Sculpture & Drawings* (London: Jason Rhodes Gallery, 1994)

LISA THOMPSON-PHAROAH, *Frank Dobson: Selected Sculpture 1915–1954* (Leeds: Henry Moore Sculpture Trust, held at Henry Moore Institute, 1994)

True and Pure Sculpture: Frank Dobson, 1886–1963 (Cambridge: Kettle's Yard, 1981)

JACOB EPSTEIN

RICHARD CORK, *Jacob Epstein* (London: Tate Gallery Publishing, 1999)

RACHEL DICKSON AND SARAH MACDOUGALL eds., *Embracing the Exotic: Jacob Epstein & Dora Gordine* (London: Papadakis, 2006)

JACOB EPSTEIN, *Epstein: An Autobiography* (London: Vista Books, [1955] 1963)

RAQUEL GILBOA, *…And there was Sculpture: Jacob Epstein's Formative Years 1880-1930* (London: Paul Holberton Publishers, 2009)

JUNE ROSE, *Daemons and Angels: A Life of Jacob Epstein* (London: Constable, 2002)

EVELYN SILBER, *Jacob Epstein: Sculpture and Drawings* (Leeds: Leeds City Art Gallery and London: Whitechapel Art Gallery, 1987)
——— *Rebel Angel: Sculpture and Watercolours by Sir Jacob Epstein, 1880–1959* (Birmingham: Birmingham Museums and Art Gallery, 1980)
——— *The Sculpture of Jacob Epstein with a Complete Catalogue* (Oxford: Phaidon, 1986)

FREDERICK ETCHELLS

MARY CHAMOT, DENNIS FARR AND MARTIN BUTLER, *The Modern British Paintings, Drawings and Sculpture* (London: Oldbourne Press, 1964)

HANS FEIBUSCH

JOANNA CHEETHAM, *A Forgotten Legacy: Iconoclasm and the Church Murals of Hans Feibusch* (unpublished MA dissertation, London: Courtauld Institute of Art, 2010)

DAVID COKE, *Hans Feibusch: The Heat of Vision* (London: Lund Humphries in association with Pallant House Gallery Trust, 1995)

ROGER FRY

CHRISTOPHER GREEN ed., *Art Made Modern: Roger Fry's Vision of Art* (London: Merrell Holberton in association with the Courtauld Gallery, Courtauld Institute of Art, 1999)
——— *A Roger Fry Reader* (Chicago: University of Chicago Press, 1996)

FRANCES SPALDING, *Roger Fry: Art and Life* (Berkeley: University of California Press, 1980)

DENYS SUTTON, *Letters of Roger Fry* (London: Chatto and Windus, 1972)

VIRGINIA WOOLF, *Roger Fry: A Biography* (New York: Harcourt, Brace and Company, 1940)

HENRI GAUDIER-BRZESKA

SEBASTIANO BARASSI et al., *'We the moderns': Gaudier-Brzeska and the Birth of Modern Sculpture* (Cambridge: Kettle's Yard, University of Cambridge, 2007)

H S EDE et al., *Savage Messiah: A Biography of the Sculptor Henri Gaudier-Brzeska* (Cambridge: Kettle's Yard, University of Cambridge, 2011)

PAUL O'KEEFE, *Gaudier-Brzeska: An Absolute Case of Genius* (London and New York: Allen Lane, 2004)

EVELYN SILBER, *Gaudier-Brzeska: Life and Art* (London: Thames and Hudson, 1996)

MARK GERTLER

N CARRINGTON ed., *Mark Gertler: Selected Letters* (London: 1965)

ANDREW CAUSEY AND JULIET STEYN eds., *Mark Gertler: Paintings and Drawings* (London: Camden Arts Centre; Nottingham: Castle Museum; Leeds: Leeds City Art Gallery, 1992)

SARAH MACDOUGALL, *Mark Gertler* (London: John Murray, 2002)
——— *Mark Gertler: A New Perspective* (London: Ben Uri, The London Jewish Museum of Art, 2002)
——— *Mark Gertler: Works 1912–28* (London: Piano Nobile Gallery, 2012)

Mark Gertler: The Early and the Late Years (London: Ben Uri Art Society, 1982)

JOHN WOODESON, *Mark Gertler: Biography of a Painter, 1891–1939* (London: Sidgwick & Jackson, 1972)

HAROLD GILMAN

ANDREW CAUSEY, *Harold Gilman 1876–1919: His Life and Work* (London: Arts Council of Great Britain, 1981)

TIM CRAVEN, *Harold Gilman & William Ratcliffe: 'A Clean and Solid Mosaic'* (Southampton: Southampton City Art Gallery, 2002)

A R ROBERTS, *The Studious Eye: A Study of Visual Sources and Ideas in the Work of Harold Gilman* (unpublished MPhil thesis, University of East Anglia, 1992)

CHARLES GINNER

WENDY BARON, 'The Many Faces of Dora Sly' *Burlington Magazine* 145, no. 1204 (July 2003) pp.516–19

MICHAEL LEE, 'Charles Ginner: Two Decades Portraying Flask Walk', in *Flask Walk N.W.3,* Michael Lee et al., (London: Pumpkinseed Productions, 2006)

FRANK RUTTER, 'Charles Ginner', in *Some Contemporary Artists* (London: L. Parsons, 1922)

BRIAN SEWELL, *Charles Isaac Ginner A R A (born Cannes 1878, died London 1952)* (London: Fine Art Society, c. 1985)

H R WILLIAMSON, *The Theory and Practice of Neo-Realism in the Work of Harold Gilman and Charles Ginner* (unpublished PhD thesis, University of Leicester, 1992)

SPENCER GORE

ROSAMOND ALLWOOD, *Spencer Gore in Letchworth* (Letchworth Museum and Art Gallery, 2006)

FREDERICK GORE AND RICHARD SHONE eds., *Spencer Frederick Gore, 1878–1914* (London: Anthony d'Offay, 1983)

YSANNE HOLT, 'An Ideal Modernity: Spencer Gore at Letchworth', in *British Artists and the Modernist Landscape* (Aldershot: Ashgate, [2002] 2003)

JAMES ROBERTSON, *Spencer Gore and His Circle: With Special Focus on John Doman Turner* (Richmond, Surrey: Piano Nobile, 1996/1997)

DUNCAN GRANT

WENDY BARON, *Duncan Grant & Bloomsbury* (Edinburgh: Fine Art Society, 1975)

FRANCES SPALDING, *Duncan Grant* (London: Chatto and Windus, 1997)

DOUGLAS BLAIR TURNBAUGH, *Duncan Grant and the Bloomsbury Group: An Illustrated Biography* (London: Bloomsbury, 1987)

SIMON WATNEY, *The Art of Duncan Grant* (London: Murray, 1990)

BARBARA HEPWORTH

SOPHIE BOWNESS et al.,, *Barbara Hepworth: The Plasters* (Farnham: Ashgate/Lund Humphries, 2011)

PENELOPE CURTIS AND ALAN G WILKINSON eds., *Barbara Hepworth: A Retrospective* (Liverpool: Tate Gallery, 1994; New Haven: Yale Center for British Art, 1995; Toronto: Art Gallery of Ontario, 1995)

SALLY FESTING, *Barbara Hepworth: A Life of Forms* (Harmondsworth: Penguin Books, 1996)

MARGARET GARDINER, *Barbara Hepworth: A Memoir* (London: Lund Humphries, 1994)

J P HODIN, *Barbara Hepworth* (London: British Council, 1959)

CHRIS STEPHENS ed., *Barbara Hepworth: Centenary* (St Ives: Tate Gallery; Yorkshire: Yorkshire Sculpture Park, 2003)

GERTRUDE HERMES

KATHERINE EUSTACE ed., *The Wood Engravings of Gertrude Hermes and Blair Hughes-Stanton* (Oxford: The Ashmolean Museum, 1996)

Gertrude Hermes. Bronzes and Carvings, Drawings, Wood Engravings, Wood and Lino Block Cuts: 1924–1967 (London: Whitechapel Gallery, 1967)

JANE HILL, *The Sculpture of Gertrude Hermes* (London: Ashgate, 2011)

IVON HITCHENS

ALAN BOWNESS ed., *Ivon Hitchens* (London: Lund Humphries, 1973)

PATRICK HERON, *Ivon Hitchens* (Harmondsworth: Penguin Books, 1955)

Ivon Hitchens and the Sussex Landscape (Chichester: Pallant House Gallery, 2004)

Ivon Hitchens: A Retrospective Exhibition (London: Arts Council of Great Britain, 1963)

Ivon Hitchens: A Retrospective Exhibition (London: Royal Academy of Arts, 1979)

PETER KHOROCHE, I*von Hitchens* (London: Lund Humphries, 2007)

STANISLAWA DE KARLOWSKA

Memorial Exhibition Paintings by S de Karlowska (1876–1952), (Mrs Robert Bevan) (London: Adams Gallery, 1954)

Stanislawa de Karlowska: Paintings 1909–1936 (London: Maltzahn Gallery, 1969)

LEON KOSSOFF

AL ALVAREZ, *Leon Kossoff: From the Early Years, 1957–1967* (London: Mitchell-Innes & Nash, 2009)

RICHARD CALVOCORESSI AND PHILIP LONG eds., *From London: Bacon, Freud, Kossoff, Andrews, Auerbach, Kitaj* (London: British Council in association with the Scottish National Gallery of Modern Art, 1995)

PAUL MOOREHOUSE ed., *Leon Kossoff* (London: Tate Gallery, 1996)

ANDREA ROSE ed., *Leon Kossoff: London Landscapes* (London: Annely Juda Fine Art, 2013; Paris: Galerie Lelong, 2013; New York: Mitchell-Innes & Nash, 2013; Venice, California: L A Louver, 2014)

COLIN WIGGINS ed., *Leon Kossoff: Drawing from Painting* (London: National Gallery, 2007)

JACOB KRAMER

JONATHAN BLACK ed., *20th Century British Art: Painting, Sculpture, Drawings, Prints* (London: Osborne Samuel, 2005)

RACHEL DICKSON, *William Roberts and Jacob Kramer: The Tortoise and the Hare* (London: Ben Uri, The London Jewish Museum of Art, 2003)

Jacob Kramer, 1892–1962: A Centenary Exhibition (Leeds: University Gallery, 1992)

DAVID MANSON, *Jacob Kramer: Creativity and Loss* (Bristol: Sansom, 2006)

JOHN ROBERTS, *The Kramer Documents* (Valencia: private publisher, 2003)

FRANCES SPALDING, *Jacob Kramer Reassessed* (London: Ben Uri, The London Jewish Museum of Art; Bournemouth: Russell-Cotes Art Gallery and Museum; Kingston-Upon-Hull: Ferens Art Gallery, 1984)

RUPERT LEE

DENYS J WILCOX, *Rupert Lee: Painter, Sculptor and Printmaker. With a Catalogue Raisonné of the Graphic Work* (Bristol, Sansom, 2010)

WYNDHAM LEWIS

PAUL EDWARDS AND RICHARD HUMPHREYS eds., *Wyndham Lewis Portraits* (London: National Portrait Gallery, 2008)

PAUL EDWARDS ed., *Volcanic Heaven: Essays on Wyndham Lewis's Painting and Writing* (Santa Rosa, CA: Black Sparrow Press, 1996)
——— *Wyndham Lewis: Painter and Writer* (New Haven and London: Yale University Press, 2000)
——— ed., *Wyndham Lewis: Art and War* (London: Wyndham Lewis Memorial Trust in association with Lund Humphries, 1992)
——— *Wyndham Lewis (1882–1957)* (Madrid: Fundación Juan March, 2010)

RICHARD HUMPHREYS, *Wyndham Lewis* (London: Tate, 2004)

WYNDHAM LEWIS, *Creatures of Habit and Creatures of Change: Essays on Art, Literature and Society, 1914–1956*; edited by Paul Edwards (Santa Rosa, CA: Black Sparrow Press, 1989)

Wyndham Lewis and Vorticism (London: Tate Gallery, 1956)

L S LOWRY

LINDSAY BROOKS AND MERLIN JAMES, *Lowry's Places* (Salford Quays: The Lowry, 2001)

T J CLARK AND ANNE WAGNER eds., *Lowry and the Painting of Modern Life* (London: Tate Gallery, 2013)

MICHAEL HOWARD, *Lowry: A Visionary Artist* (Salford: Lowry Press, 2000)

MICHAEL LEBER AND JUDITH SANDLING, *L S Lowry* (London: Phaidon, 1995)
——— *Lowry's City: A Painter and his Locale* (Salford: Lowry Press, 2000)

SHELLEY RHODE, *L S Lowry: A Life* (London: Haus, 2007)

T G ROSENTHAL, *L S Lowry: The Art and the Artist* (Norwich: Unicorn Press, 2010)

CLAIRE STEWART ed., *A Lowry Summer* (Salford: Lowry Press, 2013)
——— ed., *Unseen Lowry* (Salford: Lowry Press, 2013)

EDNA MANLEY

DAVID BOXER ed., *Edna Manley, Sculptor: A Retrospective* (Kingston, Jamaica: National Gallery of Jamaica and the Edna Manley Foundation, National Gallery of Jamaica, 1990)

WAYNE BROWN, *Edna Manley: The Private Years, 1900–1938* (London: André Deutsch Ltd., 1976)

RACHEL MANLEY, *Edna Manley: The Diaries* (London: André Deutsch Ltd., 1989)

BASIL MCFARLANE, *Edna Manley: Fifty Years a Sculptor: A Short Survey of Her Work and Career* (Kingston, Jamaica: Herald, 1972)

KENNETH MARTIN

ANDREW FORGE ed., *Kenneth Martin* (London: Tate Gallery, 1975)
——— ed., *Kenneth Martin* (New Haven: Yale Center for British Art, 1979)

ANN JONES ed., *Kenneth Martin* (London: Hayward Gallery, 2001)

Kenneth Martin: The Chance and Order Series, Screw Mobiles and Related Works, 1953–1984 (London: Annely Juda Fine Art, 1999)

MARY MARTIN

Kenneth Martin and Mary Martin: Constructed Works (London: Camden Arts Centre, 2007)

Mary Martin 1907–1969: The End is Always to Achieve Simplicity (West Yorkshire: Huddersfield Art Gallery, 2004; Cambridge: Kettle's Yard House and Gallery, 2005; Eastbourne: Towner Art Gallery, 2005; Bournemouth: Russell-Cotes Art Gallery and Museum, 2005)

Mary Martin (London: Tate Gallery, 1984)

DOROTHY MEAD

6 Young Painters: Peter Blake, William Crozier, David Hockney, Dorothy Mead, Bridget Riley, Euan Uglow (London: Arts Council for Great Britain, Art Gallery, Blackburn, 1964)

Dorothy Mead, 1928–1975: Retrospective Exhibition (London: Boundary Gallery, 2005)

London South Bank University, 'Borough Road Gallery Digital Archive' www.lsbu.ac.uk/w2/boroughroadgallery/digital-archive

BERNARD MENINSKY

Bernard Meninsky 1891–1950: Oil Paintings at the Belgrave Gallery, Works on Paper at Blond Fine Art (London: Belgrave Gallery; London: Blond Fine Art, 1990)

Bernard Meninsky, 1891–1950 (Oxford: Museum of Modern Art; Coventry: Herbert Art Gallery; London: Blond Fine Art, 1981)

ANN COMPTON AND GILL HEDLEY, *A Singular Vision: Drawings and Paintings by Bernard Meninsky* (Liverpool: University of Liverpool Art Collections, 2000)

NORA MENINSKY, *Bernard Meninsky 1891–1950* (London: Belgrave Gallery, 1976)

JOHN RUSSELL TAYLOR, *Bernard Meninsky* (Bristol: Redcliffe, 1990)

HENRY MOORE

JANE BECKETT AND FIONA RUSSELL, *Henry Moore: Space, Sculpture, Politics* (Burlington, Vermont: Ashgate, 2003)

ANDREW CAUSEY, *The Drawings of Henry Moore* (Farnham: Lund Humphries, 2010)

SUSAN COMPTON ed., *Henry Moore* (London: Royal Academy of Arts in association with Weidenfeld and Nicolson, 1988)

HENRY MOORE, *On Being a Sculptor* (London: Tate, 2010)

GREGOR MUIR ed., *Henry Moore: Ideas for Sculpture* (Zurich: JRP/Ringier; Hauser and Wirth, 2008)

HERBERT READ, *Henry Moore, Sculpture and Drawings* (London: Lund Humphries, 1944)

CHRIS STEPHENS ed., *Henry Moore, 1898–1986* (London: Tate Britain, 2010)

DAVID SYLVESTER, *Henry Moore* (London: Arts Council of Great Britain, 1968)

RODRIGO MOYNIHAN

JOHN MOYNIHAN, *Restless Lives: The Bohemian World of Rodrigo and Elinor Moynihan* (Bristol: Sansom, 2002)

Rodrigo Moynihan: A Retrospective Exhibition (London: Royal Academy of Arts, 1978)

RICHARD SHONE ed., *Rodrigo Moynihan Paintings and Drawings 1938–1947: The End of the Picnic* (London: Imperial War Museum, 1998)
——— *Rodrigo Moynihan: Paintings and Works on Paper* (London: Thames and Hudson, 1988)
——— ed., *Rodrigo Moynihan* (New York: Robert Miller Gallery, 1983)

DAVID SYLVESTER, *Meditating on Light: Rodrigo Moynihan in Conversation with David Sylvester* (London: Lecon Arts, 1980s)

PAUL NASH

ANDREW CAUSEY ed., *Paul Nash: Writings on Art* (New York and Oxford: Oxford University Press, 2000)
——— *Paul Nash: Landscape and the Life of Objects* (Farnham: Lund Humphries, 2013)

DAVID FRASER JENKINS ed., *Paul Nash: The Elements* (London: Scala in association with Dulwich Picture Gallery, 2010)

DAVID BOYD HAYCOCK, *Paul Nash* (London: Tate Publishing, 2002)

JEMIMA MONTAGU ed., *Paul Nash: Modern Art, Ancient Landscape* (London: Tate Gallery, 2003)

HERBERT READ, *Paul Nash* (Harmondsworth: Penguin Books, 1944)

C R W NEVINSON

RICHARD INGLEBY ed., *C. R. W. Nevinson: The Twentieth Century* (London: Merrell Holberton, in association with the Imperial War Museum, 2000)

MICHAEL J K WALSH, *A Dilemma of English Modernism: Visual and Verbal Politics in the Life and Work of C. R. W. Nevinson* (Newark: University of Delaware Press, 2007)
——— *C. R. W. Nevinson: This Cult of Violence* (New Haven: Yale University Press, 2002)
——— *Hanging a Rebel: The Life of C. R. W. Nevinson* (Cambridge: Lutterworth, 2008)

VICTOR PASMORE

ALAN BOWNESS AND LUIGI LAMBERTINI eds., *Victor Pasmore: With a Catalogue Raisonné of Paintings, Constructions and Graphics, 1926–1979* (London: Thames and Hudson, 1980)

LAWRENCE GOWING et al., *Victor Pasmore* (New Haven: Yale Center for British Art, 1988)

ALASTAIR GRIEVE ed., *Victor Pasmore: Writings and Interviews* (London: Tate Publishing, 2010)

Victor Pasmore (London: Arts Council of Great Britain; Bradford: Cartwright Hall; Liverpool: Walker Art Gallery; Norwich: Sainsbury Centre, UEA; Leicester: Leicestershire Museum and Art Gallery; London: Royal Academy of Arts, 1980)

JOHN PIPER

ALAN BOWNESS et al., *John Piper* (London: Tate Gallery, 1984)

DAVID FRASER JENKINS AND FRANCES SPALDING eds., *John Piper in the 1930s: Abstraction on the Beach* (London: Dulwich Picture Gallery; Nottingham: Djanogly Art Gallery, 2003)

DAVID FRASER JENKINS ed., *John Piper: The Forties* (London: Philip Wilson, in association with Imperial War Museum, 2001)

ORDE LEVINSON, *John Piper: The Complete Graphic Works: A Catalogue Raisonné, 1923–1983: Etchings and Engravings, Lithographs and Screenprints* (London: Faber, 1987)

FRANCES SPALDING, *John Piper, Myfany Piper: Lives in Art* (Oxford: Oxford University Press, 2009)

CERI RICHARDS

Ceri Richards: Four Themes (Chichester: Pallant House Gallery, 2003)

Ceri Richards (London: Tate Gallery, 1981)

MEL GOODING, *Ceri Richards* (Moffat: Cameron & Hollis, 2002)

JOHN RUSSELL, *Ceri Richards, Relief Constructions, Paintings and Drawings, 1931–1939* (London: Fischer Fine Art, 1974)

ROBERTO SANESI, *Rilievi, Disegni e Dipinti, 1931/1940* (Macerata: Nuova Foglio Editrice, 1976)

ANNA SOUTHALL AND MICHAEL TOOBY eds., *Ceri Richards: Themes and Variations: A Select Retrospective* (Cardiff: National Museums and Galleries of Wales, 2002)

WILLIAM ROBERTS

ELIZABETH CAYZER ed., *William Roberts, 1895–1980: A Retrospective Exhibition* (London: Maclean Gallery, 1980)

DAVID CLEALL (William Roberts Society), 'William Roberts: Catalogue Raisonné' (last revised 12 August 2013), www.users.waitrose.com/~wrs/catchron.html

ANDREW WILLIAMS, *William Roberts: An English Cubist* (Aldershot: Lund Humphries, 2004)

ROBIN GIBSON ed., *William Roberts, 1895–1980: An Artist and his Family* (London: National Portrait Gallery, 1984)

ANDREW HEARD ed., *William Roberts (1895–1980)* (Newcastle: Hatton Gallery, University of Newcastle; Sheffield: Graves Art Gallery, 2004)

CLAUDE ROGERS

Claude Rogers: Paintings and Drawings (London: Ben Uri, The London Jewish Museum of Art, 1992)

PETER FITZGERALD AND ANDREW FORGE, *Claude Rogers: Paintings and Drawings, 1927–1973* (London: Whitechapel Art Gallery, 1973)

JENNY PERY, *The Affectionate Eye: The Life of Claude Rogers* (Bristol: Sansom & Co., 1995)

ETHEL SANDS

WENDY BARON, *Miss Ethel Sands and her Circle* (London: Owen, 1977)

WALTER RICHARD SICKERT

WENDY BARON AND RICHARD SHONE eds., *Sickert: Paintings* (London: Royal Academy of Arts in Association with Yale University Press. London: Royal Academy of Arts; Amsterdam: Van Gogh Museum, 1993)

WENDY BARON, *Sickert: Paintings and Drawings* (New Haven and London: Yale University Press, 2006)

RUTH BROMBERG, *Walter Sickert, Prints: A Catalogue Raisonné* (New Haven: published for the Paul Mellon Centre for Studies in British Art by Yale University Press, 2000)

ANNA GRUETZNER ROBINS, *Walter Sickert: Drawings* (Aldershot: Scolar Press, 1996)
———— *Walter Sickert: The Complete Writings on Art* (Oxford and New York: Oxford University Press, 2000)

DAVID PETERS CORBETT, *Walter Sickert* (London: Tate Gallery Publishing, 2001)

RICHARD SHONE ed., *From Beardsley to Beaverbrook: Portraits by Walter Richard Sickert* (Bath: Victoria Art Gallery, 1990)

ROBERT UPSTONE, *Sickert in Venice* (London: Scala, 2009)

BARNABY WRIGHT ed., *Walter Sickert: The Camden Town Nudes* (London: Courtauld Gallery; Paul Holberton, 2007)

MATTHEW SMITH

JOHN GLEDHILL, *Matthew Smith: Catalogue Raisonné of the Oil Paintings with a Critical Introduction to his Work* (Farnham: Lund Humphries, 2009)

ALICE KEENE, *The Two Mr Smiths: The Life and Work of Sir Matthew Smith* (London: Lund Humphries, 1995)

Matthew Smith: Flamboyant Colour (Chichester: Pallant House Gallery, 2003)

Matthew Smith (London: Barbican Art Gallery, 1983)

MALCOLM YORKE, *Matthew Smith: His Life and Reputation* (London: Faber and Faber, 1997)

RUSKIN SPEAR

ROBERT BUHLER, *Ruskin Spear, Carel Weight, and Their Friends* (Seattle: Linton Court Gallery, 1987)
———— ed., *Ruskin Spear, RA: A Retrospective Exhibition* (London: Royal Academy of Arts, 1980)

MERVYN LEVY, *Ruskin Spear* (Chicago: Academy Chicago Publishers, Limited, 1986)

EUAN UGLOW

SUSAN CAMPBELL ed., *Euan Uglow: Some Memories of the Painter* (London: Browse and Darby, 2003)

RICHARD KENDALL AND CATHERINE LAMPERT, *Euan Uglow: The Complete Paintings* (New Haven and London: Yale University Press, 2007)

ANDREW LAMBIRTH, *Euan Uglow: Paintings and Drawings from the Estate* (London: Marlborough Fine Art Ltd., 2007)

CATHERINE LAMPERT, *Euan Uglow* (London: Hayward Gallery, 2002)
———— *Euan Uglow* (London: Browse and Darby, 1997)

PAULE VÉZELAY

RONALD ALLEY, *Paule Vézelay: Paintings and Constructions* (London: Annely Juda Fine Art Gallery, 1987)

Paule Vézelay 1892–1984: Retrospective Exhibition (London: England & Co. Gallery, 2004)

Paule Vézelay: Imagination, Mathematics, Balance (New York: Zabriskie Gallery, 1988)

SARAH WILSON, *Paule Vézelay and her Circle: Paris and the South of France* (London: England & Co. Gallery, 2007)
———— *Paule Vézelay/Hans Arp: The Enchantments of Purity* (Leeds: Henry Moore Institute, 1995)

EDWARD WADSWORTH

JONATHAN BLACK, *Edward Wadsworth: Form, Feeling and Calculation: The Complete Paintings and Drawings* (London: Philip Wilson, 2005)

RICHARD CORK, *Edward Wadsworth: Early Woodcuts* (London: Christopher Drake Ltd., 1973)

JEREMY LEWISON ed., *A Genius in Industrial England: Edward Wadsworth, 1889–1949* (Bradford: Arkwright Arts Trust and London: Camden Arts Centre, 1990)

BARBARA WADSWORTH, *Edward Wadsworth: A Painter's Life* (Wilton, Salisbury: Michael Russell, 1989)

CONTRIBUTORS

Dr Wendy Baron, OBE, is former Director of the British Government Art Collection and has been the leading Sickert scholar since her monograph on his paintings in 1973. Her publications include *Miss Ethel Sands and Her Circle* (Peter Owen, 1977), an important study of the Camden Town Group (Scolar Press, 1979), *Sickert Paintings* (joint editor, Yale University Press, 1992), *Perfect Moderns* (Ashgate, 2000) and *Sickert: Paintings & Drawings* (Yale University Press, 2006).

Lauren Barnes holds a BA and an MA in Art History from The Courtauld Institute of Art, University of London. She has convened and participated in conferences on a range of art historical subjects, and in 2013 curated the exhibition *Ships of Stone: The Islands of Mervyn Peake* at Gerald Moore Gallery. She is currently Exhibitions Assistant at Barbican Art Gallery.

Dr Jonathan Black studied History and History of Art at St John's College, Cambridge and University College, London. His PhD thesis (UCL, 2003) explored the image of the First World War British soldier in the art of C R W Nevinson, Eric Kennington and Charles Sargeant Jagger, *c.* 1915–25. His publications include: *Form, Feeling and Calculation: The Complete Paintings and Drawings of Edward Wadsworth* (Philip Wilson, 2006), *Dora Gordine: Sculptor, Artist, Designer* (Philip Wilson, 2008), *The Face of Courage: Eric Kennington, Portraiture and the Second World War* (Philip Wilson, 2011) and *The Spirit of Faith: The Sculpture of John Bunting* (The John Bunting Foundation, 2012). Currently, he is a Senior Research Fellow in History of Art at Kingston University.

David Boxer, a leading artist and art historian, is the former Director and Chief Curator of the National Gallery of Jamaica. Among his many publications is a major monograph on Edna Manley, *Edna Manley: Sculptor* (National Gallery of Jamaica, 1990).

Dr Grace Brockington is Senior Lecturer in the History of Art at the University of Bristol. She is the author of *Above the Battlefield: Modernism and the Peace Movement in Britain, 1900–1918* (Yale University Press, 2010), and has edited a collection of essays on the subject of *Internationalism and the Arts in Britain and Europe at the Fin de Siècle* (Peter Lang, 2009). She is currently working on a study of Vanessa Bell.

Joanna Cheetham is an AHRC-sponsored PhD candidate at the Courtauld Institute of Art. Her research interests involve the work of German émigré artists in Great Britain, twentieth-century mural painting and postwar arts policy and patronage. Her PhD thesis concerns the paintings, prints and murals of Hans Feibusch.

David Cleall has researched and compiled an online catalogue raisonné of the works of William Roberts, which can be accessed through the website of the William Roberts Society. He has contributed to catalogue entries for Christie's, Sotheby's and various art galleries.

Dr Richard Cork is an art historian, editor, critic, broadcaster and curator. His appointments include Slade Professor of Fine Art at Cambridge (1989–90), Henry Moore Senior Fellow at the Courtauld Institute of Art, London (1992–95), and Chair of the Visual Arts Panel at the Arts Council of England (until 1998). He has been art critic for the *Evening Standard*, *The Listener*, *The Times* and the *New Statesman* and is the former editor of *Studio International*. His award-winning books include a pioneering study of Vorticism, *Vorticism and Abstract Art in the First Machine Age* (Gordon Fraser Gallery, 1976), *Art Beyond The Gallery* (Yale

University Press, 1985), *David Bomberg* (Yale University Press, 1987), *A Bitter Truth: Avant-Garde Art and the Great War* (Yale University Press/Barbican, 1994), four volumes of his critical writings on modern art (Yale University Press 2003), and *Wild Thing: Epstein, Gaudier-Brzeska, Gill* (Royal Academy, 2009).

Rachel Dickson is Head of Curatorial Services at Ben Uri. She is co-curator, with Sarah MacDougall, of the *Whitechapel Boys* exhibitions series and the survey exhibition *Forced Journeys: Artists in Exile in Britain, c.1933–45*. Her most recent exhibition and catalogue was a major retrospective of contemporary American artist Judy Chicago (Ben Uri, 2012–13).

Professor Paul Edwards is currently Lecturer in British Modernism at the University of East Anglia and the leading scholar on Wyndham Lewis. He is editor of *Blast: Vorticism 1914–1918* (Ashgate, 2000) and author of *Wyndham Lewis: Painter and Writer* (Yale University Press, 2000). He co-curated (with Richard Humphreys) the exhibition, *Wyndham Lewis Portraits* (National Portrait Gallery, 2008) and was principal author of the exhibition catalogue. He is currently working on a Lewis catalogue raisonné for the Modern Art Press and overseeing a multi-volume critical edition of Lewis's writings for Oxford University Press.

Jane England has been the Director and Curator of England & Co Gallery in London since she founded it in 1987. She is an art historian with broad research interests, as reflected in the programme at England & Co, which alternates between contemporary art and the work of artists of the British and European avant-garde of the 1930s through to the postwar period of the 1950s to 1970s.

Stephanie Farmer has a BFA in Fine Art from the University of Oxford and an MA in History of Art from the Courtauld Institute (2009). She is the principal researcher for a catalogue raisonné of Leon Kossoff's paintings, to be published by Modern Art Press. Recently, she was exhibitions assistant on the artist's current international touring exhibition, *London Landscapes* (Annely Juda Fine Art, 2013).

Rachel Fleming-Mulford is a curator and arts consultant with over a decade of experience in the visual arts. She has worked with a wide range of organisations including Tate Modern, Beaconsfield, Art in the Open, SPACE Studios and Freud Museum, London. She is currently curator of the Borough Road Gallery at London South Bank University, where she recently curated a solo exhibition of Dorothy Mead's paintings, which drew from *A David Bomberg Legacy – The Sarah Rose Collection* (2013). Rachel holds an MA from the Courtauld Institute of Art.

Hugh Fowler-Wright is an aficionado of John Piper's art. He has helped with several John Piper books, exhibitions and catalogues at the Imperial War Museum, Dulwich Picture Gallery, the River and Rowing Museum, Henley-on-Thames, Blenheim Palace, Reading Museum and Art Gallery, Hereford Museum and Art Gallery, Mascalls Gallery, Towner Art Gallery, Dorchester Abbey, Renishaw Hall, Narborough Hall and the Monnow Valley Arts Centre. His interest includes Piper's ephemera and his many collaborations have led to *Piper in Print* (Artist's Choice Editions, 2010) and *John Piper: Creative Partnerships* (Broad Street Gallery, 2011).

Mel Gooding is an art critic, writer and curator. His monographs include *Bruce McLean* (Phaidon, 1990), *Michael Rothenstein's Boxes* (Art Books International, 1991), *Patrick Heron* (Phaidon, 1994), *Gillian Ayres* (Lund Humphries, 2001), *Ceri Richards* (Cameron & Hollis, 2002), *Patrick Hayman Visionary Artist* (Belgrave Gallery, 2005), *John Hoyland* (Thames & Hudson, 2006), *herman de vries: chance and change* (Thames & Hudson, 2006) and *Frank Bowling* (Royal Academy of Arts, 2011). He has also contributed to numerous exhibition catalogues on artists including Terry Frost, Joe Tilson, Sandra Blow and Wilhelmina Barns-Graham.

Irving Grose is the founder and director of Belgrave Gallery (established 1974). His expertise spans twentieth-century British Art, with a longstanding focus on postwar abstract artists (especially those associated with the St Ives modern movement), and contemporary artists working in a wide range of approaches and media. He is an authority on modern British and Jewish artists and has curated exhibitions and contributed to publications on numerous artists during his forty-year career. His 1978 survey exhibition and catalogue, *Jewish Artists of Great Britain, 1845–1945*, has become a reference point for collectors and scholars alike.

Anna Gruetzner Robins is a Professor in History of Art at the University of Reading. Her areas of research include the work of Degas, Gwen John, Sickert and Whistler, internationalism, reception theory and the formation of taste, and exhibition histories. She has also curated a number of exhibitions including *Modern Art in Britain 1910–1914* (Barbican, 1997) and Degas, Sickert and Toulouse-Lautrec (Tate Britain and the Phillips Collection, Washington, 2005-2006).

Frances Guy is Head of Collection and Exhibitions at the Hepworth Wakefield, Yorkshire's major new art gallery which opened in May 2011. Previously she was Head of Curatorial Services at Pallant House Gallery, Chichester, the winner of the 2007 Gulbenkian Prize for Museum of the Year, where she was in post from 1998. Frances studied History of Art and took her Diploma in Art Gallery Studies at the University of Manchester, which led to her first job as curator of an exhibition about Jewish women in Britain at the Manchester Jewish Museum (1993).

Dr David Boyd Haycock is a freelance cultural historian, curator and lecturer. He is the author of a number of books, including *Paul Nash* (Tate, 2002), *A Crisis of Brilliance: Five Young British Artists and the Great War* (Old Street Publishing, 2009) and *I Am Spain: The Men and Women who went to Fight Fascism* (Old Street Publishing, 2012). He is also the curator of the *Crisis of Brilliance* exhibition at Dulwich Picture Gallery (2013).

Hannah Higham is acting Curator of Modern and Contemporary Art at Norwich Castle Museum and Art Gallery. She is concurrently working on a PhD with the University of Birmingham.

Jane Hill is an independent writer, lecturer and curator. She is the author of *The Art of Dora Carrington* (Herbert Press, 1995) and selector of *Carrington: the Exhibition* (Barbican, 1995). Her most recent book is *The Sculpture of Gertrude Hermes* (Ashgate, 2011).

Neville Jason divides his time between the spheres of acting and art. Married to the art dealer Gillian Jason, he is author of *The Sculpture of Frank Dobson* (Henry Moore Foundation/Lund Humphries, 1994). As an actor he now concentrates on voice work, broadcasting for the BBC and recording audiobooks, notably classic literature for the Naxos label.

Dr Monika Keska has a degree in History of Art (2002) and a PhD (2009) from the University of Granada. She received a post-doctoral fellowship in 2011 from the Ministry of Education in Spain to carry out a project on the work of Francis Bacon.

Andrew Lambirth is a writer, critic and curator, who knew Eileen Agar well and helped her to write her autobiography, *A Look At My Life* (Methuen, 1988). Currently the art critic for *The Spectator*, he is the author of numerous art books, his latest

being a paperback collection of his *Spectator* reviews entitled *A is a Critic* (Unicorn Press, 2013).

Sarah MacDougall is the Eva Frankfurther Research and Curatorial Fellow for the Study of Émigré Artists, and Head of Collections at Ben Uri. She is co-curator, with Rachel Dickson, of the *Whitechapel Boys* exhibitions series and the survey exhibition *Forced Journeys: Artists in Exile in Britain*, c. 1933–45. Her recent exhibitions include *From Russia to Paris: Chaïm Soutine and his Contemporaries* (Ben Uri, 2012). She is the author of a biography on Mark Gertler (John Murray, 2002) and is preparing a catalogue raisonné of his work (Yale University Press, 2015).

Dr Alexandra MacGilp is an independent curator, writer and art historian based in London. She studied at University College London, Birkbeck College and the Royal College of Art, and undertook her PhD at the University of Reading in collaboration with Tate Britain, writing on the development of the Tate Collection. She has contributed to *The Rise of the Modern Art Market in London 1850–1939* (Pamela Fletcher and Anne Helmreich eds., Manchester University Press, 2011).

Paul Martin is the son of Kenneth and Mary Martin. He is an artist/curator living in London.

Jenny Pery, artist and art historian, has written many monographs on artists, including Solomon J Solomon RA (Ben Uri, 1990), Claude Rogers OBE (Sansom & Company, 1995), Tristram Hillier RA (Royal Academy of Arts, 2008), John Dodgson (Fine Arts Society, 1995), Caziel (AM Publications, 1996), Anthony Eyton RA (Royal Academy of Arts, 2005), Edward Piper (David Messum Fine Art, 2000), Robert Organ (Sansom & Company, 2003), Benedict Rubbra (Halstar, 2008) and Daphne Todd OBE (David Messum Fine Art, 2008).

David Redfern is a practising artist and was elected to The London Group in 2000. In 2003 he was invited by the president, Peter Clossick, to become Group Archivist and to update the Tate Archive and record the Group's current activities. A further result of his work, *The London Group: 1913 to 2013 – a history of the Group*, is due for publication in October 2013.

Dr Richard Shone is an art historian and critic specialising in modern British art. He has been editor of *The Burlington Magazine* since 2003. He has curated many exhibitions including *From Beardsley to Beaverbrook: Portraits by Walter Richard Sickert* (Victoria Art Gallery, Bath, 1990); (with Wendy Baron) *Sickert: Paintings* (the Royal Academy of Arts, London; Van Gogh Museum, Amsterdam, 1992–93); and *The Art of Bloomsbury* (Tate, 1999). His publications include *Bloomsbury Portraits: Vanessa Bell, Duncan Grant and their Circle* (Phaidon, 1976), *Rodrigo Moynihan* (Thames & Hudson, 1988), *Walter Sickert* (Phaidon, 1988), *Sisley* (Phaidon, 1992) and *Sensation* (Royal Academy, 1997).

Evelyn Silber is Hon. Professorial Research Fellow at the University of Glasgow and is currently researching the marketing of modernism by London commercial galleries in the early twentieth century. A former director of Leeds Museums and Galleries and the Hunterian, University of Glasgow, she published *The Sculpture of Epstein* (Phaidon, 1986) and co-organised the major exhibition, *Jacob Epstein Sculpture and Drawings* (Leeds Art Gallery and the Whitechapel Art Gallery, 1987). She was actively involved in Leeds's acquisition of Epstein's *Flenite Relief*.

Quentin Stevenson was ten when he was first asked to explain why he was so drawn to a painting by Jessica Dismorr. He has assembled paintings and drawings by her for exhibitions at the Archer Gallery (1972), the Mercury Gallery (1974) and the Fine Arts Society (2000). For the catalogue of the

last of these he wrote a long biographical essay. His other lives have been as a poet and, as John Quentin, actor.

Claire Stewart is Curator of The Lowry Collection at The Lowry in Salford, home to the largest public collection and archive of Lowry's work. She has curated exhibitions including *A Lowry Summer* (2013) and *Unseen Lowry* (2013) and is responsible for the permanent displays of LS Lowry's work at The Lowry.

Rachel Stratton has a BA in History of Art from the University of Cambridge and an MA in European Modernist Art from the Courtauld Institute of Art (2011). She is curatorial assistant at Ben Uri, where she has assisted on exhibitions including *From Russia to Paris: Chaïm Soutine and his Contemporaries* (2012), *Judy Chicago and Louise Bourgeois, Helen Chadwick, Tracey Emin: A Transatlantic Dialogue* (2012–13) and *Boris Aronson and the Avant-garde Yiddish Theatre* (2013).

Robert Upstone is Director of Modern British Art at the Fine Art Society, London. He joined the FAS in 2010 from Tate Britain, where he was Curator of Modern British Art. During his 23 years at the Tate, he curated major exhibitions including *The Vorticists: Manifesto for a Modern World* (2011) and *Modern Painters: The Camden Town Group* (2008), the survey of William Orpen held at the Imperial War Museum (2005), *Sickert in Venice* at Dulwich Picture Gallery, and *J W Waterhouse: The Modern Pre-Raphaelite* at the Royal Academy (both 2009). He has written, edited and contributed to many books and catalogues produced in conjunction with major museum exhibitions, and to academic journals.

Michael J K Walsh is Associate Chair (Research) at the School of Art, Design and Media, Nanyang Technological University, Singapore. His DPhil, supervised by David Peters Corbett, was awarded

in 2001 by the University of York for a study of the early work and career of C R W Nevinson. Some of his subsequent books on English art include: *This Cult of Violence* (Yale University Press, 2002), *A Dilemma of English Modernism* (University of Delaware Press, 2007), *Hanging a Rebel* (Lutterworth Press, 2008), and *London, Modernism and 1914* (Cambridge University Press, 2010).

Alice Wiggett studied History of Art at University College London and undertook her MA at the Courtauld Institute of Art. In 2010 she curated the Lynn Chadwick exhibition at Stowe Art School and now works as a researcher and exhibition assistant at Lypiatt Studio, the Estate of Lynn Chadwick.

Dr Denys J Wilcox undertook his Doctoral thesis on The London Group (Bristol, 1997) and is also the author of *The London Group 1913–39: The Artists and their Works* (Scolar Press, 1995) and 'British Art, Nazi Germany and the London Group', *Apollo* CXLII, no. 404 (October 1995). His many publications include the introduction to *John Lessore: London Paintings* (Berkeley Square Gallery, 2002), *Tom Early: The Catalogued Work* (with Michael Miller, Sansom & Company, 2005), *Rupert Lee: Painter, Sculptor and Printmaker* (Sansom & Company, 2010) and *The Camden Town Group Centenary Exhibition* (with Robert Upstone, the Fine Arts Society, 2011).

Rosie Wardle read Modern Languages and Linguistics at the University of Oxford (2010) and completed her MA in History of Art at the Courtauld Institute, London (2011). Her specialisms include German art and cultural politics in the twentieth century.

Philip Wright, formerly of Marlborough Fine Art, Waddington Galleries and Austin/Desmond Fine Art, is interested in the history of British 20th century art dealing and collecting.

Maurice Yacowar is Professor Emeritus in English and Film Studies, University of Calgary, Canada. In addition to *The Great Bratby* (Middlesex University Press, 2008) he has written critical studies of Woody Allen, Mel Brooks, Hitchcock's British Films, Tennessee Williams, Paul Morrissey, *The Sopranos,* a comic novel *The Bold Testament* (Bayeux Arts, 2000) and a memoir of his boyhood relationship with Roy Farran, *Roy and Me* (Athabasca University Press, 2010). He writes short analyses of current films on www.yacowar.blogspot.com.

LENDERS AND CREDITS

LENDERS TO THE EXHIBITION

Aberdeen Art Gallery and Museums
Collections

Annely Juda Fine Art

Ben Uri, The London Jewish Museum of Art

British Council Collection

British Museum, London

Estate of Lynn Chadwick

Gillian Jason, Modern & Contemporary Art

Jonathan Clark Fine Art

The Hepworth Wakefield

Kettle's Yard, University of Cambridge

Leeds Museums and Galleries (Leeds Art
Gallery)

Leicester Arts and Museums Service

Manchester City Gallery

Museums Sheffield

The National Trust

Norwich Museum and Archaeology Service

Pallant House Gallery, Chichester

Ruth Borchard Collection c/o Robert Travers
Work of Art Ltd, Piano Nobile, London

The Samuel Courtauld Trust, The Courtauld
Gallery, London

Southampton City Art Gallery

Tate

University of Leeds Art Collection

Victoria and Albert Museum

Whitworth Art Gallery, The University of
Manchester

Williamson Art Gallery and Museum,
Birkenhead

And other private collectors who wish to
remain anonymous

PICTURE CREDITS

Aberdeen Art Gallery and Museums
cats. 19, 25

Ben Uri, The London Jewish Museum of Art
cats. 16, 50
figs 1, 7, 8, 12, 14, 18, 19

British Council, 2013
cats. 12, 40

Kettle's Yard, University of Cambridge
cat. 8

Leeds Museums and Art Galleries (City
Museum), UK / Bridgeman Art Library
cats. 7, 23

Leicester Arts and Museum Service /
The Bridgeman Art Library
cats. 5, 17, 24

Manchester City Galleries
cat. 26

Museums Sheffield
cat. 29
fig. 3

National Trust Images
cat. 14 (photo: Roy Fox)

Norfolk Museums & Archaeology Service
cat. 47

Pallant House Gallery, Chichester
cat. 30

Private Collections
cats. 2, 11, 34, 35 (photos: Nigel Noyes)
cats. 9, 33, 37, 46 (photos: Justin Piperger)
figs 31, 32

Private Collection, on loan to
The Lowry Collection, Salford
cat. 41

Potteries Museum and Art Gallery,
Stoke-on-Trent
cat. 36

Southampton City Art Gallery, Hampshire, UK
/ The Bridgeman Art Library
cats. 1, 4, 39

Tate, London 2013
cats. 3, 32, 42, 45
figs 2, 4, 5, 11, 15

The Diana Brinton-Lee Estate
figs 9, 10, 20, 22–26

The Henry Moore Foundation Archive
figs 6, 13

The Hepworth Wakefield
cats. 27, 28 (photos: Norman Taylor)

The London Group Archive, 2013
figs 16, 17
figs 27–29 (photos: David Redfern)

The Samuel Courtauld Trust,
The Courtauld Gallery, London
cats. 13, 22

The Trustees of the British Museum
cat. 10
fig. 30

Victoria and Albert Museum, London
cats. 6, 21
fig. 21

Williamson Art Gallery and Museum,
Birkenhead
cat. 48

Whitworth Art Gallery,
The University of Manchester
cat. 18

Ongoing efforts are being made to seek formal
permission from the estates of the artists
currently untraced. The museum offers its
appreciation to all those who have granted
permission and apologies to those where we
were unsuccessful in making contact.

Art, Identity, Migration

The London Jewish Museum of Art, Bridging Communities since 1915

SHORT HISTORY AND MISSION STATEMENT

Ben Uri, 'The Art Museum for Everyone,' focuses distinctively on *Art, Identity and Migration* across all migrant communities to London since the turn of the 20th century. It engages the broadest possible audience through its exhibitions and learning programmes.

The museum was founded on 1 July 1915 by the Russian émigré artist Lazar Berson at Gradel's Restaurant, Whitechapel, in London's East End.

The name, 'The Jewish National Decorative Art Association (London), "Ben Ouri"', echoed that of legendary biblical craftsman Bezalel Ben Uri, the creator of the tabernacle in the Temple of Jerusalem. It also reflects a kinship with the ideals of the famous Bezalel School of Arts and Crafts founded in Jerusalem nine years earlier in 1906.

Ben Uri's philosophy is based on our conviction that, by fostering easy access to art and creativity at every level, it can add weight to our two guiding principles: 'The Dignity of Difference' and 'The Equality of Citizenship'. Ben Uri connects with over 300,000 people a year via its various creative platforms.

The museum positively and imaginatively demonstrates its value as a robust and unique bridge between the cultural, religious, political differences and beliefs of fellow British citizens.

Our positioning of migrant artists from different communities in London within the artistic and historical, rather than religious or ethnic, context of the British national heritage is both key and distinctive.

Through the generous support of our 'Preferred Partner' Manya Igel Fine Arts, we provide Free Entry to all our exhibitions, removing all barriers to entry and participation.

Ben Uri offers the widest access to all its extensive programming and physical and virtual resources including exhibitions, publications, website and outreach through:

- **THE PERMANENT COLLECTION:** Comprising 1300 works, the collection is dominated by the work of first and second generation émigré artists and supported by a growing group of emerging contemporary artists, who will be a principal attraction in the generations to come. The largest collection of its kind in the world, it can be accessed physically via continued exhibition, research, conservation and acquisitions or virtually.

- **TEMPORARY EXHIBITIONS:** Curating, touring and hosting important internationally-focused exhibitions of the widest artistic appeal which, without the museum's focus, would not be seen in the UK or abroad.

- **PUBLICATIONS:** Commissioning new academic research on artists and their historical context to enhance the museum's exhibitions and visitor experience.

- **LIBRARY AND ARCHIVE:** A resource dating from the turn of the 20th century, documenting and tracing in parallel the artistic and social development of both Ben Uri and Jewish artists, who were working or exhibiting in Britain, as part of the evolving British historical landscape.

- **EDUCATION AND COMMUNITY LEARNING:** For adults and students through symposia, lectures, curatorial tours and publications.

- **SCHOOLS:** Ben Uri's nationally available 'Art in the Open' programme via the 'National Education Network' and The London Grid for Learning' is available on demand to 25,000 schools across the United Kingdom. Focus-related visits, after-school art clubs, family art days and competitions are also regular features.

- **ARTISTS:** Regular artists' peer group programmes, International competitions, Guidance and affiliation benefits.

- **WELLBEING:** A pioneering set of initiatives addressing the young with special needs and the elderly who may be living in some isolation or with early stages of dementia. The programmes recognise the significant importance of the carer within the relationship and uses art practice as an effective bridge for positive engagement.

- **WEBSITE:** Provides an online educational and access tool, to function as a virtual gallery and reference resource for students, scholars and collectors.

The strength of the museum's growing collection and our active engagement with our public – nationally and internationally – reinforces the need for Ben Uri to have a permanent museum and gallery in the heart of Central London alongside this country's great national institutions.

Only then will the museum fulfil its potential and impact the largest audiences from the widest communities from home and abroad.

INDEX